SECOND EDITION

Great Comedy FILMS

Or: How I Learned to Stop Worrying and Love Funny Movies

CHRIS LAMONT

Kendall Hunt
publishing company

Cover and Chapter Opener images © Shutterstock.com
Back cover photo © Lifetouch Portrait Studios

Kendall Hunt
publishing company

www.kendallhunt.com
Send all inquiries to:
4050 Westmark Drive
Dubuque, IA 52004-1840

CONTENTS

ACKNOWLEDGMENTS

To pull off a project like this, you need a team of amazing people coming together for one goal—to make this book the best ever:

Lindsey Wynne, the dynamite Acquisitions Editor at Kendall Hunt, who convinced me to do this book—and supported my crazy idea about making a book about comedy film funny—instead of boring. And she gifted me with chocolate and caffeine to keep up my spirits;

Ryan L. Schrodt, the incredibly supportive Senior Project Coordinator at Kendall Hunt who kept me out of trouble for the first edition of this book. Even when I was ducking him because I was late on my deadlines, he never gave up on me;

Brenda Rolwes, the Kendall Hunt Project Coordinator who had to put up with me during the Second Edition. She had no idea how obnoxious and lazy I was, but she definitely knows now;

Jody Choberka, freelance copy editor who helped clean up the mess which was the entire first half of the book, putting her husband Andy and her kids Jake, Jana, Jillian, and Jennie's sanity to the test. Many nights went by where Jody was working and the family was forced to get pizza delivered;

Greg Bernstein, the Associate Director of the Arizona State University School of Film, Dance and Theatre in the Herberger Institute of Design and the Arts, for all of his support, along with Jake Pinholster, Linda Essig, Jeanette Beck, Cindy Noldy, and Dr. Tiffany Lopez, Director of the School of Film, Dance & Theatre for all they did to support me and this project;

John Landis, iconic writer/director of such great comedy films as *National Lampoon's Animal House*, *The Blues Brothers*, *Trading Places*, *Spies Like Us*, *Three Amigos!*, *Coming to America*, and scores of other films. I was hoping for a half-hour interview, and he gave me 2½ hours. That morning was one of the best things about writing this book and his involvement catapulted this project into something truly special;

Joe Russo, my incredible screenwriting partner in Los Angeles, and his amazing wife Crystal and adorable dog Bella, who took the time to wade through my interview with John Landis and gave me help and advice on how to make it all work;

Brian Kohatsu, professional stand-up comedian and one of my friends for over twenty years, He was the first one to review the manuscript and gave me some tremendous ideas for edits, and I used every single one of his suggestions;

Philip Taylor, my colleague at Arizona State University, who was the first one that graciously took the time to read and review the book. I knew the whole thing was making sense when he came back and said he was impressed. That meant a lot;

Gregory Maday, another colleague at Arizona State University, who also read through this weighty tome and gave me my second peer review. He's way too smart for me, and still thought the book was good;

Nick Nobs, talented graphic designer who jumped onboard for some super-fast images (he's the one who killed the cat) when I needed them the most;

And a ton of other people who gave me their support, **Paul Skiera**, who knows how to give me a hard time, **Janaki Cedanna** who coined the phrase "he thinks he's a lot funnier than he actually is," and my family **David**, **Madeline**, **Michelle**, **Marleen**, **Cayla**, **Derek**, **Brandon**, and my wife's family in Ohio—**Lynne**, **Beth**, **Reese**, **Chase**, **Amy**, **Tom**, **Jamie**, and **Carter** who have always been huge fans;

My two favorite children, **Luke** and **Lindsay LaMont**. [Editor's Note: they're his only children.] They had to put up with a ridiculous amount of "Dad's working in his office," taking my laptop on vacation, and missing at least one or two sports practices and parent pick-ups. I love you two goofballs;

And finally, the love of my life, my beautiful, patient, understanding, effervescent wife, **Lisa LaMont**—my toughest critic who's supported me since Day One on this and every other crazy project I happen to find myself in. She's the one who pushes me to work harder and make whatever I do the absolute best it can be. I couldn't (and wouldn't) want to do any of it without her.

That's it. If I forgot anyone, blame one of our cats.

INTRODUCTION

Hey You! That's right, I'm talking to you! Whether you're just browsing the shelf, clicking the website "Preview" button, stuck buying this thing because of a class you're taking, or maybe you just like movies and were seduced by the hilarious title—this is the book you've been waiting for!

Welcome to *Great Comedy Films or: How I Learned to Stop Worrying and Love Funny Movie*s.

This is pretty much the best book about American Comedy Films that has ever been written. I'm not bragging here. I've read a LOT of books about comedy films, essays, articles, blogs, and Wikipedia pages. Strike that, everyone knows that anything you read on Wikipedia is crap.

So I've read all these books and I'm telling you that *they're not very good.*

It's such an amazing topic that it breaks my heart to get into some of these ultra-thick academic tomes filled with hyperbole and a love of dense language that tends to overwhelm the poor reader.

This book is not one of those books!

I've spent nearly eighteen years of painstaking research (give or take about seventeen years and six months) writing this massive doorstop. It's been a passion of mine for some time and now you can enjoy the fruits of my labors. It is designed to inform and entertain, educate and illuminate, open your eyes and ears and your mind, body, and soul to the world of comedy in film.

Now, I know a big question that you have is "how exactly do you define a 'Great Comedy Film' Mr. Big-Time-Author?"

Fair question indeed. One of my primary resources is the American Film Institute's "100 Years . . . 100 Laughs" list, published in 1999. Those brainiacs over at the AFI are pretty darn smart, and make a lot more money than I do. So if you can't trust a non-profit organization (with a fabulous Film Graduate program) that spends their time celebrating and pontificating all things movies, then I don't know who to trust. I do have an encyclopedic knowledge of film, so I may pull some examples of comedy movies that are not on the list. Which in my opinion is perfectly okay, I mean—they can't all be great. *Or can they?*

Some of you may have a differing opinion on what you think great is. You may think some of the choices in this book are "mediocre," even "poor," but let's face it—who the hell is going

to buy a book called "Mediocre Comedy Films"? My publisher and editor decided that if we throw "Great" in the title, then we will sell a LOT more books. So, ta-da!

One thing about this book, if you're a sharp-eyed reader over the last few paragraphs, you may notice that I keep using the term "American" comedy films. First, the AFI only considered American narrative comedies for their list. Since this book is over 2,000 pages long, I have refrained from focusing on two different genres of film: foreign films and animated films. Frankly, I don't know what "funny" is in many countries, even in Britain—which created the "English" language of which I profess is my native tongue. Frankly I am still trying to figure out three-quarters of the dialogue in every Guy Ritchie movie ever made (who's with me? *Lock, Stock and Two Smoking Barrels? Rock and Rolla?* Anyone? Bueller? Bueller?).

I also had to refrain from animated films, specifically some of the Pixar movies—sorry Disney, but all you're giving us is princesses that aren't particularly funny (*Mulan?* Is she really a princess worthy of the $80 meet-and-greet Magic Kingdom breakfast?). But I do mention a few of them along the way, such as *Shrek* in the Mike Meyers section. Forgive me, but I could write a whole book on Pixar and their films such as *Toy Story* (1995), *Finding Nemo* (2003), *Up* (2009), and *Inside Out* (2015), but I have to keep this one under three thousand pages.

You can always disagree with me by posting on my website greatcomedyfilms.com or send me an email. I read them! I have nothing else better to do (since I actually finished this book, I have LOTS of free time).

Last thing, I'd like to thank the number crunchers, button-pushers, and computer nerds and nerdettes over at Box Office Mojo (boxofficemojo.com) for their comprehensive breakdown of how much movies have made at the box office through thousands of years of movie ticket selling. I shamelessly use their data throughout this book, and hope to my Lord and Savior that we don't owe someone a boatload of cash.

I discovered a long time ago that people like to find out how much money a movie makes. It's like checking sports scores or working on your fantasy sports team. Which sometimes sucks, because really good movies sometimes don't make any money. But luckily you won't find any "really good movies" in this book. It's called Great Comedy Films for a reason. You paid for Great, so you're getting Great!

I hope you enjoy this book and maybe, just maybe, you'll learn a little something about comedy and the amazing films that have made us laugh for over a hundred years now. This is a genre that will continue to entertain the world long after I'm dead.

With Love and Appreciation,

Chris LaMont
Author and Humanitarian

ABOUT THE AUTHOR

Chris LaMont is a multi-award winning independent writer, director, and producer. He is one of the Founders of the Phoenix Film Festival and has taught film production and analysis at the ASU School of Film, Dance and Theatre for the past twelve years.

Chris graduated Magna Cum Laude from Arizona State University and after graduating co-wrote and directed *Film Club*, a parody of *Fight Club* that was an Internet sensation, sold into distribution and DVD, and featured on CNN Headline News and on the home page of MSN.com.

The independent feature films that he has directed and/or produced include: *The Best Movie Ever Made, Writer's Block, 14 Days in America, Netherbeast Incorporated, My Apocalypse, The Graves, Justice Served,* and *Postmarked*.

Chris LaMont

© Lifetouch Portrait Studios

In 2015, his screenplay *Road Rage,* written with Joe Russo, was named in the Top 10 Finalists for Horror/Thrillers in the Final Draft Big Break Contest. The script finished in the Top 1% of over seven thousand entrants. In 2016, they were named "Top 100 New Writers in Hollywood" by industry insider The Tracking Board, and in 2017, their screenplay *Soul Mates* was named to The Blood List for unproduced Horror screenplays, The Hit List for unproduced Hollywood screenplays, and then optioned in 2017. He is currently repped by The Gersh Agency and Hollander Entertainment.

In 2000, he started the Phoenix Film Festival, which has grown to be the largest film festival in Arizona, and is a continual Best of Phoenix winner from both the *Arizona Republic/AZ Central* and the *New Times*. It has been named one of the "25 Coolest Film Festivals in the United States" by *MovieMaker* magazine.

He also started the non-profit Phoenix Film Foundation, served as both Chairman of the Board and the President for a combined fifteen years, and currently serves as the President of the National Advisory Board. He also founded the Phoenix Film Society and the local chapter

of the national filmmaker organization IFP—Phoenix (Independent Filmmaker Project). He also co-founded the International Horror & Sci-Fi Film Festival and the Arizona Student Film Festival.

He has been teaching at Arizona State University at the School of Film, Dance & Theatre in the Herberger Institute of Design and the Arts since 2003.

He completed his first book, *Great Comedy Films: or How I Learned to Stop Worrying and Love Funny Movies*, a comprehensive overview of American Comedy Film since the beginning of cinema in 1892, and might start writing a second book called *Filmmaker Nightmares*.

He has been married to his beautiful wife, Lisa, for what seems like forever, has two occasionally adorable children, Luke and Lindsay, and two cats. They live in Phoenix, Arizona, and enjoy the dry heat.

CHAPTER 1

The Birth of Comedy Film

OR:

The Obligatory Exposition on How We as a Human Race Figured Out How to Combine Both Comedy and Film into One Place

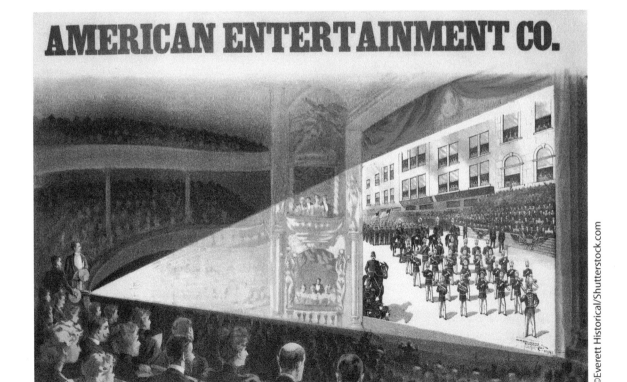

In the olde-tymes, this was an advertisement for one of those fancy mo-shun pict-chure companies

©Everett Historical/Shutterstock.com

> **CHAPTER FOCUS**
> ► What Is Comedy?
> ► What Is Funny?
> ► The History of Comedy
> ► The Invention of Film Comedy

Chapter Focus

Welcome to Chapter 1! I'm excited that you've muddled through and read my Introduction Page and are ready to start reading and learning. Hopefully I don't crash and burn. If I do, it's not me. It's you. To truly understand comedy, you need what we call in the academic world a "sense of humor."

If you don't have a "sense of humor," then return this book immediately. Unfortunately, by the time you actually start reading this thing, you missed out on the seven-day return policy. So now if you're in college, sell it back to the bookstore, and get back pennies on the dollar. On the Internet, there are never any refunds. Trust me on that one.

So maybe you should stick it out. Maybe you will find that sense of humor you have subconsciously buried since you sprang from the womb. I'm confident that over 50 percent of the content in this book is entertaining. Those are pretty good odds.

On with the book!

What Is Comedy?

The Definition of Comedy

Busting out the Merriam-Webster Dictionary (not one of your newfangled website, Internet dictionaries, but the original, hold it in your hand while you're in the bathroom publication) they simply define comedy as:

> COMEDY—noun: a play, movie, television program, novel, etc., that is meant to make people laugh: things that are done and said to make an audience laugh: comic entertainment: the funny or amusing part of something.

They have more full definitions of comedy, but my Editor says we can't put them here without paying a huge amount of money to get the clearance and permission. [Editor's Note: It would cost us nearly $8,000. More than we're going to make on this book.]

What Is Funny?

"And on the Eighth Day, God Created Comedy..."

Genesis 12:345

Comedy has been around since the birth of man. Actually before the birth of man. If you believe in a celestial being, then you know God has a great sense of humor. If you are an atheist, skip this part and go straight to the next part.

Like I was saying, God has a great sense of humor. How else do you explain the creation of things like the tomato (the most gender confused of all the food products: is it a fruit? is it a vegetable? Who knows?); the platypus (and look how long that thing lasted); and the Kardashians? I mean, the Big Guy in the Sky is still rolling on that one.

So the content of comedy has always been there, but what about us humans? Why do we find things funny?

OR, it all comes down to the evolution of humans. Again, if you believe in that sort of thing. If you don't, go back and reread the last part.

When you go to the zoo, you'll see monkeys jumping, throwing crap at each other, and slipping on banana peels. A 2005 *Quarterly Review of Biology* article by Matthew Gervais and David Sloan Wilson theorized that monkeys make breathy, panting sounds and gestures to signal that everything is okay in the world. It's a voluntary thing that tells the rest of those monkeys that it was okay to kick back, relax, explore, play, and socialize. You know, laughter!

The History of Comedy

Okay. God is funny. Check! Telling jokes and being funny wasn't reserved just for God. Scientists have identified the earliest recording of a joke found on a cave wall in Outer Mongolia and in the fabled "Well of Souls" in Tanis, Egypt.

"Caveman slipping on a banana peel, funny 10,000 years ago and still funny today." [Editor's Note: Both the editorial team and the publisher of this book have grave concerns that this is a doctored photo.]

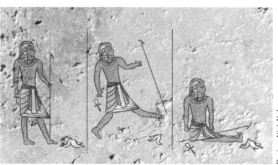

I told you this was still funny. Yes, that is an actual banana peel, imported thousands of miles to Cairo from Southeast Asia. Many lives were lost delivering these delicious fruits to the royalty of Ancient Egypt. [Editor's Note: Really pretty sure that this photo is not real. We have no idea how he made this. He might be a bit more clever than we initially thought.]

Moving on to more modern times, the origins of the word "comedy" come from Ancient Greece, and can be traced back by noted academics (i.e., me) to the Greek word "komast" which you can dissect with your fancy educations to "a drunken party." Face it, drunk people are always funny. Doesn't matter what century you're in.

I can go on about Aristophanes, the original comedy writer with his twenty-nine plays that he wrote (eighteen of them have been lost to the centuries, hopefully they were the bad ones), how he started the era of "Old Comedy," which was topical humor and based on local personalities and then "New Comedy," which was more general content.

Here's the rest of the history of comedy after Aristophanes:

Middle Ages—The Catholic Church comes down on the public writing and live performance of comedy. As if the Inquisition wasn't depressing enough, they also bummed everyone out. It still survives in medieval rural villages and at various festivities.

Italy in the fourteenth to eighteenth centuries creates an era of Commedia dell'arte, aka "Comedy of Art" to you non-Italian reading types, which relied heavily on actor improvisation, and all actors wore masks.

The Renaissance happened and people were allowed to laugh again. Take that Catholic Church!

William Shakespeare (1564–1616)— Shakespeare was a prolific playwright, poet, and from what I understand, a pretty good actor.

Ten of his thirty-eight plays are comedies, and they all share several similarities. Tremendous verbal comedy, slapstick, a bunch of sex jokes all over the place, and some dark elements underneath all of the light-hearted faire.

Moliere (1622–1673)—From France in the seventeenth century, this famed playwright and actor used commedia dell'arte and traditional dramatic structure, and that hilarious French wit. He established himself as the foremost comedic talent of his time and in Western literature. Beloved by King Louis XIV, he gained his fame through farces.

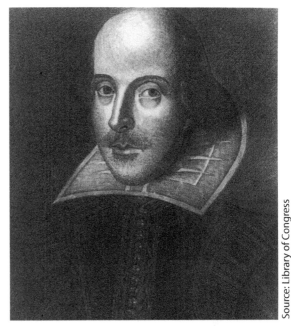

William Shakespeare, an up-and-coming playwright that has a bright future in the film industry.

Source: Library of Congress

Two hundred years passed, from the seventeenth through the early nineteenth centuries, and comedy was confined to the stage, performing the plays from the Irish novelist and playwright Oscar Wilde, the genius behind the comedy of manners such as *The Importance of Being Earnest* (which I'm sure you had to read in English class), and George Bernard Shaw.

In Great Britain, there was a proliferation of music hall theatres, where performers such as Charlie Chaplin and Stan Laurel got their starts. Physical comedy, verbal comedy, and pantomime were the mainstays of the British music halls. There were many risqué performances, burlesque shows, and a lot of alcohol.

Transported to America, the concept eventually became what is known as "vaudeville." Vaudeville was both traveling shows and non-traveling staged variety shows. They were advertised not with single performers, but it was branded as a contained wide assortment of acts. Some historians believe that the word "vaudeville" is derived from a French word that means "variety." And variety is what the audiences got.

For over seventy years the vaudeville circuit was the primary entertainment choice for audiences. But then things changed . . .

(cue dramatic music)

The Invention of Film Comedy

Photography had been around since 1800 in a variety of forms with inventors trying to figure out camera technology like lenses and housings, techniques for photographing in natural light, the need for artificial light, and the chemicals eventually used to develop negatives. Finally in 1888, George Eastman created the Kodak camera and actual dry paper gel that he dubbed "film," a chemical *film* placed on the paper instead of tintypes.

Photographers started playing in the 1830s with drums that would spin and someone looking through the drum would see an image moving. The term you are looking for is "persistence of vision." This optical illusion of movement is created when you watch a succession of still images.

The first known recording of actual moving images, as opposed to the posed images used for the revolving drums, was in 1878. British photographer Eadweard Muybridge had a bet with former Governor of California, Leland Stanford, revolving around the notion that all four feet of a horse were simultaneously off of the ground while the horse was trotting. Up until then, artists had always painted horses with one hoof on the ground. [Editor's Note: That is not a typo. Eadweard is actually how you spell his first name. We didn't believe it at first either.]

Muybridge set up twelve multiple cameras and photographed a galloping horse in a series of rides. When watched in succession through a lantern box, which was a primitive projector, it was plain to see that the horse had all four legs suspended in the air. Not extended out, but actually pulled underneath the horse's body.

Eadward Muybridge—The Man who Invented the Matrix

Source: Library of Congress

This technique was actually brought back to the forefront of artistry in 1999 for the movie *The Matrix*. The famous "bullet time" effect was created by firing multiple cameras on a 360-degree stage. See, I knew you'd eventually learn something cool from this chapter.

After Muybridge's bold experiment, several inventors began working on bringing a motion picture camera to life. The most successful in America was W. L. Dickson, who worked for the famed inventor Thomas Edison. Dickson created a machine called the "Kinetoscope" that took a series of instantaneous photographs on George Eastman's Kodak 35-mm film. In 1893, at the Chicago World's Fair, Edison debuted the machine. Truth be told, his "movies"

were pretty mediocre, like his assistant Fred Ott sneezing. So content-wise, it was pretty thin, and only one person could look through the kinetoscope to watch the movie.

In 1892 (a year before the debut of Edison's kinetoscope), Auguste and Louis Lumiere of France began experimenting with their own camera, called the "cinemotograph." The machine was able to both photograph moving pictures and show them on a wall, thanks to their innovative use of sprocket holes on the sides of the film. These holes would help wind the film through the camera and the projector.

This machine did three things: photographed, developed the negative, and projected the image for more than one person to view at a time. Because of this, the Lumiere brothers are known as the "Fathers of the Motion Pictures."

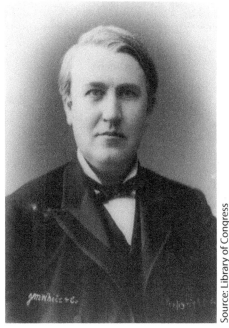

Source: Library of Congress

Thomas Edison—a promising young inventor

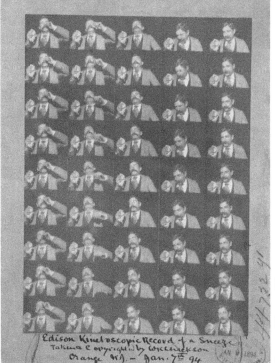

Source: Library of Congress

Fred Ott's Sneeze—The highest-grossing American movie of 1894

Their machine, the "cinematograph," gave birth to the term "cinema" and the art of motion picture photography, which is called "cinematography," from the French word "kinema" meaning movement, and "graphein" meaning to write. There you go—that's got to be something you didn't know!

They perfected their machine in 1895, and had their first public screening of films. Hand-cranking their machine, each of their ten short films was a single, unedited scene that ran about fifty seconds.

Most of the short films shown were little more exciting than a sneeze. The very first film screened was called *Workers Leaving the Lumiere Factory*. The scene is the first documentary ever shot, which they called "actualities," and it's an exciting scene filming workers leaving a building after work.

But the second film on the bill is the one to pay the most attention to.

The Sprinkler Sprinkled (in some records it's also known as *Watering the Garden*) is the first narrative film in history. It also happens to be a comedy! A Man has a hose and waters some plants in a garden. A Boy comes up behind him, stands on the hose and the water stops. The Man, bewildered by the lack of water, holds the hose up to his face to see what's what, and then the Boy takes his foot off the hose and you got it, the Man gets hit square in the face with a burst of water!

A poster with the word "Cinematographe" on it (the stock image company had real slim pickings for this one)

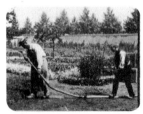 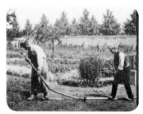 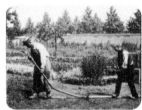 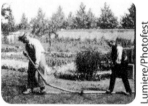

The Sprinkler Sprinkled (1895)—Directed by the Lumiere Brothers, aka the cinema's first wet t-shirt contest

Okay, it's not exactly *The Hangover,* but for 1895 that was comedy gold.

And from there everything changed!

How's that for a cliffhanger?

FADE OUT

CHAPTER 2

The History of Silent Film—Part I

OR:

I've Never Watched a Movie Without Sound in My Life— Except When My Sound Bar Was Turned Off

Pin-up models from the Mack Sennett Comedies

Source: Library of Congress

> **CHAPTER FOCUS**
> ▶ The Edison Years
> ▶ Silent Film Clowns
> ▶ Mack Sennett and the Keystone Film Studio

Chapter Focus

So, back to our ongoing history lesson! If you read the synopsis of this book (or is it a summary? Sure it's one of those two, so confusing all this English language stuff) then you know we're taking you through the Magical Mystery Tour of Comedy Films. So buckle up as we turn the DeLorean up to 1.21 gigawatts and let the history of the genre enfold you in its warm blanket of love.

I know many of you aren't history fans. In fact, a recent poll conducted by the Reuters Agency found that 72 percent of human beings don't care about history. They prefer to live in the now. They remember history, but it doesn't impact their daily lives—except for those who forgot to do the poll the day before, and then it SIGNIFICANTLY impacted them. [Editor's Note: We suspect that this poll and its ridiculous claim are complete fabrications. We are contacting our legal team.]

In our previous chapter, we discovered the hilarious *Sprinkling the Sprinkler* by those cinematic pioneers, the Lumiere brothers. They had the corner on the film business in Europe, but in America the invention of motion pictures is credited to Thomas Edison.

The Edison Years

Edison, you remember him? The guy who invented the lightbulb? How about the phonograph (aka the "record player," please see my next book *Great Audio Inventions of the Late 19th Century* available at fine bookstores very, very soon) which Edison built using principles from the telegraph, where he kick-started his fledgling inventor career.

Suffice to say, Edison invented a bunch of stuff, and after improving the telegraph, he and his lab team in Menlo Park, New Jersey, did even more: the fluoroscope (x-ray machine), the harnessing of electric current (he started a little company called General Electric), and stock tickers. In 1891, his greatest invention, the kinetoscope, a peep-hole viewer was designed

with his lab assistant W. K. L. Dickson. It was exactly what it sounds like—a box that a single person could look through to watch a little movie.

Quick note: Some of you out there are probably like "Hey, didn't those Lumiere Brothers make their cinematonic thing in 1895? That's like four—or was it five years before—the Edison guys?"

Thank you for the inquiry. Edison and Dickson created a camera and a **single** viewer contraption in 1891. The Lumiere Brothers invented a recording and projection system so a roomful of people can watch it. That's why they get the credit!

In 1894, Edison and his team filmed the first comedy film in the United States, the immortal *Fred Ott's Sneeze*. This is a documentary, not a narrative film like *Sprinkling the Sprinkler*. In this film, one of Edison's employees, Fred Ott of the title, takes some snuff (for some reason, old-time people liked to stick tobacco up their nose) and sniffs it and hilarity ensues. Spoiler alert! He sneezes!

It's also the very first motion picture copyrighted in the United States, and it's a documentary. It's no *March of the Penguins*, but at the time, and to many still, the short film is hilarious. The guy sneezes on camera. We call that slapstick comedy, folks!

But since it's not scripted, *Fred Ott's Sneeze* doesn't really count as a "comedy film" in my book. The book you are reading right now. That's the book I'm talking about. This one in your hands. See, I made a joke there!

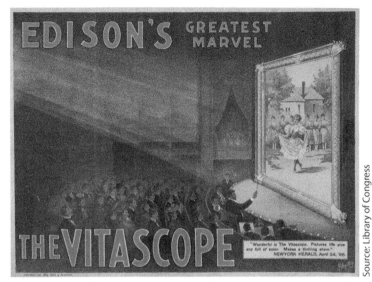

Source: Library of Congress

After Thomas Edison stole the design from the Lumiere Brothers Cinematographe, he "invented" The Vitascope

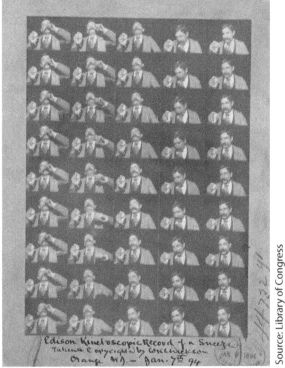

Source: Library of Congress

Fred Ott's Sneeze (1894) in case you missed it in the last chapter

Don't get me wrong, Edison and his team in New Jersey made plenty of comedies later on.

How about *Why Foxy Grandpa Escaped a Dunking*, when two boys set a water bucket on a door to drench Foxy Grandpa (yes, that is the name of the character) and slyly, Foxy Grandpa (okay I am totally smiling when I type that name) turns the tables on these kids by tying the string to the doorbell, instead of the doorknob. When the boys ring the doorbell to get Foxy Grandpa (I'm addicted to typing this name now) to open, they get drenched—HA!

Some of the great titles from Edison and other film production companies (that's right, other companies started making movies) included *The Schoolmaster's Surprise* in 1897, where two schoolboys put flour in a lantern, and when the Schoolmaster tries to turn the lantern on— BOOM! He gets covered in flour. Hilarious! Then there is *A Boarding School Prank* from 1903 where some young scalawags put flour into a closed umbrella on a rainy day, and when the poor schmuck opens the umbrella—PAFLAM! They get covered in flour! In *A Blessing from Above* in 1904, some rascals put flour into a bucket and tie a string to a doorknob, and when an unsuspecting target opens up the door—FLORP! They are covered in flour.

I think you're starting to get the hint here—comedy filmmakers in the 1900s were not at the top of the creative food chain. However, these visual gags set the stage for the beginnings of the silent film clowns and the slapstick techniques that they will employ to make some of the most original films in cinematic history.

Silent Film Clowns

When I say Silent Film Clowns, I'm not talking about actual clowns. Don't get me wrong, I'm sure that there were some clowns in these silent films, but we want to look at the leading figures of the silent comedy films that I'm sure you've never heard of!

Max Linder

Max Linder was one of the pioneers in silent film comedy and became the first comedic leading man to star in French films that were imported to America. His career was ahead of Charlie Chaplin and Buster Keaton. The complete opposite of Chaplin's famed "Little Tramp" character, Linder's comic persona was one of a fancy rich guy who got into shenanigans.

Working for producer Charles Pathe, who had bought the Lumiere Brothers' patents, Max starred in a number of comedic short films beginning in 1907. Some of the great films Max starred in were *Les Debuts d'un Patineur* (1905) where Max goes ice skating, *Max and the Quinquina* (1911) where Max takes medicine that turns him into a crazy drunkard, and *Max Plays at Drama* (1912) where Max creates a parody of seventeenth-century French royalty.

In 1916, Linder went to America for the princely sum of $5,000 a week to work for the Essanay Film Company in order to directly compete with Chaplin after he had left them to make more money with the Mutual Film Company. Max's American films did not catch on with American audiences. He also suffered from chronic depression at the time. In 1917, Linder returned to France and opened a movie theatre; he attempted to revive his film career, with poor results. Max's career waned and he and his wife died in a double suicide pact in 1925.

John Bunny

Max Linder may have been huge in France, but John Bunny was the first comedy star in the United States, and not only that, Bunny was also the first fat guy film comedian. His plumpness paved the way for such comic actors as Fatty Arbuckle, W. C. Fields, Oliver Hardy, Lou Costello, and John Candy. Don't forget Chris Farley, that dude was hilarious.

Bunny started in minstrel shows, which if you recall, were extremely racist. He moved to vaudeville and from there, graduated to working with Vitagraph Studios, one of the biggest film studios in the world, which was eventually bought out by Warner Brothers in 1925, and he made over a hundred short comedies.

Source: Library of Congress

John Bunny, the cinema's first "Fat Guy in a Little Coat"

Most of his films were broad slapstick where Bunny would drink, smoke, gamble, and chase around women (also known as Thursday at my house). In 1912, he starred in *A Cure for Pokeritis*, where his wife wanted him to go to church and get sober, and instead he starts a poker game. Also in 1912, he starred in *Stenographer Wanted*, where he and his business partner are looking to hire a new secretary based solely on her looks. His wife is not happy about their choices.

He was one of the first film celebrities, his face was insured for $100,000 and he has a star on the Hollywood Walk of Fame. He died in 1915 from Bright's disease, which is a terrible illness of the kidneys. An interesting fact, poet Emily Dickinson also had Bright's disease, and she died from it too! Thanks Wikipedia!

Mack Sennett and the Keystone Film Studio

Anytime you ever see a clip of a silent film in some montage shown during every Academy Awards broadcast since the beginning of time, you see some of Sennett's work. The crazy car chases of the Keystone Kops is his most famous work. He also opened the door for some of the cinema's greatest comedians, and won an honorary Academy Award in 1937 for his inspiration, genius, and platform for bringing new talent to the cinema.

The Canadian-born actor, singer, and director, known to many as "The King of Comedy" started making films for the Biograph Company, the first company in the world that exclusively produced and distributed films. Biograph was started by Thomas Edison's former assistant W. L. Dickson and released thousands of short films. It was the top American film company and in the top five in the entire world.

Sennett got investors and started Keystone in 1912. It was part of a wave of film productions that were forced to leave the East Coast because of Thomas Edison and his Motion Pictures Patents Company, who were suing independent film producers because they were "infringing" on his invention. His trademark filming style was full of crude slapstick comedy, primarily improvised, and employed a lot of machinery and vehicles. Unlike a lot of comedies of the time, the Keystone films were pure physical humor. The stories were fast, funny, and furious and didn't have any social or intellectual commentary at all.

He was also one of the first filmmakers to put a bunch of women on camera wearing bathing suits and objectifying them. "Sennett's Bathing Beauties" were a staple of the Keystone Films from 1915–1928.

"Sennett's Bathing Beauties"—the first actresses to learn about "the casting couch"

Source: Library of Congress

He also created the Kid Comedies which, as the name implies, employed young kids in wacky stories of slapstick and hilarity. The short film series idea was borrowed by producer Hal Roach when he started the *Our Gang* series, which was renamed as *The Little Rascals* for television distribution.

In 1915, Sennett produced *Tillies' Punctured Romance*, the first feature-length comedy film. He also made thousands of short films and became one of the most important film producers in Hollywood. The actual studio in the name "Keystone Studios" was in what is now Echo Park in Los Angeles. It was the first completely-indoor film soundstage ever built.

Keystone is known for opening up the world of motion pictures to such talents as Fatty Arbuckle, Mabel Normand, Harold Lloyd, W. C. Fields, and Bing Crosby. There was also some yahoo named Charlie Chaplin who also got his start working with Sennett and the Keystone Film Company.

Eventually, Sennett fell victim to many circumstances: The Great Depression, the bankruptcy of Pathe' Distributors that were showing his films, the advent of feature films, and choosing to make films that were only slapstick comedy.

What Sennett didn't realize was that the movie audiences wanted something more, and boy, oh boy, were they about to get it . . .

CUT TO BLACK!

CHAPTER 3

ARTIST SPOTLIGHT

Charlie Chaplin

©Olga Popova/Shutterstock.com

©neftali/Shutterstock.com

Source: Library of Congress

Stamps from around the world depicting Charlie Chaplin as "The Little Tramp"

> **CHAPTER FOCUS**
> ► Charlie Chaplin—The Early Years
> ► The Biggest Star in the World
> ► The Genius
> ► The Stuff That Happened When He Got Older

Chapter Focus

Okay, you've seen him. I know you have. Everyone *in the world* knows Charlie Chaplin. Or more precisely, his unforgettable character "The Little Tramp" with the small moustache (in which Chaplin complained how Adolph Hitler stole his look), the bowler hat, the cane, and the funny walk.

He is the icon of the silent film era. Even today, you can watch his films and appreciate the comedy, storytelling, and the masterful use of character. His commentaries on society (specifically the social divide between wealth and poverty) still resonate today.

Charlie Chaplin—The Early Years

Charles Spencer Chaplin was born in London on April 16, 1889. His dad was an alcoholic who abandoned his family after Chaplin was born. His mother, Hannah, was a music hall singer and raised Charlie and his older half-brother, Sydney, as a single mom, and the family was poor. Unfortunately, show business wasn't exactly the most lucrative of careers, especially back in the late 1800s. Growing up without money would play an important role in the creation of "The Little Tramp."

Think about it, "The Little Tramp" is a homeless bum. How many homeless bums are heroes in the cinema? Storytellers steer away from these types of characters. They are the unwashed living on the fringes of our society. Hard to avoid, easy to look past, and it's not a priority to pity your movie protagonists, but somehow he did it.

Famously, his mother was performing when her voice broke, and the stage manager pushed the five-year-old Charlie onstage because he had heard him singing. Of course, he performed marvelously. Her voice breaking was the end of her career. It didn't help that Hannah suffered from mental illness and was insane, and would be committed to an asylum soon

after. At fourteen years old, Charlie and his brother were forced to live in charity homes and workhouses.

Yet in spite of adversity, Charlie was a gifted performer, and at eight years old he signed on with a vaudeville act called "The Eight Lancashire Lads." Playing music halls in England for the next ten years, he caught the eye of Fred Karno, a music hall and burlesque producer. Karno caught lightning in a bottle when Charlie got more laughs than Karno's biggest comedians. As part of the comedy ensemble, Charlie played a drunken character that also was a forbearer of the Tramp character.

Karno took the troupe to New York City in 1910. Charlie was performing onstage when producer Mack Sennett spotted him and offered the princely sum of $150/week to come to the Keystone Studios in Hollywood. A star was born.

The Biggest Star in the World

Charlie's film debut was in 1914's *Make a Living*, where he decided to differentiate himself by creating a unique character that was easily recognizable. He grabbed some clothes from the wardrobe department, utilized a duck walk from a homeless man he remembered when he grew up in London, and "The Little Tramp" was born.

All in all, Chaplin ended up directing and starring in thirty-five short films for Keystone, helping the studio to become one of the most profitable of the early film studios. The Keystone style of comedy fit perfectly with Chaplin's sensibilities. The fast-moving physical comedies gave him the opportunity to put his Tramp character in all types of hilarious situations.

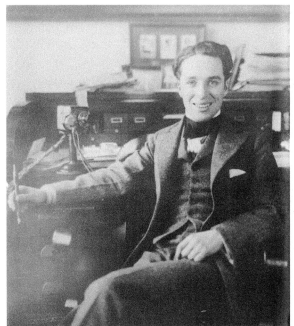

Chaplin made films with The Essanay Company in 1915

Source: Library of Congress

One of his most notable films was 1914's *Dough and Dynamite*, where the Tramp gets into a fight in a bakery, and soon started throwing flour, pies, bread, and dough. During the fight, the Tramp fashions weapons out of the dough, such as boxing gloves, a mallet, a slingshot, and a chair for his attack. During the battle, he's also flirting with a pretty girl. These films gave Chaplin his physical comedy backbone, but he began to add layers of storytelling when he moved on to his next studio.

After bringing his half-brother Sydney to Hollywood to become his manager, he accepted an offer from The Essanay Company to work for $1,250 a week. At Essanay, he made fourteen films, most notably *The Bank* (1915) where he played an incompetent janitor who dreams of saving his unrequited love from bank robbers.

The film had slapstick comedy and also a little sympathy toward the way Tramp is treated by the hopeful love of his life. In the end, we discover that the Tramp stopped the robbers only in his dreams. *The Tramp* (1915) found Chaplin's character on a farm where he falls in love with the farmer's daughter.

Charlie had his own problems at Essanay. He started making two-reel comedies that ran twenty-two minutes and spent a lot more time on production. He made less movies than he had at Keystone. They wanted him to use other people's scripts and he refused. The studio was unhappy about the $10,000 bonus paid to Chaplin, because he had never heard of the Little Tramp.

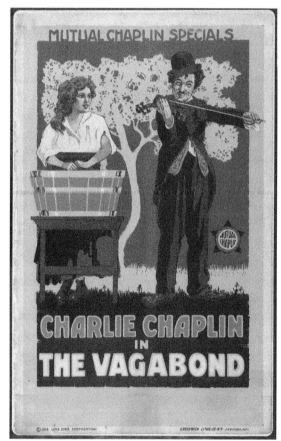

Essanay marketed and merchandised Chaplin's signature character including toys, postcards, cartoon strips, and even dolls. That's right, you could get a Little Tramp action figure, and he turned into a car! [Editor's Note: The Little Tramp dolls were neither Action Figures nor Transformers. For a more accurate depiction of the Transformers in motion pictures, please check out our two-page pamphlet *The Best of the Transformers Films*, selling for $80 at a bookstore near you.]

Now things were clicking for Chaplin. He was offered a contract by the Mutual Film Corporation to make movies, and earned $670,000 a year in 1916, the largest salary in the history of motion pictures. That was a crap load of money, I mean, soup was like a penny. But he deserved it.

Chaplin had total creative freedom. Mutual gave Chaplin his own studio lot, and he guaranteed them that he would make one film a month. The studio let him do whatever he wanted.

The Vagabond (1916)—early Chaplin film

Source: Library of Congress

In several Mutual films, Chaplin didn't play The Little Tramp. He was a firefighter in *The Fireman* (1916), a drunk in *The Cure* (1917), and a cop in *Easy Street* (1917).

Whatever he did, it didn't matter what character he was playing, the films were all hugely successful. The public wanted to know all about him, and he did a series of articles with a reporter that later became a book. Chaplin was now the most famous person in the world. To put this in context for our younger readers, he's like the Kim Kardashian of movies, without the sex tape.

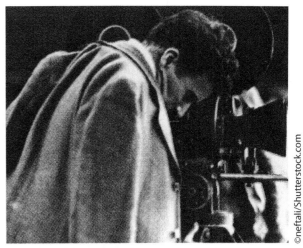

At the Mutual Film Company, Chaplin started directing his own films without studio interference

©neftali/Shutterstock.com

Chaplin finished up his contract with Mutual and then signed with First National Exhibitor's Circuit for eight films under his complete creative control. For these eight films, he would make (pause for dramatic effect) one million dollars. He took the money and built his own studio lot and stages in 1918.

Of most interest is 1918's *A Dog's Life* where he and his little dog struggle to survive in the big city. The film was forty-five minutes long and hailed by critics as one of the first motion pictures that was a great work of art.

Chaplin also was going through his first marriage, to the lovely seventeen-year-old actress Mildred Harris. He believed that he got her pregnant. But she apparently faked it. But then she REALLY did get pregnant with his first-born son. Unfortunately the boy was malformed and died three days after he was born.

The Genius

At this point he had finished his contract with First National, and joined the biggest actors in the world, Douglas Fairbanks and Mary Pickford, along with the most celebrated film director of his time, D. W. Griffith, in creating United Artists.

After Chaplin lost his newborn son, he wrote and directed *The Kid* (1921). The Little Tramp becomes the caretaker of a young boy (Jackie Coogan) who he found abandoned by the side of the road.

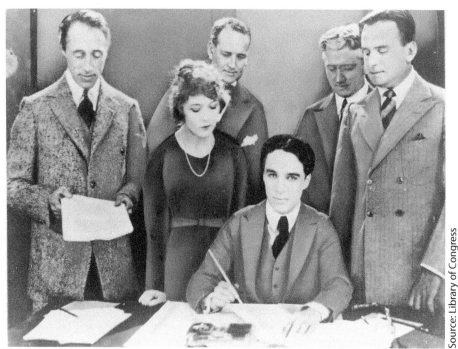

Source: Library of Congress

Charlie Chaplin (center) signs the contract to create United Artists with D. W. Griffith (left), actress Mary Pickford, and actor Douglas Fairbanks, with a bunch of lawyers hovering in the background

Moving forward five years, the Kid and the Little Tramp spend their time doing petty crimes, such as breaking windows and then showing up to fix them. The boy is taken away from the Tramp after the boy gets sick and the authorities find out that he's not his father. Meanwhile, his mother has become a wealthy actress and they accidentally meet at a flophouse. Eventually mother and son are reunited, and the Little Tramp is welcomed into their home for all he had done for the boy.

The film was the second-highest grossing film of the year, and is now in the Library of Congress at its National Film Registry. Many critics consider it Chaplin's most nuanced and important film, setting the stage for his later works where he successfully had woven drama and comedy into a complex story. Many also say it is one of the greatest films of the silent movie era.

We're going to forget all about his ill-fated marriage to his second wife, another teenage actress, the young Lita Grey. Chaplin got her pregnant and then married her. He was thirty-five at the time and could have been charged with statutory rape. He snuck down to Mexico for a quickie wedding, and his two sons, Charles Jr. and Sydney, were born within two years. Shockingly, their marriage was a disaster.

Next, came one of the seminal films of Chaplin's career, 1925's *The Gold Rush*. The film is the number 25 film on the AFI's 100 Laughs . . . 100 Years list (see the Super Great Movie Spotlight in Chapter 4).

Overall, *The Gold Rush* is enormously entertaining, and the perfect Chaplin film. Okay, *City Lights* is the perfect Chaplin film, but *The Gold Rush* is pretty awesome as well. *City Lights*? That's coming up—don't skip ahead!

For his next film, he decided to film *A Woman of Paris* in 1923. There are a couple of things about this movie: first, Chaplin isn't in it; it's a romantic drama; it failed miserably when his audience realized it wasn't a comedy.

So things get messy real fast. Charlie and Lita had a nasty divorce, which

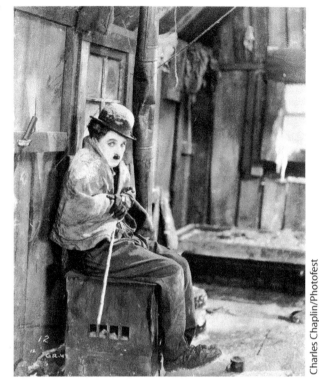

The Gold Rush (1925)

Charles Chaplin/Photofest

cost him a ton of money and went on in court forever. His mom died, and the IRS was after him for back taxes. Things were tough on the perfectionist filmmaker. So much so that the filming of Chaplin's next feature, *The Circus*, was delayed for over eight months; but, the film is the eighth highest grossing film in silent film history. Chaplin was never a fan of the film because of all of the personal stuff that was happening with him. Yet, it still earns another paragraph in the book.

The Circus (1928) follows the Tramp when he accidentally becomes the star of a circus (yes, you knew there had to be a circus in there somewhere). He hides under the big top after being chased by police because they think he's a thief, and the audience loves his antics. The owner of the circus hires him and soon the crowds are coming. He also falls for Merna, a trick horse rider, but her heart is smitten with Rex, the tightrope walker. She is also treated poorly and beaten by her stepfather, the Ringmaster. (Who thought that was funny? No idea.) The Tramp is heartbroken, his act suffers, and he's about to be fired. When the tightrope walker disappears, the Tramp takes his place in a huge stunt involving a bunch of monkeys. Eventually, the tightrope walker returns, marries Merna, and the Tramp beats up the Ringmaster for abusing her. When it's time for the circus to move on, the Tramp stays behind, tired of the circus life.

The best thing about *The Circus* for Chaplin was winning his first Academy Award "for versatility and genius in acting, writing, directing and producing *The Circus*." This was actually given to him at the very FIRST Academy Awards presentation. Though he was a genius, the Academy gave him only three Oscars, the other two were later in life when he had retired from the film business.

When *The Circus* was released, there was also a new attraction, talking pictures. Needless to say, Chaplin was not a fan of "the talkies." He didn't want to mess with his success, and change something that he knew that worked. He also doubted the artistry of sound films and thought they were inferior to silent films. He rejected the idea of the Tramp talking. He especially worried that the film would suffer overseas if the Tramp talked in English. Additionally, he found he liked being able to do his own musical scores, instead of trusting orchestras or piano players to do it for him.

Chaplin had been working on a script for his next film for over a year. The story of *City Lights* (1931) finds the Little Tramp falling in love with a blind girl with him trying to raise money to get her an eye operation. It comes in at #38 on the AFI 100 Years . . . 100 Laughs countdown. But somehow, the AFI 100 Years , , , 100 Movies list has it as the #11 greatest film in American cinema history. I don't get that math.

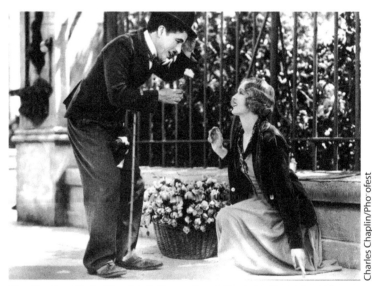

Charlie Chaplin is "The Little Tramp" and Virginia Cherrill is "The Blind Girl" in *City Lights* (1931)

Charles Chaplin/Photofest

The film was the hardest project that Chaplin had ever completed. He started filming at the end of 1928 and filmed for 190 days. That's a lot of filming.

The story goes like this—The Tramp meets this blind Flower Girl, buys a flower from her, and she hears a limousine pull away and thinks that the Tramp is a millionaire. The Tramp happens upon a real millionaire trying to kill himself. The Tramp talks him down and the millionaire is thrilled that he has a friend and brings him back to his mansion. Along the way, the Tramp spots the Flower Girl, and convinces the millionaire to buy all of her flowers. She gets to go to the mansion too, and at this point she is firmly convinced that the Tramp IS a millionaire.

Then things go crazy as they usually do in Chaplin films. The millionaire doesn't remember the Tramp helping him out, and kicks him out. The Tramp discovers that the Flower Girl and her grandmother will be evicted from their home, and promises to find the money to save them. He gets a job and loses it. Then he enters a boxing match looking for a quick payday. Guess how that one ends? There are some robbers, some bullies, and he even gets jailed for a couple of months.

I know I'm not giving you any details, and I'm sure not telling you how this movie ends. I know that more responsible authors would go into the most nuanced detail, but not me. I will say that you need to see this movie. I'm going to wait right here. Watch it all, then come back. You have a bookmark or something? [Editor's Note: It's not necessary for you to go out immediately and watch this amazing film before returning to your reading. You will not be penalized if you skip down to the next paragraph.]

Wow! Was that amazing? The last scene in the film is beautiful. Some critics say it's the best scene in the history of film. So amazing after all he went through, and he finally sees her. Okay, I am not lying here, I am getting a tear in my left eye, and it's rolling down my cheek. I hate to admit it, but I'm getting a little emotional right now. I'm sensitive. You have a problem with that? Go read somebody else's comedy book.

The film was selected in 1992 to become part of the Library of Congress National Film Registry. In 2008, AFI named it the Best Romantic Comedy in American cinema history. Chaplin said that *City Lights* was his favorite out of all of his films. So if you skipped that part about seeing *City Lights*, you're probably feeling pretty silly right now.

Fresh from his horrible divorce, Chaplin traveled the world, became interested in foreign affairs, tried to make a radio show, and met actress Paulette Goddard. The twenty-one-year-old actress (here we go again) became the leading lady for his next two films, both which would continue to show the world that Chaplin was more than just a funny guy with a little moustache.

Modern Times (1936) is a satire about life after the Great Depression, with machines taking over for man in factories, and how the Little Tramp navigates this industrialized world. Not just a slapstick comedy, the film presented larger themes of storytelling than his previous work. It is the #33 film on the AFI 100 Years . . . 100 Laughs list, and was placed in the National Film Registry by the Library of Congress in 1989.

The idea for the film came to him during his global travels after meeting with Mahatma Gandhi, and Gandhi expressing his concerns about factory workers and their place in the new world of machines. The Little Tramp is a factory worker, in over his head while trying to keep up with the machines that make everything go faster. He gets caught up in the machinery, literally being chewed up on a conveyer belt, and is arrested when he has a nervous breakdown from all of the work.

After meeting Ellen (Paulette Goddard), the Tramp falls in love, is arrested multiple times for having cocaine (accidentally given to him by someone else), for being mistaken for a communist, for stealing food, becoming a night watchman at a store and letting thieves in to eat, hitting his boss with a brick during a labor strike, and more. Much more.

Firmly ensconced in the sound era of cinema, Chaplin actually wrote *Modern Times* and the Tramp spoke. After filming for a couple of days, Chaplin threw it away. There is one scene where he does talk, but it's a rush of indecipherable dialogue and a poor attempt at a song. It was the only time that audiences would ever hear words coming out of his mouth.

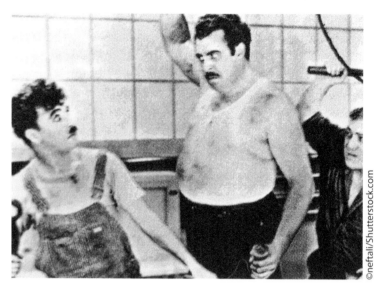

Charlie Chaplin stars in *Modern Times* (1936)

He still employed a lot of sound in the film, even dialogue from a speaker in the factory where the boss talks to his employees and a salesman on a record player. Chaplin did do a number of sound effects for the film himself, and also wrote the musical score. The song "Smile" was written for the film, and became famous after lyrics were added in 1954.

The song was eventually recorded by a number of artists including Nat King Cole, Barbara Streisand, and Josh Groban. This is the only time in this book that you will ever see Josh Groban's name. Let me do it one more time for all of his fans out there: Josh Groban.

Okay, I got that out of my system.

Modern Times wasn't a big box office hit with its themes of politics and social upheaval. It was also controversial for the Tramp scenes when he does cocaine. It did make some money overseas where his message resonated strongly. The film has one other significant part, it was the last appearance of The Little Tramp. Chaplin never wore the trademark outfit ever again. He donated his costume to the Museum of Natural History in Los Angeles and you can still see it there today.

The last of his most notable films was *The Great Dictator* in 1940, which is the #37 film on the AFI 100 Years . . . 100 Laughs list, and was placed in the National Film Registry by the

Library of Congress in 1997. This film was REALLY controversial, taking on Adolph Hitler and Fascism in a political satire that didn't hold back in its criticism of Nazi Germany and Mussolini's Fascist Party in Italy.

Chaplin was one of the first filmmakers to use his films to reflect the culture of the times. His was the first feature film to openly mock Nazi Germany and Fascism. A subject that would be taboo for the next four years.

The film is also Chaplin's first all-sound production. Since the Tramp had been retired at the end of *Modern Times*, Chaplin was able to end his concern about the worldwide appeal of his greatest creation.

The film starts in 1918 when a Jewish barber (Chaplin) saves the life of Schultz, a wounded German pilot, Tomania. Twenty years later, the barber lives in a ghetto patrolled by soldiers under the oppressive rule of Adenoid Hynkel (talk about non-subtle), a ruthless dictator (also played by Chaplin).

When Hynkel orders the Jews to leave the ghetto, Schultz protests and is branded a traitor. He escapes and finds the barber and his girlfriend Hannah (Chaplin's girlfriend Paulette Goddard) plan their escape to Austria (known as Osterlich in the film). Things get crazy when Hynkel is mistaken for the Jewish barber when he is out of uniform on a duck hunt and is thrown in jail. There is a big switcheroo when the Jewish barber takes Hynkel's place onstage for a rally. Onstage, he makes an impassioned speech for peace and harmony, saying he's changed his mind about his horrible ways.

One of the most famous scenes in the film is when Hynkel is playing with a giant balloon in the shape of the globe, singing and dancing around.

The similarities between Chaplin and Hitler were inevitable, given their choice of moustache style. Chaplin was very popular in the world at the time that the Nazi party was taking over Germany. Chaplin even put a disclaimer at the end, saying "Any resemblance between Hynkel the Dictator and the Jewish barber is purely coincidental." Some historians have said that Hitler did watch the film, and others say he didn't. Frankly, how could he not watch? Adolph was a psychotic egomaniac. I'd be shocked if he DIDN'T watch it.

The film was very popular in both America and England, especially since it was released when Great Britain was already at war with the Nazis. It was nominated for five Academy Awards, including Best Picture, Best Actor, Best Screenplay, Best Supporting Actor, and Best Music. It was the last great comedy that Chaplin would do.

The Stuff That Happened When He Got Older

After the success of *The Great Dictator*, Chaplin's personal life REALLY fell apart. He had an affair with actress Joan Barry, who said she was pregnant with his child. He denied this, and she filed a paternity suit. The FBI investigated him for the Mann Act, which prohibited transporting women across state lines for sexual purposes. He was acquitted of that. He lost the paternity suit when Carole Ann was born to Barry in 1944. The media coverage was like TMZ and Fox News headline stuff.

Things didn't help when Chaplin, who was fifty-four at the time, married eighteen-year-old actress Oona O'Neil, the daughter of famed American playwright Eugene O'Neill. The two of them remained married until Chaplin passed away in 1977.

He made two more features, *Monsieur Verdoux* in 1947, where Chaplin portrayed a serial killer who murders widows for money. He considered the film a black comedy but it was skewed by the critics and died at the box office. It did get nominated for the Best Screenplay Oscar, but lost. The film did do well in France where the movie took place.

Then he became friendly with several suspected Communists, and the FBI launched another investigation. He was subpoenaed by the House of Un-American Activities Committee but denied being a Communist himself, and then refused to become an American citizen.

His next feature is considered his last great film. *Limelight* (1952), is the story of a former vaudeville performer whose career dies and he becomes an alcoholic. Calvero (Chaplin) saves a young dancer, Terry, from suicide (much like in *City Lights*) and he nurses her back to health, gaining confidence in himself in the process. He tries a comeback and fails. Terry wants to marry him but Calvero feels he can't help her and leaves. He goes off and becomes a street entertainer and she becomes a famous dancer. She convinces Calvero to try one more time onstage, and reunites with his own vaudeville partner, played by the amazing Buster Keaton. We will talk about him soon. So sit tight!

In the end, Calvero gives the performance of his life, and then has a heart attack and dies in the wings while Terry dances, oblivious to her friend's demise. Talk about a bummer ending.

The film is noted for Chaplin and Buster Keaton in the same film. The two are considered the greatest comedians of the silent film era, and both had waned in popularity by then.

If you didn't figure it out yet, it was semi-autobiographical for Chaplin, as he wrote of his own disappointment as his own popularity had crashed. The character of Terry was modeled after his own mother, the dance hall entertainer. Calvero's father discovers his wife is having an affair and becomes an alcoholic just like Chaplin's dad. He also had his immediate family, including his son Sydney in a supporting role, play parts in the film.

The reception to *Limelight* was received well in Europe with over $8 million at the box office and also in Japan. Not so well in America, where it made a little over $1 million, and only played in a few cities like New York City and Boston. Even worse, Chaplin's visa to America was revoked, due to his Communist sympathy.

He and Oona sold his Los Angeles home and movie studio, unloaded his stock in United Artists, and moved to Switzerland. He stayed politically active and was awarded an International Peace Prize by a Communist organization. He made a film called *A King in New York* in 1954, satirizing the politics of the day, the Cold War and Communist paranoia. His film comments on many targets: TV commercials, plastic surgery, and one of his favorites, upper-crust society. Another semi-autobiographical film that skewed his own history of his exile from the United States.

The film was not released in the United States until 1973.

He was over seventy years old, and as time passed, he began to garner sympathy from the film industry, collectively asking the government to allow him to visit the United States. He rereleased some of his short films as a compilation called *The Chaplin Review* in 1959. He wrote *My Autobiography* which became a worldwide bestseller.

His last feature was in 1967, when he directed Marlon Brando in the romantic comedy *A Countess from Hong Kong* based on a script that Chaplin and Pauline Goddard had written thirty years before. It was another box office and critical failure.

Charlie Chaplin at Madame Tussaud's Wax Museum in Hollywood, California

The Jon B. Lovelace Collection of California Photographs in Carol M. Highsmith's America Project, Library of Congress, Prints and Photographs Division.

In 1972, he was invited back to America by the Academy of Motion Pictures Arts and Sciences to receive an Honorary Oscar for "the incalculable effect he has had in making motion pictures the art form of the century." He decided to return to the United States for the first time in twenty years. The Oscars' audience gave him a twelve-minute standing ovation during his emotional acceptance.

In 1974, he completed another autobiography *My Life in Pictures*. In 1975, he was awarded a knighthood by Queen Elizabeth II, and died on Christmas Day in 1977 with Ooli Chaplin at his side after suffering a stroke. He was eighty-eight years old.

If you want to see a GREAT movie about the life of Charlie Chaplin, back in 1992 the Oscar-winning director of *Gandhi*, Sir Richard Attenborough (who also played billionaire visionary John Hammond in the *Jurassic Park* films), made a biographical film called, you guessed it, *Chaplin*. Which actor played Charlie Chaplin? How about Iron Man himself? Robert Downey Jr. Not kidding here, and the movie is pretty good!

Charlie Chaplin's star on the Hollywood Walk of Fame is at 6751 Hollywood Blvd

Downey Jr. was nominated for an Oscar for Best Actor, won the BAFTA Award (British Academy for Film and Television Arts) for Best Actor, beating out Daniel Day-Lewis in *The Last of the Mohicans*. I'm not a huge fan of the Chaplin makeup when he is old in the film, but don't let that distract you. It's a fine film and will tie up all of this learning for you!

SLOWLY FAAAADING TO BLACK

CHAPTER 4
SUPER GREAT MOVIE SPOTLIGHT

The Gold Rush
(1925)

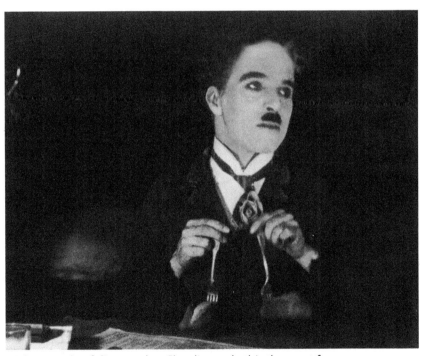

Dreamworks/Photofest

With a couple of dinner roles, Chaplin made this the most famous scene from *The Gold Rush* (1925)

> ► Starring Charles Chaplin, Mack Swain, Tom Murray, and Georgia Hale
> ► Written and Directed by Charles Chaplin
> ► Subgenres: Action, Fish-Out-Of-Water, Romantic Comedy
> ► Comedy Types: Slapstick, Dark/Black Comedy, Deadpan

I know the idea of watching a film in black and white with no sound except for some piano music and voice-over narration is a little daunting. But it's time to put on our big boy pants and get cultural-ified.

The Gold Rush is the best primer to begin watching silent films because of the broad slapstick physical comedy. I guarantee your money back on this book if you can sit through the entire movie and not laugh once. [Editor's Note: We are not honoring that.]

If you would rather watch something like D. W. Griffith's *The Birth of a Nation* instead, you are certainly welcome to do so. But there is nothing funny about the Ku Klux Klan. Stick with Charlie Chaplin and *The Gold Rush* instead.

Chaplin saw a photo of Klondike gold miners and read a book about the Donner Party in 1846 who were forced to eat each other when they were snowbound. Look it up. That's totally true. [Editor's Note: The Donner Party was also the influence of Trey Parker and Matt Stone's *Cannibal: The Musical.*] Though the idea was dark and disturbing, Chaplin believed that he could make a comedy out of this subject matter. Thus, the Little Tramp became a gold prospector in Alaska. This was one of the first films that Chaplin made with a script in place before he began production.

Synopsis

Set in northern Canada in 1898, Charlie Chaplin's iconic character The Little Tramp becomes The Lone Prospector, searching for fame and fortune during the Klondike Gold Rush. Out of place with his trademark bowler hat, walking stick, and threadbare jacket in sub-zero temperatures, he's immediately in over his head and nearly mauled to death by a bear in the beginning of the film.

During a blizzard, the Lone Prospector finds his way to a cabin owned by Black Larsen (Tom Murray), a fellow gold rusher who's wanted for murder. Larsen tries to throw him out, but is interrupted when Big Jim (Mack Swain) also takes refuge in the cabin. Big Jim has stumbled

upon a huge gold strike. The three of them wait out the storm, but food starts running out. After drawing straws, Larsen is sent out to find food but also discovers Big Jim's gold stash.

Back in the cabin, the two men are so hungry that the Lone Prospector cooks up one of his shoes, and eats the laces like they are spaghetti. But Big Jim is too hungry and a shoe won't suffice. He hallucinates that the Lone Prospector is a chicken and tries to shoot him.

After the blizzard ends, the two men part ways and the Lone Prospector heads to the next town and falls in love with a beautiful dance-hall girl, Georgia (Georgia Hale). He invites her and her friends to celebrate New Year's Eve with him, and as he waits that night for them to arrive, he takes some rolls and forks and turns them into legs and feet and does a little dance. But the girls never come, and he goes out looking for her.

In the meantime, she slipped away from her snooty friends and found that he had planned out their dinner and had even given her a present. She writes him an apology note that eventually gets to him, but before he can find her Big Jim appears. Black Larsen had attacked him, and during the fight, Big Jim hit his head and couldn't remember where the gold was! He needs the Lone Prospector to lead him back to the cabin, and promises him that he will make him a millionaire.

Another blizzard arrives as the Lone Prospector and Big Jim arrive back at the cabin. This time the storm is so bad that the cabin begins to teeter on the edge of the cliff. In an amazing scene with the cabin bouncing up and down, the two men try to escape with their lives before the cabin is destroyed. Will they survive and find the gold? Will the Lone Prospector hook up with Georgia? Does that bear come back thirsting for revenge?

Best Scenes

Eating Shoes and the Chicken Hallucination—Starving in the cabin, Big Jim and the Lone Prospector start cooking up one of the Lone Prospector's shoes. Big Jim gets the tongue, leaving the heel for the Lone Prospector, who also takes the shoelaces and eats them like spaghetti.

But Big Jim is so hungry that he hallucinates the Lone Prospector is a giant chicken, and chases the Prospector around the cabin with his shotgun, hoping to kill and eat his supper.

The Dance of the Dinner Rolls—As the Lone Prospector is waiting on New Year's Eve for Georgia and her friends, he dreams that he entertains them as he takes two rolls, sticks a fork in each, and begins to dance them around the table. Sweet and funny, it turns sad as the girl looks through the window with her friends and is peer-pressured into blowing him off.

Some of you ladies out there may recall the outright theft of this scene in the 1993 Johnny Depp romantic comedy, *Benny and Joon*. Depp calls the film a homage. We all know the truth . . .

The Teetering Cabin—The Lone Prospector and Big Jim try to survive as a blizzard shakes their cabin and eventually it plunges over a cliff! Chaplin had the cabin built on a tilting platform in a soundstage to make the characters struggle and look more realistic and even had a miniature cabin built as a special effect to show the outside of the cabin as it teetered precariously over the precipice.

Awards and Recognition

The Gold Rush is the fifth highest-grossing silent film in history making $4.2 million at the box office on a budget of $923,000. Of that $4.2 million, it's said that Chaplin made $2 million of that himself. At the Academy Awards in 1943, *The Gold Rush* was nominated for Best Sound Recording and Best Music when the film was re-issued in 1942. It didn't win anything when it first came out, because there was no such thing as the Academy of Motion Picture Arts & Sciences back in 1925.

The American Film Institute lists *The Gold Rush* as the #25 movie on their 100 Years . . . 100 Laughs List and it is the #74 film on their list of America's 100 Greatest Movies. In 1989, the film was one of the first twenty-five films placed in the National Film Registry at the Library of Congress.

CHAPTER 5

ARTIST SPOTLIGHT

Buster Keaton

Silent film genius Buster Keaton

Source: Library of Congress

Chapter Focus

When academics such as myself meet up at the University Club and gather around the fireplace, wearing our tweed jackets with the elbow patches, smoking our Sherlock Holmes' pipes, and holding a warm snifter of brandy to discuss the topics that we fancy—inevitably the question of Buster Keaton's place in the lexicon of American motion picture history comes up.

Some will argue, with a hearty laugh and an eye on their pocket watches, that Keaton's mastery of deadpan comedy, his sheer brilliance with mechanics and gadgets, the intricate building and organizing of lavish set pieces, his physical prowess, and his willingness to try new things raised the bar for film comedy, and overshadowed the great Charlie Chaplin as the greatest comedy filmmaker of the silent film era.

The Birth of the Great Stone Face

Joseph Frank Keaton was born in Piqua, Kansas, in 1895. This wasn't his hometown. He didn't have a hometown. His parents Mary and Joe Keaton were both in vaudeville. His father owned and performed in a traveling vaudeville show called the Mohawk Indian Medicine Company. Besides selling medicine on the side, the show was known for Joe's business partner, the famous magician and escape artist Harry Houdini who would travel the country and the world with the Keatons.

In fact, it's Harry Houdini that is credited for bestowing the nickname of "Buster" upon the young man at the ripe old age of eighteen months. Legend has it that the young boy fell down a flight of stairs and sat back up without getting hurt. Apparently Houdini complemented the boy, "That was a real buster!" In vaudeville, the term "buster" was when a performer took a

fall that could have caused serious injury if the performer didn't know what they were doing. From that point on, "Buster" Keaton would have a career destined for physical comedy performing.

At the age of three, he officially became part of his family's act. Onstage, he would not listen to his father, who would pick him up and throw him across the stage, into the orchestra pit or even into the audience. Shockingly, he was never hurt in all of these acts. He was actually known as "The Little Boy Who Can't Be Damaged."

All of this rough-and-tumble stage work helped Buster grow into the phenomenal comedy genius that he became. He was adept at improvisation and impressions. He loved the spotlight, and would laugh onstage when his father tossed him across the place. He soon realized that the audience laughed more when he didn't laugh. If he showed no expression, they laughed harder.

Thus was born his "deadpan" expression—no emotion and the lack of reaction gives the audience an even bigger surprise at the end. He would go on to be considered by many the most popular deadpan comic in history with the title of "The Great Stone Face" placed upon his mantle. His groundbreaking character would inspire thousands of comedians including Chaplin, who's Little Tramp character would have his own deadpan expressions as his reaction (or lack thereof) to the wildness of his own adventures.

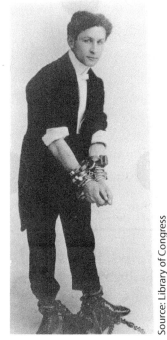

Famed escape artist Harry Houdini took time out from defying death to nickname the young actor

Source: Library of Congress

At the age of twenty-one, he started a solo act and was hired to appear on Broadway with Shubert's Passing Show of 1917 for $250 a week. Two months later he met Roscoe "Fatty" Arbuckle [Editor's Note: Chapter 6] and his life changed. Arbuckle knew Keaton to be a comedic star of the stage, and invited him to see what the movie business was all about. Keaton wasn't sure about this new "motion picture" thing but gave it a try. He appeared in his first film with Arbuckle, *The Butcher Boy*, and then asked to take home the camera so he could see how it worked. Arbuckle said yes, and Keaton took it apart and then put it back together. From that point on, he was sold. He

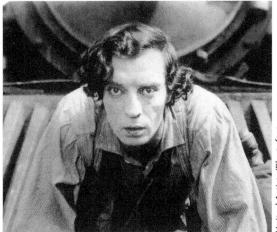

Buster Keaton is the King of Deadpan Comedy with the nickname of "The Great Stone Face"

United Artists/Photofest

quit his vaudeville contract and began working for Producer Joseph M. Schenk for $40 a week.

When Arbuckle went to do features in 1920, Keaton took over the writing staff and started making his own two-reelers under the banner of "Buster Keaton Comedies," and immediately did his first feature, *The Saphead*. Buster starred as the hapless son of a millionaire whose wedding is ruined when his jealous brother-in-law accuses him of getting a girl pregnant. Wow, that's pretty scandalous for the 1920s! The film is notable for the last time that Keaton smiled on camera. After that, it was just deadpan.

Keaton's character of "The Great Stone Face" was the same from film to film, and though he didn't react to the violence and mayhem around him, he was also very smart and resourceful. His woe-is-me attitude was far different than every other comedian in the movies.

He and Schenk followed up *The Saphead* with a series of two-reelers, including such films as 1920's *One Week*, where Keaton and his wife purchase a house that can be assembled in a week. Not only do the crates get mixed up, but they also built the house on the wrong side of the property, and are forced to move the house across the railroad tracks. Let's just say you should never do that. The film is a great example of the huge set pieces that will come to define his work.

He also had a personal life in here too! In 1920, he married Natalie Talmadge. She spent a lot of Buster's money, but also gave him two sons, Joseph "Buster" Jr. and Robert. She also forced Buster to buy a huge Italian villa in Beverly Hills that he couldn't afford, let her entire family move in, and made him sleep in a separate bedroom since she didn't want any more kids. Needless to say, they had a loveless marriage until they divorced in 1932.

He also wasn't invulnerable like he had been back on the days of the vaudeville stage. He broke his foot on an escalator filming 1921's *The Electric House*. In 1923's *Our Hospitality*, he almost drowned. There would be more injuries as time went on, including breaking his nose (1927's *Steamboat Bill, Jr.*), getting knocked unconscious by a cannon (1926's *The General*), and even breaking his neck (1924's *Sherlock Jr.*) However, he kept on making films, and never let these injuries slow down his pace.

In 1923, he left two-reel short films for good and returned to the world of feature films. His second feature was *Three Ages*, which Keaton wrote, directed, produced, and starred in, where he created a parody of D. W. Griffith's acclaimed epic *Intolerance*. This film is credited as being the first feature length comic parody film. His next feature was the satire, *Our Hospitality*, which used the famous Hatfield–McCoy feud as the setting for his comedy about a famous family feud between his family and the Canfields. The film ends in a huge chase scene at a waterfall where Buster's character almost falls to his death. That's where the whole "almost drowned" sentence from the above-paragraph reference.

The Brilliance of Genius

In 1924, Keaton starred and directed in one of his most-celebrated films, *Sherlock Jr.* He plays "The Projectionist," a movie projectionist who dreams of being a detective. His life is upended when he is accused of stealing a pocket watch from the father of "The Girl" played by Kathryn McGuire, whom he fancies. When it was actually his rival for her intentions, "The Local Sheik" (Ward Crane), who set him up for the embarrassment of his now-ruined love affair.

The Projectionist falls asleep at work and dreams that he goes into the movie that's playing on his screen as the World's Greatest Detective—Sherlock Jr. All of the characters in the film are now all of the people that the Projectionist is dealing with in his real life. Think *The Wizard of Oz* where "you were there, and you were there!" but Keaton did it twenty years beforehand.

In the film, the Villain (who looks like the Local Sheik) tries to kill Sherlock Jr. through elaborate traps, but Sherlock Jr. outwits him, saves the Girl, and returns to his own reality. When he wakes up, the Girl is there telling him that she found out that he didn't steal the watch and they kiss. All is good!

The neat thing about the film is the visual effect that Keaton employs to move Sherlock Jr. through different scenes. There was a visual continuity to the shots that hadn't been used by filmmakers, which Keaton was able to create using camera placement. Of course, he did his own stunts, and surprisingly, did the stunts for everyone else!

The film was not a big success upon its release, but the critics fawned over it and it has been recognized as one of the great silent films of the early days of cinema. *Sherlock Jr.* was placed in the National Film Registry of the Library of Congress in 1991.

Next up was 1924's *The Navigator,* which is the #81 Film on the AFI 100 Years . . . 100 Laughs list. This film continues to raise Keaton's own mark for extraordinary physical stunt work and visual scenery, including the use of a former Navy passenger ship from World War I. That's correct, the movie pretty much takes place on a ship in the ocean which any filmmaker worth their salt (I think that's a vague sea reference/pun there) will tell you is the absolute worst conditions for making a film.

Buster plays Rollo Treadway, a wealthy aristocrat who proposes marriage to his neighbor Betsy (Kathryn McGuire who was in *Sherlock Jr.*) and books a honeymoon cruise for he and his soon-to-be wife. She says no, but Rollo decides to take the trip anyway. Unfortunately he goes to the wrong ship, and shenanigans ensue as the ship sets off for a small country to use for its war.

By sheer coincidence, the boat just happens to be owned by Betsy's father. Thinking her father is on the ship, she sneaks aboard and ends up stuck when the ship is set adrift by saboteurs. When the ship crashes into a small island, Rollo climbs overboard and tries to repair the ship underwater. That's right, you read it correctly—underwater. Of course, Buster was underwater in the ocean, no special effects trickery there. No CGI back then. A group of native cannibals attack the boat, looking to have Rollo and Betsy for dinner, and now Rollo has to fight them off to save Betsy and they have to get the ship going (spoiler alert), the Navy saves the day!

Whew! I get exhausted just writing about it!

His next film was *Seven Chances* (1925), where he has the chance to win a huge inheritance if he can find a woman that can marry him by 5 p.m. that day. His girlfriend says no, and starts him on a wild chase looking for a bride where he asks seven women at the country club (hence the title) and all of them say no. Then a reporter writes a story of the bride hunt, and the church is practically attacked by a mob of brides-to-be, all intent on marrying the budding millionaire. He runs for his life, and finds a note that says his girlfriend changed her mind and she will marry him.

The most ambitious scene is the bride chase through the city streets while Jimmy tries to escape the horde. There must be three hundred women in the sequence. It is laugh out loud hysterical. Give it up to YouTube, the silent film fan's best friend! They run through the city streets, through a football game, through neighborhoods, through a railroad yard, through fields, creeks, hunting grounds, and he eventually ends up climbing up a mountain, causing an avalanche that chases him back down the mountain with rocks rolling everywhere! Okay, they weren't real rocks, but man, this one was awesome.

His next films, *Go West* (1925), where Buster goes west in search of fame and fortune as a cowboy, and *Battling Butler* (1926) both featured some great visual stunts. *Go West* has Keaton driving cattle down the streets of Los Angeles and *Battling Butler* has some smaller moments as wealthy Alfred has a hard time camping unless he's wearing his tuxedo. When he pretends to be a prizefighter, he tears off his robe to reveal a tuxedo underneath.

These films were merely appetizers, and the main course was about to be served with four films, a couple of which could rival Chaplin's best.

The Pinnacle of Success

In 1926, Buster Keaton directed, along with Clyde Bruckman, one of the greatest movies ever made. Period. Not just in the silent era. I'm talking in the history of movies. This is some serious filmmaking, folks.

The movie is *The General.* I wrote a lovely Super Great Movie Spotlight about it—it's over in Chapter 6.

I can't tell you how many people watch *The General* after my high recommendation and are blown away. This is the film that my academic colleagues present as evidence that the genius of Buster Keaton was light years ahead of the playful Little Tramp. Chaplin may have cornered the industry with his playful Little Tramp character, but Keaton hands down made a world of such big budget and comedy spectacle that couldn't be topped for the rest of the silent film era.

And therein lies the problem.

The General was the highest budgeted comedy of all time at that point. The train crash on the collapsing bridge scene, which was done with a real train on a real bridge that was really destroyed, was the most expensive single shot in movie history for $42,000. The film's budget was $750,000

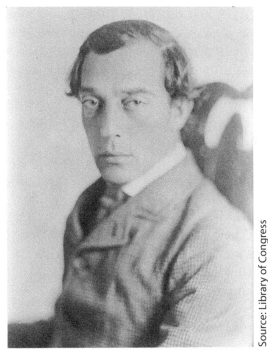

Buster Keaton as Johnny Gray in
The General (1926)

Source: Library of Congress

and Producer Robert Schenck barely recouped his money after all was said and done. People in the film business want to make money. Not lose it.

The Studio Deal with the Devil

After *The General*, Schenck sold Keaton's contract to MGM. Keaton was assured it was the right thing to do especially in an era where only big studio money could cover Keaton's big ideas. Even though it was reported that both Charlie Chaplin and Harold Lloyd told Keaton not to take the deal, he went ahead and did it anyway. This was the biggest mistake of his creative life.

After *The General*, Keaton needed a hit and came up with 1927's *College* where he starred as Ronald, a young college freshman who in high school made his valedictorian speech about "The Curse of Athletics" and was despised by everyone. His girlfriend Mary drops him like a hot potato, telling him that everyone loves sports, and the only way she would ever love him would be if he became an athlete.

What follows is Ronald attempting to make the college baseball team and the track and field team, competing with Mary's new jock boyfriend. Ultimately, he makes the college rowing team, helps the team win the big meet and gets redeemed and, for some reason, Mary's jock boyfriend holds her hostage until Ronald saves the day.

The film is a bit of a puzzler to academics. It seems to be a knock-off of Harold Lloyd's infinitely superior film *The Freshman*, where the young comedian tries to make it on the school football team. [Editor's Note: See more about Harold Lloyd in Chapter 8.] This film didn't do well either. Let's pretend that one didn't happen. The next one is much better.

The Last Hurrah

The genius of Buster Keaton came roaring back in *Steamboat Bill, Jr.* (1928). William "Bill" Canfield Jr. (Ernest Torrence) is the owner and captain of a paddle steamer in the South. He's excited that his son, Bill Jr. (who he hasn't seen since he was a baby), has come home after graduating college. William needs his son's help so he can compete against his fierce rival, John James King (Tom McGuire).

Unfortunately, Bill Jr. (Keaton) isn't steamboat worthy material, he's a bit of a fancy lad, wearing a pencil-thin moustache and playing the ukulele. He's also in love with his rival's daughter, Kitty (Marion Byron). To make matters worse, Bill Sr.'s ship is condemned because it's unsafe, and the father is jailed after attacking King who he believes orchestrated the whole thing to drive him out of business. When Bill Jr. tries to break him out of jail, the Sheriff knocks Bill Jr. out and he goes to the hospital.

When Bill Jr. wakes up, a huge cyclone is bearing down on the town. With the town falling apart, buildings are torn open, and one nearly falls on Bill Jr. He ends up saving Bill Sr., Kitty, and even her father from the killer storm. In the end, the fathers relent so their children can be together, and a wedding is just around the corner.

The greatest scene in the film is the cyclone scene which cost over $100,000 to have the building facades get torn off and fall apart. The town was built on a riverbank so it could go into the water when the storm hit. At times, Keaton flies through the town, carried by the wind (in which he was attached to a 120-foot crane that propelled him from building to building).

In the film's most memorable moment, Keaton stands in front of a building, and the entire front of the building falls down on him except he's saved when his body goes through an open window. It's a real effect. The building front weighed two tons. If he had been off in his calculations by a few inches, he would have died.

It's one of the most visual gags ever put on film. Unfortunately, the movie was a box office failure. The critics ravaged it and Keaton lost any creative leverage he had with his new studio.

His 1928 film *The Cameraman* is considered by many to be the last good Keaton film. It's similar in tone to *Sherlock Jr.*, using the façade of the movies as a background where he plays Buster, an aspiring cameraman trying to woo Sally, played by Marceline Day, who works for MGM in their Newsreels department.

Of course, he's a total failure at it, but Sally cares for him. There's a rival for Sally's affections that wants nothing more than for Buster to fail. He shoots footage of a gangland war, but forgets to load the film. Or so he thought; there's a wacky monkey who swapped out the film reels. In the end, he's recognized for his Great War footage, and saves Sally from near death during a boat race he happened to be filming.

Unlike his recent run of critical failures, *The Cameraman* was well received. It didn't lose as much money for MGM as they projected. The film was chosen by the Library of Congress to be placed in the National Film Registry in 2005. But, that didn't help Buster back then.

It's said that MGM wanted Keaton to smile at the end of *The Cameraman*. They apparently filmed it and tested it with screen audiences. They hated it. But the incident typifies the world that Keaton now found himself—he would never call the shots again. Producers, directors, and writers who now oversaw his material surrounded him and forced him to act in films that he didn't care for. Sound films were now coming to the studio. He would make one more silent feature, *Spite Marriage*. And now, "The Great Stone Face" would have to talk.

It didn't help that he became a terrible alcoholic, and was committed to a mental asylum (but escaped the straight jacket with a technique that Harry Houdini had once taught him as a young lad on the vaudeville stage). His voice wasn't the best, and like Chaplin he was a product of the silent films. Coupled with the loss of his creative freedom, he spiraled downward and after a few lackluster films that were some of the most profitable of Keaton's career, he was fired by MGM in 1933.

He made a film in Paris and another in England. He went back to Hollywood to make two-reeler comedies, and began writing for other film comics such as The Marx Brothers. His loveless wife Natalie left him and took most of his money and in a bizarre alcoholic binge, he married his nurse after a blackout. She left him after a wife swapping scandal and took the rest of his money. Then, he met Eleanor Norris and they married in 1940. She helped him recover from his alcoholism to get him back on solid ground and would stay with him until his death.

He went on to do television, appearing in *The Twilight Zone* and had his own unsuccessful shows, *The Buster Keaton Show* in 1950, and *Life with Buster Keaton* in 1951. He even had a biography made about him, *The Buster Keaton Story*, starring Donald O'Conner (*Singin' in the Rain*) that was released in 1957.

He appeared in a number of films, most notably Billy Wilder's classic *Sunset Blvd.* in 1950, *It's a Mad Mad Mad Mad Mad Mad World* in 1963, *Beach Blanket Bingo* in 1965, and *A Funny Thing Happened on the Way to the Forum* in 1966. However, the force that was Buster Keaton, the visionary writer and director, had been gone for a long time. In 1966, he passed away from lung cancer.

He has two stars on the Hollywood Walk of Fame, one for his film work and one for his television work. He won an Honorary Academy Award in 1959 for his lifetime of tremendous achievement and is now regarded as one of the greatest comedians of all time, being named the twenty-first greatest male film star by the AFI and the seventh greatest director by *Entertainment Weekly* magazine. Finally, in 1992, the International Buster Keaton Society was formed that celebrates his life and legacy with annual conventions and the continuing mission to spread the brilliance of Buster Keaton to generations to come.

REALLY SLOW FADE TO BLACK

CHAPTER 6
SUPER GREAT MOVIE SPOTLIGHT

The General (1927)

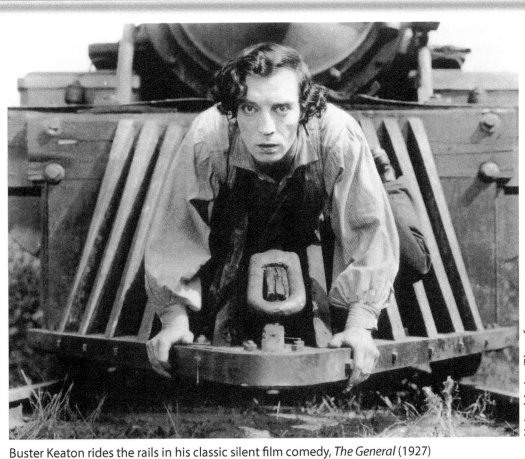

Buster Keaton rides the rails in his classic silent film comedy, *The General* (1927)

> ▶ Starring Buster Keaton and Marion Mack
>
> ▶ Written and Directed by Clyde Bruckman and Buster Keaton
>
> ▶ Adapted Screenplay by Al Boasberg and Charles Smith
>
> ▶ Based on the novel *The Great Locomotive Chase* by William Pittenger
>
> ▶ Genre-Hybrid: Action-Comedy
>
> ▶ Subgenres: Military, Romantic Comedy
>
> ▶ Comedy Types: Deadpan, Slapstick, Dark/Black Comedy

The deadpan world of Buster Keaton reached its zenith with this madcap Civil War epic film where Keaton saves the South from the dreaded Northern Army through his love for his girl and his train. A huge feature-length chase scene with astonishing stunts, all performed by Keaton himself, yet at its core is a romantic comedy that centers the gravity of the situation.

And it also includes the most expensive practical special effect at that time, the destruction of a steam engine crossing a wooden bridge. Definitely one for the ages!

Summary

Set in 1861 during the American Civil War, the film follows Johnnie Gray (Keaton), a young train engineer with, as the film says in the opener, "two loves of his life," his locomotive, nick-named The General, and his girlfriend, Annabelle Lee (Mack). When war rears its ugly head, and both his train and Annabelle are kidnapped by the Northern army, it's up to Johnnie to save the day.

The General was one of the biggest budget films of the silent era, ringing in at $750,000. Anchored by Keaton, known as The Great Stoneface for his deadpan reactions to the chaos around him, the film was a failure upon its initial release. As time has passed, the film has gained acceptance by many critics who believe it to be the greatest silent film ever made.

When war is declared, Johnnie goes to sign up, and is immediately rejected by the Confederate Army. He's more valuable as a train engineer, but no one actually tells him that. Instead, Annabelle wants nothing to do with him "until you are in uniform."

A year passes and when Annabelle's father has been wounded in battle, she takes the General, ignoring Johnnie the entire time, to see him. When the train arrives at the platform, Union spies steal his beloved train. Worse, Annabelle is on the train as well.

From there, Johnnie does whatever he can to chase the train—from running to bicycling to railway handcars—and ultimately reaches Chattanooga where he is able to get his hands on another locomotive, The Texas, to give chase with a car of Confederate soldiers along to take The General back by force. Unfortunately, Johnnie didn't realize that the other cars were unhooked, so Johnnie leaves on his own, the troops wondering what happened.

The chase heats up as Johnnie steers The Texas after his beloved stolen train. The Union spies throw rail ties on the track, disconnect cars, and switch lines, all to no avail. As Johnnie finally approaches, the Union spies realize that he's alone and surround him. He stops the train and escapes into the forest.

Tired and hungry, Johnnie finds an old cabin in the middle of the woods, where the Union spies happen to have set up their base. He overhears plans for a surprise attack, and then Annabelle is brought to the cabin. Quickly they escape and Johnnie steals back The General, and with Annabelle hidden in a flour sack and with the Union on their tail, they speed home to tell the Confederates about the Union's plan.

Cue the big ending! There's a big train, which is not The General—and it's about to crash—oh, just go ahead and read the below paragraph.

Best Scenes

Signing up to Serve—After Annabelle sends Johnnie away, he goes to sign up for the Confederate Army. It doesn't go as planned.

Every Chase Scene—Since the movie is pretty much entirely made up of chase scenes, you will be amazed at the physical choreography that Keaton goes through, with him continuously running after the train trying to catch up by running down the hill is one of the best ones.

The Big Crash—With the Union Troops about to attack, the Union General demands that the train go across a bridge that has been sabotaged by Johnnie. The train promptly starts across, and with a huge explosion, the train and bridge crash into the river. It was the biggest and most expensive special effect in the history of silent motion pictures.

Awards and Recognitions

The American Film Institute lists *The General* as the #18 film on their 2009 list of America's Greatest Movies as well as being #18 on the 100 Years . . . 100 Laughs List. In 1989, the film was one of the first twenty-five films placed in the National Film Registry at the Library of Congress.

CHAPTER 7

The History of Silent Comedy Film—Part II

OR:

There Were Other Comedians in the Silent Film Era BESIDES Charlie Chaplin?

Stan Laurel and Oliver Hardy star in one of their best, *The Sons of the Desert* (1933)

MGM/Photofest

> **CHAPTER FOCUS**
> ▶ Who Is Hal Roach?
> ▶ Who Is Harold Lloyd?
> ▶ Who Are Laurel and Hardy?

Chapter Focus

The silent film era lasted through the 1920s, with the advent of this crazy technology called "sound recording." It gave audiences a chance to hear what the actors were saying on-screen. We in the film industry call that "dialogue." They also could hear "music" and "sound effects." This "sound recording" was an immediate success for the motion picture, and is still in use today.

Until the sound revolution, the biggest change for the comedy filmmakers of the time was the gradual decline and eventual end to the one-reel (10-minute) and two-reel (20-minute) films that started the careers of so many performers. The shift moved away from the shorter situation-led comedies to the performer-led feature films that celebrated individual filmmakers.

Besides Chaplin and Keaton, there were other comedians and filmmakers that made their mark and brought smiles to audiences across the world. Here's but a few of them:

Who Is Hal Roach?

Born in 1892, Hal Roach was born in upper state New York and traveled as a young man across the world. He was a cowboy in Alaska and got the chance to be an extra in a silent film. He got the film bug, and quickly rose up the ranks to become a movie producer.

After he received a sizable inheritance, he started Hal Roach Studios with comedian Harold Lloyd, and together they created Lonesome Luke, a competitor of Charlie Chaplin's The Little Tramp. The Roach/Lloyd films were highly profitable, and Roach added a number of stars to his roster: comedian Will Rogers, Jewish comedian Max Davidson, famed actress ZaSu Pitts, and most famously, he discovered Stan Laurel and Oliver Hardy. The team of Laurel and Hardy would go on to cinematic superstardom.

Roach bought land in Culver City, California, and built the Hal Roach Studio lot. He created the "Our Gang" little kids comedy short films, renamed them "The Little Rascals," and started stealing talent from his biggest competitor Mack Sennett. [Editor's Note: Details about Sennett are back in Chapter 4.] Unlike the Sennett comedies, Roach's films had warmth and emotion, not just fast-paced car chases and slapstick comedy.

With Laurel and Hardy's 1931 debut *Pardon Us*, he moved from short films into featured. He was criticized for a production deal he did with budding Italian filmmakers Vittorio and Benito Mussolini. Not kidding, the Italian fascist wanted to be in the Hollywood film business. Hal Roach's studio deal with MGM fell apart due to his poor choice of business partners and his films, except for the Laurel and Hardy features, did poorly at the box office.

Young actors Mickey Daniels and Peggy Eames from the Hal Roach "Our Gang" one-reelers

Source: Library of Congress

In 1942, he was drafted by the Army and made over 400 training films (along with such actors as future President Ronald Reagan) and after the war, the Army upgraded his studio lot in appreciation for his work. In 1943, he started reissuing his older films to television companies, and he was one of the first Hollywood film producers to embrace the new medium. In the 1950s, he recognized that feature films were losing momentum at the box office and retooled his soundstages and backlots for dozens of television productions. In 1983, he was also one of the first producers to start colorizing black and white films.

He received an Honorary Academy Award in 1984 for his contributions to the industry, and passed away at the ripe old age of 100 in 1992. His legacy in the film business will live on for many years to come.

Who Is Harold Lloyd?

The image of a young bespectacled man hanging above Los Angeles from a clock tower is one indelibly associated with silent film comedy. I wish we could show you that picture, but the rights for getting still images for this book turned out to be a bit more

complicated than I thought when I first pitched the idea of this book. Let's just say that my publisher was pretty firm when it comes to how much they are spending to make this book happen.

[Editor's Note: The Harold Lloyd Estate has taken over all images and reproductions of Lloyd's films, and we were forced to come up with something more artistic at a fraction of the hefty licensing fee. Suffice to say that this book is affectionately known around the office as "the Money Pit."]

Born in Nebraska in 1893, Harold Lloyd was a stage actor discovered by the Edison Film Company and cast as a background extra in the film *The Old Monk's Tale*. He ended up sneaking onto the Universal Studio backlot (much like a young fledgling film director named Steven Spielberg would do in the early 1970s and look how he turned out) where he met Producer Hal Roach. [Editor's Note: See three paragraphs above.]

Source: Chris LaMont

This rough crude drawing, which we aren't paying a dime for, is similar to a famous still photo of Harold Lloyd hanging above Hollywood in *Safety Last!*

Roach put him in a couple of forgettable films and then they created Lloyd's character, Lonesome Luke. With a threadbare suit, a moustache, and a backward fedora, Lonesome Luke was pretty much The Little Tramp, except at a different studio.

But when Lloyd and Roach decided that he needed to differentiate Harold from Charlie Chaplin, Lloyd put on a pair of eyeglasses and changed into a normal pair of clothes.

With the "Glasses" character, Lloyd stood out as a regular guy who gets stuck in extraordinary situations. The audience could more identify with his comedy than with Chaplin, and Lloyd immediately grew popular in a series of shorts.

Unlike The Little Tramp, the glasses-wearing Lloyd was a young man trapped in society, looking to better himself, and also could fall in love. Lloyd's work is some of the first appearances of the subgenre that we call romantic comedy. In an interview with CBS reporter Harry Reasoner in 1962, Lloyd said, "When I adopted the glasses, it more or less put me in a different category because I became a human being. He was a kid that you would meet next door, across the street, but at the same time I could still do all the crazy things that we did before, but you believed them. They were natural and the romance could be believable."

Lloyd did his own stunts, and that trademark also would come back to bite him. He had a brush with death in 1919, when he was doing promotional photos with what was thought to

be a prop bomb. He held it in his hand while light-ing a cigarette from the lit fuse. Surprise! It was a real bomb, it exploded and Lloyd was temporarily blinded and lost his hand. Doctors said his career was over and he would never see again. Boy, were they wrong. A special glove was created that he would wear in his films so that audiences wouldn't be distracted by his handicap.

In 1923, Lloyd starred in his first feature, *Safety Last!* In this romantic comedy, he plays The Boy who leaves for the big city so he can find his for-tune, and with his success he intends to send for and marry The Girl, played by Mildred Davis (who he would later marry).

Harold Lloyd and actress wife Mildred Davis

In the city, the best he can do is as a department store sales clerk, but one night he and his room-mate "Limpy" Bill (lots of colorful nicknames back then) played by Bill Strother, see a friend from The Boy's hometown who is now a police officer. He decides to pull a prank on his old friend and knocks him over only to realize that he accidentally knocked over *a different* police officer. The Boy runs off as "Limpy" Bill escapes by climbing up a building face, and the police officer vows to track him down.

The crazy thing about this is that Lloyd did it all himself, a daredevil without the aid of wires or special effects. Though with trick camera angles and editing, he was only up about three stories at any time. But still! Remember, he only had one hand!

Safety Last! was a huge hit, and Lloyd had the foresight to start his own production company outside of Roach, and was able to keep a lion's share of the profits. After the success of *Safety Last!*, Lloyd starred in a string of features, all featuring amazing chase scenes and daredevil stunts. *Girl Shy*, about an aspiring stuttering writer known as The Poor Boy, falls for a girl, named The Rich Girl, played by Mary Buckingham, but can't marry her until he sells his book *The Secret of Making Love*.

He finds out too late when he reaches a publishing deal that the woman he loves is marrying someone else. He rushes to stop the wedding in a crazy chase through the countryside and into Los Angeles proper involving horseback, streetcars, bootleggers, wagons, and multiple car crashes. I don't think it's a coincidence that the guy she's trying to marry looks like Charlie Chaplin especially when Lloyd kicks him down the stairs!

His next film was his greatest triumph. *The Freshman* (1925) stars Harold Lloyd as Harold Lamb (how's that for clever character naming? It's like Charlie Sheen being named Charlie in

Source: Library of Congress

every single sitcom he's ever done), a young man entering Tate University. On the train, he meets Peggy, played by Jobyna Ralston, and they immediately fall for each other.

He wants to be popular, but his antics actually make him the school loser. He tries out for the football team, but the coach isn't impressed. The captain of the football team suggests that he become the water boy, and he is excited. Poor Harold thinks he made the team. Then he goes to the school dance, where the school bully is hitting on Peggy. Harold stands up to him, and is humiliated when it's revealed that Harold isn't the popular guy he thought he was.

Harold decides the only way to make everything right is to get into the big football game, and gets his chance when the players drop out one by one with injuries from the bigger team they are playing. He gets the chance to win the big game . . . does he do it? Watch it for yourself!

Harold Lloyd's star located just east of the Baja Fresh at 6906 Hollywood Blvd

The Freshman was Harold Lloyd's most popular film, is the #79 film on the AFI Comedy Film list and was placed in the National Film Registry of the Library of Congress in 1990.

After the success of *The Freshman*, Lloyd was one of the biggest comedic stars in the world. He actually made more money in the 1920s than Chaplin, made more movies than Chaplin, and had a less-messy personal life than Chaplin. He was the top-grossing box office star of 1927 and 1928.

He was one of the most innovative filmmakers in the silent film world, pioneering new camera techniques, and was the first filmmaker to preview his movies to live audiences and get their feedback. He would then go back and re-edit the film based on their notes.

The transition to sound was handled easily by Lloyd, unlike his contemporary Buster Keaton. His next film was filmed in both silent and sound film versions. *Welcome Danger* in 1929 was a big hit, but the stock market crashed thirteen days after the movie's release.

Harold Lloyd stamp, released in 1994—look how cheap stamps were back then!

He continued making films, but his popularity waned through the Depression, and he made films until the 1940s. His last film was in 1947 and wasn't well received. He did some television work, and since he owned all of his films, he wouldn't exhibit them unless he was paid a lot of money.

He was a founding member of the Academy of Motion Pictures Arts & Sciences, and he received an Honorary Oscar in 1953 for being a "master comedian and good citizen," as opposed to his rival Charlie Chaplin, who was fighting Communist sympathizing charges at the time. He has two stars on the Hollywood Walk of Fame, and his handprints, along with an outline of his famous glasses, are in concrete at the TCL Chinese Theatre in Hollywood.

He died in 1971, leaving behind a legacy of brilliant films that still hold up to this day.

Who Are Laurel and Hardy?

Maybe you've heard the line "Another fine mess you've gotten me in." If you have, you already have a taste for the team of Stan Laurel and Oliver Hardy, the original "fat guy and skinny guy" comedy act. They became the first real comedy duo to achieve motion picture stardom. Just to keep it straight, Stan Laurel is the thin guy and Oliver Hardy is the big one.

Laurel and Hardy

©neffali/Shutterstock.com

Arthur Stanley Jefferson, the son of actors, was born in 1890. Like Chaplin, he went into the British music hall circuit at an early age. In fact, Chaplin and Laurel were in the Fred Karno vaudeville troupe that traveled to America from England in 1910, and they both remained in America. He adopted the stage name of Stan Jefferson, and primarily worked the vaudeville stages. He made his first film in 1917, starring in *Nuts in May*, where he plays a lunatic in an asylum. He ended up changing his name to Stan Laurel at the suggestion of actress Mae Dahlberg, who he had partnered with in a series of films, and they lived together as common-law man and wife until 1925, which seems weird to me. She eventually left the country when Producer Joe Rock said she was distracting Laurel from his work and bribed her to leave. This seems even weirder to me.

Laurel made twelve two-reel films for Joe Rock, and then signed with Hal Roach Studios. Soon, the first motion picture comedy team would come together.

Norvell Hardy was born in 1892 in Harlem, Georgia. His father Oliver had died soon after Norvell was born. At an early age, his mother recognized his talent for singing and sent him to Atlanta to study music and theatre. He changed his first name to Oliver as a tribute to his father. He had no interest in school and studies, and found himself a job as a movie projectionist. It was there that his lifelong attraction to the movies first appeared.

He moved to Florida where he was a cabaret and vaudeville singer. He appeared in a series of one-reelers for the Lubin Manufacturing Company. Because of his size (he weighed over 300 pounds), he was confined to play the bad guys, also known as the "heavy" in storytelling. I am not making this up.

In 1921, he found himself in a one-reel titled *The Lucky Dog*, where he met and appeared on-screen for the first time with British actor Stan Laurel. Oddly, they wouldn't

Laurel and Hardy

act in another film together until 1926, when Hardy was hired by the Hal Roach Studios.

Finally in 1927, the two men came together in three two-reel films and Roach realized that the men were a great team that the audience loved. They officially began their partnership with *The Battle of the Century*, which contained the largest pie fight ever filmed. Scores of films followed, including their transition from silent to sound films in 1929's *Unaccustomed As We Are*.

The first of their seminal films is 1929's *Big Business*. Stan and Oliver are Christmas tree salesmen who get into a heated war that escalates when a would-be customer destroys their demonstration tree with a pair of hedge clippers. Things get out of control quickly, with the boys destroying his doorframe, and it accelerates from there. The slapstick short film was placed into the National Film Registry of the Library of Congress in 1992.

Sound coming to the movies was a big boon for Laurel and Hardy. Unlike Chaplin, who was not keen on sound films; or Lloyd, who had a hard time with them; or Keaton, who flat out couldn't make the transition at all—Laurel and Hardy flourished. Sound gave them the opportunity to express their characters. It wasn't just the fat guy and the skinny guy. Laurel was the sensitive lad while Hardy was the headstrong leader of the two. Oh, I forgot to mention that they both were idiots!

The interesting thing about their partnership was that Laurel was actually the writer of the team's work. He spent countless hours on their work, and Hardy would go play golf. But their partnership, in which the sum of their parts was stronger than themselves alone, was cast with an eye toward hilarity. Their partnership lasted thirty years, and Laurel never appeared without Hardy ever again.

They appeared overall in 106 films, including small parts in some musical revue films (essentially vaudeville acts put on film). It was in 1931 that they starred in their first feature, *Pardon Us*. They still continued to make shorts and two-reels until 1935, and won an Academy Award for their short film *The Music Box* in 1932. The film is all about Laurel and Hardy pushing a piano up a huge flight of stairs. It's in the National Film Registry in the Library of Congress, so you know it has to be good. I'm telling you, go hit the YouTube video.

Their big film together was *Sons of the Desert* in 1933.

Stan and Oliver are members of the Sons of the Desert, a fraternal lodge having a huge convention in Chicago. Oliver is all set to go, but Stan is afraid to ask his wife. When he does ask, she has no problem with it; however, it's Oliver's wife who actually won't let him go. Because of his oath to his brothers requiring him to go to the convention, they concoct an elaborate scheme. Oliver says he's sick and the doctor says the only cure is for him to take a cruise ship to Hawaii. It works! Off to the convention they go!

Unfortunately, the ship they told their wives that they were on sinks in a typhoon and their wives go to the boat company's office to see if they survived. The boys have arrived home, found out about the ship sinking, and hide in the attic while the grief-stricken widows return home. In need of a laugh, the women go to the movies where they see a newsreel story about the Sons of the Desert Convention, with Stan and Oliver featured in several shots. When the wives see this, it bodes poorly for the guys. Or does it? [Editor's Note: It does.]

The film is listed as the #96 film on the AFI Great Comedy Films list, and was placed in the National Film Registry of the Library of Congress in 2012.

They stayed with the Hal Roach Studios until 1940 and then moved to 20th Century Fox and later MGM. Unlike their time at Roach, they were employed as actors for the studios, and had limited creative input with the director. Their films were wildly successful at the box office, and in their last film *Atoll K* (1951), the boys are stranded on a desert island. The film was a misfire. Commercially unsuccessful, both Laurel and Hardy became sick with severe illnesses.

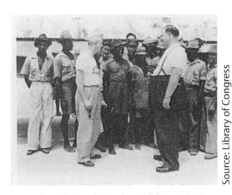

Source: Library of Congress

Laurel and Hardy in the USO in 1943

The two men did a tour of British music halls in the 1950s, appeared on the television programs, and Oliver did some acting on his own until he passed away after he suffered several strokes in 1957.

Laurel disappeared from the public eye, refusing to appear on camera without his best friend and comedy partner. In 1960, Stan Laurel was given an honorary Academy Award for his work, but was too ill to attend the ceremony. He died in 1965.

As the original "fat guy and skinny guy" comedy team, they opened the door for comedy partnerships including Abbott & Costello, Burt Reynolds & Dom Deluise, Dan Aykroyd & John Belushi, Penn & Teller, David Spade & Chris Farley, Conan O'Brien & Andy Richter, and Jay & Silent Bob.

There are a couple of other notable performers instrumental to the art and popularity of comedy films.

Roscoe "Fatty" Arbuckle—In the mold of John Bunny (because he was another fat guy), Arbuckle was one of the Keystone Films stars who mentored Charlie Chaplin, discovered Bob Hope and Bing Crosby, and is best known for his career being destroyed by the accusation that he had raped and murdered actress Virginia Rappe. Though he was acquitted after three trials, the stigma of the whole sordid affair ruined his career. He was the O. J. Simpson of the 1920s!

Source: Library of Congress

"Fatty" Arbuckle, pretty happy guy before he was accused of murder

Ben Turpin—One of the more recognizable silent comedians, primarily because he had crossed eyes. He worked with Chaplin at Essanay Studios, but did not like Chaplin's style of filmmaking. He moved on to the Keystone Studios, where Mack Sennett put him in crude slapstick comedy films where he became a well-known star. He was always worried that one day his eyes would uncross, and he retired from film when sound came to the industry.

> As you've read, when sound came to the movies, it became a whole new ballgame. For many of the silent film comedians, it was the end of an era and for many, their careers. Forgive me, but what a terrible way to end this chapter.

END SCENE!

CHAPTER 8

The Comedies Started Talking

OR:

Why All of Those Olde-Time Movies Have Everybody Talking So Fast

Columbia Pictures/Photofest

Cary Grant and Rosalind Russell in *His Girl Friday* (1940)

Chapter Focus

"And on the Ninth Day, God created sound in the movies.
That's because he created the movies on Day Eight."

—Chris LaMont, author

There was always sound in the movies. Somebody used to play the piano or the organ along with the movie to match the action, to help with the emotional undertones of the film, and also to cover up the sound of the really, really loud projectors.

From the beginning of cinema until 1927, the language of the cinema was purely visual. Title cards were used to represent dialogue and filmmakers told stories understanding how to convey action and emotion without saying a word.

I won't bore you with the science stuff of how they got sound to match the pictures and changed the world of film forever. What I do know is that four of the biggest companies in America—RCA, Western Electric, AT&T, and Warner Brothers Studios—came together to create the machines that both recorded sound and then amplified them in a movie theatre setting.

In the beginning, they would record the audio for the film and place it on a big phonograph, or a "record player" as many of the kids called it back then. The phonograph would be rigged to the film projector, and then the audio would play in what was supposed to be in perfect synchronicity with the film running through the spools.

Eventually they were able to affix a magnetic strip with the recorded audio on the side of the film, with the audio amplification system built into the projector. This way both sound and picture were always in perfect synchronicity. [Editor's Note: Didn't he say he wasn't going to bore us with science stuff that we wouldn't understand?]

The End of Silent Films

In 1926, Warner Brothers tested the technology by releasing some one-reelers where comedians told jokes and others sang and played musical instruments. This technology was ultimately developed through Western Electric and called the Vitaphone recording system.

Most of the stuffy archivists and film historians and academics (I'm not talking about myself here or any of my esteemed colleagues) talk about the Warner Brothers film, *The Jazz Singer*, produced in 1927. They will tell you it was the first film to feature sound. Not true!

Poster for *The Jazz Singer* (1927) which at the time wasn't racist, but now I am cringing writing this caption

Warner Brothers released the feature film *Don Juan*, starring John Barrymore, which had a synchronized score played by the New York Philharmonic. So *The Jazz Singer* was not the first sound film, and not even the first "talkie," or even the first musical. But, it's the one everyone remembers!

Technically, *The Jazz Singer* was the first feature film to have spoken dialogue used as part of the story. About 25 percent of the movie had dialogue, the rest were musical numbers. The first all-talking feature film was the Warner Brothers mafia drama, *Lights of New York*, which premiered in 1928.

The Jazz Singer had all the attention. You can't have a retrospective montage of Hollywood's early days without hearing and seeing star Al Jolson's most famous line from the film, "Wait a minute! Wait a minute! You ain't heard nothin' yet!" Okay, it's a little offensive because he's wearing blackface. Besides that, it was huge. *The Jazz Singer* grossed $3.5 million. In today's money, that's worth $46 million.

The Beginning of the "Talkies"

Once the technology worked, and the studios saw how much money Warner Bros. was making from *The Jazz Singer*, everyone jumped onboard. Warner Bros. had put up $500,000 to develop the Vitaphone technology. They made that back easily on the first movie. Producers all over the industry took all their films in production and stopped everything to adjust to the

new technology. However, notable comedy geniuses like Chaplin, Keaton, and Lloyd continued to ply their trade in silence as sound emerged to audiences.

To see a hilarious movie about the advent of sound, you should check out the 1952 Gene Kelly musical *Singin' in the Rain*, which we will discuss later in the book. [Editor's Note: Chapter 19.] It's a very funny movie, made even better by Jean Hagen's hilarious Academy Award-nominated performance as the screen actress diva Lina Lamont. That's right, the character's last name is just like mine! So the movie must be good!

The silent film stars who didn't have great voices were left in the dust, as well as the one- and two-reel comedy format. There were those comics who rose out of the silent film heap and were able to transition into the next era of sound motion pictures, such as Stan Laurel and Oliver Hardy, which we discussed previously. [Editor's Note: Chapter 7.] Other notable personalities quickly migrated from vaudeville and music hall stages and planted their feet firmly in Hollywood.

Once people started talking on-screen, suddenly the audiences couldn't get enough of sound in the movies. Cumbersome microphones were brought in, limiting the amount of physical comedy that could be filmed. Actors were tethered to wherever the director could hide the microphone.

There was also a major cultural shift for Hollywood studios. They had to find writers to come up with dialogue and directors to work with the actors. It's a lot easier to pantomime emotion than to act in a convincing way so the audience is engaged.

To make great movies, you need great screenwriters. Huge literary figures, such as John Steinbeck, Dorothy Parker, William Faulkner, and Ernest Hemingway, were brought to the West Coast to write for the movie industry. Unlike the silent films, where the performers were the creative forces, it's now the writers and directors that were the true stars of the silver screen. The actors memorized their lines and went where the director told them to go, and the success of the film was based on the collaboration between these three separate disciplines coming together for maximum effect.

With the emphasis on dialogue, slapstick physical comedy disappeared and a new style of comedy developed: the verbal comedy. From the loins of verbal comedy sprang its most celebrated comedy style—screwball comedy. There were also chaotic comedies, which combined verbal comedy and slapstick. The Marx Brothers were the kings of chaos, so they get their own chapter, which they richly deserve. I just don't hand out full chapters to any comedy star. (They have to earn it!)

There were three different categories of comedy films made during this era before 1944—Verbal Comedy, Chaotic Comedy, and Screwball Comedy. Check out Chapter 10 about

W. C. Fields and Mae West, the biggest stars of the Verbal Comedies and Chapter 11 about the Masters of the Chaotic Comedies, the Marx Brothers.

But the biggest comedy films of the era were the Screwball Comedies.

What the Heck Is a Screwball Comedy?

The name came from the glorious game of baseball where a pitcher is able to contort his arm into a pitch that breaks away from the batter. When a batter expects the ball to slide toward them like a curveball, instead it goes the opposite way. Hall of Famer Christy Mathewson, who played for the New York Giants from 1900–1916, invented the pitch. Yes, I'm a sports fan too.

Screwball comedy is exactly that. It goes the other way from a story perspective. Instead of the traditional male-focused romantic comedy, the woman is the protagonist of the film. She's the strong hero of our story, and the men are merely window dressing.

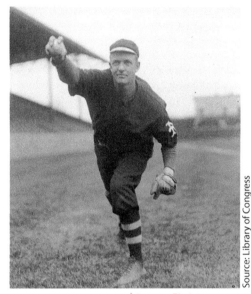

Source: Library of Congress

New York Giants Hall of Famer Christy Mathewson really messed with batter's heads with his perplexing "screwball" pitch

The primary characteristic of the screwball comedy is the battle of the sexes. It's a romantic comedy dressed up, with fast-talking dialogue and a plot revolving around a man and woman that don't like each other. The film then follows them as they eventually fall in love.

Furthermore, conflicts abound besides the romantic kind—truth vs. lies, rich vs. poor, educated vs. uneducated—and the stakes are love, courtship, and marriage. There is also an element of slapstick and farce, with big comedy set pieces in direct contrast to the verbal comedy.

One of the earliest battles-of-the-sexes comes from playwright William Shakespeare. He wrote *Taming of the Shrew*, the original screwball comedy, which has been adapted a ridiculous twenty-five times over the history of the movies. Adaptations include the Cole Porter musical *Kiss Me Kate* (1948), *McClintock!* (1963) with John Wayne and Maureen O'Hara, *10 Things I Hate About You* (1999) with Julia Stiles and Heath Ledger, and *Deliver Us from Eva* (2003) with Gabrielle Union and LL Cool J.

Screwball comedy started in the 1930s, coinciding with three things: the emergence of the United States from the Great Depression with audiences desperately needing to laugh again;

the suffragette movement that gave women more equality (including that whole right-to-vote thing); and the advent of sound film. The style and subgenre would last until the early 1950s when Hollywood would change as a response to the repressions of the Cold War.

I categorize Screwball in two ways: one as a style of comedy, and the other as a subgenre of comedy. You can have screwball elements in a romantic comedy film, like fast-talking dialogue, but a film has to have all of the elements of the screwball comedy-style to be classified in the screwball comedy subgenre.

In the screwball comedy subgenre, there was a high level of talent involved in all facets of film production. The writers had to be the best in the business, and many of them came from theatre backgrounds. The directors had to have a skill working with

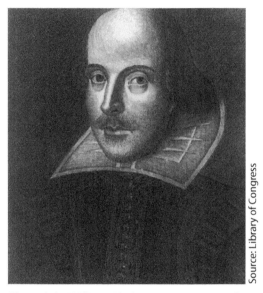

Source: Library of Congress

Playwright William Shakespeare pioneered the battle-of-the-sexes theme, yet in an ironic twist—all of the women in his plays were performed by men

actresses, such as Leo McCarey, who gave them the opportunity to improve and create a natural style to his screwball films such as *The Awful Truth* and *Adam's Rib*. Of course you needed handsome men and beautiful women with exquisite comic timing to pull off scenes with fast dialogue and physical slapstick comedy.

One last thing about the screwball comedy film is many of them were part of a unique subgenre of films called "comedy of remarriage." To get around the censors of the Hays Code that forbade adultery and illicit sex, these plot devices allowed men and women to divorce, get together with each other or others, and then get back together with their spouse. A number of screwball comedies were created with this story element in place.

Let me talk about some of the more renowned screwball films in cinema history. Lights, please!

The first screwball comedy was actually a musical, 1929's *The Love Parade*, starring Jeanette MacDonald and Maurice Chevalier. This romantic comedy was directed by acclaimed director Ernst Lubitsch [Editor's Note: Chapter 13] and was a major box office success. Though stuffy academics will say it isn't exactly a screwball comedy, I will wrestle anyone who disagrees with me. This film opened the door for the battle-of-the-sexes theme and the sexual undertones that are staples of the screwball comedy subgenre.

The biggest screwball comedy film is 1934's *It Happened One Night*, the multi-Oscar winning film directed by Frank Capra and starring Clark Gable and Claudette Colbert. That movie

gets its own Super Great Movie Spotlight. [Editor's Note: Chapter 9.] That's a great movie! Here's some others worth investing your precious entertainment bingeing time . . .

Some Great Screwball Comedy Films

My Man Godfrey (1936)

During the Great Depression, scatterbrained socialite Irene Bullock (Carole Lombard) hires vagrant Godfrey Smith (William Powell) to help with their high society scavenger hunt list where they need to find a "forgotten man." She wins the contest, but he chastises the party-goers for their snobbish ways. Afterward, Irene offers him a job as her butler to apologize. He accepts the offer and moves into the Bullock estate, but we soon discover that Godfrey is more than he seems. Instead of being homeless, he's actually wealthy Godfrey *Parkes*, who dropped out of society when he got his heart broken. But could love be a possibility for them both?

My Man Godfrey was nominated for six Oscars, including Best Director, Best Actor, Best Actress, Best Screenplay, and Best Supporting Actor and Actress. Strangely enough, it was the first film nominated for all four acting categories and was not nominated for Best Picture. It was named the #44 film in the AFI 100 Years . . . 100 Laughs List and was put in the National Film Registry by the Library of Congress in 1999.

The Awful Truth (1937)

Directed by Leo McCarey (Duck Soup), this was the first screwball comedy for actor Cary Grant, who eventually would be dubbed as the "King of Screwball Comedy" after his starring role with Mae West in 1933's *She Done Him Wrong*. [Editor's Note: Go to Chapter 15 for more on Mr. Grant.]

The Awful Truth follows the story of a divorcing high-society married couple Jerry (Grant) and Lucy Warriner (Irene Dunne) who fall in love with other people, but they realize that they might still be in love with each other.

This was the first of three Cary Grant and Irene Dunne films. They also appear in the 1940 screwball comedy *My Favorite Wife* and the 1941 drama *Penny Serenade*. *The Awful Truth* was nominated for five Academy Awards: Best Picture, Best Director, Best Actress, Best Supporting Actor for Ralph Bellamy, and Best Screenplay, with McCarey winning Best Director. It's the #68 Film on the AFI 100 Years . . . 100 Laughs List, and in 1996 *The Awful Truth* was placed into the National Film Registry.

Cary Grant and Katharine Hepburn star in *Bringing up Baby* (1938)

Bringing Up Baby (1938)

Legendary director Howard Hawks serves up a classic as paleontologist David Huxley (Cary Grant) is caught up in the wildest week of his life. He's trying to assemble a full brontosaurus skeleton at his museum, but is short one last bone. He's also getting married to Alice (Virginia Walker) and trying to get wealthy patron Elizabeth Random (May Robson) to make a sizable donation to the museum so it can stay afloat.

Everything comes to a head when Huxley meets Susan Vance (Katharine Hepburn), an eccentric heiress who recently got a leopard ("Baby" from the title) and plans to give it to her aunt as a gift. Eccentric is putting it mildly. She's absolutely bonkers, and thinks Huxley is a zoologist (not a paleontologist, if you don't know the difference then wait for my next book, "The Difference between Zoologists and Paleontologists," releasing in spring 2024). [Editor's Note: This comes as news to us. As far as we're concerned—this is the only time we will be working with this idiot.] Alice invites David to her country house to help with Baby. David reluctantly agrees, because he's got the missing bone and wants to get back to the museum.

If you are a sharp-eyed reader, you probably read that she was giving the leopard to her aunt. Her aunt is actually David's wealthy donor, Mrs. Random! When Susan falls in love with David—shenanigans ensue.

Bringing Up Baby is ranked as the #14 film on the AFI 100 Years . . . 100 Laughs List; #88 on the AFI Top Movies list; "100 Essential Films" by the National Society of Film Critics and in 1990 the film was put in the National Film Registry of the Library of Congress.

His Girl Friday (1940)

In this reteaming of *Bringing Up Baby* Director Howard Hawks and star Cary Grant (you've got to be kidding! Him again?), comes this remake of the 1931 comedy *The Front Page*, one of the early verbal comedies of the sound era. Instead of two men as the editor and reporter battling over a hot news story, the reporter role is now a woman. Presto! Screwball comedy for table two!

The whole story takes place on one crazy day. The fast-talking former star reporter Hildy Johnson (Rosalind Russell) pays Walter Burns (Cary Grant) her former tough-as-nails newspaper editor AND her ex-husband a visit. Here's a great example of a film with the "Comedy of Remarriage" story focus.

She tells Walter that she's marrying Bruce Baldwin (Ralph Bellamy—back again with Grant from *The Awful Truth*), overall nice guy and insurance agent. He's the exact opposite of Walter because he's normal. In a desperate attempt to keep her in his life, Walter begs her to come back to The Morning Post for one last story. Earl Williams (John Qualen), is a mild-mannered bookkeeper on death row for killing a cop and he'll be executed soon, but he believes that she could write the story that keeps him alive.

Hildy refuses. She's done with the newspaper business and wants to be a normal woman. Walter wants to meet her fiancée, so she arranges a lunch with the three of them. He learns that the couple is leaving at 4:00, and Walter offers Hildy the chance to write the story before she leaves. Hildy agrees but only if Walter will buy a sizable insurance policy from Bruce. Deal! As Hildy races to the courthouse, Walter sets about to make sure that Bruce doesn't make the train. Walter even gets him arrested multiple times with a series of ridiculous charges and has Bruce's mother kidnapped. Let's just say that Walter is definitely still in love with Hildy and willing to do whatever it takes to win her back.

The critics enjoyed the film, even though it was a remake of *The Front Page*. The remarkable thing is how fast the dialogue is. You really need to pay attention to keep up with it, but if you love good screwball and verbal comedy then this is a film for you. The film is ranked as the #19 film on the AFI 100 Years . . . 100 Laughs List and was placed in the National Film Registry of the Library of Congress in 1993.

The Lady Eve (1944)

This celebrated romantic comedy is considered the best of writer/director Preston Sturges' immortal five-year run of seven amazing comedy films—all box office successes. It's classic screwball: fast-paced dialogue, strong woman character, slapstick physical comedy scenes, and a major theme of rich versus the poor. There is also a hint of satire involving the larger role of men and women and gender relations, specifically the allusion to Adam and Eve in

The Garden of Eden and how a woman can seduce a man into complete submission. Larger themes layer Sturges' work and made them more than just simple romantic comedies.

Wealthy brewery heir Charles Pike (Henry Fonda) has spent the last year of his life studying snakes in the Amazon jungle. While on his return to America, he is set on during the ocean voyage by a team of swindlers, led by conniving Jean Harrington (Barbara Stanwyck), and her father. Together they hatch a plan to take the naïve ophidiologist (That's someone who studies snakes. Yes, I had to look it up. I'm smart but not that smart.) for all he's worth. Jean plies him with her feminine wiles to gain his trust, but then she commits the biggest sin when you're conning a man, she falls in love with him.

The film was a big hit for Sturges and Paramount Pictures and helped make writer/director Preston Sturges one of the wealthiest men in America. The critics loved the film and *Time Magazine* named the film as the Best Picture of the year.

In contemporary appreciation, *The Lady Eve* was named one of the greatest films of all time by *Premiere* magazine, *Empire* magazine, *The New York Times, Sight and Sound* magazine, and *Entertainment Weekly*. It is the #55 film on the AFI 100 Years . . . 100 Laughs List and in 1994 the Library of Congress placed the movie in the National Film Registry.

Overall, screwball comedy took the advent of sound pictures and turned them into a great way to enjoy fast-paced dialogue, strong women characters, and zany situations about falling in and out of love.

Unfortunately, the screwball comedy pretty much died out in the mid-1940s as a result of this little thing that changed the nature of film comedy. It wasn't a big technology paradigm shift like sound recording, or this new "color" film that was starting to come into vogue . . .

It was this little thing called World War II. We'll get to that later.

Lastly, though there isn't anyone to credit with coining the term "screwball," I'm going to go out on a limb and break down my hypothesis behind the term: "screw" coming from the common vernacular for having sex, and "ball" in reference to the male scrotum. At the end of the day, some would say that all of these films are about getting laid. Indeed, they are. While talking really, really, really fast.

CHAPTER 9

SUPER GREAT MOVIE SPOTLIGHT

It Happened One Night (1934)

Columbia Pictures/Photofest

Claudette Colbert and Clark Gable try to catch a ride in the Oscar Best Picture winner *It Happened One Night* (1934)

- ► Starring Clark Gable and Claudette Colbert
- ► Directed by Frank Capra
- ► Written by Robert Riskin
- ► Based on the story *Night Bus* by Samuel Hopkins Adams
- ► Subgenres: Screwball comedy, romantic comedy, social class
- ► Comedy Types: Screwball, Verbal Comedy, Slapstick

"Behold the walls of Jericho!"

—Peter Warne (Clark Gable)

Every now and then, a film comes along and shatters the expectations of what a movie can do to popular society and culture. Movies like *The Godfather*, *Jaws,* and *Star Wars* hustled in the era of the blockbuster movie and effectively ended the "New Hollywood" Director's Era.

I'm not saying *It Happened One Night* changed the way filmgoers watched movies and the studios made them. I'm talking about something that affects most of humanity, the sexiest of sundries—underwear.

I'll get to all this, and much more! (This opening is what we in the industry call a "grabber," because it's supposed to "grab" your attention! Hopefully it worked and you will continue reading to find why this film is a classic.)

Summary

Ellie Andrews (Claudette Colbert) is the spoiled daughter of wealthy banker Alexander Andrews. Against his wishes, she elopes and marries playboy bachelor King Westley. Her irate father takes her to his yacht and tells her that he had their marriage annulled. She's so upset that she jumps into the water and swims away. With her prominent family being well-known within social circles, her escape makes the news. Everyone is out to find her, especially the press.

By chance, she takes a bus back to New York City, and sits next to out-of-work reporter Peter Warne (Clark Gable). He recognizes her from the newspapers, and promises to get her back to the city in exchange for an exclusive interview.

In the hotel room, Warne is a perfect gentleman and hangs a blanket between their two beds (remember that back in the old-time days they couldn't show two people sharing the same bed. Thanks Hays Code!) which he calls the "Walls of Jericho."

The next day they hop on another bus, and a passenger who wants to collect the $10,000 reward money that her father has put up to bring her back recognizes her. Gable scares him off and they get off the bus to escape from him. They decide to hitchhike and sleep in a barn the next night.

Back on the road, they hitchhike again, and Ellie gets a car to pull over by flashing her leg. Unfortunately he's a thief and robs them blind. Warne runs off and comes back slightly injured with the thief's car.

Meanwhile, her father is persuaded to allow the marriage of Ellie and King to go on if she returns safely home.

Another night, and another hotel room. As Warne hangs up the "Walls of Jericho" to divide the room in two, Ellie crosses over—she's falling in love with Warne—but he puts her off without telling her why. He can't be with her if he's dead broke, so he sneaks out to New York City, and sells his story to his old editor for $1,000. He drives back to the motel, flush with cash and ready to propose—he's fallen in love with her too.

Unfortunately the hotel manager wakes up Ellie and kicks her out since Warne is gone. She's upset and calls her father. He comes to pick her up, and they drive away from the motel, just as Warne pulls into the driveway. Will Peter go after her? What about his newspaper story and the reward? Will she really go back to marry King? Doesn't she love Peter? Doesn't Peter love her? Too many questions—you'll have to watch this yourself.

Best Scenes

Clark Gable Strips—Warne is getting ready for bed and gives Ellie a lecture on how a man takes off his clothes. *And he's not wearing an undershirt.* Which was crazy back then—EVERY GUY wore an undershirt. As legend has it, because Gable went bare-chested, the underwear industry took a beating. Undershirt sales plummeted 75 percent. Yes, I didn't have a typo there. SEVENTY-FIVE PERCENT. Some academics dismiss the story as legend. I will not. It sounds good to me.

The Motel Room—After Peter has taken off his shirt and destroyed the men's undergarment business, he hangs up a blanket between Ellie's bed and his own, touting it as the "Wall of Jericho." The conversation they have between the blanket, with Ellie's expression and Peter's million-dollar-smile say more than any words can say.

The Woman's Guide to Hitchhiking—Peter brags that he's going to write a book about how to flag down a ride, and to prove he knows what he's talking about—he shows Ellie the proper techniques to hold out his thumb. Doesn't work. In fact, there's nothing he can do to hail down a passing car. Ellie shows him exactly how to do it, and better than he ever could!

Awards and Recognition

It Happened One Night was nominated for five Oscars: Best Picture, Best Director, Best Actor, Best Actress, and Best Screenplay. It won ALL OF THEM.

That's right, it's one of the most honored films of all time by the Academy. It was the first film to win these categories, which are known as the "Big Five." Only TWO OTHER FILMS in the history of the Academy Awards have won all five of these awards: *One Flew Over the Cuckoo's Nest* in 1975 and *The Silence of the Lambs* in 1991.

It Happened One Night is the #8 Film on AFI's 100 Years . . . 100 Laughs List, the #3 on the AFI Best Romantic Comedy list, #35 on the AFI Great Movies list, and #38 on the Great Passions list (for love stories). In 1993, the Library of Congress placed it in the National Film Registry.

CHAPTER 10

ARTIST SPOTLIGHT

W. C. Fields and Mae West

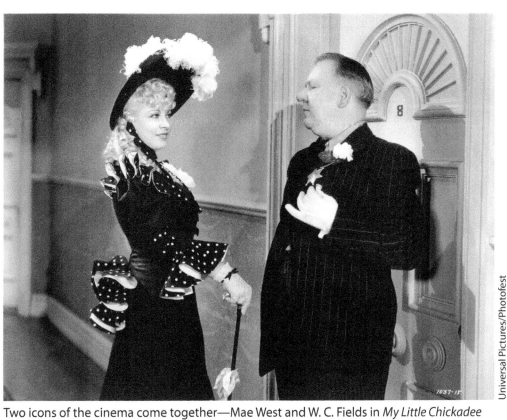

Two icons of the cinema come together—Mae West and W. C. Fields in *My Little Chickadee* (1940)

> **CHAPTER FOCUS**
> ▶ Who Is W. C. Fields?
> ▶ Who Is Mae West?

Chapter Focus

The popular saying goes, "the three most important things in storytelling are character, character, and character." When sound came to the movies, it gave many actors the opportunity to showcase their individual personalities to the audiences and entertaining on a much grander scale. These two comedy performers took over the motion picture industry outside the sub-genre of screwball comedy and are still remembered by many as two icons of the cinema.

Who Is W. C. Fields?

To fans of early twentieth century comedy film, the character of W. C. Fields is indelibly inked. He's the long-suffering cantankerous drunk with a huge vocabulary, big nose, nasal drawl, an affinity for gambling, sarcasm, and the air of a working con man. "Never give a sucker an even break," was one of his catchphrases. You knew that when a W. C. Fields film appeared, it was going to involve wife hating, manhandling children, dog kicking, and a whole lot of alcohol.

He was born in Philadelphia, Pennsylvania, in 1880 with an affinity for the stage. He learned how to juggle as a kid, and toured across the world with the famous stage act "The Ziegfield Follies." He quickly moved to silent films, starring in *Poppy* (1923) and *The Comic Supplement* (1924). He became disillusioned by the focus on physical slapstick and the inability to say his witty one-liners in the music halls disappeared. So, he quit the movies and became one of Broadway's highest paid actors.

The microphone changed all of that.

Fields was one of the vaudeville actors who easily graduated from the stage to the screen, like Chaplin and Keaton before him. But he was an actor and not in control of budgets and content.

He did a series of one- and two-reelers for Mack Sennett where he developed two on-screen personas. It was either the sly conman working the angles or the beleaguered family man constantly terrorized by overbearing wives, tormenting children, and being on the wrong

end of accusations and suspicion. The laughter comes from watching his journey through the constant turmoil with a biting wit commenting on his poor lot in life.

He appeared in his first feature film at the ripe old age of 45, an age where Chaplin and Keaton were already past their prime in the cinematic world. Cast by D. W. Griffith in his film, *Sally of the Sawdust*, Fields' character was the perfect vehicle for his on-screen personality as a con man in a traveling circus.

His film, *If I Had a Million* (1932), was an anthology by a myriad of directors, including Ernst Lubitsch [Editor's Note: Chapter 13] and Field's segment, *Road Hogs,* was about an ex-vaudeville performer Emily La Rue (Alison Skipworth) and former vaudeville juggler Rolio (Fields), who dreams of having a new car and things go nuts. The one notable moment in the film is when Rolio calls La Rue "my little chickadee." This line soon became W. C. Fields catchphrase, and inspired the title for one of his future films.

The Official W. C. Fields Top 3 Great Comedy Film Checklist

It's a Gift (1934)

W. C. Fields plays Harold Bissonette, an exasperated husband (aren't they all?) ducking his overbearing spouse and Baby Dunk (Baby Leroy: weird that a baby was an actual character name back then) as he attempts to survive life as a family man. This man gives up his grocery business for the dream of making it rich in the citrus business. Things don't always go as planned when you're following a dream and citrus is involved, if you know what I mean. [Editor's Note: We have no idea what that means.]

The story is just a series of scenes where Fields must survive one insult after another. He used some of his best Broadway material including a great scene where he escapes his wife and goes to sleep on the back porch. Trying to sleep, he is inundated with noise from all over the place: neighbors, salesmen, and babies. Guess what? It's on YouTube. I can't imagine writing this book without the magic of YouTube. It would be more like a leaflet, twelve pages long, and still you would have to pay eighty bucks for it. [Editor's Note: If you paid eighty dollars for this book, you were ripped off. Consult your local Better Business Bureau, or even better, give them a low rating on Yelp.]

My Little Chickadee (1940)

W. C. Fields successfully teamed up with sexpot actress Mae West [Editor's Note: Six paragraphs below] in a battle of the sexes, pitting two icons of the cinema into a Western that serves as a springboard for the two to engage in a duel of wits, his top hat perpetual drunk versus her seductive one-liner double entendre.

The script was written by West, as she did for nearly all of her films, yet the studio decided to give them both credit for writing, which made West very unhappy.

The story is another mishmash of scenes set up for individual character laughs. She's Flower Belle Lee, a music hall singer kidnapped by the Masked Bandit (Joseph Calleia) and then escapes. "I was in a tight spot but I managed to wriggle out of it," says West. If you didn't realize it—she's talking about having sex with him. Oh, you did. Got it. My bad.

She escapes and meets Cuthbert J. Twillie (W. C. Fields), a traveling con artist, who she thinks is rich. They get married in a small Western town, Twillie is named Sheriff, and tries to stop the Masked Bandit. Along the way, Twillie unsuccessfully tries to consummate their marriage.

Twillie is mistaken for the Masked Bandit, but before he is executed, she tries to hunt down the Masked Bandit. The best part is the ending lines of the movie. Fields says *her* signature line, "Come up and see me some time," and she replies with *his* catchphrase, "I will, my little chickadee." A very fitting ending to this pairing, which ended up being a box office success grossing $2 million.

The Bank Dick (1940)

W. C. Fields plays Egbert Souse (which in French translated to drunkard—how clever!) who leaves home to escape his nagging wife and his daughter who couldn't care less about him. He stumbles upon a film shooting on location that is waiting for the director to show up. Egbert volunteers for the job—and then gets credit for stopping a bank robbery. The grateful bank hires him to be their security guard.

Then things get out of control, when Egbert convinces his son-in-law to "borrow" $500 from the vault for a "can't-lose" investment. Guess what? He loses. And then the bank examiner shows up for an audit. Shenanigans ensue.

Many film historians and academics note the film as a classic and the Library of Congress added it to the National Film Registry in 1992.

His last great film was *Never Give a Sucker an Even Break* (1941), taking place in the film industry and contained shades of theme that were explored by Buster Keaton's *The Cameraman*. He's a movie star by the name of W. C. Fields (by sheer coincidence I'm sure) that is trying to make a movie—a weird tale!

Fields died at the very ripe old age of sixty-six. The cause of his death, wait for it, was liver failure caused by decades of boozing it up. He literally died in character, but his work was indelible to the continued success of cinema—as the first wise-ass in the talking pictures.

Who Is Mae West?

What W. C. Fields was to boozing, Mae West was to sex. As the first female comedy star, she wasn't just a voluptuous blonde conquering men in her path with her bravado, wit, and drop-dead gorgeous looks. She was a talented writer and performer who flaunted sexuality during the restrictive times of the Hays Code and flourished in a time where scandal was a four-letter word.

What was the Hays Code? From 1938 to 1968, Will Hays was the President of the MPPDA which eventually became the Motion Picture Association of America (the group that does the film ratings). He instituted a morals guideline for studio films. It wasn't a rating, it was a mandate designed to promote "traditional values." Things like profanity, nudity, drugs,

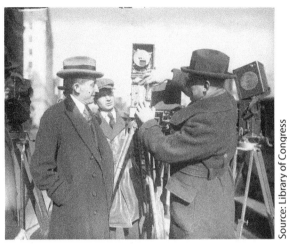

Source: Library of Congress

Will Hays made life very difficult for filmmakers for thirty years

sexual perversion, white slavery (as opposed to black slavery?), the use of firearms, murder, men and women in the same bed, excessive kissing (in which director Alfred Hitchcock flaunted in his film *Notorious*, where Cary Grant and Ingrid Bergman famously shared a series of kisses that were each less than the thirty-second time limit imposed by the code, rather than one looooong kiss. It's actually a pretty sexy scene.) and dozens more. Sex was quite the hot-button topic with the Hays Code.

And Mary Jane West couldn't care less.

She was born in 1893 in Brooklyn, New York, and took to the stage as a singer and dancer with the encouragement of her parents. At the age of five, she first entertained a church audience and soon left school to perform.

Then she hit puberty and grew up in all the right places. She went to vaudeville as a comic performer, met Frank Wallace, who became her stage partner and first husband (even though she was only sixteen) and at eighteen went to Broadway. In 1911, she changed her name to Mae West, started wearing tight dresses and wisecracking highly-charged sexual comments that oozed seduction and lust.

She started writing, and in 1926 launched her play, *Sex*. Apparently Mae West was not a fan of subtlety. The show had a tremendously successful run, but was targeted by protests from various religious groups. I guess the prostitution, suicide, bribery, and guns caused a bit of

an uproar. After all, it was a New York City in the grips of Prohibition, and religious groups were in-style.

West was actually arrested on the forty-first week of the show's performance for corrupting the morals of the youth. I am not making this up. She received ten days in jail, but was released two days early for good behavior. My, how the times have changed in a hundred years!

Continuing her trend of outrageousness, West wrote a play about homosexuality (remember this is the 1920s!) called *The Drag* in 1926. Producer C. William Morganstern begged her not to take the play to Broadway after a scandalous short run in New Jersey. In 1928, she wrote *Adamant Lil* where she said her famous catchphrase, "Why don't you come up and see me sometime?" She wrote two more plays, *Pleasure Man* (1928) and *The Constant Sinner* (1931), which were both protested. The police raided *Pleasure Man's* opening night and *The Constant Sinner* closed after two shows when she was threatened to get arrested again.

Tired of Broadway's censorship, she signed with Paramount Pictures for the unheard of amount of $5,000 a week (especially for a female performer in her forties). She first appeared in *Night After Night* in 1932, and though she wasn't the star, the studio let her rewrite her scenes. Here's a sample of her dialogue: a coat check girl remarks "Goodness, what beautiful diamonds." West replies, "Goodness had nothing to do with it." Zing!

The Official Mae West Top 3 Great Comedy Film Checklist

She Done Him Wrong (1933)

Mae West wanted to do her own material, and brought out her stage play *Diamond Lil* and adapted it for the big screen. The story follows burlesque singer Lady Lou (Mae West), adored by her boss Gus Jordan (Wallace Beery), who owns the nightclub where she sings. She discovers that his excessive back account is financed through ill-gotten gains like prostitution and is being investigated by undercover FBI Agent Captain Cummings (Cary Grant) at the neighborhood Salvation Army center. Maybe they fall in love . . .

She Done Him Wrong grossed $2 million at the box office and was nominated for Best Production (or as we latter-day folk like to call it, Best Picture) at the Academy Awards in 1933. It was selected for the National Film Registry in 1996 and the AFI named it the #75 movie in the Great Comedy Films list.

She Done Him Wrong was the perfect showcase for the sassy seductress. The film is also notable for its casting of Cary Grant in his first starring role. West saw him on the Paramount back lot and demanded that he be cast in the film.

Mae West and her boy-toy discovery, the soon-to-be King of the Screwball Comedies, Mr. Cary Grant, in *She Done Him Wrong* (1933)

Shockingly, the film immediately hit the fan with the Hays Code. Because of the play's noto-rious reputation, the studio wasn't allowed to say that the film was based on the play in its advertising campaign. It's also the film where she uttered her seductive catchphrase "Why don't you come up sometime and see me." That's right, it actually wasn't "Why don't you come up and see me sometime." But the men in the audience were probably too entranced with Mae's bodacious figure to pay attention to the actual dialogue.

I'm No Angel (1934)

Mae's a circus performer on the run after she thinks her boyfriend murdered one of his con artist victims. She asks her boss for money to leave town. Instead, he convinces her to do his big act and put her head in a live lion's head during the circus act. She does, and the notori-ety of the act takes them both to New York City. She ends up meeting wealthy Cary Grant and they fall in love, hopefully in time to save her from the reappearance of her murdering ex-boyfriend.

This film was even MORE successful than *She Done Him Wrong*, and history has borne the fact that Mae West's films single-handedly saved Paramount Pictures from bankruptcy. Her

memorable lines include "When I'm good, I'm very good. But when I'm bad, I'm better." At this point, Mae West was now the second highest paid person in America.

Her next films, *Belle of the Nineties* and *Klondike Annie* (1936), were both controversial; in fact *Belle of the Nineties'* original title was *It Ain't No Sin*. William Randolph Hearst (the publisher of "yellow journalism" and the basis for Orson Welles' *Citizen Kane*) was offended by *Klondike Annie's* mixing of sex and religion. He banned advertising Mae West's name for any film she would do from that point forward, but that didn't stop the movie from being one of the highest grossing films in Mae West's filmography.

My Little Chickadee (1939)

Her head butting with the Hays Code landed her on a list of actors and actresses, including Greta Garbo, Joan Crawford, and Marlene Dietrich, that Harry Brandt of the Independent Theatre Owners Association said were "box office poison." This coincided with the box office failure of *Every Day's a Holiday* in 1937, and Paramount Pictures cancelled her contract. Universal Studios approached her to star in what is considered her last notable film, the W. C. Fields team-up *My Little Chickadee*.

Mae West successfully teamed up with alcoholic wise-guy W. C. Fields [Editor's Note: a few pages back in this chapter] in a battle-of-the-sexes, pitting his top-hat-perpetual-drunk versus her seductive-one-liner-double entendres smoking hot figure.

In 1943, Mae, almost fifty years old, made her next film for Columbia Pictures, *The Heat's On*, which was a box office failure and ravaged by the critics.

She left the movie business and went back to the stage, touring several shows across the world. She did some television appearances and some music recordings. She acted in a couple of films after she turned seventy, but they were curiosities that failed to generate any interest. She died at the age of eighty-seven from complications from diabetes and a stroke she suffered in a fall.

Mae West blazed a trail that few women have been able to match. She was sexy, smart, creative, and knew exactly what she wanted and how to get it. It's been said that she lived a life of no regrets. We should all be so lucky. She has a star on the Hollywood Walk of Fame and her legacy is complete.

FADE OUT

CHAPTER 11

ARTIST SPOTLIGHT

The Marx Brothers

The Marx Brothers, counterclockwise from right, Groucho, Harpo, Chico, and Zeppo.
Karl Marx is not pictured.

> **CHAPTER FOCUS**
> ▶ Who Are the Marx Brothers?
> ▶ Humble Beginnings
> ▶ Lighting up the Silver Screen
> ▶ The MGM Years
> ▶ The Part of the Last Part

Chapter Focus

When we talk about how sound changed the way movies were made, it's clear the Marx Brothers shook the traditional film narrative and turned it on its ear. And then flipped it over again on the other ear. Then dropped it off of a two-story window, not enough to hurt, but just enough to leave a mark. I mean, a *marx*. Get it?

Big introduction: The Marx Brothers are considered the single greatest comedy team in history. They have five films in the AFI Great Comedy Films list, they were inducted into the Motion Picture Hall of Fame in 1977, and they're worth your attention for the next few pages.

Who Are the Marx Brothers?

There were FIVE Marx Brothers. They all had their own individual personalities and talents— each of them easily distinguishable from each other. (To be honest, I have a hard time telling Gummo and Zeppo apart, but let's do the three fun ones first.)

Julian "Groucho" Marx is the best known of the brothers due to his transition from movies to television in the 1950s. With his bushy eyebrows, glasses, hunched over walk, ever-present cigar, and thick moustache, he is also the most identifiable of the Marx Brothers. You can also get a Groucho mask at your local costume shop.

He came up with the outfit and character onstage during the brothers' vaudeville days. He was late to a performance and instead of tacking on a fake moustache, he put some black greasepaint where the moustache should be. Then he had to match the color with the eyebrows so he covered those as well. The effect was so comical he kept the look for the rest of his professional life.

He was the fast-talking insulting con man with an eye for the ladies and his next scam. He was renowned for his incredible improvisation skills and his quick wit frustrated most film directors.

Groucho made twenty-six films, thirteen of them with his brothers. He also launched radio shows, including one of the most popular shows of the late 1940s, *You Bet Your Life*. It was an interview show where Groucho could zing off one-liners all under the context of contestants winning money. It really was all about Groucho and his quick mind. The show moved to television in the 1950s where it continued to be a hit.

He was married three times, always to younger women including his last wife who he married when he was in his sixties and she was in her twenties. He won an Honorary Oscar in 1974 for his outstanding contribution to motion pictures and died three years later.

Arthur "Harpo" Marx was born in 1888 and is the clown of the group. He wore a raincoat, battered top hat, and a curly wig. He doesn't talk but instead used pantomime, whistling, and a squeaking horn to communicate. He also played the harp. I guess that's where he got his nickname? That's right—call me Mr. Obvious.

In the films, he also was known for pulling outrageous props out of his coat, like in *Duck Soup* when he pulls out a blowtorch to light a cigar. He was a master of physical and slapstick comedy while his brothers relied on their dialogue and verbal comedy to draw laughs.

Legend has it that his actual first name was Adolph, but he changed it during World War I. But you know how fast these Internet rumors get started. Also, a lot of people thought he couldn't talk. Not true—he could speak, but chose not to. Again, legend has it he had a low voice and difficulty with dialogue when he was first onstage. So he became the classic silent clown character that populated vaudeville comedy acts. He died from a heart attack in 1964.

Leonard "Chico" Marx was born in 1887 and is the con artist of the group. He wore an Alpine hat, has curly hair underneath, and played the role of a poor Italian migrant. He also played a mean piano. He usually had some sort of scheme going on with his brother Harpo Marx in several of their films.

Interestingly, he was also the manager of the comedy team after their Mom passed away and negotiated a deal where the brothers got a percentage of the profits for their films. They were the first performers in Hollywood that accomplished that feat, and it made them all millionaires. Which helped to feed his well-known habits of obsessive gambling and seducing women (even while he was married). Man, this guy could party! He passed away in 1961 from arteriosclerosis (that is a seriously long word).

Herbert "Zeppo" Marx, the youngest of the Marx Brothers was born in 1901. When he was old enough, Gummo left the stage and Zeppo took over the role as the "straight man." He is the normal guy that all the zaniness of the other three bounces off, and is able to react without reaction. His deadpan expression, taken from Buster Keaton, was used umpteen-million times in the world of comedy.

Many critics, including Roger Ebert, have dispelled the notion that Zeppo was not funny, since many had said that he seemed to shirk in the background while his brothers took over the screen. He was the perfect comic foil that could stand up and hold his own to Groucho; when other actors would go on and play the straight-man role, they would get chewed up in the process.

He appeared in the first five Marx Brothers films, and left to become a mechanical engineer and inventor with three patents, creating equipment for the World War II allies. He also worked with his brother Gummo on the talent agency that they started in the 1940s. It's noted that his wife Susan Blakely ended up having an affair with and eventually marrying Frank Sinatra. He died of lung cancer in 1979.

Milyon "Gummo" Marx was born in 1892, and was the Marx Brother who didn't appear in any movies. For that reason, he's known as "The Forgotten Marx Brother." He appeared in vaudeville when the brothers were first started, but left to serve in World War I. After the war, he returned to New York but retired from acting because he didn't like performing.

He started a raincoat business and went on to become an inventor and started a talent agency with Zeppo Marx to represent their brothers until their film careers ended. Then Gummo represented Groucho for his TV work and developed the popular TV Series *Life of Riley*. Gummo passed away in 1977 of a brain hemorrhage.

And on that uplifting note . . .

Humble Beginnings

The Marx Brothers were born in New York City to Miene ("Minnie") Schonberg and Simon ("Sam") Marx, Jewish immigrants from Germany. Minnie's brother was stage comedian Al Sheen and Minnie was also a stage performer. She wanted her four sons to get into show business (Zeppo was too young at the time) and became their business manager.

Gummo, Groucho, and Chico became a musical act, "The Three Nightingales," and then when Harpo joined them, they became "The Four Nightingales." The Marx Brothers officially became a comedy team with their vaudeville play, 1912's *Fun in Hi Skule*. Young Zeppo joined the troupe during a cross-country tour soon after Gummo left to serve in World War I.

They developed their zany style, unique personas, and gained acclaim for their hilarious shows and quick improvisation. They made fun of rich people and politicians, great subjects that are always popular with audiences. Everyone knew that anything could happen in a Marx Brothers production, and they pioneered the style of Chaotic comedy.

They went to Broadway with *I'll Say She Is* (1924–1925), and because of its popularity were able to hire the best for their next production. *The Cocoanuts* ran for two years with a script by Pulitzer Prize-winnning playwright George S. Kaufman, and music by Irving Berlin (*White Christmas*). It was a huge smash, and they reunited with Kaufman on *Animal Crackers* (running onstage 1928–1929). Both would soon be turned into films.

You know what happened next. Sound came to the movies, and Paramount Pictures called with a two-picture deal. Their first film would be the adaptation of *The Cocoanuts*.

Lighting up the Silver Screen

The Cocoanuts (1929) follows the adventures of Mr. Hammer (Groucho) and his assistant Jamison (Zeppo) as they run a Florida resort. Soon enough, Chico and Harpo (played by—you guessed it—Chico and Harpo) show up looking to rob and con the few guests staying at the hotel. Making her on-screen debut with the Marx Brothers is actress Margaret Dumont, playing the role of society snob Mrs. Potter, who would appear in a total of seven films with the team. Her stuffy demeanor contrasts against the perfect romantic foil for Groucho. His hysterical attempts to seduce her in every film are the stuff of running gag legend.

Groucho is trying to auction off some land that may not be the ideal land acquisition, Bob Adams (Oscar Shaw) is in love with Mr. Potter's daughter Polly (Mary Eaton). But, Mrs. Potter wants her to marry social climber Harvey Yates (Cyril Ring) instead of the lowly bellboy who is studying at night to be an architect. Suddenly, Mrs. Potter's diamond necklace is stolen.

There are a few hilarious scenes such as Groucho running an auction where he's instructed Chico to bid up the prices on the land to disastrous results and Harpo getting drunk on spiked fruit punch, but the film is marked by its terrible sound quality and clumsy staging. Working with microphones and music for the first time was a bit of an experiment and the Marx Brothers were upset with the way the film turned out. Paramount refused to sell it back to them and it became a huge box office hit. As the first publicly successful musical, it gave audiences a chance to experience the madcap adventures of the Marx Brothers in their first cinematic stomping ground.

While the Marx Brothers were filming *The Cocoanuts* in 1928, they were performing *Animal Crackers* on Broadway every night and it became their second film for Paramount Pictures in 1930.

Comedy and anarchy reign supreme in this story about a high society party thrown by Mrs. Rittenhouse (Margaret Dumont—back for more!) to welcome home famed African explorer

The Marx Brothers' debut was in their screen adaptation of their Broadway hit, *The Cocoanuts* (1929).

Captain Spaulding (Groucho) whose tales of adventure are a little suspect. To make matters worse, a valuable painting is stolen! Who could it be? The Professor (Harpo) who chases after the ladies (literally)? Perhaps it's the suspicious Italian musician Signor Ravelli (Chico)? Who cares when you've got ninety minutes of Marx Brothers insanity in front of your face?

The film is known for three things: the performance of "Hooray for Captain Spaulding"; the musical number that became Groucho's theme song; the scene where Harpo starts pulling crazy stuff out of his jacket in rapid succession; and a scene where Groucho dictates a letter to Zeppo who does his own editing during the conversation. It's this scene that film theorists point to as definitive proof that Zeppo Marx was a good comedian. My concern is that there are people sitting around debating insane things like the relative value of the fourth Marx Brother's contribution to comedy. Get a life folks.

There's also this classic joke from Groucho: "One morning I shot an elephant in my pajamas. How he got into my pajamas, I don't know." And this one: "Africa is God's country—and He can have it."

The Marx Brothers had another hit on their hands, and Paramount Pictures renewed their contract for another three films, scoring the brothers a huge payday. Off they went to Hollywood for their next movie. Based on a couple of sketches the brothers had done on Broadway, *Monkey Business* came to life in 1931.

Much like their previous two films, *Monkey Business* has a barely-there plot. Four stowaways (Groucho, Harpo, Chico, and Zeppo) are found on a cruise ship and are on the run from the captain and his crew for the rest of the film. The four of them stumble into the middle of a mafia feud, are hired as bodyguards on opposing sides of the ensuing confrontation (why anyone would hire these four as bodyguards is beyond me), Groucho has an affair with one of the boss' wives, Harpo poses as a puppet to escape from the crew, and even Zeppo gets to fall in love with one of the mobster's daughters.

The big difference in this film is that there are no musical numbers and even the Marx Brothers' uncle, comedian Al Sheen, helped write the script. You can even see their dad in a cameo when the ship docks at the end of the movie.

Monkey Business was box office gold and the critics loved it. The film is the #73 film on the AFI Great Comedy List. And they keep getting better!

Flush from the success of *Monkey Business*, the Marx Brothers jumped straight to 1932's *Horse Feathers*, a comedy set during Prohibition at fictional Huxley College, where new college president Quincy Adams Wagstaff (Groucho of course) wants to win the big football game against Darwin College. His son Frank (Zeppo) suggests they hire a couple of ringers to play. As these things tend to happen, Wagstaff mistakes Pinky (Harpo) and Baravelli (Chico) as the professional football players. Cue the mayhem!

There are a couple of great scenes in this film. Chico and Harpo guard the door at the speak-easy with the password of "swordfish."

There's the musical number where Groucho and the college professors complain about their students and sing "I'm Against It."

Quincy and Frank are also competing for the romantic affections of Connie (Thelda Todd, fresh from *Monkey Business*) a "college widow," which basically means she's a slut and gets it on with college boys. And the big climax at the football game is one that even cable network ESPN says is one of the top football scenes in the history of movies.

Horse Feathers was another (dare I say it? I do!) a "feather" in the cap of the Marx Brothers. The critics loved it, the audience loved it, they got on the cover of *Time* magazine and it's the #65 film on the AFI Great Comedy Films list.

In-between Groucho and Chico doing a radio program, many academics and critics consider their next film as their greatest. 1933's *Duck Soup*, directed by Leo McCarey [Editor's Note: See Chapter 12] follows the guys to the country of Freedonia, where Groucho has just taken over as President. Head over to that chapter and then zip back here.

This was the first Marx Brothers movie that didn't do well at the box office. Though it was the sixth-highest grossing film of the year, Paramount chose not to renew their contract. When that happened, Zeppo left the act to pursue his theatrical agency with Gummo—and now The Four Marx Brothers (as they had been billed for their previous films) were now The Three Marx Brothers.

The MGM Years

The head of Metro-Goldwyn Mayer, Irving Thalberg—just as he had done with Buster Keaton—brought the Marx Brothers over to MGM and signed them for two films. Thalberg wanted their films more commercially appealing, where the story was interwoven between comedy set pieces and musical numbers, and they became more sympathetic characters instead of just anarchists as they aid a young man and woman to come together in a romantic subplot.

Thus was born 1935's *A Night at the Opera*, which followed the brothers as they attempt to help two young lovers set against the snooty world of the opera (hence the "opera" part in the title). There are a bunch of musical numbers in the film as well. (Again, the film has the word "opera" in the title.)

Mrs. Claypool (our old friend Margaret Dumont) wants to get into high society social circles. She enlists her snarky business manager, Otis P. Driftwood (Groucho), to make it happen.

He convinces her to make a hefty contribution to the struggling New York Opera Company, giving them enough money to hire legendary Italian tenor Rodolfo Lassparri (Walter Woolf King) and his bullied assistant Tomasso (Harpo).

Meanwhile, up-and-coming singer Riccardo Baroni (Allan Jones) hires his friend Fiorello (Chico) as his manager to help him get to the big time—and help him woo the beautiful Opera Company employee Rosa Castaldi (Kitty Carlisle) who Lassparri wants to seduce.

Everything goes awry (because that's what happens in a Marx Brothers film) when Driftwood tries to make some money on the side by convincing Lassparri that he should be his manager, since he knows the contract money is coming in. When he bumps into Fiorello backstage looking for Lassparri, Fiorello points him to Riccardo, and Driftwood signs him to a contract with the negotiating help of Fiorello.

The contract-signing is considered one of the best of the Marx Brothers' verbal comic scenes ever. It's all in one take!

Of course, Driftwood is pretty steamed when he realizes he signed the wrong guy. When Rodolfo insists that Rosa come to New York with him to star in his New York Opera Company debut, she is forced to say goodbye to a distraught Riccardo.

Driftwood accompanies Mrs. Claypool, Rudolfo, and Rosa as they sail off to America, and while unpacking his luggage in his small stateroom, he discovers that Riccardo, Fiorello, and

The Marx Brothers (Harpo, Groucho, and Chico) are not wearing pants

Tomasso have all stowed away in his steamer trunk. Not wanting to be kicked out, he orders the three to get out of his room. Rudolfo promises that the three of them will only leave after Driftwood feeds them.

Driftwood rings for the porter, and one of the best set pieces in the history of comedy begins. The Porter takes his order, then two maids show up to clean the room, the engineer and an assistant come in to fix the heater, and on and on it goes, the tiny room filling up with people. Legendary comedian Buster Keaton worked with the Marx Brothers to develop the scene, which is modeled after a scene from Keaton's *The Cameraman*.

Things fall apart when Rudolfo spots his romantic rival for Rosa's affections and Riccardo, Tomasso, and Fiorello, as stowaways. They are thrown in the brig but quickly escape thanks to Driftwood, and get off the ship disguised as three famous bearded aviators who are also onboard.

This sets up the madcap ending, where Driftwood, Tomasso, and Fiorello kidnap Riccardo and—ack! I've already said too much! Suffice to say that young love triumphs overall! Now go watch the film—it's the #12 movie on the AFI List of Great Comedy Films list and was named the #85 movie on the AFI 100 Greatest Movies in their updated 2007 list.

The film had a good box office return, and it seemed that the kinder, gentler Marx Brothers were still the comedy giants that they had established in their previous works. And their biggest box office hit was just around the corner!

Even more important, the legendary rock band Queen named their fourth album "A Night at the Opera." So I'd say that the film's legacy is complete.

In 1937, MGM released *A Day at the Races* as the second film in the Marx Brothers' contract. The film contains a lot of the elements from *A Night at the Opera* such as their musical numbers, the brothers aiding a romantic couple, Harpo is sympathetic instead of maniacal, Chico and Groucho's hilarious verbal sparring, Harpo and Chico are a team, and a high-profile environment where they get to play.

At the Standish Sanitarium, wealthy patient Mrs. Upjohn (the previously mentioned stalwart Margaret Dumont) insists on being treated by Dr. Hugo Z. Hackenbush (Groucho) to the chagrin of owner Judy Standish (Maureen O'Sullivan).

She goes along with it hoping that Mrs. Upjohn will make a large donation to the sanitarium to stop banker J. D. Morgan (Douglas Dumbrille) from taking over the nearly bankrupt hospital. She has handyman Tony (Chico) contact Hackenbush, who accepts the job of Chief of Staff, just in time to avoid being arrested for treating human beings. He's in fact a veterinarian who conned Mrs. Upjohn awhile back.

Meanwhile, Judy's fiancé Gil (Allan Jones) has put aside his singing career to help find the money to help the sanitarium by purchasing a racing horse named Hi Hat. Gil has a tip on a horse, but no money so Tony promises to find someone to swindle to get the money. In one of the noted scenes in *A Day at the Races*, in the "Tutti-Frutti Ice Cream Scene," Tony cons Hackenbush out of enough cash to place the bet and win. (Go watch this clip online—and yes, I bet you think I own stock in YouTube since I refer to it so much.)

Back at the sanitarium, Whitmore tries to discredit Hackenbush by setting him up with a beautiful blonde seductress, in the hopes of having Upjohn find the two of them together. Thanks to Tony and Stuffy, Whitmore's plan is thwarted so he brings in noted Austrian physician Dr. Steinberg to examine Mrs. Upjohn to prove that Hackenbush is a quack. (Fun fact: The Marx Brothers wanted to call the character Dr. Quackenbush, but were afraid that they would get sued by a *real* Dr. Quackenbush!) Thanks to a series of diversions, Hackenbush, Tony, Stuffy, and Gil are able to escape and hide in Hi Hat's stable. Don't want to give it away, but let's take a guess—"true love wins out at the end?"

A Day at the Races was a huge hit with both the critics and at the box office. The film is the #59 entry in the AFI Great Comedy Films list, and is widely considered by many wise academics (who are all older than me and some of them are probably dead) to be the last great Marx Brothers film.

The Part of the Last Part

Two weeks after filming started for *A Day at the Races*, Irving Thalberg, the visionary head of MGM who had softened the Marx Brothers to make them more commercially appealing, died from pneumonia at the age of thirty-seven. Without Thalberg supporting them, the Marx Brothers ended their contract with MGM and went to RKO Pictures.

They made the film *Room Service* in 1938, but it was clear that the interest in the Marx Brothers was beginning to wane.

The film lost $300,000 and the critics were not kind to this film about a struggling theatre troupe that takes over a hotel. Next, the team moved back to MGM. They made *At the Circus* in 1939, with the most notable scene being Groucho's rendition of "Lydia the Tattooed Lady," but the critics roasted them again.

1940's *Go West* was also filmed at MGM, and the critics were kind to this film where the Brothers were in the Old West. *The Big Store* was in 1941 and was their last film for MGM and also their announced final feature film. It made a modest profit, but the critics were unimpressed.

Four years later, the team went on to make two more feature films, *A Night in Casablanca* in 1946 and *Love Hurts* in 1948. The films were made for purely financial purposes to help pay off a number of Chico's gambling debts.

The brothers had gone their separate ways, doing radio and vaudeville, sometimes in pairs, but never the three of them performing together again. Groucho went on to star in a television game show *You Bet Your Life*.

Groucho found later success as a TV game show host

He also appeared in several high-profile feature films including 1957's *Will Success Spoil Rock Hunter?* and 1968's *Skidoo* where he played God.

What happens to all of us: Chico passed away in 1961, Harpo died in 1964, Groucho and Gummo both died in 1977, and Zeppo, the youngest, died in 1979.

Groucho has three stars on the Hollywood Walk of Fame, one each for radio, television, and movies.

The Marx Brothers were named by the AFI as the #20 Male Screen Legends in Classic Hollywood on one of the millions of lists that they continue to generate on what seems to be a daily basis.

Ultimately, The Marx Brothers cemented their legacy as the most popular comedy team in film history. Their special blend of chaos and anarchy, their special blend of screwball, verbal, and slapstick comedy, and their unique personalities created films that are unparalleled in the annals of comedy cinema.

Groucho Marx's star on The Hollywood Walk of Fame

CHAPTER 12
SUPER GREAT MOVIE SPOTLIGHT

Duck Soup
(1933)

The four Marx Brothers in *Duck Soup* (1933)

Paramount Pictures/Photofest

- ► Starring Groucho Marx, Harpo Marx, Chico Marx, Zeppo Marx (The Four Marx Brothers), and Margaret Dumont
- ► Directed by Leo McCarey
- ► Screenplay by Arthur Sheekman and Nat Perrin
- ► Story by Harry Ruby and Bert Kalmar
- ► Subgenres: Farce, Satire
- ► Comedy Types: Verbal Comedy, Slapstick

Groucho Marx explained the name of the film, *Duck Soup*, "Take two turkeys, one goose, four cabbages, but no duck and mix them together. After one take, you'll duck soup for the rest of your life."

Summary

The country of Freedonia is on the edge of financial bankruptcy. Wealthy Gloria Teasdale (frequent Marx Brother co-star Margaret Dumont) loans the country enough money to keep the government going—in exchange for her choosing the new President. The powers-that-be reluctantly agree, and her choice turns the country on its ear.

Enter Rufus T. Firefly (Groucho Marx)—the fast-talking con man who has been wooing the widow Teasdale to ensure his good fortune. Needless to say, Firefly makes quite a splash in a huge musical number.

As the newly vested President, Firefly immediately insults the country of Sylvania—hindering their plans to annex part of Freedonia. Sylvanian ambassador Trentino (Louis Calhern) has dispatched his two best spies, Chicolini (Chico Marx) and Pinky (Harpo Marx), to infiltrate Firefly's capital for information that can be turned against him to show Mrs. Teasdale that Firefly is bad for the country and should withdraw her support. He also is making a romantic play for Mrs. Teasdale to further his conquest.

Sylvania's spy network must be pretty incompetent if Chico and Harpo are the best they could come up with for this momentous assignment, because they fail horribly when they report on the early shadowing of the President. Trentino gives them one more chance and they set off back to Freedonia.

Back home, Firefly insults his entire cabinet and is forced to hire a new Secretary of War. After seeing Chicolini and Pinky outside his window selling peanuts and harassing a poor

lemonade vendor (a running gag throughout the movie), he appoints Chicolini to the post. Pinky has taken up the job as Firefly's motorcycle-with-a-sidecar chauffer—but in another great running gag—always leaves him in the dust and fails to drive him anywhere.

It's lunchtime and Firefly goes to meet Mrs. Teasdale, only to find Ambassador Trentino and his confidant, dance hall girl Vera Marcal (Raquel Torres), have beaten him to the punch. Based on the advice of his assistant, Bob (Zeppo Marx), Firefly insults Trentino intending to have the Ambassador deported, and the two countries are headed for war.

And then it gets even more ridiculous . . .

After a huge musical number with over one hundred extras, all of them celebrating Freedonia going to war, the ending battle scene is one of the most chaotic endings in the history of comedy cinema (with Mel Brooks ending for *Blazing Saddles* a close second) and has got to be seen to be believed. Hopefully I have piqued your interest!

Best Scenes

The Mirror—Late at night, Firefly hears something in the hallway—it's Pinky and Chicolini sneaking into his room. To avoid detection, they pretend that they are Firefly's mirrored reflection. It's a ridiculous ballet as Firefly tries to outwit his reflection and prove that there's somebody else there.

The Lemonade Vendor—In the best running gag in the movie, Chicolini and Pinky harass a poor lemonade vendor after they get into a squabble about who gets to park their vendor cart where. It goes from burning the vendor's hat and stomping in his lemonade case to invading his home and terrorizing his family. Slapstick physical comedy at its best.

The Final Battle—We're talking rampaging elephants, a musical number, Firefly changing uniforms in every other shot, bombs, explosions—everything you would expect and would never expect to see in a war scene.

Awards and Recognition

The film caused a huge uproar across the globe. Fascist Italian dictator Benito Mussolini banned the film in his country because he was insulted by its satirical bend against government leaders like himself. We know how well that turned out . . .

The AFI named Duck Soup as the #5 movie on the 100 Years . . . 100 Laughs List and it's the #85 film on the Great Movies List. In 1990, the film was placed in the National Film Registry at the Library of Congress.

CHAPTER 13

ARTIST SPOTLIGHT

Directors Ernst Lubitsch, Preston Sturges, and George Cukor

> **CHAPTER FOCUS**
> ► Who Is Ernst Lubitsch?
> ► Who Is Preston Sturges?
> ► Who Is George Cukor?

Chapter Focus

There were hundreds of movies made from when sound came to the movies until the Cold War in the United States. So, I'm going to take a few pages and talk about the most influential comedy filmmakers of the era. I guarantee you will want to see a plethora of films after going through this chapter.

Who Is Ernst Lubitsch?

Do you want to impress your friends at parties? Show them how well educated you are? Drop the name "Ernst Lubitsch" in the conversation. He is one of the most critically acclaimed and popular comedy filmmakers from the silent pictures into the sound era and is well-known in Hollywood creative circles.

German-born Jewish writer/director Ernst Lubitsch was drawn to the stage and appeared in German music halls. He acted in film, and eventually moved behind the camera to notably write and direct the 1919 German silent film *Die Austemprinzessin* (*The Oyster Princess*) which was a satire on America.

Ernst Lubitsch and his wife

Source: Library of Congress

It was with this film that first appeared his famous "Lubitsch Touch," his style of compressing scenes into single shots that were key character moments for the theme of the film. His two main subjects were sex and money, and he was able to strike a balance where the audience felt empathy for the story and the characters that hasn't ever been duplicated. Lubitsch was a master director—understanding the technical aspects of the medium, and bonded with his actors to bring about honest performances that the audience sympathized with.

He moved to America in 1922 because "America's Sweetheart" actress Mary Pickford (a partner in United Artists studios with Charlie Chaplin, D. W. Griffith, and Douglas Fairbanks) wanted him to direct her next film, 1923's *Rosita*. He followed with 1924's *The Marriage Circle*, both box office hits and critical favorites.

In 1929, he directed his first sound film, the musical comedy *The Love Parade*. When sound came to film, he was able to utilize his gift for dialogue, quick wit, and use of songs to further cement his legacy. The film follows the story of Queen Louise (Jeanette MacDonald) as she attempts to avoid getting married to satisfy the people of her small country of Sylvania. Things are turned on their head when she meets Count Alfred (dashing Maurice Chavalier) and falls for him. The caveat being that he will not be the King if they marry, he will be the Prince Consort (which means he's the guy she's having sex with, but in a royal kind of way).

The film was a massive box office hit, and credited with saving Paramount Pictures from bankruptcy when the stock market crashed in 1929. It also was a critical home run, garnering six Oscar nominations, including Best Picture, Best Actor, Best Cinematography, Best Art Direction, and Best Sound Recording. Lubitsch received his first Academy Award nomination for Best Director, but lost to Lewis Milestone for *All Quiet on the Western Front*.

In 1935, Lubitsch was named the head of Paramount Pictures, but was terrible at it and was fired after a year. He went back to film and started a remarkable comedy film run.

The Official Ernst Lubitsch Top 3 Great Comedy Film Checklist

Nintochka (1939)

©Anneka/Shutterstock.com

A comedy starring one of the greatest dramatic actresses of the time seemed far-fetched, but the legendary Greta Garbo was game for this script co-written by Lubitsch and first-time screenwriter Billy Wilder (who would later do *Some Like It Hot* and many more classic comedies). The film was a departure for Garbo, a silent film star and a famous dramatic actress who had played *Mata Hari*, starred in the 1931 Best Picture winner *Grand Hotel*, and had been nominated for three Best Actress Oscars for dramas *Anna Karenina, Romance,* and *Camille.*

Looking for a change of pace, the studio put her in her first comedy and *Ninotchka* had the famous tagline of "Garbo Laughs!" She plays a Soviet undercover agent in Paris looking for three thieves who stole precious jewels from a Russian Grand Duchess and ends

Ernst Lubitsch directed Oscar-winner Greta Garbo in her first screen comedy

up falling in love. The film was known for its satirical depiction of life in the Soviet Union and was actually banned in the USSR. It was nominated for four Oscars including Best Picture and Best Actress for Garbo. It was selected for the National Film Registry in 1990 and is the #52 film on the AFI Great Comedy Films list.

The Shop Around the Corner (1940)

Jimmy Stewart plays Alfred Kralick, a salesman in a leather goods shop in New York City. He's stuck to his work and can't meet anyone, so he finds a woman in a dating newspaper ad. He begins to correspond with her by letter, and soon becomes smitten with her culture, wit, and intelligence.

Meanwhile a new salesgirl, Kiara Novak (Margaret Sullivan), is hired into the shop, and she immediately gets on Alfred's nerves. When Alfred finally arranges to meet with his mysterious pen pal and plans to propose, he's shocked to discover Kiara is the mystery girl.

He decides to talk to her and see if she really is the wonderful woman he hopes for, but she's upset that her "mystery man" isn't there, and she takes it out on Alfred. Dejected, he leaves— vowing to be done with her. But this is a romantic comedy after all . . .

Though the film didn't catch on with audiences, it was placed in the National Film Registry by the Library of Congress in 1999.

To Be or Not To Be (1942)

Vaudeville comedian and radio star Jack Benny starred with Clark Gable's real life wife Carole Lombard (*My Man Godfrey)* in this black comedy satire about a Polish theatre company producing a play that pokes fun of the Nazis on the eve of World War II. They're forced to don soldier's costumes and do everything to thwart the Nazi effort. Critics were divided in their opinions with many thinking that the film was crass and in bad taste—I guess because Nazis weren't that funny back then.

Ernst Lubitsch's star on The Hollywood Walk of Fame

Tragically, this was Carole Lombard's last film before she died in a fatal plane crash selling war bonds to support American troops. Mel Brooks (*Blazing Saddles*) and his wife, Anne Bancroft (*The Graduate*), remade the film in 1983. The original was placed in the National Film Registry in 1996 and is the #49 film on the AFI Great Comedy Films list.

Lubitsch was nominated for three Best Director Oscars for *The Patriot* (1928), *The Love Parade* (1929), and the romantic comedy *Heaven Can Wait* (1943). He won an Honorary Academy Award in 1947 for his "distinguished contributions to the art of the motion picture." He died of a heart attack in 1947 and has a star on the Hollywood Walk of Fame.

Who Is Preston Sturges?

In the beginning of the cinema, there were performers who wrote and directed their own material—Charlie Chaplin, Buster Keaton, Harold Lloyd—but with the advent of sound in the movies, the dynamic of filmmaking changed. Writers appeared, directors were hired, and together they brought films to life. What about those talented individuals who were both writers AND directors?

That position didn't exist until Preston Sturges came along. Originally a performer on Broadway, Sturges stepped off the stage and began writing and producing plays. His second play, *Strictly Dishonorable,* was a massive hit. Soon Hollywood came calling.

His first script was 1933's *The Power and the Glory* starring Spencer Tracy as a railroad employee who slowly grows more ambitious and power hungry as he climbs over anything that gets in his way up the corporate ladder. He wrote the script on his own, and Twentieth Century Fox bought the script in exchange for a tidy salary and more importantly, a percentage of the gross sales. This was one of the first deals where a writer made money from the profits of their screenplay. The film, told in a series of flashbacks, was an inspiration to Orson Welles and Herman J. Mankiewicz on a little movie called *Citizen Kane*.

At this point, he had found his style: fast-paced scenes, quick and clever dialogue, and a bit of slapstick. He also had an affinity for strong female protagonists. Put all of this together and you have all the ingredients of a Screwball comedy. He has been called "The Father of Screwball Comedy" by academics and scholars that make a lot more money than I do.

Sturges was making $2,500 a week for his work as a screenwriter working for any studio that would hire him, but was unhappy how directors took his scripts and changed them. He decided he wanted to have more control, and made a deal with Paramount Pictures for them to buy his spec, *The Great McGinty,* for $1. That's right! You read that correctly. One dollar. In exchange, he got to direct it. (The Paramount legal team upped it to $10 for some unknown reason, but doesn't a dollar sound so much more exciting?) It was the first writer/director deal in film industry and Sturges blazed a trail that filmmakers such as Billy Wilder would later capitalize upon.

The film follows Dan McGinty (Brian Donlevy) as he moves up the social ladder in an unprecedented way—from hobo, to Mayor, and then Governor, due to a corrupt political system and a mafia boss trying to take everything over. But McGinty is through with being a mafia stooge and balks at staying under the boss's thumb. Shenanigans ensue (as they often will when you're talking about shenanigans). Though the film was a modest hit, Sturges had firmly established his talent as a writer/director. To top it off, he won the very first Best Original Screenwriting Oscar for the *The Great McGinty*. He was on his way to becoming, not kidding here, the third highest paid person in the country. Not just in Hollywood. The United States. Seriously. Over the next five years, Sturges wrote and directed one of the greatest comedies of all time, *The Lady Eve* (1941).

I've got a couple of pages about *The Lady Eve* over in Chapter 8, so you can jump over there NOW—or finish this one up first and then swing by the other one. You bought this book. You can do whatever you want with it.

The Official Preston Sturges Top 3 Great Comedy Film Checklist

Sullivan's Travels (1942)

Movie director John L. Sullivan (Joel McCrae) decides to switch from light comedies to social drama against the advice of his studio boss. To experience how hard life is, he dresses as a hobo and hits the road, where he meets "The Girl" (the stunning Veronica Lake in her first starring role) who believes he's homeless and buys him breakfast. To pay her back, he takes her to his estate and while driving her back home, he's mistaken for a real hobo by the police and arrested for stealing his own car. Sullivan finally tells The Girl that he's a film director and she decides to help him learn about life.

The film was a modest box office hit, and the critics were mixed in their reviews. But both *Time Magazine* and the *National Board of Review* named it as one of the best films of the year. As time has gone on, *Sullivan's Travels* has been honored in many ways—it's the #39 movie on the AFI 100 Years . . . 100 Laughs List, the #61 film on the AFI's 100 Greatest Movies list (from the updated 2007 list), and in 1990 was placed in the National Film Registry of the Library of Congress.

The Palm Beach Story (1942)

That same year as *Sullivan's Travels* saw Sturges score his next hit, a romantic comedy starring Claudette Colbert (*To Be Or Not To Be*) and Joel McRae (*Sullivan's Travels*) as Gerry and Tom Jeffers, a struggling formerly well-to-do New York couple that face eviction while Tom looks for seed money to start his airport architectural project. Gerry is given money to help with their bills by an interested millionaire who wants to rent their Fifth Avenue apartment and Tom is upset with her for taking the money. Ultimately, she decides that the best way to get out of their financial hardship is to divorce Tom and find a rich millionaire to marry instead. She can then give Tom money to invest in his airport project.

Just as planned, she meets millionaire J. D. Hackensacker (popular crooner Rudy Vallee) and intends to marry him, but Tom has decided her plan is ridiculous and heads to Palm Beach to find her. He hopes to convince her that she needs to come back with him and give up this crazy plan.

And then—zaniness! (You have to be impressed with how many different words I can come up with to describe the moment in a film when things go awry! That's a good one. Maybe I'll use that one next.) Suffice to say, you have to see it to believe it. I'm not a big fan of the twist in this one, but judge this one for yourself. You can't argue with my good friends at the American Film Institute, who named it the #77 film on the 100 Years . . . 100 Laughs List.

The Miracle of Morgan's Creek (1944)

How this one got past the Hays Code still remains a mystery. Take a story about teen pregnancy, unwed motherhood, getting "roofied" and date raped, and somehow turn it into a rollicking comedy and you have this film.

Betty Hutton stars as Trudy Kockenlocker, who goes to a party of departing soldiers heading off to war, and ends up married to a man she can't remember, and also pregnant with his child. She tries to find the father of the baby with the help of her longtime admirer Norval Jones (Eddie Bracken) who she starts to fall in love with, but doesn't want to saddle him with the burden of the child. Making matters worse is Trudy's father who takes his anger out on the whole business by having Norval arrested. Then things get crazy when Norval escapes jail and is on the run.

Again, no spoiler alert, but how Sturges pulled this one off is beyond the understanding of a simple academic like myself. Wait until you see what the actual miracle is (Hint: it has something to do with the birth of the baby) and the end result, which has the power to shake the world. Not kidding either!

The film was a HUGE hit for Paramount, becoming the highest grossing film of the year. Sturges was nominated for the Best Original Screenplay Oscar but didn't win. The National Board of Review named it one of the best films of 1944 and Betty Hutton won the Best Actress award. *Time Magazine* named it one of the Best Films made between 1942 and 1944. Finally, *The Miracle at Morgan's Creek* is the #54 movie on the AFI 100 Years . . . 100 Laughs List and in 2001 was placed in the National Film Registry by the Library of Congress.

Sturges's last released film with Paramount Pictures was the satirical comedy, 1944's *Hail the Conquering Hero* about a marine who was medically discharged but is recognized as a war hero when he comes home. The film was well received by critics and Preston Sturges received his final Oscar nomination for Best Original Screenwriting, the same year that *The Miracle at Morgan's Creek* also was nominated. He didn't win for either of them. *The New York Times* named it one of the top ten films of 1944, and The National Board of Review also named it one of the top films of the year.

Then things unravel for Sturges. His next film for Paramount—*The Great Moment*—is the true life story of Dr. Thomas Morton, who discovered the effects of ether and started using the gas as an anesthetic for his dentistry patients. The film wasn't a comedy and didn't test well with preview audiences, so the studio took the film away from Sturges and ended their contract with him.

He partnered with multi-millionaire Howard Hughes and was able to add producer to his title of writer/director. He was the first American filmmaker to claim all three titles. But the films he did with Hughes went nowhere, and soon Hughes sold his production company to

MGM. Sturges ended up back at Twentieth Century Fox, but his films flamed out there as well. The IRS showed up, he became an alcoholic, and left for Europe. He died in 1959, ironically working on his biography entitled *The Events Leading Up To My Death*.

Who Is George Cukor?

When you're talking great film directors, George Cukor is definitely one of them. Not only did he make some of the biggest films in cinematic history but he also directed a number of great comedy films. Steven Spielberg, one of the top three directors in the history of the cinema, is terrible at comedy. Did anyone see *1941*? I did. It's like Voldemort in the *Harry Potter* films. You dare not speak its name. So we won't.

However, George Cukor is a completely different story. Born in 1899, he grew up with a love for theatre and performed as an actor and dancer. After high school he served briefly in the U.S. Army during World War I and afterward attended City College in New York, but soon left to work as a stage manager. He worked his way up and became a celebrated Broadway director. One of his biggest plays was the stage adaptation of F. Scott Fitzgerald's *The Great Gatsby*.

With the arrival of sound pictures, Cukor was recruited by Hollywood because of his great work with actors onstage, especially with actresses. He would become known as a "woman's director" with many of his films featuring strong female characters.

His first film was *The Tarnished Lady* (1932), with the feature film debut of celebrated Broadway actress Tallulah Bankhead (who thought that filmmaking was boring and returned to Broadway soon after) and famously discovered actress Katharine Hepburn [Editors' Note: see Chapters 14, 15, and 16—wow, that's a lot] and directed her in both 1932's *A Bill of Divorcement* and *Little Women* in 1933.

The Official George Cukor Top 3 Great Comedy Film Checklist

Dinner at Eight (1933)

This social class comedy stars a who's who of celebrated actors from the 1930s. Millicent Jordan (Billie Burke) is obsessively planning a dinner party but secretly her husband has a heart condition and is on the verge of losing his shipping business. He's hoping to convince

one of the wealthy dinner guests, Dan Packard (Wallace Beery), to buy enough stock to keep the company afloat.

Instead, Dan sees an opportunity to steal the company while his wife Kitty (Jean Harlow) looks forward to seeing her lover, Dr. Wayne Talbot (Edmund Lowe), at the party with his wife Lucy (Karen Morely) as well. The other guests at the party are also secretly in sad shape, Carlotta Vance (Marie Dressler), the aging bankrupt movie star and Larry Renault (John Barrymore), a washed-up silent film star.

Things run amok as the evening progresses. Affairs are revealed, the company takeover is discovered, and careers are nearly ruined. All before dinner!

Dinner at Eight was a big hit for MGM, making nearly a million dollars at the box office and the film was named the #85 film on the AFI Great Comedy Films list. Cukor's great reputation with actors continued to open doors for him. He was the initial director on *Gone with the Wind* and cast both Vivian Leigh and Olivia de Haviland. They were already filming when he clashed with legendary producer David O. Selznick about his filming pace. It was also rumored that Clark Gable didn't want to work with him because he was homosexual. That's right, Cukor was gay at a time where "being gay" was reserved for being "very happy at parties." Cukor was already unhappy with the script and walked away from the project.

The next film from George Cukor is the celebrated 1940 film, *The Philadelphia Story*.

Check out the "Super Great Movie Spotlight" in Chapter 14. *The Philadelphia Story* was a huge success for MGM and made a ton of money. Cukor was in even higher demand, and then this minor blip in history happened. Japan bombed Pearl Harbor, and World War II started. Bad news for everyone who loved the movies as a ton of talent went off to support their country.

Adam's Rib (1949)

After the end of World War II, Cukor returned to comedy with this screwball comedy starring Katharine Hepburn and Spencer Tracy. With a tremendous friendship, Cukor and Hepburn made eight films together throughout their careers. This classic screwball comedy finds the two stars as opposing counsel in a divorce case. Doris Attinger (Judy Holliday) follows her husband (Tom Ewell) to his mistress, and shoots him in the shoulder in a fit of hysteria. Assistant District Attorney Adam Bonner (Spencer Tracy) tries the case because he believes that someone that shoots somebody is guilty. Across the aisle is his attorney wife, Amanda (Katharine Hepburn) opposing him on the case. She thinks if the husband found *his wife* in the arms of another man, the court would find the shooting was justified. She believes Doris won't be treated fairly with "equal rights under the law" unless she champions the case.

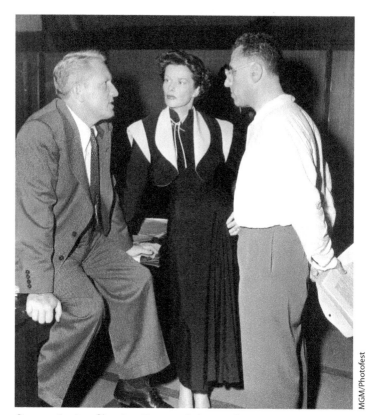

Oscar-winning filmaker George Cukor with Spencer Tracy and Katharine Hepburn, stars of 1949's screwball comedy *Adam's Rib*

Of course, as in all screwball comedies, the movie comes down to a battle-of-the-sexes as Adam and Amanda go toe-to-toe in the courtroom. The best thing about the film is watching the fireworks between Hepburn and Tracy. The two of them had started a love affair during 1942's *Woman of the Year*, and they are very natural as a married couple (even though they never got married in real life. He was married and it's a whole part of Chapter 15).

Born Yesterday (1950)

Based on a successful Broadway play, Judy Holliday stars as Billie Dawn, the sassy dumb blonde, former showgirl fiancée of millionaire Harry Brock (Broderick Crawford). Together they go to Washington, D.C., to bribe some influential politicians who can help him with his construction business. Because Judy is a bit uncouth, Brock hires local reporter Paul Berrall to tutor her so she can be a bit more refined to fit in with Washington society.

Things take a turn as Billie is a terrific student. In fact she's the smartest person in the entire movie! Berrall teaches her all about history, politics, and the law. Billie realizes that her fiancée is a crook. She also falls in love with Berrall. Push comes to shove when Brock realizes

that he has signed over most of his assets to Billie to hide them from the government and tries to get them back, but Billie is a lot smarter than she looks!

The film was nominated for five Academy Awards, including Best Picture, Best Director, Best Screenplay, Best Costume, with Judy Holliday winning Best Actress for her role as Billie. The film is the #24 film on the AFI Great Comedy Films list, and was placed in the National Film Registry in 2012.

Cukor went on to direct such films as 1952's *Pat and Mike*, another screwball comedy starring Katharine Hepburn and Spencer Tracy, 1954's *A Star is Born* with Judy Garland, 1956's *Bhowani Junction* with Ava Gardner, and 1964's *My Fair Lady*, starring Rex Harrison and Audrey Hepburn, which won eight Oscars, including Best Picture and Best Director.

After *My Fair Lady*, Cukor slowed down and made six films, none of which were of any consequence. He passed away from a heart attack at the age of 84. Looking at the cinematic landscape, he was one of the first prominent (but closeted) homosexuals in the Hollywood industry with a career full of amazing highs and lows. He was named the eighteenth Greatest Director in history by *Entertainment Weekly* magazine, and ultimately stands as one of the great comedy filmmakers of all time.

> Overall, Ernst Lubitsch, Preston Sturges, and George Cukor were amazingly talented filmmakers that contributed to the success of Hollywood film comedy before and after World War II. There are more filmmakers from the era that I highlight in another chapter, but because this one already has too many pages, I'm saving them.

CHAPTER 14

SUPER GREAT MOVIE SPOTLIGHT

The Philadelphia Story
(1941)

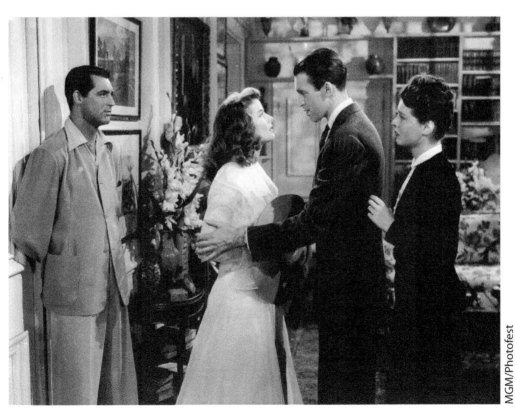

MGM/Photofest

Cary Grant, Katharine Hepburn, Jimmy Stewart, and Ruth Hussey star in *The Philadelphia Story* (1941)

▶ Starring Katharine Hepburn, Cary Grant, and Jimmy Stewart

▶ Directed by George Cukor

▶ Screenplay by Donald Ogden Stewart

▶ Based on the play by Phillip Barry

▶ Subgenres: Screwball comedy, romantic comedy, social class

▶ Comedy types: Screwball, Verbal, Slapstick

There is so much to this movie that it staggers the comedy imagination. It's got it all: perfect casting, impeccable direction, and a great script that works on several levels. Plus Jimmy Stewart goes skinny-dipping! What more do you want?!!

The Broadway play of the same name was written specifically for Katharine Hepburn, who had her boyfriend at the time, Howard Hughes, pay for the play—and subsequent rights for the film. She didn't take a salary—just a percentage of the profits—along with the caveat that she would star in the film version. Which was a pretty smart investment on her part.

Summary

Two years after divorcing wealthy socialite Tracy Lord (Katharine Hepburn) because of his alcoholism and her infuriating demeanor, C. Dexter Havens (Cary Grant) hears from his former boss at Spy Magazine that Tracy is getting married again. He blackmails Dexter into getting his top reporter Mike Connor (Jimmy Stewart) and favorite photographer Liz (Ruth Hussey) into the wedding. He wants the scoop on the biggest high society event of the year and Dexter reluctantly agrees to get them into the soiree, knowing full well that Tracy is not his biggest fan. Luckily, her family still adores him.

Passing them off as friends of Tracy's brother, Dexter takes them to Tracy's father's estate as the wedding preparations are getting set. Tracy figures out everything pretty quickly, but she's impressed with Mike. And is a little uncertain on whether or not she's doing the right thing by marrying wealthy banker George Kittredge (John Howard).

As the wedding draws closer, Tracy becomes attracted to Mike, rekindles her feelings for Dexter, with George waiting in the wings. Nervous before the wedding, she gets drunk with Mike (nothing happens! Swear!) and is caught in this completely innocent indescretion by

George. She breaks off the engagement the morning of the wedding because he suspects the worst of her, but with all of the guests arriving—she knows that she has to marry *somebody*.

Who will it be? Dexter? Mike? George? You'll have to watch the movie to find out!

Best Scenes

Opening Scene—Visually told with no dialogue, Dexter slams the front door on his way out of the house as he leaves Tracy. She comes outside with his pipe holder, which she crushes, and breaks one of his golf clubs over her knee. He rushes back in the house, intent on hitting her (because as has been noted previously that domestic abuse was funny back in the 1940s), but instead pushes her out of his way.

The Swimming Pool—It's late night before the big wedding, and Tracy and Mike get wasted. It's the second time in her life that she's ever gotten drunk, and in the moonlight they peel off their clothes in the pool—and then they get it on (we don't really see that part). It's an unbridled moment of pure joy as Tracy's restrained visage is (literally) stripped away as she actually has fun as her sexiness comes to bear on a clearly smitten Mike, who has come to learn that Tracy could be the right woman for him.

The Wedding Scene—It's the "who-does-she-pick" scene. Many people think she chooses poorly. Some think that she doesn't. (I think she picks the wrong guy.) The best part is that she has her pick of THREE MEN—something that doesn't happen in your typical romantic comedy. Forget the "love triangle"—it's a "love quadrangle"! She's a sexy woman with options, not tied down to one man and able to choose her own path—and isn't that what a good screwball comedy is all about?

Awards and Recognition

The film broke the record for box office sales at Radio City Music Hall—racking up $600,000 in six weeks.

It was the fifth most popular film in 1941 and made over $3 million worldwide.

It was an example of a subgenre of screwball comedy called "Comedy of Remarriage" where the female protagonist struggles with either a new marriage, reconciling a new marriage, or getting back into a relationship with a former husband. Other films that have this plotline include *It Happened One Night*, *The Awful Truth*, *Bringing up Baby*, and *His Girl Friday*.

The movie was nominated for six Oscars: Best Picture, Best Director, Best Actor, Best Actress, Best Supporting Actress, and Best Screenplay. It won for Jimmy Stewart (who beat out Henry Fonda for *The Grapes of Wrath*) and screenwriter David Ogden Stewart.

The film is the #15 film on the AFI 100 Years . . . 100 Laughs List, #51 on the AFI Great Movies list, and AFI's #5 of their Great Romantic Comedies. In 1995, our friends at the Library of Congress placed the film in the National Film Registry.

CHAPTER 15

ARTIST SPOTLIGHT

Actors Cary Grant, Katharine Hepburn, and Jimmy Stewart

CHAPTER FOCUS

▶ Who Is Cary Grant?

▶ Who Is Katharine Hepburn?

▶ Who Is James "Jimmy" Stewart?

Chapter Focus

I know, you're already exhausted from all of the great content in this book, especially when I'm talking about movies that were shot in black and white, but there's so much more to go. Believe me, we'll get to movies made by people that are still alive soon enough. In the meantime, open your minds and funny bones (which to be honest, when you hit it on that table edge, it hurts like a mother&$%^&#. Where's the "funny" in that?), and appreciate some hilarious stars of the comedy screen.

Who Is Cary Grant?

"Everybody wants to be Cary Grant. Even I want to be Cary Grant."

—Cary Grant

Cary Grant

If you've read any of the last four chapters, you know the name of Cary Grant. You've got to admit that "Cary Grant" is a much better name than "Archibald Leach," his actual birth name when he came to Hollywood in his early thirties. As studios were wont to do in those days, they would christen them with stage names. Known as the "King of Screwball Comedy," he was an actor who could play in any genre. He did musicals, drama, suspense, and thrillers. I guess he didn't do any horror or science fiction films, but back then they were considered lesser forms of entertainment. He would make us laugh with his dashing, classy, confident, and debonair persona that he brought to all of his films. He wasn't an actor in the sense of the method work of Marlon Brando or Robert DeNiro. He transcended the role of actor and became an icon.

He also had quite the personal life. Rumors abound that he was bisexual, backed up by him living with Western film leading man Randolph Scott. The two shared an apartment before Grant's marriage and then bought a beach house in Santa Monica after Grant was divorced. Though they both dated many women, they were constant friends who even did publicity stills together. Not that there's anything wrong with that . . .

Then there was the whole LSD thing. That's right, Grant started getting legal LSD psychiatric treatments in the 1950s. And he loved to tout the effects of the hallucinogen, and not just the residual interests in wearing a tie-dye t-shirt. He took it as therapy to help him get past his incredibly miserable childhood growing up in England.

His voice, an amazing transatlantic accent (that means both American and Englander) that makes you swoon. Fine, I'll admit it, I have a huge man crush on Cary Grant. I don't care if he died over thirty years ago—that guy was amazing.

Alright, let's get to the bio!

Born in 1904, his father was a drunk, and his mother was clinically depressed and eventually committed to an insane asylum when Archie was nine.

The only good thing his father did for him was take him to the theatre. He started performing onstage when he was six. His father took him to the movies, where he saw the Hal Roach films featuring John Bunny and Mabel Normand and got an interest in film comedy. His father remarried and didn't want Grant to be a part of his new family, and placed him in the custody of one of the dancing troupe members. His father must have read an article from "Horrible Parenting Magazine."

He drifted between grammar schools (allegedly getting kicked out of a school for either stealing pants or peeking into the girl's locker room), but always kept performing onstage. He joined "The Pender Dance Troupe" as an acrobat when he was fourteen and fell in love with the applause.

He finally got the chance to go to America when he was twenty-two, and performed a vaudeville tour with The Pender Troupe across the States. He stayed in America when the troupe went back to England and headed for the Broadway stage.

He performed onstage for the next ten years, and with his good looks and winning charm attracted a following of enthusiastic fans and critics. It was this stage success that brought him to Hollywood in 1931 and the studio changed his name.

His feature film debut was for *This Is The Night* in 1932, then Mae West "discovered him" on the Paramount lot and made him her leading man in 1933's *She Done Him Wrong* [Editors Note: read Chapter 10] and again with her in *I'm No Angel*, and his career took off.

He was doing so well that when his contract ended with Paramount Pictures in 1936, he hired an agent and struck out on his own. This was unheard of. During that time, a studio only signed actors to multi-year exclusive contracts. Now he could pick and choose his projects, and the amount of money he would make. He even could negotiate for a percentage of the box office grosses. Grant was so successful that he rewrote the rules. He had his biggest hit to date the following year and began his ascent to the throne as "the King of Screwball Comedy."

Supernatural comedy *Topper* (1937) follows the story of George Kerby (Cary Grant) and his wife Marion (Constance Bennett) who die in a car accident and come back as ghosts. They realize that they can't get to Heaven unless they perform a good deed. They pick Cosmo Topper (Roland Young) a friend of theirs who lives a boring life under the thumb of his overbearing wife. The Kerbys appear to him, explain the situation, and take him out to party.

Which he does a little *too* much. He gets drunk and arrested for intoxication. His wife is livid, but his friends start to enjoy the new and spontaneous Topper. Marion, who Topper always

had a crush on, appears and flirts with him. He takes her out for ice cream and a trip to the dress shop. George finds out that Marion is spending time with George, and he gets jealous. Topper and Marion have checked into a hotel and George tracks them down.

Along the way there's a bunch of ghostly shenanigans and ultimately everything is resolved. Again, I won't give it away—but let's say that Topper's wife sees Cosmo in a whole different light, and George and Marion get a chance to go to the afterlife.

Topper was a big box office hit, and Grant was smart enough to get a piece of the profits. The film got two Oscar nominations, Best Supporting Actor for Roland Young and Best Sound. Even better, the film is the #60 film on the AFI Great Comedy Films list and, therefore, gets a mention in my book!

With the major success of *Topper*, Grant found himself cast in a series of high-profile comedies (many of which are in Chapters 9, 10, and 13):

The Awful Truth (1937)—Directed by Leo McCarey and co-starring Irene Dunne and Ralph Bellamy. This is the one where they are the rich couple that think each other is having an affair and decide to call it quits, but then they both fall back in love and try to sabotage their relationships with the new people in their lives.

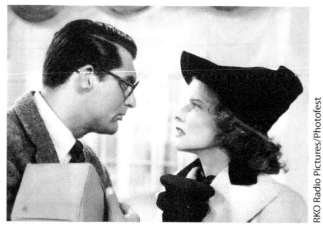

Bringing Up Baby (1938)—Directed by Howard Hawks and co-starring Katharine Hepburn. It's the one where he's the paleontologist searching for the dinosaur bone and she's the airhead heiress with the leopard that makes his life insane.

Holiday (1938)—Directed by George Cukor and again co-starring Katharine Hepburn. This is the one where he's a businessman who decides to quit the business world and go on a permanent vacation after he marries his wealthy fiancée.

Stars Cary Grant and Katharine Hepburn from *Bringing up Baby* (1938)

The Philadelphia Story (1940)—Directed by Howard Hawks and co-starring with Katharine Hepburn. This is the one where she's the wealthy heiress and he's her ex-husband. On the eve of marrying her new husband, he brings in a reporter (Jimmy Stewart in his Oscar-winning role) and tries to win her back.

His Girl Friday (1940)—Directed by Howard Hawks and co-starring Rosalind Russell and good ol' Ralph Bellamy. This is the one where Russell is the fast-talking reporter and Grant is the editor who still loves her. He sends her out on one last story to try and win her back.

My Favorite Wife (1940)—Directed by Garson Canin, Produced by Leo McCarey, and co-starring Irene Dunne (his co-star from *The Awful Truth*) and Randolph Scott (Grant's roommate!). Ellen (Dunne) was stranded on a desert

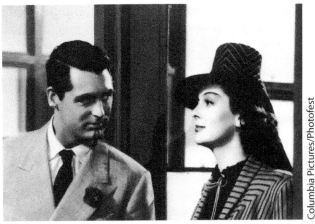

Cary Grant and Rosalind Russell in *His Girl Friday* (1940)

Columbia Pictures/Photofest

island for seven years but finds her way back to husband Nick (Grant) who has finally moved on with his life and is engaged. Now, he's forced to choose between his once-thought dead wife and his new potential bride. The film was another huge box office hit for Grant and the film was nominated for Best Story, Best Score, and Best Art Direction for the Oscars that year.

Arsenic and Old Lace (1944)—Directed by Frank Capra and co-starring Priscilla Lane and Raymond Massey. This is the one where Mortimer (Grant) is getting married and discovers that his aunts are poisoning lonely old men and burying them in the basement. If that isn't bad enough, his escaped convict brother appears on the scene to cause havoc.

Mr. Blandings Builds His Dream House (1948)—Directed by H. C. Potter and co-starring Myrna Loy and Melvyn Douglas. The film follows the story of Jim Blandings (Grant) who lives with his wife Muriel (Loy) and two daughters in a cramped New York apartment. He decides they are leaving the city to move to the spacious land of Connecticut. They end up buying a complete disaster of a house, which they tear down and try to build their "dream house" of the title. Hilarity ensues when the house-building proves to be more than anyone bargained for as a litany of problems force the family to the edge of personal and financial disaster. The film is the #72 film on the AFI Great Comedy Films list.

I Was a Male War Bride (1949)—Directed by Howard Hawks and co-starring Ann Sheridan. This screwball comedy follows Grant as an Army Captain who falls in love with a Lieutenant in Germany. The only way he can get back to the United States and be with her is for him to dress as a nurse.

Monkey Business (1952)—Directed by Howard Hawks and co-stars Ginger Rogers and Marilyn Monroe. In this film, he's the research chemist searching for the medicinal Fountain of Youth, and when his lab chimpanzee spills some chemicals, the serum works and everyone in the lab starts acting younger.

Besides all of these films, he made a few movies with Alfred Hitchcock, the Master of Suspense, who thought of Grant as the personality he wish he had (as opposed to Jimmy Stewart, who was the personality that Hitchcock knew he had). He starred in some of Hitchcock's most successful films: *Suspicion* with Oscar-winner Joan Fontaine, as a possibly murderous newlywed; *Notorious*, the World War II spy-thriller with the vivacious Ingrid Bergman; *To Catch a Thief* as "The Cat" a retired international jewel thief opposite the angelic Grace Kelly; and finally *North by Northwest* as playboy Roger Thornhill, who gets sucked into a CIA plot to stop an international spy ring. I'm sure you've seen the biplane scene, where he's escaping a machine-gun attacking plane in the middle of a cornfield in nowhere Iowa. Go watch the whole movie, or watch the scene on YouTube. Either way, it's brilliant.

Famed Director Alfred Hitchcock worked with Cary Grant on four of the Master of Suspense's most notable feature films

Besides the films with Alfred Hitchcock, he also starred in such classics as *Gunga Din, An Affair to Remember, Operation Petticoat,* and *Charade.*

He turned down the role of James Bond for *Dr. No* (saying he was too old) and refused the role of Humbert Humbert in *Lolita.*

He appeared in over seventy films, was nominated for two Best Actor Oscars for his work in the dramas *Penny Serenade* in 1941 and *None But the Lonely* in 1944. He received an Honorary Oscar in 1970 for his lifetime of achievement for acting.

In 1962, he left show business to spend time with his newborn daughter by actress Dyan Cannon. That's right, he had a daughter when he was sixty-one years old. When he died in 1986, he was one of America's richest actors worth $60 million. In 1999, he was named the second greatest male star of classic Hollywood (behind Humphrey Bogart) in the AFI's Greatest Screen Legends list and has the most films on the AFI list of Great Romantic Films and Great Comedy Films. *Entertainment Weekly* named him the Sixth Greatest Movie Star of All Time. In 2005, *Premiere Magazine* named him the #1 Movie Star of All Time.

Which begs the question—what actor is the new Cary Grant?

Answer—There isn't one.

Who Is Katharine Hepburn?

Just as there was only one Cary Grant, there was only one Katharine Hepburn. Dubbed the "First Lady of the Cinema," she was the epitome of Hollywood class and style, winning four Oscars for Best Actress, and the only actor or actress in Oscar history to win four awards in this top honor. (Daniel Day-Lewis does have three, and Meryl Streep has two. Don't believe me? Google it up and then come back and apologize.)

But she was so much more than an actress, she was also an activist and a feminist. In the 1930s, that was a big deal. She was never quiet and many found her unbearable, and she suffered through many career ups-and-downs because of her strong-willed personality.

Katharine Hepburn was born in Hartford, Connecticut, in 1907 and had good parents who encouraged her to speak her mind. She was a tomboy who played golf and tennis, and unfortunately lost her brother when she was fourteen years old when he tried to do a hanging trick (though there was a persistent rumor that he hung himself). She was home-schooled after the incident caused her to become shy and withdrawn. Luckily for the movies, that wouldn't last long.

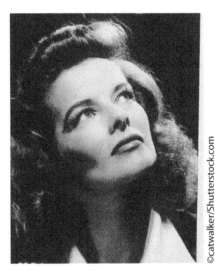

Katharine Hepburn

She attended the all-women's Bryn Mawr College, and there discovered her love for acting. After she graduated, she went to Baltimore to meet theatre producer Edwin H. Knopf, who cast her in her first professional stage production. She took voice lessons after being criticized for her shrill voice, and went to Broadway where she struggled to find her way. She quit acting to marry a friend she knew from her college days.

Always the free spirit, she couldn't let go of acting and returned to Broadway. She finally got her big break in *The Warrior's Husband*, and then got the chance to audition for director George Cukor and his film *A Bill of Divorcement*. He was impressed with her and she accepted the leading role after negotiating a large salary for herself (which was unheard of for a first-time film actress). But, this lady was headstrong. She definitely made quite the impression.

A Bill of Divorcement got a huge reception. The critics fell in love with her, she was signed to a long-term contract, and George Cukor ended up working with her on nine more films. She received great reviews for her next film, *Christopher Strong,* about a woman who has an affair with a married man, and she won her first Best Actress Oscar in 1933 for her role of an eager young actress in *Morning Glory.*

Next up was her starring role as Jo in the Hollywood adaptation of the classic Louisa May Alcott book, *Little Women*. The film was loved by critics, a huge box office hit and nominated for Best Picture and Best Director for George Cukor, and the film won for Best Adapted Screenplay.

Then things started going off the rails. She went to Broadway and her performance in *The Lake* was a flop, and the critics came out in full force. She had a terrible relationship with the press, refusing interviews and wearing pants instead of dresses for her public appearances. You read that correctly, she was the first big Hollywood actress to wear pants on-screen and off. The world was funny back in the 1930s.

What followed for Hepburn was a series of eleven films, with nine of them box office failures, including her two 1938 pairings with Cary Grant, *Holiday*, and the classic screwball comedy *Bringing Up Baby* (which is now considered a classic!).

She did get her second Best Actress Oscar nomination for her turn in 1935's *Alice Adams*, where she plays a young woman who tries to pass herself off as wealthy to land a husband, but the goodwill and positive reviews disappeared quickly and soon Hollywood considered her "box office poison."

Now, here's where things get interesting. She bought out her studio contract and decided to launch a comeback and found the play *The Philadelphia Story*. Her boyfriend, Howard Hughes, bought the film rights for her, and the play was a huge hit, running for over a year on Broadway.

Of course, Hollywood came back to Hepburn, and she gave the rights to MGM as long as she starred in the film and brought George Cukor on to direct. They hired Cary Grant to play her ex-husband C. Dexter Havens.

The film was crafted for Hepburn to remake her image. She was the spoiled rich girl, but the audience felt sympathy for her as she tries to figure her way between her impending marriage, her ex-husband who is still in love with her, and the reporter she meets that falls in love with her, played by Oscar winner Jimmy Stewart.

You can read all about it in my Chapter 14 Super Great Movie Spotlight!

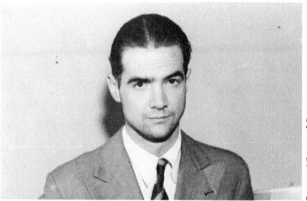

Multi-millionaire Howard Hughes bought the rights to *The Philadelphia Story* and gave them to Katharine Hepburn

Source: Library of Congress

More importantly for Hepburn, she was back. The film was huge, the critics loved her again, and she got her third Oscar nomination for Best Actress. Her next film was a major milestone for her both professionally and personally.

Hepburn and her friend Garson Kanin developed the script for 1942's *Woman of the Year* and they pitched the project to Producer Joseph L. Mankeiwicz. He was excited to buy the project. They brought on celebrated director George Stevens who had directed Hepburn in her second

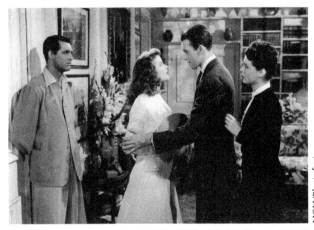

Katharine Hepburn stars in *The Philadelphia Story* (1940)

Oscar nomination for *Alice Adams*, and hired two-time Oscar winning actor Spencer Tracy (for *Captains Courageous* and *Boys Town*) for a romantic comedy that followed the lives of two reporters and how they attempt to balance their careers with their marriage.

Political affairs columnist and self-declared feminist Tess Harding (Hepburn) clashes with sports journalist Sam Craig (Tracy) at their jobs for the New York Chronicle. Both are from different backgrounds, she is a well-educated writer who speaks multiple languages, and he's a regular guy who likes sports. They fight about baseball through their respective columns, but eventually bury the hatchet when they fall in love and get married.

As a political activist, Tess disrupts her and Sam's home when she brings home Chris, a six-year-old Greek refugee, without talking to Sam first. Things get thrown for a loop when Tess is awarded "America's Outstanding Woman of the Year" and wants Sam to go with her to the awards banquet, and leaves Chris at home to fend for himself. Not exactly Mom of the Year!

Sam refuses to go, saying he has more important things to do, and after getting her award, she comes home to find both Sam and Chris are gone. Sam has taken Chris back to the orphanage, and Sam refuses to talk to her.

Again, no spoilers! But if you believe that love triumphs in the end, this is the right movie for you.

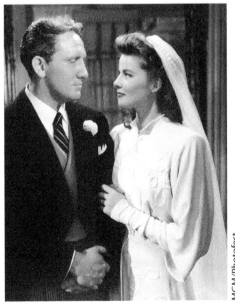

Woman of the Year

The movie is quintessential Hepburn—a strong female with success on her mind who doesn't need a man to define who she is, and Tracy is the regular guy who happens to be in love with her. The actors are perfect in their roles, because they are pretty much them. And yes, they did fall in love during the movie, but behind the scenes as well.

As was the custom back in the day, Tracy did not divorce his wife. But everyone knew that Hepburn and Tracy were a couple. Their love affair would last until his death in 1983. Besides *Woman of the Year*, they did eight other movies together, three of them comedies, and all three had similar themes:

Without Love (1945)—A romantic comedy (originally a play written for Hepburn) where Jamie (Hepburn) undergoes a marriage of convenience with a scientist (Tracy) who is trying to make an oxygen mask for high-altitude pilots. Though it's all business, love begins to bloom! This one sounds pretty silly.

Adam's Rib (1949)—A screwball comedy which is discussed in the George Cukor chapter. [Editor's Note: See Chapter 13.] In case you forgot, it's the one where they are both lawyers on opposite sides in the case where the wife shot her husband.

Pat and Mike (1952)—A film directed again by George Cukor and written specifically for them by Garson Kanin and Ruth Gordon. This was another battle-of-the-sexes screwball comedy, where Pat (Hepburn) is a superstar golf and tennis star who hires Mike (Tracy) to keep her fiancé away from her because she loses confidence whenever he's around. That one sounds pretty silly too.

Her teaming with Spencer Tracy cemented her legacy as a comedy actress. She did do a handful of comedies, but switched up and focused on those "dramas" that aren't really important in a book like this.

Yes, all of those other genre movies *did* lead to a little bit of attention, such as her additional Best Actress Oscar Nominations for *The African Queen* (1951), *Summertime* (1955), *The Rainmaker* (1956), *Suddenly Last Summer* (1959), *Long Day's Journey Into Night* (1962), and winning the Best Actress Oscar for *Guess Who's Coming to Dinner* (1967), *The Lion in Winter* (1968), and *On Golden Pond* (1981).

She passed away in 2003 having appeared in a total of fifty-two feature and television movies. She's the #1 actress on the AFI's "50 Greatest Movie Legends" list, she has six films in the AFI "100 American Love Stories" list (*The Philadelphia Story, Bringing Up Baby, The African Queen, On Golden Pond, Guess Who's Coming to Dinner,* and *Woman of the Year*), and was voted the "2nd Greatest Movie Star of All Time" by *Entertainment Weekly*.

Like I said, icon of the cinema and a gifted comedienne who sparkled in her roles with a strength and beauty that will never be rivaled.

Long live Katharine Hepburn!

Who Is James "Jimmy" Stewart?

Another icon of the silver screen, known for his on-screen "Everyman" persona with a congenial nature and distinctive drawl (even I can do a killer impersonation). [Editor's Note: Unfortunately for his friends, *all* of his impressions sound like Jimmy Stewart. It's sad.] He starred in some of the greatest films of the twentieth century, and several are comedy film classics!

Jimmy Stewart

James Stewart had a very normal childhood. He wanted to be a pilot in the Air Force, but his father made him go to college instead. His love for acting started at Princeton University and joined a summer stock theatre troupe where he became fast friends with a young Henry Fonda. He went to Broadway and struggled to find work during the Great Depression, but was eventually seen by Hollywood talent agents who brought him to Los Angeles.

He appeared in eighteen films in a variety of leading and supporting roles until hitting success with his 1938 comedy triumph *You Can't Take It With You* for director Frank Capra. This is the one where he plays Tony Kirby, the banker who falls in love with Alice Sycamore, played by Jean Arthur. They have to deal with their contrasting families. His is the rich banker and hers is the eccentric family living in the way of the banker's new housing development. The film won Best Picture and Best Director for Capra and opened the door for Stewart's success. He reteamed with Frank Capra for the classic 1939 political drama *Mr. Smith Goes to Washington*, where Stewart received his first Best Actor nomination. That film was a big hit.

Next up was the 1940 Ernst Lubitsch romantic comedy *The Shop Around the Corner*, where Stewart starred with longtime friend Maureen Sullavan. In this story about two store clerks who carry on a secret pen pal relationship, the whole time not realizing that they work together. Worse, they hate each other! The film was another hit for Stewart.

©catwalker/Shutterstock.com

In 1939, he starred with Marlene Dietrich in the western comedy *Destry Rides Again*, playing the title character, a pacifist deputy who is enlisted to stop a war in the small town of Bottleneck. A fight was started by the local boss of the town, who killed the now deceased former Sheriff and aims to rule the town. The movie was a big hit, and Stewart and Dietrich had a short-lived affair during filming. Not bad, Jimmy. Not bad at all!

His biggest triumph came with 1940's *The Philadelphia Story*, with Katharine Hepburn and Cary Grant. You know all about this film. But the biggest takeaway was how much the audiences and critics loved Stewart. It was for this film that he won his Best Supporting Actor Oscar and starred in three other films, and then the Japanese bombed Pearl Harbor.

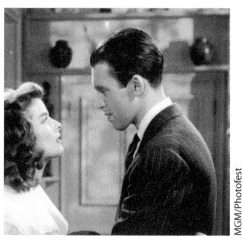

Jimmy Stewart won a Best Supporting Actor Oscar for *The Philadelphia Story* (1940)

He had learned to pilot in 1935, and after being rejected twice for being underweight, he made it into the U.S. Army as a private, and was eventually promoted to Brigadier General before he retired in 1959. He had a storied career, going through from Lieutenant to Captain and eventually Colonel, flying combat missions and not making training films (which was the one thing he didn't want to do). He was twice decorated with the Distinguished Flying Cross, and after the war joined the Reserves.

He went back to Hollywood and picked up where he left off, starring in his last Frank Capra production, the seminal classic *It's A Wonderful Life* in 1946. The story of George Bailey garnered Stewart his third Best Actor nomination. But the film was a box office failure and Stewart had doubts that he had a viable acting career. He did one more comedy, *Magic Town*, which also fared poorly.

Then famed film director Alfred Hitchcock came calling. He liked the idea of Stewart as the "Everyman" who gets caught up in extraordinary situations and felt the audience would sympathize with his plight. Their first film together was the experimental single take stage play adaptation of *Rope*. He played a college professor who discovers his former students murdered and stuffed a body into a trunk in the middle of a dinner party. Unfortunately, this film was a flop too.

This didn't stop Hitchcock and Stewart from working together again on such amazing films as *Rear Window*, the remake of *The Man Who Knew Too Much*, and *Vertigo*. In fact, *Vertigo* is considered one of the greatest films ever made, and recently supplanted *Citizen Kane* as the top film of all time in *Sight and Sound* magazine.

Worried about his box office appeal after *Rope*, he switched to Westerns and began working with celebrated director Anthony Mann on a string of successful genre films, including the hit *Winchester 73* in 1950. This was the first film where Stewart had traded his salary for a piece of the profit receipts. He made over a half million dollars from the film. Soon other stars would start doing the same thing.

In-between his film acting, he decided to tackle Broadway in the lead role in the Pulitzer Prize-winning stage play *Harvey*. Stewart built up quite a following, and critical praise, performing the role for nearly three years when its main leading man would go on vacation and then he starred in the film adaptation.

Alfred Hitchcock also worked with Jimmy Stewart on four memorable films

Harvey (1950) follows the tale of Elwood P. Dowd, just your average guy who happens to have a six-foot-tall silent, invisible rabbit named Harvey as his best friend. (He actually says it's a "pooka," a mythological spirit that likes social misfits.) Elwood tells us that Harvey has the power to stop time and transport himself and anyone with him anywhere in the Universe, and he's also a very good listener.

Everyone in town seems to be okay with his unusual eccentricity, but his sister Veta (Josephine Hull) and niece Myrtle Mae (Victoria Horne) have had enough of him. Soon, they take him to the local mental sanitarium to be committed. Once there, it's actually *Veta* that gets committed when she babbles on to one of the staff doctors about the rabbit that she admits to seeing occasionally.

Over the course of the film, a slew of psychiatrists try to convince Elwood that Harvey isn't real. In the end, he convinces everyone that Harvey *is* real. There's a ton of tomfoolery with Dr. Chumley, who ends up believing in Harvey so much that he actually leaves town with the invisible rabbit. People fall in love, and at the center of the maelstrom is a smiling Elwood. The nicest guy in the world with his best friend.

The film garnered Stewart his fourth Best Actor nomination and Josephine Hull won for Best Supporting Actress. The movie was a monster hit with audiences, but because Universal has spent $750,000 to acquire the rights, and with Stewart again getting a percentage of the box office—the film lost money. *Harvey* is the #35 film on the AFI Great Comedy Films list.

He did another forty films after *Harvey*, including such wonderful movies as *The Greatest Show on Earth* (1952), *The Glenn Miller Story* (1954), the classic Hitchcock films mentioned previously, *The Spirit of St. Louis* (1957), *Bell, Book and Candle* (1958), his fifth Best Actor Oscar-nominated turn in *Anatomy of a Murder* (1959), *The Man Who Shot Liberty Valance*

(1962), *How the West Was Won* (1962), *The Shootist* (1976), and *Airport '77* (okay, maybe that last one isn't so wonderful). And, he did a lot of television, having two short-lived series in the early 1970s.

Overall, Stewart appeared in ninety-two films and television programs. He had one wife, Gloria, for his entire life, two adopted kids and two daughters, was a philanthropist and donated to charity, supported the Boy Scouts, and was a major Republican supporter. He also wrote poetry. He passed away from a pulmonary embolism in 1997 at the ripe old age of eighty-nine. And the world was a little less bright on that day.

He is one of the most recognized actors in film history and won another Oscar for Lifetime Achievement in 1985 and the Cecil B. DeMille Lifetime Achievement Award from the Golden Globes in 1965. He is the AFI's third Greatest Male Star of All Time (behind Cary Grant and Humphrey Bogart), has the most films in the AFI's list of Greatest Movies, has two (*It's a Wonderful Life* and *Mr. Smith Goes to Washington*) of the top five films in the AFI's 100 Years . . . 100 Cheers listing of most inspirational films, and on and on and on. I can't type anymore because there are too many awards and recognitions for his amazing body of work.

Just like Cary Grant and Katharine Hepburn, there will never be another Jimmy Stewart. Hold on a second, I think that Tom Hanks might be our generation's Jimmy Stewart. Okay, that's another book I have to write.

Long live Jimmy Stewart!

Alright my friends—let's turn the page and see more of the talented actors, actresses, and films of the 1940s and 1950s! Onward!!

Jimmy Stewart's footprints in the cement in front of the TCL Chinese Theatre in Hollywood

©Philip Pilosian/Shutterstock.com

CHAPTER 16

ARTIST SPOTLIGHT

Directors Frank Capra and Howard Hawks

CHAPTER FOCUS
► Who Is Frank Capra?
► Who Is Howard Hawks?

Chapter Focus

Continuing our series on great directors that kick-started verbal and screwball comedy and made some of the classic comedy films of the last century.

So your head is spinning at this point. I mean, I get it! "They made a ton of really good movies, but before I read this chapter and that other one about directors I never heard of before and the learning is too much! Give me somebody familiar! Please!"

But if you look at it, the fact you are learning things that you never knew before proves that this book is doing its job. You didn't spend $120 to buy this book, and not expect to learn something, did you? Education comes with a price. [Editor's Note: Why does he keep saying the price is getting more and more expensive? If you spent $120 for this book, whoever sold it to you should be embarrassed of themselves. Please shoot us an e-mail and then refer this to the local authorities.]

So let's learn a bit about a director you probably *have* heard of before. His name is Frank Capra, and he made some of the biggest movies in history: *It's a Wonderful Life, Mr. Smith Goes to Washington, It Happened One Night*, and I could go on and on in this introductory paragraph, but then what would I have to write about? Remember I'm getting paid by the word.

Who Is Frank Capra?

Known as the director of the "feel-good" movie, Capra was born in 1898 in Sicily. His family immigrated to the United States when he was five. He sold newspapers throughout school and went to Caltech to study chemical engineering. He graduated in 1918 and joined the U.S. Army. He was discharged after he got the Spanish flu and spent the next couple of years drifting across the United States.

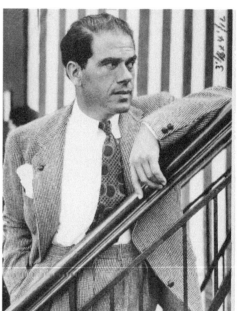

Frank Capra

He got into the film business in 1921 after reading a newspaper article about the industry coming to Los Angeles. He initially worked with producer Harry Cohn as a writer and director. Then he worked with Hal Roach on the *Our Gang* kiddie comedies and then moved over to Mack Sennett and the Keystone Film Studios to work with comedian Harry Langdon. [Editor's Note: Chapter 7 if you want a refresher.] Langdon was at First National Studios where they worked on two features, *The Strong Man* (1926) and *Long Pants* (1927), and then Capra was fired after a fight with his leading man.

When sound came to the movies, he went to Columbia Studios where his first employer, Harry Cohn, was now in charge of the studio. Capra's engineering background helped him to make the transition to sound much easier. He made ten silent feature films and his first sound film, *The Younger Generation*, in 1929. Capra had a real affinity for the material as the story followed a young immigrant trying to make his way from the streets in New York City. But it was his next film that would lay the foundation for one of the greatest legacies in film history.

The movie is 1934's *It Happened One Night*, starring Clark Gable and Claudette Colbert. It's such a great movie, it gets a "Super Great Movie Spotlight"—check it out in Chapter 9.

Library of Congress, Prints & Photographs Division, NYWT&S Collection [reproduction number LC-DIG-ds-04081]

It Happened One Night firmly established Capra as a filmmaker to be reckoned with, and his next film was another screwball comedy, 1934's *Broadway Bill*, starring Myrna Loy and Warren Baxter. It's about Dan Brooks (Baxter) who dreams of becoming a racehorse trainer and shenanigans ensue. Capra would return to a familiar theme from *It Happened One Night* where a rich woman, Loy's Alice, was in love with Dan even though her rich father doesn't approve of him. She must push past her society upbringing to chase after her heart.

Columbia Pictures/Photofest

Claudette Colbert

This idea of a thematic storyline enriching a character's journey brings Capra's directing to a higher level. By adding this additional depth, a film will resonate more strongly with audiences, and that sense of heart and purpose is what continues to define Capra's style that enthralls audiences today.

Speaking of themes, one of his biggest was the "underdog" where our protagonist faces an uphill journey to achieve his goal in the face of adversity that would destroy any normally sane person. This is a theme that Capra identified with when he started in the film business without any experience. It took him a long time to get where he was, and he never forgot his own journey.

The Official Frank Capra Top 3 Great Comedy Film Checklist

Mr. Deeds Goes to Town (1936)

This brings us to his blockbuster smash romantic comedy starring Gary Cooper (*Sergeant York, High Noon*) as Longfellow Deeds, a regular Joe that suddenly inherits $20 million from his dead uncle during the Great Depression. His uncle's scheming lawyer, John Cedar (Douglass Dumbrile), has been embezzling funds from the uncle's accounts. They bring Deeds to New York City to keep an eye on him. Deeds is immediately set upon by the press wondering about the poor tuba player who's a millionaire, including beautiful reporter Louise "Babe" Bennett (Jean Arthur). She goes undercover as a poor factory worker to find out all about him. She "faints" and he catches her, and soon falls in love without realizing her true intentions of humiliating him in the press.

When he discovers that "Babe" is a reporter, he's heartbroken. After a confrontation with a farmer who lost everything when the market crashed, he decides to give his money away to homeless families by purchasing three thousand farms. Cedar, worried about his thievery being discovered, tries to get Deeds declared mentally incompetent. Will Mr. Deeds go to an insane asylum? Go watch the film and find out for yourself!

Mr. Deeds Goes to Town was a hit with the critics and at the box office. It was nominated for five Oscars, including Best Picture, Best Director, Best Actor, Best Screenplay, and Best Sound. It won Gary Cooper his first Oscar for Best Actor, and Capra won his second Oscar for Best Director. The film is also ranked the #70 film in the AFI Great Comedy Films list. Adam Sandler starred in an inferior remake of the original in 2002.

You Can't Take It With You (1938)

Based on a hugely successful play, the movie is similar to *Mr. Deeds Goes to Town* since the film is a social class comedy, but this time it's the rich guy who learns how to be poor.

Jimmy Stewart plays Tony Kirby, the son of a wealthy banker, who falls in love with Alice Sycamore (Jean Arthur) who works at one of his father's companies. When he proposes, she's worried that her family won't be able to get along with his rich family. Suffice to say, her family is waaaaaay out there. Even worse, her family is stalling a major real estate project that Tony's father is trying to lock up.

Fireworks ensue (literally) when Tony brings his family to meet Alice's family one night for dinner. It's a disaster, and then the police come and arrest everybody for disturbing the peace (I wasn't joking about those fireworks!) and they all end up in jail. After that, the families hate each other and Tony's mother insults Alice for not being worthy of her son's affections. Alice breaks off the engagement and leaves town.

Alice's family decides to sell the house to Tony's father. Along the way, Tony's father realizes that money isn't the most important thing and it's family that really counts. In the end, everyone comes together as Tony and Alice are reunited. Fade out!

The film's box office was huge, nearly $6 million worldwide and it was the highest-grossing film of 1938. *You Can't Take It With You* was nominated for seven Oscars, including Best Picture, Best Director, Best Supporting Actress, Best Screenplay, Best Cinematography, Best Editing, and Best Sound. It won two: Best Picture and Capra's third Best Director Oscar.

It was at this point that Frank Capra could be considered the most important film director during this era in the industry. His name was above the title for his movies, and along with Alfred Hitchcock, had become one of the first celebrity directors.

His next film was the controversial 1941 drama *Meet John Doe*, about a reporter played by Barbara Stanwyck who makes up a story about a suicidal homeless man. The newspaper is forced to hire a real homeless man, played by Gary Cooper, to play the part when the public becomes concerned for him.

The film is the ultimate Capra production, a true "underdog" facing insurmountable obstacles in the face of an oppressive society intent on keeping he and others like him down. Again, Capra identifies with the little guy, and since he drifted around before discovering the film industry, *Meet John Doe* could be considered a very personal film.

Arsenic and Old Lace (1941)

Capra's next film was this dark screwball comedy based on a hugely successful Broadway play. *Arsenic and Old Lace* stars Cary Grant as theatre critic Mortimer Brewster, who has spent his entire adult life dismissing the idea of marriage as a pointless mistake. When he meets a minister's daughter, Elaine Harper (Priscilla Lane), he is smitten. Soon they are headed down the aisle with him eating his words the whole time.

Visiting his aunts Abby and Martha (Josephine Hull and Jean Adair) on the way to their honeymoon, he discovers a dead body in a trunk. After suspecting his insane Uncle Teddy (John Alexander), his aunts reveal that they are the ones who actually killed eleven men and buried them in the cellar. They say they are performing a service by taking in lonely elderly men and poisoning them with the arsenic in the film's title, giving them a peaceful send-off.

Mortimer is now in a panic. He saves their current boarder and discovers his criminally insane brother Jonathan (movie heavy Raymond Massey) has shown up with an accomplice, Dr. Einstein (real movie heavy Peter Lorre), and their own dead body. Wackiness ensues as everyone starts hiding bodies when Elaine shows up at the house—ready to go on her honeymoon, then a policeman and his partner, and then the Captain of the precinct. It's madcap! Now go and watch it!

Positive critical reviews followed and the film was a box office success. The AFI named *Arsenic and Old Lace* their #30 film on the Great Comedy Film list.

And then World War II happened. The entire Hollywood movie business ground to a halt. Capra made movies for the U.S. Army and upon returning from the war, he joined forces with Hollywood legendary director William Wyler (*Ben-Hur, The Best Years of Our Lives*) and George Stevens (*Shane, Giant, The Diary of Anne Frank*) and started Liberty Films. They only made one film, 1946's *It's a Wonderful Life*.

It's the quintessential Capra "underdog" film, where Jimmy Stewart plays George Bailey, a small-town banker who has spent his life helping his friends, but now contemplates suicide after his Savings & Loan Company is about to be shut down due to a missing payment.

As he is about to jump off of a bridge after crashing his car, an angel named Clarence visits Bailey. George tells him that he wished that he had never been born. Taking this as a challenge, Clarence gives George the chance to see what would have happened if he hadn't been born.

Frank Capra

It's a Wonderful Life was nominated for five Oscars, including Capra for Best Director, but only won a special technical achievement award for creating fake snow. After repeated television viewings during Christmastime, the film has gained an amazing appreciation by audiences. It's the #11 film on the AFI Greatest Movies list, and is the #1 film on the AFI's 100 Years . . . 100 Cheers list for the most audience-inspiring films.

Unfortunately, *It's a Wonderful Life* lost a bunch of money for the RKO Studio, and Liberty Films disbanded. Capra made six more films after this, but it was clear that his best films were in the past. There were some hints about him being a Communist during the Cold-War hysteria that enveloped Hollywood, due to his unflattering portrayal of bankers and politicians.

He retired from Hollywood in 1952, leaving behind an incredible legacy: four-time president of the Academy of Motion Pictures Arts & Sciences; an AFI Lifetime Achievement Award in 1982; and in 1986 he won the Congressional National Medal of the Arts bestowed upon him by President Ronald Reagan. It's the highest honor that can be given to an artist in the United States and Capra was the first film director to be given the award. Overall he was nominated for six Best Director Oscars, winning three.

Capra passed away in 1991 from heart failure when he was ninety-four. One of the first filmmakers with a distinct style, he paved the way for successful directors with their own stories to tell. He's considered one of the **auteurs** of motion picture directors of the early cinema, along with Alfred Hitchcock, John Ford, Howard Hawks, and a few others. He is an icon of the cinema whose work will never be forgotten.

Who Is Howard Hawks?

He was a legend of the cinema, making forty-seven films in an illustrious career that stretched over five decades. He's made some of the most famous films in history, and the amazing thing is the wide variety of work he's amassed in his filmography. He is acknowledged as one of the best technical filmmakers in history along with Alfred Hitchcock.

Unlike Hitchcock, Hawks gave his actors the ability to work in an open and collaborative environment. He believed in a collaboration between the director and actors, and did a lot of overlapping dialogue (a signature Hawks style) to give the actors and the audience a lot to work with.

Like many of his contemporaries, he was a director who started in the silent film world. His childhood was average, his parents wealthy, and he was able to attend private school. He majored in mechanical engineering at Cornell University, got unexceptional grades, and found his way into the film industry through a chance meeting with director Victor Fleming. He recommended him to Famous Players—Lasky, the stomping ground of Charlie Chaplin where he worked in props and set construction.

He floated in and out of the film business and even started directing some scenes in a Mary Pickford film, then went back to Cornell to finish his degree. In 1917, he was called to active duty in the Army for World War I. After the war, he returned to Hollywood, and gave Jack Warner a loan from his family in exchange for directing some one-reel comedies.

When sound came to film, Hawks directed a huge hit with the Oscar winning military drama *The Dawn Patrol* in 1930. He followed with the hit crime-drama *The Criminal Code* in 1931. In 1932, he directed the Paul Muni classic gangster film *Scarface* (based on the life of Al Capone, not to be confused with the Al Pacino-cocaine-fueled version) that was a MONSTER HIT, putting him in the spotlight as a major film director. The film was a major influence on Quentin Tarantino with the incredible amount of on-screen violence it portrayed.

In 1938, he directed one of the quintessential screwball comedies, *Bringing Up Baby*, starring Cary Grant and Katharine Hepburn. This would be the first time the two of them worked together, and it wouldn't be the last! See Chapter 8 for a rundown of that movie.

He started doing all of these other movies, maybe you've heard of them: *Sergeant York*

Stars Cary Grant and Katharine Hepburn from *Bringing up Baby* (1938)

RKO Radio Pictures/Photofest

(only eleven Oscar nominations with Gary Cooper winning for Best Actor and Hawks first and only nomination for Best Director); *The Outlaw* (starring Jane Russell and produced by millionaire Howard Hughes); 1944's *To Have and Have Not* (starring Humphrey Bogart and soon-to-be wife Lauren Bacall); 1946's film noir *The Big Sleep* (again Bogart and Bacall and in 1997 placed in the National Film Registry); and 1948's *Red River*, where Hawks worked for the first time with legendary Western actor John Wayne.

The Official Howard Hawks Top 3 Great Comedy Film Checklist

Ball of Fire (1941)

Somehow in the midst of all these amazing movies, he was able to sneak in another screwball comedy that hits the AFI Great Comedy List at #92, starring Gary Cooper as Professor Bertram Potter who meets sexy nightclub singer "Sugarpuss" O'Shea (Barbara Stanwyck) while researching a book about American slang terms. You know, words that read one way but mean something else—airhead, ditch, dope, earful (and there are a lot more words I can put here, but I'm already getting the "wrap-it-up" sign soon to be followed by the "finger crossing your throat" sign. Editors, sheesh!). [Editor's Note: Does he know we're reading this?]

When "Sugarpuss" has to escape from her gangster boyfriend, she hides out with Bertram and his roommates, a bunch of stuffy professors and confirmed bachelors. Soon, she has them putting aside their stuffy academic ways and loosening up. Bertram falls for her and asks her to marry him. Brokenhearted, she goes back to her gangster boyfriend to marry him instead of letting him kill the professors.

Luckily, things go horribly awry, and let's just say that love conquers all! That's how all of these movies are supposed to end anyway!

I Was a Male War Bride (1949)

With World War II safely in the rearview mirror, this romantic comedy starring Cary Grant (again!) and the lovely Ann Sheridan was released. In Post-War Germany, Captain Henri Rochard (Grant) has to recruit a German lens maker. He's assigned Lieutenant Catherine Gates (Sheridan) as his chauffer. After a series of wacky misadventures, Rochard and Gates are locked in a hotel room, he's arrested at the black market, and the two fall in love. The title refers to the ending of the movie, when Grant is forced to dress like a female nurse to get back into the United States. One thing will become abundantly clear as the world of comedy films continues to unfurl, a guy dressed as a girl is ALWAYS funny.

Monkey Business (1952)

The King of Screwball Comedy, Cary Grant is at it again playing scientist Barnaby Fulton, searching for a drug version of the "fountain of youth." When his chimpanzee Esther (hence the title of the movie) knocks a bunch of chemicals into the lab water cooler, things get nutty! Barnaby drinks up and suddenly starts feeling like a teenager. Though married, he chases after his boss's buxom secretary, Lois Laurel (the amazing Marilyn Monroe), while his wife, Edwina (Ginger Rogers) heads to the lab and discovers the water cooler herself. To spite Barnaby, she drinks, feels younger, and decides to find her childhood crush Hank Entwhistle (Hugh Marlowe).

Typical screwball comedy antics ensue as Edwina starts drinking more and more. The other scientists at Barnaby's lab drink up too, and soon everyone is out of control. At this point, I need to let you know that I talk about Marilyn Monroe in Chapter 19 and the "King of the Screwball Comedy," Mr. Cary Grant has his owns section in Chapter 15. So enough about them! You'll have to read up on Marilyn when Hawks's next big film, the 1953 musical comedy *Gentlemen Prefer Blondes,* is also discussed in Chapter 19. That's right, you have to read even more of this book.

After that, he did a bunch more movies, including four films with John Wayne (*Rio Bravo, Hatari! El Dorado*, and *Rio Lobo.* The *Rio* movies are really, really good) and one more comedy in 1964, *Man's Favorite Sport* with Rock Hudson. He passed away at age eighty-one tripping over his dog (how very screwball comedy) in 1977.

He was awarded an Honorary Oscar in 1975 for his contributions to the art of the motion picture, eight of his films were placed in the National Film Registry, and he has a star on the Hollywood Walk of Fame.

> In summary, Frank Capra and Howard Hawks, as well as Ernst Lubitsch, Preston Sturges, and George Cukor were the torchbearers that defined film comedy for the American public for nearly twenty years. They created some of the most memorable comedies in American motion picture history, and the most amazing part is that they are films that aren't dated. They are still as fresh as they were when they got released. I hope you get to see some of them. Consult your local library. You can borrow these movies on DVD for free!

CHAPTER 17

From the World of War to the Cold of War

OR:

Fifteen Years of Comedy Films Getting Bitch-Slapped by Politics

CHAPTER FOCUS

▶ World War II Was NOT Funny!

▶ The Comedy Teams That Kept America Laughing

▶ The Red Menace That (Almost) Destroyed Hollywood

Chapter Focus

> "Comedy film, more so than in any genre of the cinema, is the best lens for understanding the culture of the time"

—Chris LaMont, author who uses phrases like "more so" in sentences.

Hollywood was cranking out brilliant films in the 1930s and the beginning of the 1940s. Think about all of the great movies that came out during that time: *Gone with the Wind, The Wizard of Oz, Citizen Kane, The Grapes of Wrath, The Maltese Falcon,* and of course *Duck Soup, It Happened One Night,* and *The Philadelphia Story.*

Meanwhile, Adolph Hitler was trying to take over the world.

This means there weren't any movies coming out of Europe because they were fighting for their lives. America wasn't really interested in getting involved, heck, we had our own problems. We're still recovering from the Great Depression, we're all building roads and dams for FDR's New Deal, and had this politically isolationist-view of the United States and its role in the world. You can't help people in the world if you can't take care of your own people first.

Don't get me wrong, Hollywood was including the Nazis and Hitler in their films. Chaplin's *The Great Dictator*, Hitchcock's *Foreign Correspondent*, Ernst Lubitsch's *To Be or Not To Be*, along with films directly focused on Nazi Germany: *Confessions of a Nazi Spy* and *Hitler, Beast of Berlin*, and the buddy comedy *Buck Privates* (with Abbott and Costello). But Germany was soooo far away. It's not like Hitler is invading New Jersey.

World War II Was NOT Funny!

Which is why the attack of December 7, 1941, on Pearl Harbor by the Japanese was such a shock. I don't think anyone even knew (besides the government) that Japan was one of the Axis powers. The USA is plunged into the biggest war that the world had ever seen. It's so big that it got Roman numerals!

So Jimmy Stewart went to be a pilot, and Frank Capra filmed the *Why We Fight* documentary series for domestic theatre's newsreels—remember there wasn't any television back then—it was all radio for your news. The film industry was able to show the country all of the atrocities of war and the heroes of America that fought valiantly for our safety and freedom.

Hollywood focused its resources on the war effort, but the studios knew that the American people needed movies more than ever. Some great films were made during this time—Humphrey Bogart hit his stride with *Casablanca*, *The Maltese Falcon*, *To Have and Have Not*, and *The Big Sleep*. Billy Wilder wrote and directed *Double Indemnity,* and Orson Welles did *The Magnificent Ambersons*. Alfred Hitchcock also had three wartime films, *Sabotage*, *Saboteur*, and *Lifeboat*.

The American public needed escapist entertainment to take their minds off of the war. Musicals made a huge impact with films like James Cagney's *Yankee Doodle Dandy*, Bing Crosby's *Holiday Inn*, and Judy Garland's *Meet Me in St. Louis*. The biggest film of 1944 was Bing Crosby's *Going My Way*.

Animation became huge, with the introduction of *Bugs Bunny*, *Tom & Jerry*, and *Woody Woodpecker*. Walt Disney released *Bambi* and *Song of the South* (oops—forget that last one. A little too racist to include in this book. Check it out online. It's horrific.)

Universal Studios created a monster, literally, when it filmed *Frankenstein* and *Dracula* in the 1930s. Wartime found the release of *The Phantom of the Opera*, *Frankenstein Meets the Wolf Man*, *House of Dracula*, and several sequels to *The Mummy*. RKO had *The Cat People* and *I Walked with a Zombie*. There is nothing better than going to a horror film during bad times. Something about being scared within the safe confines of a movie theatre and the cathartic nature of dealing with your fear. I don't know, I think I read it on the Internet somewhere. It sounds very scientific.

The Comedy Teams That Kept America Laughing

The last remaining vaudeville acts that were able to make the transfer from the stage to the silver screen were comedy teams. Laurel and Hardy were the trailblazers, but the next wave of comedy teams would take us from the 1940s and into the 1950s.

Abbott and Costello

One of the most successful comedy teams in motion picture history, Bud Abbott and Lou Costello both started on the vaudeville circuit. They raised the bar on the fat guy/skinny guy routine, but unlike Laurel and Hardy (who were both equally ridiculous), Abbott was the straight man and Costello was the moron. It's a successful formula that made them huge stars in radio, television, and movies. Their style has been imitated by all comedy teams that came after: Hope and Crosby, Martin and Lewis, Spade and Farley.

"The Skinny Guy" William "Bud" Abbott was born in 1897 and Lou Costello "The Fat Guy" was born in 1906. Both were vaudeville before working together in 1935 when Costello's onstage partner got sick and Abbott stepped in. They were a hit, and honed their act as the straight man and the doofus to perfection.

They went on the radio in 1938 and performed their highly acclaimed comedy routine "Who's on First?" (which they called "Baseball"). Abbott tries to explain the nicknames of the baseball players that were playing that night. The first baseman's nickname is "Who," and the second baseman's nickname is "What," and the third basemen's nickname is "I Don't Know" and so on. Costello spends the routine trying to grasp the player's names, never understanding that they're actual nicknames not pronouns. I think that was a terrible explanation. Cut to the YouTube clip. It's brilliant. There's a clip that plays in non-stop rotation at the Baseball Hall of Fame.

They landed their first film roles in 1940 as supporting actors in *One Night in the Tropics*, where they performed five of their comedy routines, including "Who's On First?" Their

appearance got them a two-picture deal at Universal Studios, and their first film was 1941's mega-smash *Buck Privates*.

Based on the U.S. Army's peacetime draft before the onset of World War II, they are two salesmen who accidentally enlist in the Army. They're off to boot camp for a series of misadventures, highlighted by appearances from the popular Andrews Sisters who sang a few songs, including the Oscar-nominated "Boogie-Woogie Bugle Boy," and the film was nominated for Best Score. The movie was a hit with critics and audiences, propelling Abbott and Costello into the stratosphere. They made two more armed service films, *In the Navy* and *Keep 'Em Flying*, before the end of 1941 and the start of the war.

In 1941, they also conquered radio with a weekly variety show that ran until 1947 and in-between 1940 and 1948 they made twenty-one films. Some of the big ones include the sequel to *Buck Privates, Buck Privates Come Home*, and then made the classic film that is recognized by the AFI as the #56 film on the 100 Years . . . 100 Laughs List.

Abbott and Costello Meet Frankenstein (1948)

You got to hand it to Universal Studios. They hadn't put any of their fabled monsters, *Dracula, Frankenstein's Monster,* and *The Wolfman* in any movies for awhile when someone decided to mash-up the biggest comedy team in the country with the studio's horror stable.

Train baggage clerks Chick (Bud Abbott) and Wilbur (Lou Costello) are unwittingly drawn into a horrific mystery when a phone call from Lawrence Talbot (Lon Chaney Jr.) alerts them to a special delivery to Dr. McDougol's House of Horrors. They're not supposed to deliver the crate until Talbot arrives, but when Talbot is transformed into The Wolfman, Wilbur thinks it's a prank and they head out to deliver the case.

Inside the case, the actual bodies of Count Dracula (Bela Lugosi) and Frankenstein's Monster (Glenn Strange) are both revived as soon as they are delivered. Shenanigans ensue as Dr. Sandra Mornay (Lenore Aubert) promises Dracula that she has found the perfect brain donor to put inside Frankenstein's monster's head. Talbot appears and tries to warn Wilbur and Chick, but turns into The Wolfman. Joan Raymond (Jane Randolph) is an insurance agent for Dr. McDougal's House of Horrors who vows to find the property and enlists Wilbur and Chick to do it.

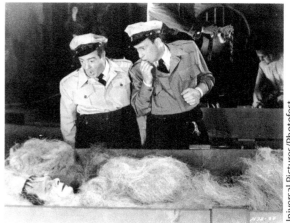

Lou Costello and Bud Abbott star in *Abbott and Costello Meet Frankenstein* (1948)

Universal Pictures/Photofest

Everything comes to a head at a masquerade ball, where Wilbur is attacked, kidnapped, and hypnotized. It's a wacky comedy that, besides its placement on the AFI Great Comedies List, was also placed in the National Film Registry by the Library of Congress in 2001.

Abbott and Costello cemented their status as a comedy force (in actual cement at Grauman's Chinese Theatre in 1941) with another sixteen films, including movies where they "meet" *The Killer*, Boris Karloff (1949), *The Invisible Man* (1951), *Captain Kidd* (1952), *Dr. Jekyll and Mr. Hyde* (1953), the *Keystone Kops* (1955), the *Mummy* (1955), and they also joined the *Foreign Legion* (1950), and *Go to Mars* (1953).

Between 1941 and 1951, the duo were in the Top 10 Box Office draws as determined by the Quigley Publisher Poll, and finished in the Top 5 in six of the ten years. They went on to much success in television in 1951, and eventually dissolved their partnership in 1957. They never achieved the success by themselves like they had as a team. Costello passed away in 1959 and Abbott died in 1974, but their legacy, especially the "Who's On First?" routine, will live forever in the annals of film comedy.

There was one comedy team that challenged Abbott and Costello for the title of Box Office Champions during the 1940s and early 1950s. They actually weren't an official team. They were two talented performers who came together for one movie, and ended up making six more. Audiences had another source for comedy in a bleak time when everyone needed every laugh they could get.

Bob Hope and Bing Crosby

Bob Hope was born in England in 1903. His family migrated to the United States and settled in Cleveland, Ohio, when he was four years old. He was a natural dancer and spun his talents on the vaudeville circuit, performing comedy routines with a variety of partners. He then went solo and to Broadway, where he was cast as the comedy sidekick in the stage show *Roberta*. It was there he met his wife of sixty-nine years, Dorothy.

From 1934 to 1936, Bob appeared on Broadway in a variety of roles as the wisecracking one-liner comedy lead and also started doing radio. It was on the radio where he first met singer Bing Crosby. Bob had his own weekly radio show that ran from 1937 until 1956. He got his big break and went to Hollywood with a contract from Paramount Pictures when he

A picture of a wax figure of Bob Hope—the budget is getting tight on this book

was cast in *The Big Broadcast* of 1938 with W. C. Fields. In the film, he sang the Oscar-winning song "Thanks for the Memory," which became his signature song. Hope became hugely popular after the film and set off on his own for leading parts.

He starred in six comedy films until his signature film series came calling when he reunited with radio performer Bing Crosby.

Harry Crosby was born in 1903 in Tacoma, Washington, and nicknamed "Bing" by a neighbor when he was seven years old. He worked behind the scenes at a vaudeville stage, began singing in local groups while studying law at Gonzaga University, and then left school to pursue a singing career in 1925. He toured across the country in various singing groups, including the acclaimed "The Rhythm Boys," which led Bing to his first film appearance.

In 1931, his brother sent a record of Bing to William Paley, the President of CBS and Bing was booked as a solo act in New York City. Throughout the 1930s, Bing's singing became hugely popular, and he soon became one of the biggest performers in the country. His biggest hit was his 1941 version of Irving Berlin's *White Christmas*, which he sang on the radio.

He went to Hollywood for his first starring feature in 1932, *The Big Broadcast*. He made nineteen feature films (and a handful of Sennett one- and two-reelers) from 1935–1940, and a really smart producer decided to team him up with comedian Bob Hope for a movie that was eventually titled *The Road to Singapore*.

Bing Crosby

©catwalker/Shutterstock.com

The Road Pictures, as they are known, were a series of seven hugely popular films that were all similar in style. Hope and Crosby would play playboys, salesmen, or con artists, and travel to different countries. They would fall in and out of love, with Hope usually the one who *doesn't* get the girl. The movies were a series of comedy routines and musical numbers, and all of the films (except for the last one) featured beautiful co-star, the entrancing singer/dancer/actress Dorothy Lamour.

There were a couple running gags featured in the Road Pictures, including Hope constantly breaking the fourth wall and talking directly to the audience and insulting Bing, as well as the boys playing a game of "Patty Cake" before starting a fight. It's said that most of the dialogue was improvised.

The first film, *The Road to Singapore*, was a parody of island adventure movies and was a huge critical and box office success. This led to the second film, *The Road to Zanzibar*, which was a

parody of African safari adventure films and the eighth biggest film of 1941. A third film was on the way, and it's the one that the AFI lists as the #78 Great Comedy Film.

Road to Morocco (1942)

After accidentally destroying the ship they stowed away on, Jeff (Bing Crosby) and Orville (Bob Hope) wind up stranded on a desert beach. They ride a camel to Morocco and, to raise money, Jeff sells Orville into slavery. Later, Jeff feels guilty and tries to rescue him, but discovers that Orville isn't in danger. In fact, he's a guest of Princess Shalmar (Dorothy Lamour) who was told by a wise man that she should marry Orville.

Will Orville be forced to marry Princess Shalmar? Or will she marry Jeff? What about the wise man's prophecy, maybe he was wrong? All I know is that the answers to the above are pretty hilarious. This is a solid movie, and Hope and Crosby are dynamite together.

The *Road to Morocco* was the fourth biggest movie of 1942, and the film was nominated for two Oscars, Best Sound and Best Original Screenplay. The film was selected in 1996 by the Library of Congress to be placed in the National Film Registry.

Hope and Crosby took a break to help overseas with the U.S. Troops during World War II. Bob Hope became famous for touring with the USO, and Bing was stateside, performing on his weekly radio show. In 1944, Bing won a Best Actor Oscar as Father O'Malley in *Going My Way*.

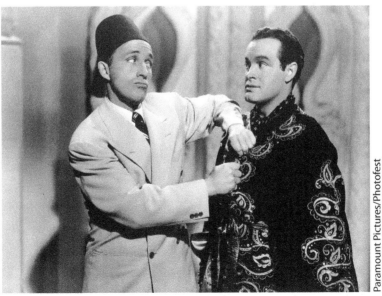

Paramount Pictures/Photofest

Bing Crosby and Bob Hope are off on the adventure of a lifetime taking the *Road to Morocco* (1942) in this zany buddy comedy

After the war, Bob Hope, Bing Crosby, and Dorothy Lamour made three more Road Pictures: *The Road to Utopia* (1946), which got an Oscar nomination for Best Screenplay and was the ninth biggest film of 1946; *The Road to Rio* (1947), which was the sixth biggest film of 1947; *The Road to Bali* was their first color film; and the final film, *The Road to Hong Kong*, with Joan Collins instead of Dorothy Lamour, was released in 1962.

Both performers continued to entertain America. Bing Crosby was instrumental in developing a new technology where he could use magnetic tape to record his radio programs. His production, pre-taping, and editing of his radio shows ended the practice of live radio programs.

He owned a piece of the Pittsburgh Pirates, has three stars on the Hollywood Walk of Fame, won the first Grammy Gold Achievement Award in 1966, and eventually stopped recording and went to television, starring in variety specials and television movies. On a personal note, in his final Christmas special in 1977, he sings "The Little Drummer Boy" with rock star David Bowie, and is my favorite Christmas song of all time.

He died October 13, 1977 from a heart attack, leaving a tremendous legacy as one of the most popular performers of his generation.

Bob Hope continued his successful comedy career, and toured with the USO until 1991. He starred in a total of fifty-four theatrical feature films during his career and hosted the Academy Awards nineteen times between 1939 and 1977. He received five Honorary Oscars (none for acting) including the prestigious Jean Hersholt Humanitarian Award in 1960. He starred in radio through the 1950s, and then switched to television starring in variety and holiday specials. He was a huge golfer and started The Bob Hope Classic tournament in 1960.

During his lifetime (he lived to be 100 and died in 2003 from pneumonia) he received over two thousand awards, including the Congressional Gold Medal in 1963 from President John F. Kennedy for service to his country, the National Medal of Arts and, in 2003, the Burbank airport was named after him. A national treasure that entertained the world for over sixty years, he was a comedy genius that will never be forgotten.

Bob Hope gets an award from Congress (1978)

Source: Library of Congress

The Red Menace That Almost Destroyed Hollywood

So World War II happened. The Allies beat the bad guys. The only problem was the uneasy alliance that the United States and Russia had created when they joined up to stop the Nazis.

Communism and Democracy don't see eye to eye. So Russia decided that they were going to stretch their wings. They put a wall up separating East and West Berlin, and began to systematically take over Eastern Europe.

Source: Library of Congress

Meanwhile America, celebrating in its triumph over Japan and Germany (and you can toss in Italy for good measure), was reveling in truth, justice, and the American Way.

But those Communists had different plans. The threat of Communism or "The Red Scare," hovered ominously over the United States as the Cold War started between the Soviet Union and the United States. The idea that anyone could be a Communist sympathizer rankled the head of the House of Un-American Activities Committee (HUAC) and its notorious chairman, Senator Joseph McCarthy.

Egomaniacal Senator Joseph McCarthy standing at microphone, no doubt denouncing innocent Americans for unsubstantiated "communist tendencies"

Founded in 1938, HUAC was formed to combat the Fascist sympathizers that permeated the US when Mussolini took power in Italy. The focus changed to Communism in 1947, with the committee contending that Communist sympathizers or "subversives" had infiltrated the government and the entertainment industry. Welcome to the Age of McCarthyism.

HUAC actively sought out suspected Communist sympathizers and dragged them in front of the committee for hearings in Washington. Individuals who refused to testify or give names of sympathizers were threatened with prison. In 1947, ten writers and directors, known as the "Hollywood Ten," were jailed and blacklisted from the film industry.

So what kind of films did Hollywood want to make? Very safe comedies such as:

Father of the Bride (1950)

Welcome back to the *Great Comedy Films* book to Oscar Winner Spencer Tracy! Here's a comedy that didn't have Katharine Hepburn in it! Stanley T. Banks (Spencer Tracy) is not happy in the days leading up to the wedding of his daughter, Kay (Elizabeth Taylor). His wife Ellie (Joan Bennett) is out-of-control with her wedding planning and Stanley is not a fan of Kay's fiance Buckley (Don Taylor.).

After a disastrous meeting with Buckley's parents and the engagement party that Stanley misses completely, he's faced with the inevitable—the small wedding that he had planned is now a monster. The guest list balloons to 250 people, and Stanley tries to get the two of them to elope.

Will Stanley be able to afford the wedding? Will he come to terms with the fact that his baby is all grown up? And will Kay and Buckley make it to their special day?

Father of the Bride was a huge smash and the film was nominated for three Oscars, including Best Picture, Best Actor for Spencer Tracy, and Best Screenplay. The sequel was released the following year, *Father's Little Dividend*, where Stanley had to deal with the birth of his first grandchild, and it was another box office triumph. *Father of the Bride* was remade in 1991 with Steve Martin and Diane Keaton and was also a success. And there was a sequel to that movie as well. Finally, the original is the #83 film on the AFI Great Comedy Films list.

Auntie Mame (1958)

First off, totally being honest here, I have not seen this movie. Frankly, I'd never heard of it. I'm looking at this AFI 100 Years . . . 100 Laughs List and I'm stumped. What is this movie? I know movies, I've seen hundreds of them, but I've never heard of this film?

Like all good non-fiction authors, I start doing some research. I learn that *Auntie Mame* was based on a famous novel, which was turned into a famous Broadway play, and then this film. And the film was the top film of 1958! Bigger than *Vertigo, Touch of Evil, Cat on a Hot Tin Roof, Gigi,* and *South Pacific*! These are all movies that I know! And it was bigger than all of them? Are you kidding me?

So I start digging deeper. The movie stars Rosalind Russell from *His Girl Friday* and this is one of her signature roles. Did you know she won a Tony, five Golden Globes, and was nominated for the Best Actress Oscar four times including this movie? Unbelievable! Who knew? Not this guy!

So forgive me for cribbing this synopsis from IMDB. She's Mame Dennis, an eccentric flapper girl in New York City during the Depression who ends up adopting her brother's son after the father suddenly dies. She and the boy grow closer even though the executor of her brother's will has orders to make sure that Mame isn't a terrible influence.

A lot of IMDB reviewers really LOVE THIS MOVIE! It's pretty amazing! I know that there are people that are reading this now and are like, how can you possibly not know this movie? We thought you knew "Comedy"! What kind of "author" are you? [Editor's Note: The question we've been asking ourselves since page one.]

I'm just not getting a good sense for this movie at all. The movie was nominated for six Oscars, including Best Picture, Best Actress (Rosalind Russell), Best Supporting Actress (Peggy Cass), Best Art Direction, Best Editing, and Best Cinematography. It's the #94 movie on the AFI List of Great Comedy Films. And yes, I'm still on the fence about this one.

Singin' in the Rain (1952)

I know you've seen the still photo, and hopefully my publisher forked over the money so they can print it here. [Editor's Note: We did.] Gene Kelly, standing on a light pole, with the biggest grin on his face. He's dancing, smiling, singing, and celebrating that he's in love. It's a moment of pure elation, and encapsulates all that cinema can do to emotionally engage you.

MGM/Photofest

Singin' in the Rain

The movie was the idea of MGM producer Arthur Freed, who had a catalog of songs that the studio owned and was looking to build a film around them. They chose "Singin' in the Rain" as the title song, which had first appeared in Hollywood Revue of 1929. The film is full of amazing songs, superb choreography, hilarious flashbacks, and a winning cast that is fantastic.

The film satirizes early Hollywood, when silent pictures gave way to the "talkies" and how the industry dealt with the change. Just like Buster Keaton, many stars didn't quite take to the new technology. That's the world that Hollywood stars Don Lockwood (Gene Kelly) and Lina Lamont (Jean Hagen) find themselves in. And Lina doesn't have the best voice for the biggest change that the film industry would ever encounter.

Don and Lina have just completed their latest silent picture, and though Lina thinks that they are one of Hollywood's power couples, Don actually despises her. Escaping from adoring fans, Don jumps into the passing convertible driven by young actress Kathy Selden (Debbie Reynolds) who has no respect for Don because he makes movies and she is a stage actress. After Kathy throws a pie at Don for laughing, which hits Lina in the face, Don falls in love with her.

Meanwhile R. F. Simpson (Millard Mitchell) has seen the success of *The Jazz Singer*, and orders all of the films currently in production to be turned into sound pictures. Don and Lina's latest swashbuckler, *The Dueling Cavalier*, is the first film that starts the process,

and everyone is freaked out when Lina starts talking and sounds like fingernails dragging on a chalkboard.

Cosmo (Donald O'Connor) is Don's best friend and his partner from their vaudeville days, and he comes up with the idea for dubbing Lina's voice with Kathy taking on the vocal duties. Don and Cosmo also convince R. F. to turn the movie into a musical retitled *The Dancing Cavalier*.

Can Don and Cosmo salvage the movie and their careers? Especially after Lina discovers that Kathy, some unknown actress, dubbed her voice? Will Don and Kathy come together? And what's the deal with the whole "splashing in the water with an umbrella" scene?

The movie was a hit with the critics and did make a small profit at the box office and was the #10 film for the year. *Singin' in the Rain* was nominated for two Oscars, Best Supporting Actress for Jean Hagen and Best Score, but didn't win either. However, Donald O'Connor did win the Golden Globe for Best Supporting Actor (Comedy or Musical) and screenwriters Betty Comden and Adolph Green won the Best Written American Musical award.

Since its release, *Singin' in the Rain* has garnered universal acclaim. The AFI loves this movie: #10 Greatest Movie, #16 on the Greatest Comedy, #16 Greatest Romance, *Singin' in the Rain* is the #3 of the Greatest Movie Songs, and the American Film Institute named *Singin' in the Rain* the #1 Movie Musical of All Time. Finally, the film was one of the first twenty-five films chosen by the Library of Congress to be placed in the National Film Registry.

Here's one more musical comedy for you. It's no *Singin' in the Rain*, but then again how many movies are?

The Court Jester (1955)

Danny Kaye was a musician, singer, actor, comedian, pratfall artist, and was one of the most popular performers in the 1940s and 1950s. Starting in vaudeville and the resort stages in the Catskill Mountains, he performed across the world as he honed his particular brand of slapstick humor and wacky tongue-twisting songs.

He was a bona fide Broadway star for five years, and then moved to radio, feature films, and television. He made twenty-four films, mostly musicals, including the biographical *Hans Christian Anderson* (1952), *White Christmas* (1954) with Bing Crosby, and I am very fond of the original version of *The Secret Life of Walter Mitty* (1947), which was remade by writer/director/actor Ben Stiller in 2014.

His most notable film is this medieval musical comedy romp, *The Court Jester*, in 1955. This spoof of swashbuckler films takes place in medieval England where Hubert (Kaye) is

a wandering minstrel who works for The Black Fox, a Robin Hood type rebel living in the forest. The rightful ruler of the land is a baby, which King Roderick is looking to kill since he doesn't deserve the throne. The baby ends up with Hubert so he devises a plan to return the baby to the throne, and then things go crazy. There's hypnotism, switching identities, and people fall in love.

The film is the #98 film on the AFI Great Comedy List, just sneaking in there! Like many of the films in this book, the Library of Congress selected it for the National Film Registry in 2004.

He also had a tremendous music career, teaming up with The Andrews Sisters, and in 1954 became a goodwill ambassador for UNICEF (United Nations International Children's Emergency Fund) to make a 40,000-mile trip around the world promoting the program. He won two Golden Globes for Acting, has three stars on the Hollywood Walk of Fame, the Jean Hersholt Humanitarian Award from the Academy Awards, and was awarded the Presidential Medal of Freedom in 1987 posthumously.

Fun comedies and musicals! That's exactly what America was looking for! All of the 1950s weren't just sugar and spice, but also a little sexy. That's right, a young lady named Marilyn Monroe takes center stage as the decade cooks along. Don't forget Jack Lemmon! And what about Writer/Director Billy Wilder, we definitely can't forget him either!

CHAPTER 18

FOCUS ON SUBGENRE

Romantic Comedy—Part I

OR:

This Is the Subgenre Where a Man and a Woman Fall in Love, or a Man and a Man, or a Woman and a Woman, or a Man and a Robot, or a Woman and a Robot, or a Robot and a Robot.

Cary Grant and Katharine Hepburn in *Bringing Up Baby* (1940)

RKO Radio Pictures/Photofest

> **CHAPTER FOCUS**
> ► What Is a Romantic Comedy?
> ► What Is the "Meet Cute"?
> ► The History of Romantic Comedy
> ► A Potpourri of Great Romantic Comedy Stars and Their Films

Chapter Focus

It's time to explore the world of the Chick Flick.

Let's face it, guys don't like these movies. In a poll conducted by me through the Internet, given a choice between (A) going to see the latest Julia Roberts movie or (B) the latest superhero film: ten out of ten guys pick the superhero movie. Even if the choice is the recent debacle, *Fantastic Four* (2015).

However in the same poll, given the choice between the two films, with the outside chance that someone is going to get laid, ten out of ten guys say they will see the Julia Roberts movie.

Maybe it's not the most scientific poll, after all—it is the Internet. I think we can draw the conclusion that, given the correct circumstances, the Romantic Comedy could be the single greatest subgenre of comedy film ever devised.

(If you want to feel like a Hollywood Insider, you can call it a "rom-com." Try it, see how easily it rolls off the tongue? You're a big shot now!)

What Is a Romantic Comedy?

Here's the official definition of Romantic Comedy from our good friends at Dictionary.com:

Romantic Comedy

1. A light and humorous movie, play, etc. whose central plot is a happy love story.

2. A genre of comedy represented by such works.

Here's a great definition from my NEW friends at the Urbandictionary.com

Romantic Comedy

1. The most vile, insipid, sanity-destroyingly horrible genre in the history of cinema.

Okay, someone over at Urbandictionary.com is a little grumpy this morning!

What's your favorite romantic comedy film? The one where the couple meet, fall in love, fall out of love, one of them realizes that they really screwed up and then does whatever they can to get back together again? Mine too! If you haven't realized that these films are completely formulaic (a big academic word meaning they are all the same), then you need to watch more romantic comedies and realize, yes—they are ALL THE SAME.

Now to be fair, sometimes the boy and the girl don't get together, maybe they fall in love with somebody else in the movie that was the right person for them all along. But let's face it, somebody ends up falling in love, except in that Vince Vaughn movie *The Break-Up* (2006). Wait a minute; I don't want to spoil any endings. What do you expect? The movie is called *The Break-Up*.

What Is The "Meet Cute"?

One characteristic that nearly every romantic comedy has is the moment in the film when the boy/girl/robot meets the boy/girl/robot, and there's some sort of magic spark. It's usually through some clever way in which the film industry screenwriters (and now you—since we've established you're a Hollywood Big Shot a couple of paragraphs ago) and movie producers describe as the "meet-cute." What are some good "meet-cutes" in romantic comedies? Glad you asked!

It Happened One Night (1934)—Peter (Clark Gable) and Ellie (Claudette Colbert) meet on a bus, where Peter recognizes she's the famous on-the-run heiress.

The Lady Eve (1941)—Charles (Henry Fonda) literally falls for con artist Jean (Barbara Stanwyck) when she trips him.

Singin' in the Rain (1952)—Movie star Don (Gene Kelly) is fleeing from a crowd of adoring fans and jumps into a car driven by Kelly (Debbie Reynolds).

Notting Hill (1999)—Bookstore owner Will (Hugh Grant) spills a drink on famous actress Anna (Julia Roberts).

Bridesmaids (2011)—Inebriated Annie (Kristen Wiig) is pulled over by Officer Rhodes (Chris O'Dowd) for drunk driving.

The History of Romantic Comedy

So romantic comedy has been around a loooooong time . . .

As long as talented people have been telling stories, there have been romantic comedies. That William Shakespeare guy wrote a few plays, especially *A Midsummer Night's Dream, Much Ado about Nothing*, and *As You Like It*. Funny to think that until Elizabethan times, there was no idea of romance. Apparently you just pointed at a woman and off you went off and started doing the nasty. Wish it worked like that nowadays.

The romantic comedy continued to appear through literature, like Jane Austen's novel *Emma*, and on the stage from Oscar Wilde and his classic works *The Importance of Being Earnest* and *An Ideal Husband*. Stage plays like 1897's Cyrano de Bergerac kept the romantic comedy fires burning as the motion picture industry came to life.

There were a handful of romantic comedies during the silent era—Ernst Lubitsch started his famous touch with 1919's *The Oyster Princess* and 1924's *The Marriage Circle*. Mary Pickford's last silent film was 1927's *My Best Girl*. For me, the greatest romantic comedy of the silent era is Charlie Chaplin's *City Lights* (1931). That's the one where he falls in love with the blind girl, and she thinks he's rich, but he's not—and he loves her so much! (sniff—sniff—tear rolls down cheek—Get a hold of yourself, buddy!)

Yet another picture of William Shakespeare in this book

The romantic comedy subgenre kicked into high gear after sound found its way to the motion picture. Now audiences could hear the words that were coming out of the characters' mouths! What a concept!

It Happened One Night (1929) and *Bringing Up Baby* (1938) were part of a long run of screwball comedies before World War II

Screwball comedy was the beautiful blonde and blue-eyed wonder child that defined romantic comedy from the 1930s to the late 1940s. These films reflect the changing cultural shift toward the equality of ladies—I mean, women. [Editor's Note: Though it reads on the page as sexist, it's really in the way that you say it—say it out loud and put the emphasis on "equality" and "women." See, totally different and not sexist at all.]

Audiences were fresh from the suffragette movement and were recognizing men and women as equals. Equal in choosing what films they wanted to see and more importantly for Hollywood producers, equal to spend their hard-earned money at the movie theatre. Such legendary films as *It Happened One Night* (1929), *The Awful Truth* (1937), and *Bringing Up Baby* (1938) highlight these verbal sparring battle-of-the-sexes entertainment.

Going into the 1950s, life was hunky-dory. The Greatest Generation was looking to settle down, make a normal life for themselves with the picturesque dream house in the suburbs with 2.3 kids and the brand new Ford Edsel in the garage.

Hollywood was looking for films that were happy and fun. Life was a nonstop party! Especially because of the "Red Scare" and the House Un-American Committee in Washington D.C. and its chairman, Senator Joseph McCarty. McCarthy supposedly had lists of Communists in the industry. Everyone was afraid of being drawn in front of Congress to testify and name names.

Senator Joseph McCarthy was a horrible person

So the Hollywood Studios decided to clean up their programming and focus on musicals and romantic comedies.

A Potpourri of Great Romantic Comedy Stars and Their Films

When you're talking romantic comedy in the 1950s, the biggest star was Marilyn Monroe. When you think about her, what's the image that comes to mind? It has to be the skirt blowing over the grate in *The Seven Year Itch* (1955).

I think about that breathless "Happy Birthday Mr. President" song that she sang to John F. Kennedy, apparently after they had sex in the Lincoln Bedroom.

She was like Meg Ryan in the 1980s and Julia Roberts in the 1990s and her beauty and sexual attraction brought both men and women into the theatre. Men wanted her and women wanted to be her.

She starred in classic comedies and musicals such as *Monkey Business* (1952), *Gentlemen Prefer Blondes* (1953), *How to Marry a Millionaire* (1953), the afore-mentioned *The Seven Year Itch* (1955), *Bus Stop* (1956), and she reached her comedic pinnacle in 1959 with *Some Like It Hot*. (Go check out Chapter 19 for her whole story and a more in-depth look at her films.)

Besides Marilyn, there were a few other romantic comedy film starlets that helped America forget all about that mean Mr. Kruschev and his similarly despotic antagonist Senator McCarthy.

One such performer was the musical and comedy star Doris Day. She was everyone's All-American girl. She had a squeaky clean image with her blonde hair, blue eyes, Midwestern upbringing, and her overall cuteness was exactly what Hollywood was looking for. She was a talented #1 hit singer who moved to romantic comedies and her three films with rugged leading man Rock Hudson were the perfect frothy

©Rob Wilson/Shutterstock.com

The skirt pose in *The Seven Year Itch* is so famous that there is a statue of it in Chicago

©rj lerich/Shutterstock.com

Even today, Marilyn Monroe still lights my candles, if you know what I mean [Editor's Note: Unfortunately we do.]

romantic comedies for a public that needed to be nurtured with happy thoughts. Audiences went crazy for their first film together, *Pillow Talk*, and she was voted the top box office Female Star by Theatre Owners, starting in 1960 for four of the next five years. She also was one of the Top 5 Female Stars from 1959–1965.

Pillow Talk (1959)

In New York City back in the 1950s, it was rare for you to have your own private phone line and you had to share the phone line with God Knows Who. I know that sounds strange, but it's the storyline of this Academy award winning romantic comedy.

Brad Allen (Rock Hudson) is a Broadway songwriter and playboy, who shares a "party line" with interior designer Jan Morrow (Doris Day). Jan detests Brad as she gets to listen in when Brad is wooing various women through the phone, specifically with one song that he uses over and over, just changing the girl's name and sometimes the language.

Jan admonishes Brad through the phone, and he's ticked off saying that she's sexually repressed and jealous. When they meet each other face-to-face, Jan doesn't recognize him, but Brad recognizes her and introduces himself as "Rex," a cowboy from Texas. And Jan falls hard for Rex, and then over the phone tells Brad that she's met a good guy. To add even more complications, wealthy Jonathan Forbes (Tony Randall) vies for Jan's affections, but she's into Rex.

Pillow Talk was a huge and critical success. It was nominated for six Oscars: Best Actress (Day), Supporting Actress (Thelma Ritter), Art Direction, Cinematography, Music, and won for Best Original Screenplay. The Library of Congress selected the film to be placed in the National Film Registry in 2009.

Another major romantic comedy of the era and a cultural touchstone in American culture also starred Audrey Hepburn.

©catwalker/Shutterstock.com

Audrey Hepburn

This pixie-faced icon of film and fashion grew up as a ballerina in Belgium during World War II. She moved to London and started her acting career when she turned nineteen. She was discovered by the writer of the French novel, *Gigi*, and was anointed the lead role of the stage adaptation on Broadway. Two years later, she had her first starring role in William Wyler's *Roman Holiday* (see below) and won her first Academy Award for Best Actress, as well as Best Actress Golden Globe and BAFTA (British Academy of Film and Television Arts)—the first actor to win all three for the same role.

Roman Holiday (1953)

Princess Ann (Audrey Hepburn) is touring Europe and sneaks away from her official escorts in Rome. Her doctor had prescribed a sedative for her to relax, and she ends up passing out on a park bench where she is discovered by American reporter Joe Bradley (Gregory Peck). He offers to take her home, but ends up letting her stay the night in his apartment when he thinks it's not safe for her to get home on her own.

The next morning, Joe discovers from his editor that the girl he thinks is "Anya" is actually the Princess Ann. He realizes he's got a chance for a big story that could get him back to a real newspaper back in America. Without revealing that he knows who she is, he offers to take her around Rome on a sightseeing adventure. He also gets his photographer buddy Irving Radovich (Eddie Albert) to grab some pictures of the Princess.

Things come to a head after a wonderful day in Rome as they fall in love. But she confesses to Joe they can't be together and says goodbye. The next day, the Princess appears at a press conference that had been canceled when she disappeared, and she sees Joe and Irving in the press corp.

Will they get together? Spoilers!

The film was a big hit at the box office and was nominated for seven Oscars, including Best Picture, Director, Supporting Actor (Eddie Albert), Art Direction, Cinematography, Editing and won three: Best Actress for Audrey Hepburn, Best Costume Design, and Best Screenplay. Notably, John Dighton and Dalton Trumbo wrote the screenplay and Trumbo had been one of the blacklisted writers from the HUAC hearings so he did not get credit on the film upon its initial release. In 2011, he received full credit for his work on the script. The film is ranked the #4 film on the AFI Top 10 list for romantic comedies, and in 1999, *Roman Holiday* was selected to the National Film Registry by the Library of Congress.

She went on to do twenty-six movies in all different genres. In 1954, she got her second Oscar nomination for Best Actress as the daughter of the chauffer to Humphrey Bogart and William Holden. They both compete for her heart in Billy Wilder's romantic comedy *Sabrina* (1954), the musical *Funny Face* (1957), and most notably *Charade* with Cary Grant, Oscar behemoth *My Fair Lady*, and her Oscar nominated turn in the suspense thriller *Wait Until Dark* (1968). The AFI names her as the third greatest actress of all time.

Her most iconic role is that of Holly Golightly in *Breakfast at Tiffany's*. If you've ever seen Hepburn with her hair done up and holding a cigarette holder, it's from this film.

Why *Breakfast at Tiffany's* isn't on the AFI's Great Comedy List—I have no idea. It could be because of Mickey Rooney playing Holly Golightly's Japanese neighbor, *Mr. Yonioshi*. Yes, this was the time when Hollywood didn't cast actual ethnically diverse characters, instead

they cast them with white people. Every scene with Yonioshi screams of ignorant and insulting racism.

Breakfast at Tiffany's (1961)

Based on eccentric author Truman Capote's novella and directed by Blake Edwards (*The Pink Panther* series), Holly Golightly is a society girl, which is like a geisha girl that entertains BUT doesn't have sex with clients, trying to make her way in New York City. She makes money by going out as an escort with rich men ($50/date) and gets $100 a week by visiting an ex-mobster at Sing Sing Prison. She's saving her money to take care of her brother Fred when he returns from the Army.

Audrey Hepburn

©Lucian Milasan/Shutterstock.com

Her new next door neighbor, past his prime writer Paul Varjak (George Peppard), introduces himself, and Holly discovers that he's in the same boat, living off of a Sugar Mama nicknamed "2E." They share an innocent night together, and she invites him to one of her famous parties, where he meets two millionaire clients of Holly's, Rusty and Jose, and he also meets her agent, who tells him how Holly was a farm girl who came to the big city and became a socialite.

What follows is a series of misadventures as Paul falls in love with Holly. He gets upset when he discovers she's marrying Rusty just to get his money. He also meets Holly's former husband, Doc Golightly (Buddy Ebsen), who had married her when she was fourteen, and together they put him on a bus back to Texas. After Rusty marries someone else, Paul and Holly spend the night to console her. But she's adamant about marrying a rich man.

Will true love win out in the end? In the book (ah, I'm spoiling something!) they don't get together. Holly leaves New York and is never seen again. I think the movie has a more positive ending.

Even though the AFI doesn't think it's funny, the audience loved it and the box office was huge. *Breakfast at Tiffany's* was nominated for both the Best Picture Golden Globe for Musical or Comedy and Audrey Hepburn for Best Actress. Holly's "little black dress" has become a fashion icon, and every woman in the world has one and wears it to parties (ladies—you know what I'm talking about. And if you don't go buy one, you're missing out).

The film received five Oscar nominations, Best Actress for Hepburn, Best Adapted Screenplay, and Best Art Direction and won two: Best Score and Best Original Song for

"Moon River" by Henry Mancini and Johnny Mercer (the AFI awarded it as the fourth best song in Hollywood history). Finally, the Library of Congress selected *Breakfast at Tiffany's* to the National Film Registry in 2012.

Not only did *Breakfast at Tiffany's* not make the AFI Great Comedy List, but it also did not make the AFI Top Ten Romantic Comedies of All Time. Here's that List!

1. *City Lights* (1931)
2. *Annie Hall* (1977)
3. *It Happened One Night* (1934)
4. *Roman Holiday* (1953)
5. *The Philadelphia Story* (1940)
6. *When Harry Met Sally* (1989)
7. *Adam's Rib* (1949)
8. *Moonstruck* (1987)
9. *Harold and Maude* (1971)
10. *Sleepless in Seattle* (1993)

You might notice that there aren't any romantic comedies chronologically between *Roman Holiday* in 1953 and the next one chronologically on the list, #9's *Harold and Maude in 1971*. Some of you may ask—why is that? It's a good thing that I'm here.

Romantic comedies were a fad that was slowly dying out as the culture shifted away from the happiness of the 1950s to the tumultuous 1960s and into the 1970s. Audiences were turning on their television sets and tuning out movie theatres. If you wanted romantic comedy, you could change the channel.

Hollywood made an abrupt change at the end of the 1960s when the film *Easy Rider* appeared and took over the movie theatres. A new dawn of filmmakers appeared, and these feisty writers and directors weren't looking to work for the big studios and make musicals. They wanted to tell their own stories on their own terms. This time in Hollywood was the second Golden Age of Cinema, also known as The New Hollywood.

That's the landscape where a unique romantic comedy like *Harold and Maude* could come to life. How unique? Glad you asked.

Harold and Maude (1972)

In this extremely dark comedy, Harold (Bud Cort) is a depressed teenager obsessed with death in an attempt to get his wealthy and neglectful mother's, Mrs. Chasen (Vivian Pickles), attention. After escaping from a boarding school fire, she thought he was dead and fell apart when the police came to tell her. After she learned he was alive, she went back to her own selfish attitude, but Harold longed for her to feel something for him again. He tries to kill himself in front of her, but she doesn't care.

Harold is so obsessed with death that he drives around in a hearse and attends strangers' funerals. It's at one of these funerals that he meets Maude (Ruth Gordon), a 79-year-old who also attends strangers' funerals. She firmly believes that eighty is the proper age to die and it's coming close.

Maude shows Harold how great life is and their friendship turns into a romance, and instead of marrying one of Mrs. Chasen's prospects, he announces to his mother that he is marrying Maude. He throws Maude a surprise eightieth birthday party, where she tells Harold that she's taken an overdose of pills, since she told him that eighty was the perfect age to die. He rushes her to the hospital and—

[Editor's Note: Once again our author has chosen not to reveal the ending.]

Harold and Maude was a dud when it came out. The critics tore it apart for its dark theme, and the film was dead. But it caught on with students in college towns and became a cult classic. The film is the #45 film on the AFI Great Comedy Films list as well as its Top Ten List for Romantic Comedies and in 1997 was selected to the National Film Registry to the Library of Congress.

How about this one—one of the most depressing endings to a romantic comedy ever made? When you talk about love being dead—this is a great example.

The Heartbreak Kid (1972)

Director Elaine May was a dynamic force in the entertainment industry at a time when women were not respected for comedy. She had teamed with actor Mike Nichols (Oscar-winning film director for the seminal 1967 satire *The Graduate* as well as a ton of other movies) on Broadway for four years in the comedy team of Nichols and May, and won a Grammy Award for a live recording of their show. [Editor's Note: See more about Mike Nichols and Elaine May in Chapter 27.] Their humor was topical with a lot of improvisation, May broke taboo by portraying strong women characters instead of the housewives that most women had become, and was a huge influence on such comedians as Steve Martin and Lily Tomlin.

In 1961, Elaine wrote plays and in 1971 her feature film writing and directing debut, *A New Leaf*, was released to positive reviews. She starred with Walter Matthau as a botanist who wants to marry rich women and kills them off for their money. Now that's what I call a black comedy.

Her second film in 1972 was *The Heartbreak Kid*, based on Neil Simon's stage play. Another unconventional romantic comedy indicative of the time and culture, the story follows Jewish newlyweds Lenny and Lila on their honeymoon to Miami Beach. After Lila is confined to their hotel room by a bad sunburn, he meets Kelly (Cybill Shepard) and her parents. Lenny decides that he made a mistake marrying. Even though Kelly doesn't seem to be into Lenny he follows Kelly back to Minnesota. Though her father (Eddie Albert) tries to buy off Lenny with $25,000, Lenny and Kelly marry. Let's just say that sometimes you can't get what you want—especially in matters of the heart.

The film was a critical hit, and garnered Oscar nominations for Eddie Albert for Best Supporting Actor and Jeannie Berlin for Best Supporting Actress. It's the #91 film on the AFI Great Comedy Films list, and the film was remade in 2007 with Ben Stiller and Michelle Monaghan and directed by The Farrelly Brothers (*Dumb and Dumber*) which was successful at the box office, but the critics haaaated it.

Next up, even though *Harold and Maude* wasn't a box office winner, director Hal Ashby came back with a huge romantic comedy in 1975, the Warren Beatty-starrer *Shampoo*. Here was yet another film with a cynical take on love and more about sex and relationships.

Shampoo (1975)

Set against the backdrop of President Richard Nixon's 1968 inauguration, the film follows the life of Beverly Hills hairstylist George (Warren Beatty in full hunk mode) as he navigates his love life, with his dreams of owning his own salon. A confirmed bachelor that sleeps with a number of his clients, unless he hustles he might never find happiness.

George lives with Jill (Goldie Hawn), who believes that their relationship is monogamous. She couldn't be farther from the truth. Did I mention that Jackie and Lester's daughter also wants to sleep with George? Yikes!

Hoping to get Lester to invest in his salon (even though he's sleeping with every woman in the millionaire's life), George accepts Lester's invitation (he thinks the hairdresser is gay) to a big Republican dinner party for Nixon. It's there that George finds himself with all of his former and current lovers and then when the group goes to an after-party, that's when things get wild. Cue the conclusion!

Shampoo got mixed reviews from the critics, but the audiences loved it. The film made $60 million from a budget of $4 million. It was nominated for three Academy Awards, Best Original Screenplay for Robert Towne and star Warren Beatty, Best Art Direction, and won Lee Grant the Best Supporting Actress Oscar.

The studios didn't quite know how to deal with this brash in-your-face artistic attitude. The best they could do was adapt Broadway romantic comedies, such as Neil Simon's Oscar-winning *The Goodbye Girl* and Neil Simon's plays *California Suite* and *Same Time, Next Year* and bring them to the big screen.

Luckily for those true believers in love and romance, things were about to change.

Okay, we're going to pick this up in another chapter. I have a page limit—designed specifically for our short attention span readers. So go online, check your phone, maybe go play a video game, watch some cat videos online, and I'll meet you back here on another page for the concluding chapter about Romantic Comedies.

HEART WIPE TO BLACK

CHAPTER 19

ARTIST SPOTLIGHT

Billy Wilder, Marilyn Monroe, and Jack Lemmon

> **CHAPTER FOCUS**
> ► Who Is Billy Wilder?
> ► Who Is Marilyn Monroe?
> ► Who Is Jack Lemmon?

Chapter Focus

So during this time, content was askew. A lot of Hollywood comedies were made, and honestly a lot of them weren't very good. What could you expect? Culturally the country was a mess as the Red Menace and HUAC reigned supreme, and Hollywood was scared sh**less. These legendary talents helped keep Hollywood afloat as television began to take a bite out of the audience and keep audiences entertained.

Who Is Billy Wilder?

Thanks to this book, you're going to be up-to-speed on this prolific director in the 1940s, 50s, and 60s. He kept the auteur director candle burning bright by making the decision to make thoughtful dramas about the human condition and frothy comedies that were as innocent as the day is long during all of the Communist turmoil.

Born in Austria, he started screenwriting, and wrote a couple of films before wisely immigrating to France. He directed his first feature, and came to the United States as Adolph Hitler and the Nazis began their march across Europe. The Nazis killed his family after he escaped.

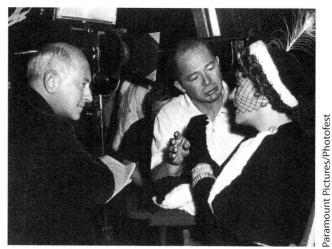

Paramount Pictures/Photofest

Oscar-winning writer/director Billy Wilder on-set with Gloria Swanson as Norma Desmond in 1950's *Sunset Blvd.*

Arriving in Hollywood and becoming a citizen in 1934, his first film was the script for the classic Greta Garbo screwball comedy *Ninotchka* with Ernst Lubitsch. The hit film was his first Oscar nomination for screenwriting and he never looked back. He wrote the AFI celebrated screwball comedy *Ball of Fire* for Howard Hawks with Gary Cooper and Barbara Stanwyk, and got his second nomination for Best Story. He wrote the romance *Hold Back the Dawn*, and was nominated for his third Oscar, this one for Best Screenplay, and then he shifted into both writing and directing. He was the second major writer/director in Hollywood, following in the footsteps of his friend Ernst Lubitsch.

What followed was a series of box office and critical successes: the film noir classic *Double Indemnity* (1944) with Fred MacMurray and Barbara Stanwyck and was nominated for both Best Director and Best Screenplay. He finally won both Best Director and Best Screenplay for his drama about alcoholism, *The Lost Weekend*, in 1944.

He followed that up with huge audience and critical hits like *Sunset Blvd.* (1950), where he won the Best Screenplay Oscar, *Stalag 17* (1953) in which he was Oscar-nominated for Best Director, and *Witness for the Prosecution* (1957) where Wilder received yet another Best Director Oscar nomination.

In 1954, Wilder also decided to make comedies, which brings us back to why you're reading about him.

The Official Billy Wilder Top 3 Great Comedy Film Checklist (not titled Some Like It Hot*)*

Sabrina (1954)

The glamourous Audrey Hepburn, fresh from her debut in *Roman Holiday,* starred in the title role for his 1954 film, *Sabrina*. This playful romantic comedy follows Sabrina, young chauffer's daughter, being pursued by her father's employers, Linus (Humphrey Bogart) and David (William Holden). Sabrina was always the cute little teenager who got underfoot, but after she leaves for Paris for two years, she comes back a full-blown woman. Both wealthy men are smitten and the film is a big love triangle. Even though Sabrina always had a crush on David, does the all-business Linus stand a chance?

The film was a big success and cemented Hepburn as a cinematic force. Wilder was nominated *yet, yet again* for Best Director and Best Screenplay. But he was on a serious roll now.

Next, he wrote and directed the hugely-successful *The Seven Year Itch* in 1955. I'm going to throw that one in my upcoming segment about Marilyn Monroe (since it was the film that made her a star), because that movie was all about her, and even though Wilder created one of the most iconic visual moments in the history of cinema, the iconic shot of Marilyn's skirt billowing over the subway grate, he didn't get any Oscar nominations for that film.

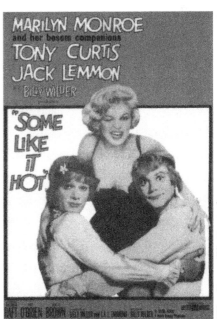

In 1957, he directed *Love in the Afternoon* with Audrey Hepburn and Gary Cooper. The film is noted as the first film that Wilder wrote with I. A. L. Diamond, in which the two would write together for the rest of their careers.

His next film was, drum roll please . . . the #1 Comedy on the AFI Great Comedy Films list, *Some Like It Hot*. A huge blockbuster film reuniting Wilder with Marilyn Monroe from *The Seven Year Itch*. This film gets its own Super Comedy Spotlight in Chapter 20. You can read all about it, but the biggest thing for this profile is Billy

Billy Wilder directed and wrote (with I. A. L. Diamond) this film which is discussed in Chapter 20

©Olga Popova/Shutterstock.com

Wilder nominations for both Best Adapted Screenplay and Best Director (but not winning either of them).

As if *Some Like It Hot* wasn't enough, he then hit a home run with his next film.

The Apartment (1960)

Directed by Billy Wilder with a script co-written with screenwriter partner I. A. L. Diamond, the film follows the sad tale of "Bud" Baxter (Jack Lemmon), trying to climb the corporate ladder by lending his apartment to upper management so they can have extramarital affairs. Hoping for a big promotion, he's cornered by personnel director Jeff Sheldrake (Fred MacMurray from Wilder's *Double Indemnity*) who wants the apartment all to himself. Bud agrees, and on the way out meets Fran (Shirley MacLaine), one of the elevator operators who he is smitten.

Jack Lemmon and Shirley MacLaine in the Oscar Best Picture Winner *The Apartment* (1960)

United Artists/Photofest

After Fran realizes that Sheldrake won't leave his wife for her, she tries to kill herself in the apartment, where Bud finds her after she overdoses on sleeping pills. [Editor's Note: Is this a comedy? This doesn't sound like a comedy.]

Bud nurses her back to health, and falls in love with her. When Fran's fiery brother-in-law, Karl, shows up looking for the missing Fran, Bud's bosses, who are irate that they lost the apartment access, direct him to Bud's place where Fran is still recovering.

Will Karl kick Bud's ass? Will Sheldrake get his just desserts? Can Bud and Fran come together with all of this drama swirling around? Can Bud even keep his job?

The film was a massive ticket office and critical success. Ten Academy Award nominations, including Best Actor (Lemmon), Best Actress (MacLaine), Best Supporting Actor, Best Cinematography, and Best Sound. The film won five of them: Best Picture, Best Director for Wilder, Best Screenplay for Wilder and Diamond, Best Editing, and Best Art Direction (Black and White).

It was one of the first films to be nominated for all five of the major Oscars, and since Wilder was the producer of the film, he was the first filmmaker to win three Oscars for the same movie.

It's also one of the few comedies that won Best Picture, along with *It Happened One Night, You Can't Take it With You, The Sting,* and *Annie Hall.* The AFI named it the #93 film on the Greatest Movies list, #20 on the Greatest Comedies list, and was placed in the National Film Registry by the Library of Congress in 1994.

With the HUAC shut down years ago, he wrote (with I. A. L. Diamond) and directed *One, Two, Three* (1961), a comedy set against the Cold War in Germany. Legendary gangster actor James Cagney plays "Mac" MacNamara, a Coca-Cola executive dealing with his daughter falling in love with a Communist. The film was more of a slapstick comedy, and it was a box office failure in both America and Germany.

A handful of comedies (with a couple of dramas thrown in as well) came next, but Wilder's career began to fade. He wrote with Diamond and directed 1963's *Irma La Douche* with Jack Lemmon and Shirley MacLaine. She got her second Oscar nomination in this romantic comedy between a prostitute and a former cop.

It was followed by the (controversial for its time) adulterous comedy *Kiss Me Stupid* (1964) and then he had a run of gentler comedies to finish off his career.

The Fortune Cookie (1966)

This film was iconic for many reasons. This tale of a TV cameraman Harry Hinkle (reuniting again with Jack Lemmon) who is accidentally run over by NFL player Luther "Boom Boom" Washington (Ron Rich) on the sidelines of a football game. Though his injures aren't serious, his shyster brother-in-law, Willie Gingrich (Walter Matthau), smells the chance for a quick payday and milks Harry's slight injuries into a massive lawsuit. Wilder earned his last Oscar nomination for Best Screenplay, it brought together Jack Lemmon and Walter Matthau in a comedy-team partnership that would last four decades, and Walter Matthau would win the Best Supporting Actor Oscar for the year. Billy Wilder reunited again with Lemmon and Matthau for 1974's *The Front Page* (a remake of the original screwball comedy but now with both leading roles being men), and *Buddy Buddy* in 1981, Wilder's last film.

In total, he received twenty-one Oscar nominations, won six, received the AFI Life Achievement Award in 1986, the Oscar Irving G. Thalberg Memorial Award in 1987, and in 1993 was awarded the National Medal of Arts, and has a star on the Hollywood Walk of Fame. He died at the age of ninety-five from a bout of pneumonia. The French newspaper *Le Monde* wrote "Billy Wilder dies. Nobody's Perfect" for his obituary, and after you watch *Some Like It Hot*, you will totally get that joke.

So, anybody here doubt that Billy Wilder was one of the biggest creative forces in the history of motion pictures? I didn't think so.

Who Is Marilyn Monroe?

"The body is meant to be seen, not all covered up."

—Marilyn Monroe

How about the sexiest movie star in history? When I think about Marilyn Monroe, I think of three things: sex, sex, and more sex. She was funny and smart and a psychological train wreck. She was the first real sex symbol and epitomized Hollywood glamour and success. As we all know, she was a legend that tragically died too soon at the hands of John F. Kennedy's henchmen, if you believe everything you read on the Internet. I just read she had sex with THREE Kennedy brothers. Leave the poor woman alone!

©Sergey Goryachev/Shutterstock.com

Born as Norma Jeane Mortensen in 1926, her mom was also a psychological wreck that abandoned her to orphanages and foster homes. She was allegedly raped and abused growing up. She became a model at nineteen when she was working in an aircraft factory during World War II. She became a pin-up model, eventually dyed her hair blonde, and signed with a modeling agency. She had a brief and unremarkable film contract, but spent most of her time taking acting, singing, and dancing lessons.

©BokehStock/Shutterstock.com

After meeting agent Johnny Hyde at the William Morris Agency, which led to a romantic relationship, under his guidance she got plastic surgery and did some nude modeling. She was picked up again for film roles, and appeared most notably in a supporting role in the classic Oscar-winning drama *All About Eve* starring Bette Davis. Hyde negotiated a contract with 20th Century Fox, and she was off to the races.

Nine films later she hit it big with her supporting role in the Howard Hawks screwball comedy *Monkey Business* (1952) with Cary Grant and Ginger Rogers. That's the one with the Fountain of Youth formula and Cary Grant goes chasing after her. After starring in dramas, *O'Henry's Full House* (1952) and *Niagara* (1953), she got her big musical/comedy leading role opportunity.

The Official Marilyn Monroe Top 4 Great Comedy Film Checklist

Gentlemen Prefer Blondes (1953)

Directed by her *Monkey Business* director, Howard Hawks, she starred with almost but not quite as sexy, okay, she's pretty hot, Jane Russell. Together they play showgirls looking to attract husbands. Lorelei (Monroe) is engaged to wealthy Gus (Tommy Noonan) and his father hates her. Dorothy (Russell) is just searching for a good-looking man. Together they have to go to France, and Gus's father sends private detective Ernie Malone to follow Lorelie to show his son that she's up to no good. Of course, Ernie falls in love, but not with Lorelie, with Dorothy!

Marilyn as Lorelei knows that "Diamonds are a Girl's Best Friend"

While onboard, Lorelie flirts with diamond mine owner Sir Francis "Piggy" Beekman (Charles Coburn) and Ernie gets pictures of the two of them together to send back to Gus and his father. Will the pictures get back to Gus? Will Dorothy figure out that Ernie isn't who he says he is? How does Piggy and his wife figure into all of this?

The most famous scene in the film is when Lorelie sings "Diamonds are a Girl's Best Friend" to Gus's father to show him why women are searching for wealthy men. Maybe it's on the YouTube. [Editor's Note: It is.]

The movie was a monster hit with audiences and critics. Both Marilyn and Jane Russell got to put their hands in the cement in front of Grauman's Chinese Theatre for their work on the film, and *Gentlemen Prefer Blondes* was the ninth-highest grossing movie of the year.

But the fourth highest grossing movie of the year was Marilyn's next film.

How to Marry a Millionaire (1953)

She had star billing above stars Betty Grable and Lauren Bacall, and follows their plans to trap wealthy men to marry them (are we sensing a pattern here?). [Editor's Note: Yes we are.] She's after wealthy J. D. Hanley (William Powell from *My Man Godfrey*). Loco finds business-man Waldo (Fred Clark), but he turns into a dud, and she finds herself falling for regular guy, forest ranger Eben (Rory Calhoun).

Ditzy Pola (Marilyn) falls for a fake oil tycoon, but accidentally boards the wrong plane. There she meets mild mannered insurance agent Freddie Denmark (David Wayne), and falls in love with him.

Will the girls give up their plans to find men with money? How lucky will these other guys be if they land these amazing women? Is it possible that one of them is actually rich?

So with two winners back-to-back, Marilyn's star was hot, but she wasn't happy with the dumb blonde roles that Fox was offering her. They suspended her contract and she hyped up publicity to explain her side. In 1953, she married New York Yankee Joe DiMaggio and in 1954 started her own production company. See, not the "dumb blonde" now, huh? She settled with the studio after winning *Photoplay* magazine's "Most Popular Female Star," and then got her biggest movie which cemented her status as the sexiest movie star in the world. This is a legacy which still exists today.

With those glasses, she really looks homely—said no one ever—as Marilyn Monroe sets her sights on a big fish in 1953's *How to Marry a Millionaire*

©BokehStock/Shutterstock.com

The Seven Year Itch (1955)

Here's that Billy Wilder film I mentioned earlier. Richard Sherman (Tom Ewell) has a problem. He's got the "seven year itch," that moment when married men begin to lose interest in their wives and start seeking other companionship. After shipping his wife and son off, he meets The Girl (Marilyn), he's immediately smitten. Richard is a mess, he goes in and out of fantasies where he's irresistible to women, and though The Girl rebuffs his advances, he thinks he still has a chance. He wants to spend more time with her, but she's not interested in him in that way. But, in his fantasy life, she totally is.

Will Richard get together with The Girl? Will his wife find out? What about their marriage? And how does the most iconic scene in the film, nay in all of filmdom (okay, there's the Rosebud thing in *Citizen Kane*, and the shower scene in *Psycho* and now that I think about it, there's a bunch more . . .) fit into the movie?

After the two of them see a movie, The Girl's walking in this amazing white dress and across a sidewalk grate when a subway car passes below, which causes this huge gust of air to blow up her skirt. She likes it. And so does Richard. Get a glimpse of those gams! Another car comes along, and the skirt blows up again. Boy she does love that burst of air going up there, and he's grinning like the Cheshire Cat. The image of Marilyn with that billowing skirt is one of the enduring images of motion pictures, and especially of Marilyn Monroe.

The *Seven Year Itch* was a big box office hit with good reviews from the critics. It's the #51 movie on the AFI Great Comedy Films list.

Being a sex symbol isn't great when it's the *other* person in the relationship who's getting all the attention. Marilyn's marriage to Joe DiMaggio ended soon after *The Seven Year* Itch was released. She went to New York to study method acting with Lee Strasburg at The Actor's Studio and ended up marrying famed playwright Arthur Miller.

Even though people said that Marilyn was a pain on the set, forgetting lines and arriving late, it didn't stop 20th Century Fox from negotiating a new contract with her. Her first film under her new contract (she made $100,000), was the 1956 film adaptation of the Broadway play, *Bus Stop*.

Marilyn's skirt blew up and she became the biggest star in the world

Bus Stop (1956)

The drama follows traveling cowboy Beau Decker (Don Murray) who stops in and hears saloon singer Cherie (Marilyn) perform at a diner in small town Phoenix, Arizona. He falls in love with her, and kidnaps her to bring her back to his home in Montana. They get stopped at a bus stop, and everything goes a little crazy when everyone realizes that Bo has kidnapped Cherie. Will Beau and Cherie get together, even though he's a kidnapper? Will Beau realize that you don't treat women like that? God only hopes so! Don Murray did get nominated for a Best Supporting Actor nomination, and Marilyn and the film were nominated for Golden Globes.

She hit a speed bump with her own company's production of 1957's *The Prince and the Showgirl*, where she co-starred with the legendary Laurence Olivier, who also directed and produced. Apparently Marilyn's method acting process led to a calamitous set and Olivier hated working with her. The response from the critics was poor and the ticket sales were not even close to her previous films.

Marilyn in her last film, *The Misfits*

She took time off from film, and settled down with Arthur Miller. She suffered a miscarriage and other health problems. She returned to Hollywood in 1959 to star with Tony Curtis and Jack Lemmon in the Billy Wilder masterpiece *Some Like It Hot*. [Editor's Note: Still there at Chapter 20.] You know all about this film by now, but for Marilyn the film was huge. She made 10 percent of the profits, and won a Golden Globe for Best Actress.

After that, she only did two more films. One was a musical/comedy *Let's Make Love*, directed by George Cukor, about an actress who falls in love with a billionaire (French actor Yves Montand) pretending to be an actor. Wow, that's a lot to absorb. The most notable piece about this movie is Marilyn having an affair with Montand that ended when the film was completed.

It's said that Truman Capote really wanted Marilyn to play Holly Golightly in *Breakfast at Tiffany's*, but the studio didn't want to put up with Marilyn's off-screen problems. Her last film was *The Misfits*, a drama written by Arthur Miller for her, and co-starring Clark Gable and Montgomery Clift. The film was a box office misfire. She fought off depression and health problems, started and then was fired from comedy *Something's Got to Give*, and in 1962, she was found dead of what we all hope is an accidental barbiturate overdose. "Candle in the Wind," baby. Just a "Candle in the Wind."

Marilyn Monroe in an iconic Andy Warhol-esque print

She's an icon that will live forever, like Elvis Presley, James Dean, Frank Sinatra, and The Beatles. The AFI named her the #6 Female Actress in History, she's in a famous painting by Andy Warhol, you still see her in commercials (that Snickers bar one with Willem Dafoe doing The-Seven-Year-Itch is pretty hilarious) and if you don't know her, then you don't consume enough pop culture and mass media. She's another comedy legend, like Katharine Hepburn and Cary Grant, and she will never be duplicated.

Who Is Jack Lemmon?

Let's talk about an actor that didn't have a trunkful of mental issues. He was prolific, appearing in ninety-five films and television appearances for over thirty years. In my book, which again, you are reading, I consider him one of the icons of comedy and one of the greatest actors of all time. Enough about me, let's find out about Jack Lemmon.

Jack Lemmon had a great childhood, growing up with wealthy parents, and he wanted to be an actor in grade school. He went to private school and then Harvard where he was the President of the Hasty Pudding Club, which annually celebrates icons of society and culture. He served briefly in World War II and decided to act professionally. He sought out master acting teacher Uta Hagen and learned how to play the piano.

Jack Lemmon on the SAG Awards red carpet in 2000

©Featureflash Photo Agency/Shutterstock.com

He did television starting in 1949 and eventually got to leap to feature films, and his first credited appearance was in the George Cukor film *It Should Happen to You* in 1954 with Judy Holliday (Oscar winner from 1946's *Born Yesterday*).

The Official Jack Lemmon Top 3 Great Comedy Film Checklist

Mister Roberts (1955)

Mister Roberts was a comedy-drama about life on a Navy cargo ship during World War II. The film is directed by the legendary John Ford (like the director of every good John Wayne movie ever) and Mervin LeRoy (director of *Little Women*) and Lemmon co-starred with Henry Fonda and James Cagney. He played Ensign Pulver, the wise guy slacker who rooms

with Fonda's Mr. Roberts, the executive officer of the ship. The movie was a big box-office hit and was nominated for Best Picture and Best Sound. More importantly to this chapter, Jack Lemmon won the Academy Award for Best Supporting Actor.

A string of movies, including 1958's *Bell, Book and Candle* with Jimmy Stewart and Kim Novak (who would later star together in Alfred Hitchcock's legendary *Vertigo*) led him to another great film. Correction—an incredible film.

His next comedy gave him the chance to work with writer-director Billy Wilder. This would be the first time that Wilder and Lemmon would work together, and they would continue their collaboration on six more films together over the next twenty-five years.

©Sergey Goryachev/Shutterstock.com

The movie they did together is the #1 movie on the AFI 100 Years . . . 100 Laughs List. That's right—it's *Some Like It Hot* with Marilyn Monroe and Tony Curtis and written and directed by Billy Wilder. [Editor's Note: If you haven't figured it out yet, it's in Chapter 20.]

Marilyn Monroe and Jack Lemmon are two sexy babes in *Some Like It Hot* (1959)

Lemmon was nominated for a Best Actor Oscar, won the Best Foreign Actor at the British Academy Awards, and won the Best Actor award at the Golden Globes.

After filming *It Happened to Jane* with Doris Day in 1959, Lemmon reteamed with Wilder for the Oscar winner *The Apartment* (look above about eight paragraphs).

His role as nebbish C. C. "Bud" Baxter was a triumph. He won the BAFTA Award for Best Actor, the Golden Globe for Best Actor, and was nominated for a third Best Actor Oscar.

He kept making movies and his next highlight was 1962's *Days of Wine and Roses*. This serious drama had Lemmon step into the role of Joe Clay, an alcoholic whose life spirals out of control and takes his wife Kirsten (Lee Remick) with him. This was Lemmon's fourth Best Actor Oscar nomination and third Golden Globe Best Actor nomination.

Showing his amazing versatility, in 1963 he teamed again with Billy Wilder and his former *The Apartment* co-star, Shirley MacLaine, in *Irma la Douce*. This romantic comedy tells the story of an ex-cop who falls in love with a prostitute and tries to get her into his life. Yes, it's a comedy and the film was a huge hit. Score another Golden Globe nomination for Best Actor!

He then starred in back-to-back hits *Under the Yum Yum Tree* (1963) and *The Great Race* (1965).

In 1966, Billy Wilder and Jack Lemmon re-teamed for *The Fortune Cookie* and brought along veteran actor Walter Matthau for the ride. It was the first of ten films that Lemmon and Matthau would make together.

Matthau had started out in television and moved into films, playing a mixture of supporting roles and bad guys, including 1963's *Charade*, starring Cary Grant and Audrey Hepburn. He also acted on Broadway, and in 1965 playwright Neil Simon cast him in his new play, *The Odd Couple*. That would be very fortunate casting for him in a couple of years and Matthau received a Best Actor Tony Award for his portrayal of slovenly sports journalist Oscar Madison.

The Fortune Cookie (1966)

In this caper film, football cameraman Harry Hinkle (Lemmon) gets run over by a running back during an NFL game. Though the injuries are superficial, his brother-in-law shyster lawyer "Whiplash Willie" Gingrich (Matthau) coerces Harry into pretending he is partially paralyzed to score a big insurance payday. Of course, the insurance company is suspicious.

The film was Walter Matthau's coming out party. He was nominated for a Golden Globe for Best Actor, but won the Oscar for Best Supporting Actor. Of course, Wilder got his usual Oscar nomination for the screenplay with I. A. L. Diamond and it cemented the partnership that Matthau and Lemmon would continue to enjoy.

Jack Lemmon and Oscar-winner Walter Matthau star in Billy Wilder's con-artist comedy *The Fortune Cookie* (1966)

When it was time for a film version of *The Odd Couple* to be made in 1968, Matthau was tapped to reprise his role as slovenly sports reporter Oscar Madison. Jack Lemmon would take the role of Felix Unger, originally played onstage by television actor Art Carney. This hilarious film is the #17 film on the AFI Great Comedy List.

The Odd Couple (1968)

You probably know the Neil Simon story, but since I'm getting paid by the word, I'll let everyone else know about it. Felix Unger (Jack Lemmon) has been kicked out of his house by his wife, and he contemplates suicide. His buddy Oscar Madison (Walter Matthau) is all too familiar with divorce and invites Felix to live with him until the dust settles.

Once Felix moves in, he starts to drive Oscar crazy. Felix runs around the house, compulsively cleaning and picking up after Oscar, making meals and doting over him. Not exactly what Oscar bargained for. Hoping to distract Felix, he asks him to go on a double date with two sisters that live in the same building. And things get worse from there.

Will Felix get over his ex-wife? Sprain his wrist dusting and mopping? Will Oscar murder him? Or maybe just throw him out?

The Odd Couple was a monster triumph, both critically and at the box office. Both Lemmon and Matthau were nominated for Golden Globes for Best Actor, Neil Simon was nominated for an Oscar for his Best Adapted Screenplay, and the film inspired not one, or two, but four different television series, the most famous being the 1970–1975 ABC network version with Jack Klugman and Tony Randall. There was a version with two black actors called *The New Odd Couple*, an animated one called *The Oddball Couple* with a dog and a cat, and a new version called *The Odd Couple* with *Friends* star Matthew Perry started airing on CBS in 2015. It should hopefully be cancelled by the time you read this. [Editor's Note: Yep, it was cancelled by the second edition printing.] It's pretty painful.

In 1998, Lemmon and Matthau starred in *The Odd Couple II*, the sequel to their hit film. At thirty years in-between films, it is the longest time passed between a movie and its sequel in motion picture history.

Jack Lemmon and Walter Matthau would make seven more films besides *The Fortune Cookie, The Odd Couple,* and *The Odd Couple II: Kotch* (1971), *The Front Page* (1974), *Buddy Buddy* (1981), *Grumpy Old Men* (1993), *The Grass Harp* (1995), *Grumpier Old Men* (1995), and *Out to Sea* (1997). They also appeared in Oliver Stone's conspiracy drama *J.F.K.* but did not share any scenes together.

Jack Lemmon and Walter Matthau made a ton of films together

Matthau would go on to star in some huge films solo, including *The Taking of Pelham One Two Three* (1974), *The Sunshine Boys* (1975), his memorable turn as Coach Morris Buttermaker in *The Bad News Bears* (1976), *First Monday in October* (1981), Mr. Wilson in *Dennis the Menace* (1993), and Albert Einstein in the romantic comedy *I.Q.* (1994). He died of a heart attack in 2000 at the age of seventy-nine.

Lemmon kept on rolling after *The Odd Couple* and his pairings with Matthau through the years. He won another Golden Globe for the Billy Wilder film *Avanti!* (1972). He was nominated for a Golden Globe and won the Oscar for Best Actor for *Save the Tiger* (1973), and was nominated for another Golden Globe for the remake of *The Front Page* (1974) with Matthau.

He was nominated again for both a Golden Globe and a Best Actor Oscar for *The China Syndrome* (1979), again for both the Golden Globe and the Best Actor Oscar for *Tribute* (1980). (I might as well start cutting and pasting this) nominated yet again for the Golden Globe for Best Actor and Best Actor Oscar for *Missing* (1982), nominated for the Golden Globe Best Actor Musical Comedy for *That's Life!* (1986), and the Golden Globe Best Actor *Drama for Dad* (1989).

He was in some pretty great movies too: *JFK* (1991), *Glengarry Glen Ross* (1992), Robert Altman's *Short Cuts* (1993), and Kenneth Branagh's *Hamlet* (1996). I can't forget all his Emmy award-winning work on television including *12 Angry Men* (1997), when winner Ving Rhames jumped onstage and said he didn't deserve the award, and called Lemmon up and handed it to him. The Emmy's made an extra statue for Ving (totally not making that up). He won his first Best Actor Emmy for his final television film, *Tuesdays with Morrie* (1999).

To sum it up, Jack Lemmon was one of the greatest actors that has ever graced the silver screen, television screen, and computer screen, and my phone. You get the idea. He holds the most Golden Globe nominations for acting at twenty-two. He's one of five actors in history to win both a Best Actor and Best Supporting Actor Oscar (Gene Hackman, Kevin Spacey, Robert DeNiro, and Jack Nicholson). He was given the AFI Life Achievement Award in 1988. *Entertainment Weekly* named him the 33rd Greatest Movie Star of All Time. He passed away in 2001 at age 74 and is buried near Walter Matthau.

> Billy Wilder, Marilyn Monroe, and Jack Lemmon not only teamed up in one of the funniest movies ever, but also kept the Hollywood studio system alive during the reign of McCarthyism. Altogether, they would make some of the greatest film comedies in cinematic history.

CHAPTER 20

SUPER GREAT MOVIE SPOTLIGHT

Some Like It Hot
(1959)

Scene from *Some Like It Hot*

United Artists/Photofest

> ► Starring Tony Curtis, Jack Lemmon, and Marilyn Monroe
> ► Directed by Billy Wilder
> ► Written by Billy Wilder and I. A. L. Diamond
> ► Subgenres: Romantic Comedy, Crime, Fish-Out-Of-Water, Farce
> ► Comedy types: Verbal, Slapstick

"Well, nobody's perfect!"

—Osgood Fielding III (Joe E. Brown)

This is it—the film that AFI said is the funniest comedy movie ever made. Just remember, this list that AFI wrote only goes through 1999. And there've been a number of hilarious comedies since this list was written in stone and placed upon Mount Sinai. Movies like *The Hangover, Superbad, Borat, Wedding Crashers, Tropic Thunder, Bridesmaids,* and the greatest of these: *Anchorman: The Legend of Ron Burgundy.*

But this is the list that we must look back upon from an academic and historical perspective—that will help shed a light on our comedy past, and who knows—maybe our comedy future. <cue dramatic yet hopeful music>

Let's face it, everyone thinks that guys who dress up as women is hilarious. Something about watching them walk in high heels I think. And there have been a ton of them! *The Rocky Horror Picture Show, Just One of the Guys, Boys Don't Cry, The Crying Game* (oh wait, those last two aren't comedies. Sorry about that!) and *White Chicks.* Everyone knows about *White Chicks.* This movie didn't do cross-dressing first (1949's *I Was a Male War Bride* with Cary Grant immediately leaps to mind), but *Some Like It Hot* did it the best.

Summary

Set in Chicago in 1929, the movie follows two musicians, Joe (Curtis) and Jerry (Lemmon), that accidentally witness the gangster slaying of a rival gang called the St. Valentine's Day Massacre. To escape from the murderers, their agent gives them a lead on a band leaving that day—which happens to need a double bass and saxophone player.

Unfortunately for them, the gig is with an all-female band, "Sweet Sue and her Society Syncopators," but they're stuck. They do the unthinkable and disguise themselves as women, Joe is now Josephine and Jerry is now Daphne, to complete the deception and get the heck out of Chicago. But as women, they both find themselves attracted to the extremely hot lead singer Sugar Kane (Monroe) who is hoping to score a rich millionaire at the hotel where they are staying at in Florida.

Smitten, Joe disguises himself *as* a millionaire named Junior, the owner of Shell Oil. He romances her, jumping back and forth between his millionaire disguise and his female disguise, while Daphne fends off the advances of a real millionaire, Osgood Fielding III (Joe E. Brown).

Things get out of control (like they're not already?) when the gangsters show up at their hotel, and recognize Joe and Jerry. So they're back on the run—will Joe and Jerry survive? Will Joe tell Sugar the truth? Will Jerry tell Osgood the truth? Are there any happy endings when the Mob has machine guns? And is *Some Like It Hot's* topper at the end of the movie the greatest topper in motion picture history?

Best Scenes

Wearing High Heels—The first scene where Joe and Jerry have changed into their dresses and are hustling to catch the train, and the two of them are trying to wrap their heads around what they are wearing and what they are doing, and then we catch our first glimpse of Sugar Kane rushing to the train, instead of reacting to how beautiful she is— Jerry focuses on how she walks and there is no way he'll be able to match her. "That's just like Jell-O on springs. She must have some sort of built-in motor or somethin'!"

Doing the Tango—Joe—now disguised as millionaire "Junior"—and Sugar are on "Junior's Yacht" and she is trying to help him overcome his medical issue that makes him have no reaction to women with kissing (and more?). Meanwhile we pan over to Daphne and Osgood who are dancing the night away at the hotel: "Daphne, you're leading again!"

The Night After—Jerry tells Joe that he's engaged to Osgood. Joe: "Why would a guy want to marry a guy?!!" Jerry: "Security."

The Topper—Last scene on the boat with Osgood and Daphne. 'Nuff said.

Awards and Recognition

Some Like It Hot was nominated for six Academy Awards including Best Director for Billy Wilder, Best Actor for Jack Lemmon, Best Cinematography, Best Costume Design, and Best Adapted Screenplay, and won for Best Art Direction. Just one? Seriously? Sometimes I hate the Academy so much! But the film swept the Golden Globes for Comedy/Musical including Best Picture, Best Actor for Jack Lemmon, and Best Actress for Marilyn Monroe.

Finally, the American Film Institute lists *Some Like It Hot* as the #14 film on their list of America's Greatest Movies. It finished higher than *Star Wars*! In 1989, the film was one of the first twenty-five films placed in the National Film Registry at the Library of Congress.

CHAPTER 21

Hollywood Gets Really Silly and Desperate

OR:

After That Whole Red Menace Thing, Hollywood Faces Another Challenge

Most of the ensemble cast of *It's a Mad Mad Mad Mad World* (1963)

United Artists/Photofest

> ▶ The Death of the Studio System
> ▶ The Last of the Comedy Teams
> ▶ The Movies Get Even More Ridiculous

The Death of the Studio System

As the 1950s ended and the 1960s began, things started to change. Television had taken a huge chunk of the audience away from the film business. To save money, the Golden Age of Hollywood came to an end.

That meant that the practice of putting actors, writers, and directors under exclusive contracts for long periods of time came to an end. Suddenly, agents and managers were representing talent and high-profile movie stars like Marilyn Monroe were starting their own production companies. Hollywood studios would only finance a small amount of movies, and the financing of films switched to outside producers, and the big studios like 20th Century Fox and Paramount Pictures would focus more on publicity, marketing, and distribution.

The movie studios were willing to try anything to keep the audiences from staying home and watching television. They added 3-D technology, widescreen filming like Vistavision, better sound in theatres, and started making films with more risqué material—hence the rise in sex comedies and the phenomenon that was Marilyn Monroe. It took them awhile to realize it, but television would end up becoming their greatest ally. Now they had a place to show all of their old movies, and they weren't going to let them be shown for free. Now instead of taking films back and rereleasing them in theatres, they had a second life being broadcast on television. But no, at that point, it was all panic and mass hysteria.

So what kind of comedies did the studios end up making? Some of the films were daring, such as Stanley Kubrick's classic *Dr Strangelove: or How I Learned to Stop Worrying and Love the Bomb*. [Editor's Note: Chapter 22.] But for the most part, there were two types: really silly movies and musical comedies.

The Last of the Comedy Teams

One of the biggest acts of the 1950s and early 1960s was Dean Martin and Jerry Lewis. The team-ups were very popular (i.e., Abbott and Costello, Hope and Crosby) during that time.

Martin was a crooner in the vein of Bing Crosby, but his singing career was going nowhere after he was discharged from the Army in World War II. In 1945, he was onstage in New York City when he met up-and-coming young comedian Jerry Lewis, and they formed a partnership that would last for the next ten years and make them one of the biggest comedy acts in America.

Their shows were part music, part comedy with Lewis in full slapstick mode with a lot of banter between the two of them. Dean was the "King of Cool" and Jerry was the wacky troublemaker that was ruining Dean's singing act. They didn't have comedy skits like Abbott and Costello. It was a lot more loose with a lot of improv. They started in nightclubs and graduated to television, and got their own radio show in 1949. They were cast in their first film, *My Friend Irma*, the same year. Together they made seventeen comedy films together from 1946–1956.

It was that time in Hollywood when actors were starting their own production companies, and Martin and Lewis were no exception. They owned everything they did and became millionaires. But Jerry was getting all of the attention, and Dean was tired of being the straight man. The team broke up in 1956, and Dean went on to become one of the greatest singers of his generation. He joined up with Frank Sinatra as part of the Rat Pack, had a huge solo movie career, and his own television variety series on NBC from 1965–1974 and the Dean Martin Celebrity Roast from 1974–1985. This legendary actor and musician died of lung cancer in 1995 at the age of seventy-eight.

As for Jerry, he started his successful solo career starring, writing, and producing *The Delicate Delinquent* in 1957. The movie was a triumph and he went on to star in a total of thirty-one films, fourteen of which he directed. Some of his most notable films include *Cinderfella* (1960), *The Bellboy* (1960), *The Family Jewels* (1965) where he played seven different roles, and *The Patsy* (1964).

But here's his biggest solo effort:

The Nutty Professor (1963)

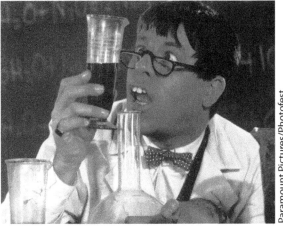

In this parody of Dr. Jekyll and Mr. Hyde, Professor Julius Kelp (Jerry Lewis, who also wrote and directed) is the nerdiest nerd you will ever meet. Buck-toothed, wild-eyed, socially inept, and a klutz, he's lucky to have a job at the University. Tired of being picked on by a football player, he invents a serum that turns him into hipster womanizer Buddy Love.

The Nutty Professor

Paramount Pictures/Photofest

Buddy is everything that Julius is not. He's a bad boy when he's Buddy, and Julius knows that he should stop taking the serum, but he can't help himself!

What happens when the serum wears off? Will Julius stop Buddy from taking over his life? What about Stella? And what happens if MORE people learn about the serum?

The Nutty Professor is the #99 movie on the AFI 100 Years . . . 100 Laughs List. In 1996, comedian Eddie Murphy remade the film to huge success. And in 2000, Murphy starred in a sequel called *The Nutty Professor II: The Klumps*, which was another hit. The Library of Congress selected the original film for the National Film Registry in 2004.

Jerry Lewis has been celebrated in France as a film auteur, due to the total control that he had creatively for his films. His charity work for the Muscular Dystrophy Association is legendary, where in 1966 he started a telethon on Labor Day weekend that he hosted until 2010.

He has won the Lifetime Achievement from the American Comedy Awards, the Emmy's Governor's Award, and the Jean Hersholt Humanitarian Award from the Oscars. He passed away in 2017 as an icon of comedy cinema.

The Movies Get Even More Ridiculous

Starting in 1959, Columbia Pictures made *Gidget*, the sun-drenched adventures of a plucky surfer girl (All-American girl Sandra Dee—made popular in that song in *Grease*) riding the waves and falling in love on Malibu Beach. Teenagers ate it up!

The film was pretty successful, and two sequels were made: *Gidget Goes Hawaiian* (1961) and *Gidget Goes to Rome* (1963). Small studio AIP cashed in on the surfer fad when they paired popular singer Frankie Avalon with former Mouseketeer Annette Funicello for 1963's *Beach Party*. It was a mammoth sensation that spawned eleven films from 1963–1967 with such titles as *Beach Blanket Bingo, Muscle Beach Party, Bikini Beach, How to Stuff a Wild Bikini*, and many, many, many more.

Elvis Presley was also pretty popular back then! From 1956–1969, "The King of Rock and Roll" made thirty-one films. Some of the more famous ones were *Jailhouse Rock* (1957), *Blue Hawaii* (1961), *Girls! Girls! Girls!* (1962), *Viva Las Vegas* (1964), *Frankie and Johnny* (1966), and more.

How about the Beatles? After taking America by storm in 1962, they filmed *A Hard Day's Night* in 1964 and *Help!* in 1965.

The Beatles (Paul, George, Ringo, and John) starred as themselves in 1964's *A Hard Day's Night,* the comedy that gave the author a chance to put the famous group in his book. Enjoy!

The musicals were all over the place: *Bye, Bye Birdie* (1960), *How to Succeed in Business Without Really Trying* (1961), *The Music Man* (1962), *My Fair Lady* (1964), *Mary Poppins* (1964), *A Funny Thing Happened on the Way to the Forum* (1966), *Doctor Doolittle* (1967), *Chitty Chitty Bang Bang* (1968), *Oliver!* (1968), *Funny Girl* (1968), and *Hello, Dolly!* (1969).

It's a Mad, Mad, Mad, Mad World (1963)

If you like your comedy on an epic scale, then this is the movie for you. Acclaimed dramatic director Stanley Kramer (*Inherit the Wind, Judgment at Nuremburg*) wanted to make the greatest comedy in the history of the world, and he might have done just that! The cast is enormous.

It's a Mad, Mad, Mad, Mad World stars some of the greatest film and television comedy stars of the era: Spencer Tracy, Milton Berle, Mickey Rooney, Sid Caeser, Phil Silvers, and Jonathan Winters. The movie also had a ton of cameos from such luminaries as Jack Benny, Jerry Lewis, Buster Keaton, and The Three Stooges. Kramer wanted it to feel big, so he shot the movie in the wide-screen process Vistavision to give it a grand feel in the movie theatres, and the film is nearly three hours long. Like I said, grand and epic!

The ensemble comedy follows the story of five strangers who come across a car accident in the middle of nowhere. The strangers find the almost dead ex-con "Smiler" Grogan (Jimmy Durante) who reveals with his last dying breath the location of a treasure chest of money buried near the Mexican border. The chase is on, as all five of them set their sights on finding the money, all the time being chased by Police Captain T. G. Culpeper (Spencer Tracy) who had been on Grogan's trail before the accident.

There's hijinks aplenty, and frankly I don't have enough ink left in my printer to tell you about the outlandish ridiculousness that everyone is put through on their way to find the cash. And no, I'm not going to tell you who gets there first. That's on you to watch. I think it's on Amazon Prime.

It's a Mad, Mad, Mad, Mad World was a major box-office hit, and was the third highest-grossing film of the year. It was nominated for six Oscars, including Editing, Cinematography, Sound, Music, and Original Song. It did win the Oscar for Best Sound Editing. It was nominated for a Best Picture Golden Globe and comedian Jonathan Winters was nominated for the Best Actor Musical or Comedy Golden Globe as well. It's the #40 film on the AFI Great Comedy List.

Cat Ballou (1965)

In this Western comedy, Catherine "Cat" Ballou (Jane Fonda) is a schoolmarm. (Why don't we call women teachers "schoolmarms" anymore?) [Editor's Note: Because it's sexist and insulting to the female gender. That's why.] When she returns home, she discovers that a land baron is trying to take her father's ranch, so she hires renowned gunfighter Kid Shelleen (Lee Marvin) to save the ranch. (Why don't we call real estate developers "land barons" anymore?) [Editor's Note: Now that's a good question. We'll work on that one.]

Unfortunately, Kid Shelleen is a drunk. When Cat's dad is murdered, she decides to go on a criminal rampage to destroy the company that killed her dad. Kid Shelleen has fallen in love with her, and resolves to clean up his act.

Will Cat get her revenge? Will Kid Shelleen sober up? What will happen to all that land? And will the long arm of the law come down on Cat with the death penalty and a hangman's noose?

Cat Ballou was a big moneymaker for the studio, but the critics were not fans. The film was nominated for five Oscars, including Best Editing, Best Music, Best Song, and Best Adapted Screenplay. For Lee Marvin's dual role, he won the Best Actor Oscar, the British Academy Award for Best Actor, and the Golden Globe for Best Actor. The film is the #50 movie on the AFI 100 Years . . . 100 Laughs listing, and it's the #10 film in the AFI Top Ten Westerns list.

Our last film is a big one (well it's two movies the original and the sequel—but it's one big comedy smorgasbord), which epitomizes the most ridiculous film series in the history of the cinema, anchored by brilliant actor Peter Sellers and written and directed by Blake Edwards (*Breakfast at Tiffany's*). I'm talking about *The Pink Panther* film series. Sellers goes from one of the most important films in comedy cinema, *Dr. Strangelove: or How I Learned to Stop Worrying and Love the Bomb*, to this . . .

The Pink Panther (1963)

This heist comedy directed by Blake Edwards follows the story of Sir Charles Lytton (David Niven), aristocrat by day and an international jewel thief known as "The Phantom" at night. He has sights set on the largest diamond in the world, the "Pink Panther" known for its pinkish hue and a flaw in the center that looks like a leaping panther.

Peter Sellers stole the show as Inspector Jacques Clouseau in the first *Pink Panther* film

His pursuit of the diamond takes him to France where he is ducking the investigation by the relentless and idiotic French police Inspector Jacques Clouseau (Peter Sellers). His wife just happens to be sleeping with Sir Charles. Soon everyone is trying to steal the diamond, including Sir Charles's conniving nephew, George (Robert Wagner). Somebody's going to end up with that diamond!

The theme song from Henry Mancini is a classic. The animated *Pink Panther* in the opening and closing credits became a Saturday morning cartoon for kids. The film was a big hit with audiences, and was named to the National Film Registry by the Library of Congress in 2010. Peter Seller's portrayal of bumbling Inspector Clouseau was the highlight of the film. As a supporting character, he literally "stole" the movie from David Niven. (Get it? Stole?) [Editor's Note: Yeah, we got it.]

A Shot in the Dark (1964)

So *The Pink Panther* wasn't about Inspector Clouseau, but Peter Sellers portrayal was the best thing about the movie. Originally a hit Broadway play, the producer of the film wanted Blake Edwards to direct the film, and the only way that Edwards would do it is if they would change the lead character in the film to Clouseau.

A Shot in the Dark follows the murder of millionaire Benjamin Ballon's (George Sanders) chauffer at the hands of Maria (the super-hot Elke Summer). Bumbling Inspector Clouseau (Peter Sellers) investigates the crime but Clouseau's boss, Commissioner Dreyfus (Herbert Lom), kicks Clouseau off the case.

Dejected because he has fallen for Maria, Clouseau goes home where he is hilariously attacked by a ninja, and trusted valet, Kato (Burt Kwouk). Quickly, we learn that Kato is under orders to try to kill Clouseau by the detective himself to keep the Clouseau's skills sharp.

Dreyfus brings Clouseau back on the case when a gardener is murdered, and then a maid, and then a butler. Of course, Maria is suspected and arrested for each of them in succession.

Will Clouseau discover the true murderer? Will Clouseau and Maria get together? Will Clouseau survive Kato's relentless attacks? Will Commissioner Dreyfus survive his nervous attacks dealing with Clouseau's incompetence?

Not only was the film a hit with critics and audiences, but it is the #48 movie on the AFI Great Comedy Films list, opening the door for three more Sellers films. In fact, including the first two, there are a total of nine films made between 1962 through 1993. Alan Arkin played the title character in 1968's Inspector Clouseau and 1982's *Revenge of the Pink Panther*, which was lamely cobbled together from outtakes from the previous Sellers films since Peter Sellers had died two years before. Talk about a cash grab!

With Sellers long gone, Blake Edwards tried one more, 1993's *The Son of the Pink Panther*, starring Italian comedian Roberto Benigni (*Life is Beautiful*) as Clouseau's illegitimate son. Lest I forget, there was a quasi-remake and a sequel in which comedian Steve Martin took over the Inspector Clouseau role. It made a ton of money. So in 2009, Martin would also make a sequel. Now that was a flop, hopefully assuring that a new Pink Panther never sees the light of day. Then again, in Hollywood there's always chance for a reboot.

So, like I said, the sixties were full of mirth, music, and silliness. But the studio film outlook would change because of two films: Mike Nichols's classic anti-establishment movie *The Graduate* [Editor's Note: Chapter 25.]; and Dennis Hopper's vibrant low-budget cinematic counterculture touchstone *Easy Rider*.

The incredible success of those two films would jump-start a series of lower-budget character-based comedies take center stage in the late 1960s and 1970s when a new mentality would take over Hollywood. Love and peace and lots of money . . .

CHAPTER 22

FOCUS ON SUBGENRE

Dark/Black Comedy

Frances McDormand won an Oscar for her role as Marge Gunderson in the black comedy
Fargo (1996)

Gramercy Pictures/Photofest

> **CHAPTER FOCUS**
> ► What Is Black Comedy and Dark Comedy?
> ► What Is Comic Distance?
> ► The History of Dark and Black Comedy

Chapter Focus

Death.
It's inevitable.
It can happen at any time.

It even can happen while you're reading this book. [Editor's Note: Please put down this book and call 9-1-1 in the event of an emergency.]

Even though I've gone on the record to state that I'm firmly against the entire thing and don't plan on participating, you can't deny the fact that death is funny.

Murder can be funny. Kidnapping can be funny. Being hit by a bus is ALWAYS funny.

Let's face it (or as I choose to by living in a blissful state of denial) that death shouldn't be that funny. But it is!

What Is Black Comedy and Dark Comedy?

So let's bust out a little explanation of black humor from our good friends at dictionary.com.

> **NOUN**—a form of humor that regards human suffering as absurd rather than pitiable, or that considers human existence as ironic and pointless but somehow comic.

What about black comedy, Mr. Dictionary.com?

> **NOUN**—a comedy that employs morbid, gloomy, grotesque or calamitous situations in its plot.

So we employ black humor to deliver a black or dark comedy. Some stuffy academics believe that they are the same thing. Indeed my friend, they are not.

There's a difference between black comedy and dark comedy—let's go ahead and do a little copy-and-paste from Dictionary.com—hey, there's two definitions!

1. noun—a play, movie, etc., having elements of comedy and tragedy, often involving gloomy or morbid satire.
2. noun—a comedy based on problems of a personal or social nature.

It's a fifty shades of gray thing, without the shitty acting or script. Here's a color wheel.

Notice that black is the complete absence of color. But dark is relative—it's not quite entirely black. Here's a better way to think about it:

Dark Comedy is when you stuff ten cats into a box. *Black Comedy* is when you stuff a cat into ten boxes.

Color Wheel

esbeauda/Shutterstock.com.

Images ©: Andreser (man), Sergio Stakhnyk (cat), Valeri Potapova (cat), Konstantin Aksenov (cat), Valerio Pardi (cat), kmsh (cat), Tiplyashina Evgeniya (cat), S. Castelli (cat)/Shutterstock.com Concept image designed by Nick Nobs.

Images ©: Koya979 (axe), Andreser (man), Yeko Photo Studio (boxes), MaxyM (cat)/Shutterstock.com
Concept image designed by Nick Nobs.

´(I might get a few strongly worded e-mails about that one, probably with a lot of words in ALL CAPS. Like JERKWAD and ASSHOLE.) [Editor's Note: We're passing them on to you directly. You deal with it, jerkwad.]

Why does black humor work? Shouldn't we all be disgusted and repelled? Or cry like little babies like when I saw that Nicholas Sparks movie—you know the one—when that young person tragically passed away from that terminal disease just as they found love?

It's because of this storytelling technique called comic distance.

What Is Comic Distance?

It's a perspective that helps audience members find things funny. An audience has the ability to separate itself or to feel an emotional tie to an event in order to laugh at it.

There are two ways to look at comic distance:

Maintaining Comic Distance is how filmmakers allow the audience to laugh at pain. Here is an example from Charlie Chaplin's 1925 film, *The Gold Rush*.

The Little Tramp is put through a series of horrible experiences, that if they were to occur in real life, would be traumatic: attacked by a bear, starving to death, chased around by a crazy person with a loaded gun, and being stuck in a cabin that nearly falls off a cliff with our hero inside.

First off, I don't find bear mauling very funny, or being chased around by a crazy person with a gun. But, because of the comedic perspective that Chaplin provides to the audience, we laugh. So that's maintaining distance. We are able to distance ourselves from the horrible situation because of the nature of the comedy context.

Breaking Distance is the opposite of *Maintaining* Distance. Where filmmakers allow the audience to identify and FEEL THE PAIN. It's when the audience sees something that they immediately know how much it hurts, because they have gone through it themselves. Generally any physical or emotional pain, the audience

A great example of "Breaking Comic Distance" is Ted (Ben Stiller) catching his junk in his tuxedo zipper on prom night in 1999's *There's Something About Mary*. Ouch—that's gotta hurt!

20th Century Fox/Photofest

will go, "yeah that's awful" and since they pretty much know what it's like, they wince along with the characters.

For women, it's usually getting dumped. So pretty much every romantic comedy contains a scene where a woman is in a relationship and the guy (or girl for that matter, hey I'm open-minded) stops seeing them and usually gets dumped in some sort of insensitive way. Freaking devastating.

Actually guys, if you've seen the movie *Swingers* (1996) starring Jon Favreau and Vince Vaughn, you'll recognize the scene where Favreau's character meets a girl in a bar, and then wants to see her again. He ends up leaving a series of voice mail messages that ends with him completely humiliating himself. It's on YouTube. Look up *Swingers*—Mikey phone call. [Editor's Note: Please be very careful when you type the word "swingers" into the YouTube search engine. You may find something completely inappropriate that may cause you mental anguish, which our company is completely free of liability due to this warning.]

So everyone can feel the pain of a breakup. It's not just the women readers.

Here's a great example that EVERY GUY READING THIS can relate to—the groin kick.

That's right, boys. When anyone in any movie ever kicks someone in the junk, every man in the audience tightens his legs and gets a sick feeling in the stomach. I've been kicked in the junk so many times I don't feel it anymore.

(I don't know if it's as painful for a woman to get kicked in the junk than it is for a guy to get kicked there.) [Editor's Note: It is.]

Here's a list of films (some of these are not comedies, but it was fun to put together this list anyway) that feature the crotches of men everywhere curling inside their bodies like small fetal pigs. Wait a minute, did I just type small? I meant big. Huge even.

- ▶ *Dumb and Dumber*
- ▶ *Casino Royale*
- ▶ *Hot Shots! Part Deux*
- ▶ *Jackass: The Movie*
- ▶ *What Happens in Vegas*
- ▶ *Butch Cassidy and the Sundance Kid*

And there are so many more!

But the greatest crotch shot, or should I say montage of crotch shots, in film goes to the Mike Judge satire, *Idiocracy* (2006), where everyone in the future is a moron. How do we know that? One of the top-rated TV shows is called *"Ow, My Balls!"*

Two people having a breakup scene where everyone acts in a professional manner, or getting hit in the head maintains distance, but getting caught having an affair or getting dumped by text, or a swift kick in the balls are examples of breaking distance.

So the filmmakers need to maintain distance for us to laugh at a death. There will definitely be a quiz about this later. So put that in the memory cache in your brain.

The History of Dark and Black Comedy

Dark and Black Comedy has been around forever—okay, not forever when you consider the Big Bang/first book of Genesis—but since mankind decided to sit down and write stories and get them published by greedy editors willing to do anything to make a buck. [Editor's Note: Now you're pushing it.]

William Shakespeare was a pretty good writer and used black humor in a number of his plays. Like Hamlet? I'm not talking about the ending when everybody dies. I'm talking about the grave digging Clowns in Act V.

> FIRST CLOWN: What is he that builds stronger than either—the mason, the shipwright, or the carpenter?
> SECOND CLOWN: The gallows-maker; for that frame outlives a thousand tenants.

Shakespeare—funny guy!

Fast-forward to 1935, when French author Andre Breton coined the phrase "black humor" in his book *Anthology of Black Humor* as a combination of comedy and satire with an emphasis on death. He credits Irish satirist Jonathan Swift (*Gulliver's Travels*) and his work, particularly *A Modest Proposal*. In that hilarious tract, Swift encourages the poor of Ireland to alleviate their poverty by selling their children to wealthy aristocrats for food. Now that's black comedy!

Black comedy really caught on in the mid-twentieth century as a reaction to such devastating events as World War I, The Great Depression, and World War II. Noted authors such as Roald Dahl (*Charlie and The Chocolate Factory*), Kurt Vonnegut (*Slaughterhouse-Five*), and Joseph Heller (*Catch-22*) were instrumental in bringing black comedy into popular literary culture.

Hands-down, there is one film that most snooty academics and film critics agree is the greatest black comedy in the history of motion pictures:

Celebrated director Stanley Kubrick (who made such legendary films as *2001: A Space Odyssey, Lolita, A Clockwork Orange,* and *The Shining*) made his mark on cinema history with the release of 1964's *Dr. Strangelove (or How I Learned to Stop Worrying and Love the Bomb)* was the first film to use the threat of nuclear war for comedic purposes. In fact, as far as I can tell—it's the *only* comedy about nuclear warfare. Check out my Super Great Movie Spotlight in Chapter 23 to read all about one of the best comedies in history.

Dr. Strangelove is actually two types of subgenres. It's a black comedy but it's also a satire. Before the film, dark and black comedy weren't films that the studios were offering to the audiences. But comedy film is a reflection of the culture of the time, and both the Cold War and the death of John F. Kennedy had put the country into a very dark period. The success of Kubrick's film led to more filmmakers exploring darker themes and opened the door for dark and black comedies that continue to this day.

There have been plenty of great black and dark comedy films since *Dr. Strangelove.* I'm going to write a quick description for each film, and consider how all of these films could easily be dramas. Just keep thinking to yourself "Maintaining Distance."

To differentiate the two (since we know they are not the same thing), here's my official Top 5 list for both categories:

The Official Top 5 List of Great Dark Comedies

9 to 5 (1980)

Three secretaries (Jane Fonda, Lily Tomlin, Dolly Parton) kidnap their sexist egotistical boss (Dabney Coleman) in order to keep them from being jailed.

The War of the Roses (1989)

Danny DeVito directs this tale of a once-happy couple (Michael Douglas and Kathleen Turner) and their bitter divorce as they battle for custody of their joint property and are willing to do whatever it takes to destroy each other.

The Wolf of Wall Street (2014)

A greedy Wall Street businessman (Leonardo DiCaprio) lives the high life of wealth, sex, and drugs as he bilks people out of their retirement funds and ruins their lives for the sake of a buck.

Lolita (1962)

Stanley Kubrick directs this twisted tale of a mild-mannered University professor and his obsession with the teenage daughter of his landlord that goes beyond mere fascination.

Fight Club (1999)

An insomniac meets an anarchist who organizes underground brawls to alleviate boredom, which turns into something more sinister than anyone imagined.

Hilarious stuff! I'm not surprised to see director Martin Scorsese on this list. Some of the best scenes in many of his dramatic films are hilarious: "Are you talking to me?" from *Taxi Driver* (1976) and "What am I a clown?" and the body in the trunk scene from *Goodfellas* (1990), and he seems to have a wicked sense of humor.

The Official Top 5 List of Great Black Comedies

Harold and Maude (1971)

Teenage Harold (Bud Cort) desperately wants to commit suicide so he can rekindle a relationship with his mother.

Heathers (1988)

A high school student (Winona Ryder) hates the popular girl clique and meets a bad boy (Christian Slater) who helps her (accidentally) kill the leader, and then subsequently murders more students and eventually wants to blow up the school.

Beetlejuice (1988)

Tim Burton directs this wild movie about a recently deceased couple (Alec Baldwin and Geena Davis) that haunts their old house. Their lives—uh, I mean their spirits—are upended when a new family moves in. When they can't scare them out themselves, they call upon outrageous "bio-exorcist" Beetlejuice (Michael Keaton) to do the job. This film is the #88 movie on the AFI Great Comedy List.

Fargo (1996)

Joel and Ethan Coen present a "true story" about Jerry Lundegard (William H. Macy), a used-car salesman who hires two incompetent killers to kidnap his wife for the ransom money, and when people start dying, it's up to Chief Marge Gunderson (Frances McDormand in her Oscar-winning role) to figure out what happened. Fargo has one of the bloodiest wood chipper scenes in modern film history, and the way that the Coen Brothers tell the story—it is a side-splitter that is so wrong to laugh at on so many emotional levels.

*M*A*S*H* (1970)

Doctors in the Korean War deal with the insanity of conflict, the hypocrisy of the military machine, and the death of dozens of American soldiers on a daily basis. Check out the Super Great Movie Spotlight in Chapter 30.

A few Dark and Black Comedy Film Honorable Mentions: *An American Werewolf in London* (1981), *Throw Momma from the Train* (1987), *Weekend at Bernie's* (1989), *Death Becomes Her* (1992), *Swimming with Sharks* (1994), *To Die For* (1995), *The Whole Nine Yards* (2000), *Horrible Bosses* (2011), and *Deadpool* (2015).

Dark and Black Comedies are not hugely popular with audiences, because they are so darn depressing. But artistically they have a lot to offer as commentaries on the human condition, the depths that man is willing to sink for greed and avarice, and the inevitability of our fragile lives.

CHAPTER 23

SUPER GREAT MOVIE SPOTLIGHT

Dr. Strangelove or How I Learned to Stop Worrying and Love the Bomb (1964)

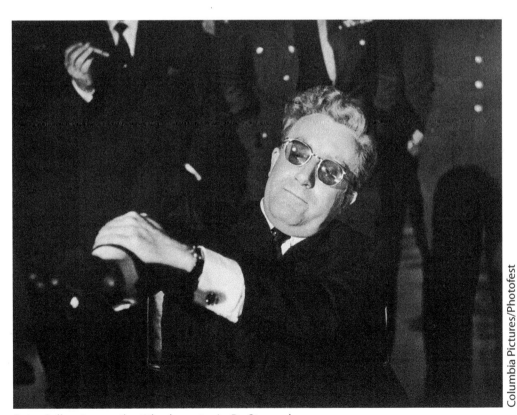

Peter Seller stars as the title character in *Dr. Strangelove*

- ▶ Starring Peter Sellers, George C. Scott, and Sterling Hayden
- ▶ Directed by Stanley Kubrick
- ▶ Written by Stanley Kubrick and Terry Southern
- ▶ Subgenres: Black Comedy, Satire
- ▶ Comedy types: Black Comedy, Verbal, Slapstick

"Gentlemen. You can't fight in here! This is the War Room!"

—President Merkin Muffley (Peter Sellers)

Welcome to the Cold War! With the end of World War II, Russia created the Union of Soviet Socialists Republic and took over Eastern Europe, turning all of these great countries such as Poland and Yugoslavia into Communists.

If there's anything that Americans hate more than Communism, I can't figure it out. It goes against everything that the USA stands for—making money. Also Russians are notoriously unhappy people, so they're not reading this book anyway.

In 1962, there was this little thing called the "Cuban Missile Crisis." Maybe you've heard of it? Russia decided to stage a bunch of nuclear weapons in Cuba, a small island country off the coast of Florida, less than a hundred miles from the United States. Needless to say that was a pretty harrowing concept, and thanks to President John F. Kennedy, that didn't happen. But Cuba has been on the American shit list since then.

So with the country still mentally recovering from what was sure to be certain annihilation, the timing was perfect for a comedy about nuclear war!

Summary

One bright and cheery morning, Air Force Brigadier General Jack D. Ripper (Sterling Hayden) wakes up and orders an attack on the U.S.S.R. to stop what he believes is the greatest threat that America has ever faced from the Communists, fluoridation in the U.S. water supply. He sends off a B-52 bomber wing led by overly enthusiastic Major T. J. "King" Kong (a tremendous Slim Pickens) to drop the hydrogen bomb on Russia and he's the only one that can recall the planes.

Luckily, stationed on the now-locked down base is Royal Air Force Captain Lionel Mandrake (Peter Sellers) who finds out from General Buck Turgidson (George C. Scott) and President Merkin Muffley (Peter Sellers too) that General Ripper is acting on his own and is the only one who can recall the bombers. Mandrake has to confront Ripper and convince him to stop his plan or the Russians have a "doomsday device" that will automatically launch an all-out response upon America if they are attacked. It's the end of the world as they know it, and General Ripper is fine with that.

As Mandrake attempts to reason with General Ripper, the President brings in his trusted advisor, wheelchaired former Nazi Dr. Strangelove (Peter Sellers in yet another role) who explains how the Russians have embraced the idea of "Mutually Assured Destruction," that will ensure a radioactive cloud covering the Earth for ninety-six years. A call to the Soviet Premier about the incoming bombers gives the brass a chance that the crisis will be averted.

Things get worse when Ripper kills himself instead of revealing the bomber recall code. Mandrake figures it out and calls the Pentagon on a payphone, and they are able to recall all of the bombers. Except for one. "King" Kong's lead B-52 and its damaged communication system.

Can the Russians shoot down the bomber before it's too late? What's all this about Dr. Strangelove's plan to re-populate the Earth in case everything goes nuclear? Time to go watch a movie!

Best Scenes

Fluoridation—As gunfire and explosions echo in the background, Captain Mandrake pleads with General Ripper to recall the bombers, and Ripper reveals his understanding of how the Communists have introduced the most monstrous plot to ever attack America, putting fluoridation into our water supply that will destroy "all of our precious bodily fluids."

The Phone Call to Dimitri—President Merkin Muffley calls the Soviet Premier Dimitri Kissoff, who seems to be a little drunk, to warn him about the B-52 bombers heading for Russia. It's a classic deadpan moment where we only hear half of their conversation: "Now then, Dimitri. You know how we've always talked about the possibility of something going wrong with the Bomb. The Bomb, Dimitri. The *Hydrogen* Bomb . . . "

The Back-Up Plan—Dr. Strangelove proposes that the major players of the government and military go deep into mines to survive the Cobalt blast, and the ratio of ten females for each male to perpetuate the species. "The women will have to be selected for their sexual characteristics which will have to be of a highly—stimulating nature." All the time fighting with his automatic reflex to make the Nazi salute. Priceless.

Slim Pickens—Every single scene he is in. Especially the last one—and that great closing song "We Will Meet Again" sung by Vera Lynn.

Awards and Recognition

Dr. Strangelove or How I Learned to Stop Worrying and Love the Bomb was nominated for four Academy Awards, including Best Picture, Best Actor (Peter Sellers), Best Director (Stanley Kubrick), and Best Adapted Screenplay (Stanley Kubrick and Terry Southern), but did not win any of them. It did win four British Academy Awards, Best British Film, Best Art Direction, Best Film from Any Source, and the UN Award for the "Best Film embodying one or more of the principles of the United Nations Charter."

The budget of the film was $1.8 million, and $1 million of that went to Peter Sellers. Stanley Kubrick joked that he got a good deal on it because Sellers played three characters instead of just one. Sellers was the first (and only) actor to be nominated for an Oscar for playing three different roles. The film reportedly made over $9 million, making it a box office hit.

The AFI loves this movie. Besides it's #3 ranking for the 100 Years . . . 100 Laughs List, they also have it as the #26 on the Great Movies list and the quote of "Gentlemen, you can't fight in here! This is the War Room!" is the #64 Movie Quote of All Time.

The Library of Congress placed the film in the National Film Registry during its inaugural selection in 1989.

CHAPTER 24

Welcome to the "New Hollywood"— Comedy Edition

OR:

How Dennis Hopper, Late Night TV, Good Drugs, and Smart Chicks Made Funny Movies

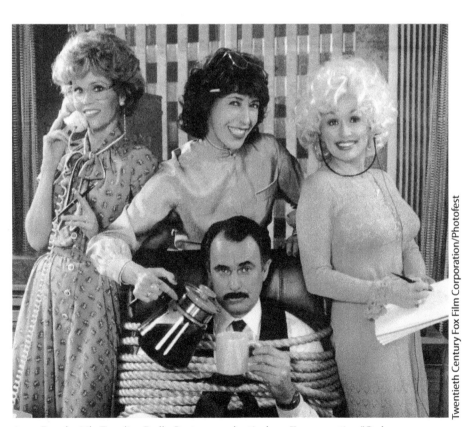

Jane Fonda, Lily Tomlin, Dolly Parton, and a tied-up "in a meeting" Dabney Coleman in the women's lib hit, *9 to 5* (1980)

Twentieth Century Fox Film Corporation/Photofest

> **CHAPTER FOCUS**
> ► Where Did This "New Hollywood" Come From?
> ► Live from New York, It's a Comedy Revolution
> ► Can I Get a Hit off That, Bud?
> ► When Did Women Get to Be So Funny?
> ► Some Other Comedy Films in This Era

Chapter Focus

As the decade continued, the America of the 1950s was long gone. In 1963, President John F. Kennedy had been assassinated, the civil rights movement became a national issue that would continue through Martin Luther King's murder, the Vietnam conflict started, and the counterculture movement was starting. A movement where people didn't accept things as easily as they did from the government in the 1950s.

And there was a new breed of filmmakers about to storm the castle.

Two things helped force Hollywood to throw out the old business model and embrace a new, more vibrant motion picture industry.

Where Did This "New Hollywood" Come From?

Easy Rider (1969) is the first mainstream successful movie made by hippies. This film is about the adventures of two freewheeling motorcycle riders: Wyatt (Peter Fonda) and Billy (Dennis Hopper) as they travel the country looking for—well, they don't really know. One of the points of the film is America has become disillusioned with itself and no one knows what is going to happen next. An anti-government, cocaine, and LSD fueled road trip where these guys buy drugs, take drugs, sell drugs, and have a lot of sex in New Orleans. The movie also has a rock and roll soundtrack of songs that were commercial films, licensed for the movie, as opposed to songs that were made specifically for the film.

Hollywood shuddered at the content, but they couldn't complain about the profits. The budget for *Easy Rider* was $300,000 and the film made $60 MILLION. So it was massive.

The other film that rocked Hollywood was the anti-establishment satire *The Graduate* in 1967. This film rang the bell in the studio executives' heads that the youth of America actually were going to the movies, in-between their peaceful protests, psychedelic drug experimentation, and listening to that loud rock and roll music. The tale of Benjamin Braddock (Dustin Hoffman) navigating his way through post-college life in a sea of disillusionment— and having sex with Mrs. Robinson (Anne Bancroft). On a $3 million budget, the movie grossed an astounding $104 million. That's a lot of plastics and scuba gear. [Editor's Note: See Chapter 25.]

Suddenly, Hollywood studios were looking for new talent and distinct voices to speak directly to the young audiences tired of such stale studio fare as Blake Edwards's musical *Darling Lili* (1970), which cost Paramount Pictures $17 million and grossed $8 million. Rex Harrison's musical *Dr. Dolittle* (1967) that "did little" at the box office [Editor's Note: Did he really just do that? God help us, he did.] and was the proverbial nail in the coffin of the big budget musicals. It cost 20th Century Fox $18 million and the film grossed $6 million. Both films crippled their studios. Where were the new comedies coming from? Glad you asked! Film School!

USC had a film program since 1929 but that was the exception. Colleges didn't have film schools, except in the place that they made movies.

Long before Luke Skywalker and Darth Vader, George Lucas was a serious filmmaker who graduated from USC in 1967. His debut writer/director feature, the sci-fi dystopian drama, *THX-1138*, was a box office failure, but his next film was—how shall I say it—not.

American Grafitti (1973)

Based on George Lucas's teenage years growing up in Modesto, California, this coming-of-age ensemble follows three different stories on a summer night in 1962. It is Curt (Richard Dreyfuss) and Steve's (Ron Howard) last night before leaving for college. Toad (Charles Martin Smith), a local nerd (who I suspect is probably the George Lucas character), gets to borrow a hot rod from John Milner (Paul LeMat) to go

Mel's Diner

Source: LaMont

cruising and ends up picking up Debbie (Candy Clark), an even hotter chick that is way out of his league. Curt finds himself chasing around a mysterious blonde (Suzanne Somers) who whispered "I love you" at a traffic light.

Will Steve and Laurie stay together? Will Curt find that blonde in the T-Bird? Will Toad get laid? Who exactly is going to college in the morning? And is that really Harrison Ford playing a hot rod driver who races John? (Yes it is!)

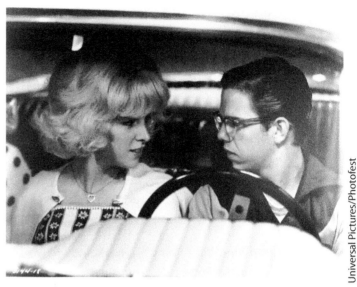

Charles Martin Smith and Candy Clark are part of the ensemble cast of the hit film *American Graffiti* (1973)

With a killer soundtrack spun by real-life DJ Wolfman Jack, that evoked the innocent days of yesteryear before the death of JFK, *American Graffiti* was a gigantic success.

That's an understatement; *American Graffiti* was bigger than *Easy Rider*, making over $100 MILLION. That's a lot of X-Wings. It was nominated for five Oscars: Best Picture, Best Director, Best Original Screenplay (Lucas, Willard Huyck, and Gloria Katz), Best Supporting Actress (Candy Clark), and Best Editing. The movie garnered Golden Globe nominations for George Lucas as Best Director and Richard Dreyfuss for Best Actor and did win the Golden Globe for Best Picture (Musical or Comedy) and Paul LeMat for Most Promising Newcomer.

As far as I can tell, it was the first movie to employ the "Where Are They Now?" technique at the end of the movie. Another thing, if *American Graffiti* had been a dud, there would have been no *Star Wars*. And that would have been crippling to the action figure toy industry. The AFI named *American Grafitti* the #77 film All-Time on the Great Movies List and it's the #43 film on the AFI Great Comedies List. Next time you're in Los Angeles, swing by Mel's Drive-In and grab yourself a tasty chocolate shake.

Another filmmaker that made his mark in the "New Hollywood" was writer/director Peter Bogdanovich, who set the landscape of the New Hollywood on fire with his 1971 film coming-of-age drama, *The Last Picture Show*. The film's success helped to solidify the anti-studio, director-driven films that were abundant from 1968 through 1981. To homage the films he loved growing up and studied as a film student, he made his *own* screwball comedy.

What's Up, Doc? (1972)

Bogdanovich was a huge fan of Howard Hawks and *Bringing Up Baby*, and when given an opportunity to make his first studio movie, he chose this homage to the screwball film.

The tale follows the adventures of four owners of four identical suitcases when they check in to the Hotel Bristol in San Francisco. The four bags are owned by: musicologist Dr. Howard Bannister (Ryan O'Neal), with his suitcase full of rocks that play music; Judy Maxwell (Barbara Streisand), one of those bad luck girls where calamity always seems to occur and her suitcase of clothes and her dictionary; Mrs. Van Hoskins (Mabel Albertson) a wealthy woman with her bag full of jewels; and Mr. Smith (Michael Murphy) a shadowy figure with a suitcase full of secret documents.

Further complicating things are Howard's dealing with his annoying fiancée Eunice (Madeline Kahn in her film debut). He is competing against Yugoslavian academic Hugh Simon (Kenneth Mars) hoping to get a big research grant from huge donor Frederick Larrabee (Austin Pendleton). A mysterious Mr. Jones (Philip Roth) has shown up to try and steal the secret documents back from Mr. Smith.

Wouldn't you know it? The bags are identical, everyone starts switching them around, causing untold tomfoolery. In the end, everything might just work out! You'll have to watch it for yourself. And yes, I am infuriating! This book is a no spoiler zone!

What's Up, Doc? was an amazing hit, the third highest film of 1972 which grossed over $60 million at the box office. It's the #61 film on the AFI's Great Comedy Films list.

Live from New York, It's a Comedy Revolution

If there is one thing that would single-handedly change the world of film comedy, it was this little sketch comedy show stuck in the worst timeslot on the network TV schedule. Who's watching TV on Saturday night? Everyone is partying out at the disco and snorting cocaine, going to "key parties" and "wife swapping." In short, it's my dream decade that I'm still pissed off that I missed.

Saturday Night Live (SNL) was the brainchild of Dick Ebersol, the NBC Vice President of Late Night Programming. He was forced to find something to fill the Saturday 11:30 p.m.–1:00 a.m. slot when Johnny Carson asked the network to pull his reruns of *The Best of Carson*. He contacted Lorne Michaels, a writer from television's *Laugh-In* and a producer for Lily Tomlin's TV specials to put something together.

It's a variety show in the tradition of *Sid Caesar's Your Show of Shows* with comedy sketches and musical acts. It was only supposed to last six episodes, but incredibly NBC's weekly late-night experiment is over forty years old. I would be shocked if someone out there is reading this and hasn't seen at least *one* episode.

There have been over 130 cast members over the forty-year history of the program, and the show has been a launching pad for new comedy performers to make the leap from television to motion pictures.

Cast members are typically members of improvisational comedy troupes from America and Canada. A number of cast members have come from The Second City, a troupe started in Chicago in the 1950s with Mike Nichols and Elaine May. The Second City has had their own theatre since 1959 and now has locations in Toronto, Canada, and Los Angeles and run classes and workshops to train new comedians.

Saturday Night Live cast members that are Second City alumni and have gone on to successful film careers include Dan Aykroyd, John Belushi, Bill Murray, Gilda Radner, Mike Myers, Chris Farley, Martin Short, and Tina Fey.

The Los-Angeles-based improvisation troupe The Groundlings came to life in 1974, and many notable *Saturday Night Live* members have come from this fertile ground of comedy, including Will Ferrell, Will Forte, and Kristen Wiig.

Cast members are also found from performers on the stand-up comedy circuit. These performers are prized due to their experience with writing their own established material.

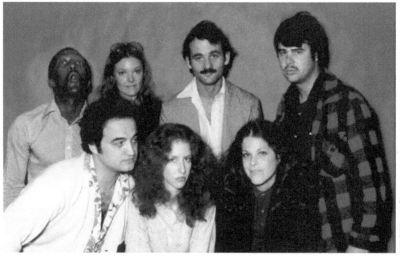

NBC/Photofest

Here are cast members from the 1977 edition of *Saturday Night Live:* clockwise—Garrett Morris, Jane Curtin, Bill Murray, Dan Aykroyd, Gilda Radner, Laraine Newman, and John Belushi

Notable stand-up comics who came up through the stand-up ranks include Billy Crystal, Eddie Murphy, Chris Rock, and David Spade.

There are two types of cast members on SNL: the Repertory Players, which are the featured cast members who appear on a weekly basis, and the Featured Players, that appear in a minimal amount of sketches on an as-needed basis as supporting cast and featured extras.

For the full season of 1975–1976, the first group of Repertory Players was christened the "Not-Ready-for-Prime-Time Players" and included performers Dan Aykroyd, John Belushi, Chevy Chase, Jane Curtin, Garrett Morris, Laraine Newman, and Gilda Radner.

More than any program in the history of television, *Saturday Night Live* has been nominated for over 200 Emmys. Equally impressive is the forty-five Emmy Awards it has won as of 2015, which is also a record for a continuously running television series.

In 1999, *The New York Times* said, "In defiance of both time and show business convention, 'SNL' is still the most pervasive influence on the art of comedy in contemporary culture." In both 1990 and 2009, the show won the Peabody Award, the nation's highest recognition for media and broadcast programming that affects and enriches culture and society, stating that *Saturday Night Live* was "truly a national institution." Not bad for a TV show that nobody thought would ever succeed.

The ultimate in anti-establishment programming, this television show will single-handedly change the world of comedy film and televison forever.

Can I Get a Hit off That, Bud?

There was a fad that popped up in the late 1960s and 1970s, this thing called "marijuana." Yes, it's been used for "medicinal purposes" since 2737 BC. Even then they got the munchies, but somehow they couldn't invent the fork?

With the widespread appeal of drugs as a major component of the countercultural movement that swept America, it was only a matter of time before the first dope comedy feature appeared. Thanks to stand-up comics Cheech Marin and Tommy Chong, also known as the stoner comedy duo "Cheech and Chong."

The two found success on the stand-up comedy circuit, which led to five best-selling Comedy Records and a chance to make their first feature film, 1978's *Up in Smoke*. Their brand of humor was so popular that the low budget comedy made $44 million. That's a lot of weed.

They also made four subsequent films, *Cheech & Chong's Next Movie* (1980) and *Nice Dreams* (1981), that were both pretty successful and then things tailed off. *Things are Tough All Over* (1982), *Still Smokin'* (1983), and *Cheech & Chong's The Corsican Brothers* all failed to catch on with audiences. After the success of their novelty song "Born in East L.A." which parodied Bruce Springsteen's "Born in the U.S.A.," Cheech went on his own and made a film based on the song in 1987. Tommy Chong was pissed off at him for doing it alone, and the duo broke up and went their separate ways.

When Did Women Get to Be So Funny?

One of the major touchstones of the 70s and 80s was the women's liberation movement, or as all you ladies out there called it "Women's Lib." If you look back at the history of comedy films, women's roles after the era of the screwball comedy were turned into sexual arm candy like Marilyn Monroe, or a doe-eyed ingénue like Audrey Hepburn. It was time for women to make some comedy on their own.

Just as Lenny Bruce and Woody Allen had come from the stand-up comedy circuit, there were female comedians that also made their way in the world from the circuit. It was just a lot harder for them to be successful in a male-dominated industry. Who am I kidding? It's still a male-dominated industry.

Writer/Director Elaine May struggled for work after leaving her act with Mike Nichols in the 1960s. When she finally got to write and direct films, she was pushed out of the industry after her first flop, *Mikey and Nickey*, came out in 1976. She didn't direct again until 1985's *Ishtar* with Warren Beatty and Dustin Hoffman (and that was one of the biggest movie fiascos of the 1980s).

Comediennes like Joan Rivers and Lily Tomlin worked onstage and moved into television. Both would write for television and eventually find themselves in front of the cameras. With film not being an option, television became the playground where female comediennes could ply their trade. Actresses like Lucille Ball, Mary Tyler Moore, Carol Burnett, and Phyllis Diller came into American living rooms every week, but were they willing to come out to see a movie that starred a woman?

Private Benjamin (1980)

The newest generation of the women's movement was front and center in this military comedy starring Goldie Hawn as Judy Benjamin. She was a widower that gets suckered into joining the U.S. Army by a zealous recruiter. Judy learns the ropes of basic training at the hands

of a merciless Captain Lewis (Eileen Brennan). When given the chance to quit, Judy decides to tough it out rather than go back home in defeat to her parents. But for all of its progressiveness toward women in combat (or lack thereof) puts Judy in the crossfire when she is selected for elite training because the commander wants to have sex with her and things get worse from there.

This movie was major and launched Goldie Hawn into the stratosphere of film comediennes. *Private Benjamin* was nominated for three Oscars, including Best Actress (Goldie Hawn), Best Supporting Actress (Eileen Brennan), and Best Original Screenplay and is the #82 film on the AFI Great Comedy Films list.

1980 was also the same year of another female-centric comedy. This next one was even bigger.

Private Benjamin (1980)

9 to 5 (1980)

In the immortal words of singer/star Dolly Parton, "9 to 5, What a Way to Make a Living." Women in the workplace have always had their share of challenges, but if you were working in an office in the late 1970s, it was a nightmare. No film in history pulled back the curtain on how hard it was to be a woman in a man's world like this movie.

Judy (Jane Fonda) is a new assistant at Consolidated Industries who meets her arrogant, sexist, and egomaniacal boss Franklin Hart (Dabney Coleman) on her first day of work. Taken aback by his boorish behavior, her supervisor Violet (Lily Tomlin) tells her how unfair it's been working for him and getting passed over for promotions simply because she's female.

Things are a lot worse for the beautiful Doralee (Dolly Parton in her debut role), Hart's secretary who has to put up with his lecherous sexual advances. She deals with the derision of the rest of the company because Hart lied and told all of his buddies that they were sleeping together.

The three women come together and party it up getting high and fantasizing about revenge against Hart if he pulls another horrible act. Imagine what happens when Violet thinks she accidentally poisoned Hart the next day? You don't have to because that's what happens next. In their slapstick haste to hide the body, they realize he's not dead. He wakes up and threatens them all with being fired, and they decide to kidnap him and hold him prisoner until

they can figure out a way out of the mess by finding evidence that would implicate Hart for embezzlement.

It's a race to see if Hart can escape before the women can implicate him, and in the meantime, the women take over Hart's department—and turn it into a productive workplace where everyone is treated equally and fairly.

Originally set to be a drama, Jane Fonda and her producing partner decided to bring in Lily Tomlin and make it a comedy. The film was a major hit for the studio, making over $100 million. The now classic theme song, "9 to 5," sung by actress Dolly Parton was a Platinum hit, went to #1 on the Billboard music charts, won two Grammy Awards, and was nominated for a Best Song Oscar. It launched Dolly's career into the stratosphere. The film is also the #74 film on the AFI Great Comedy Films list.

Some Other Comedy Films in This Era

The movies that made waves and sold tickets were the films that pushed social and cultural boundaries. Films that had unlikely heroes, sexual outrageousness, women's rights, all of them weren't on television—which made the movies relevant again.

Here's a few of the other films that made a big impact in the late 1970s and the early 1980s that are worth taking a look at when you have a spare couple of hours:

Harold and Maude (1971)

If there's one film that epitomizes the death of the traditional Hollywood romantic comedy and embracing the distinctive voice of a new generation, *Harold and Maude* is that film. It's a one-of-a-kind film that fits the category of "you-can't-remake-it-or-steal-the-idea-because-it-was-already done." And boy is it ever!

Meet Harold (Bud Cort), just like every geeky sixteen-year-old—he hates his mom and his life so much that he's obsessed with death. He likes to hang out at funerals, he likes to stage elaborate fake suicides to mess with his mom, and he drives a

Bud Cort and Ruth Gordon play the most unlikely couple in cinema history in Hal Ashby's black comedy *Harold and Maude* (1972)

hearse. Cue the definition of morbid. Everything changes when Harold meets Maude (Ruth Gordon) a feisty 79-year-old who helps Harold to appreciate life. So much so that Harold falls in love with her. His mom, the priest at church, and Harold's psychiatrist all freak out when they hear the news.

Bud Cort and Ruth Gordon have amazing chemistry together, and the ending is a thing of beauty. Bittersweet and a celebration of humanity that tells a story that many can embrace, no matter how off-putting and weird the story plays out.

This black comedy (and if you need to brush up on what a black comedy is, turn over to Chapter 22) has over the years become a cult classic and is certified fresh on Rotten Tomatoes. It's the #45 Film on the AFI Great Comedy Films list, and was selected to the National Film Registry in 1997.

The Bad News Bears (1975)

There have always been sports comedy films, such as Harold Lloyd's *The Freshman*, but this is a satirical tale of the underbelly of Little League baseball and a team of misfits that come together to contend for the league championship. They are led by their alcoholic coach Morris Buttermaker (played to perfection by Walter Matthau). This was one of the first slobs versus snobs movie and a trailblazer that opened the door for a slew of raw and vulgar 1970s popular sports comedies such as *Slap Shot* and *North Dallas Forty*. And yes, you hear the N-word in *The Bad News Bears*.

A lawsuit against the city requires that the underperforming kids be given a team to play on, and Coach Buttermaker recruits teenage *girl* pitcher Amanda Wurlitzer (Oscar winner Tatum O'Neal) and motorcycle-riding tough guy Kelly Leak (Jackie Earle Haley) to lend a hand to this group of obscenity-spewing geeks, spazzes, and nerds. This is also the film that launched the "underdog" cliché tradition in sports movies that still continues to this day. And, every teenage guy wanted to get with Tatum O'Neal.

The movie was a big hit with the critics and audiences, making over $40 million. You read that right $40 million with a budget of $9 million. It spawned two pretty lame sequels in 1977 and 1978. *Rolling Stone* magazine named it "The Greatest Baseball Movie Ever Made" on April 7, 2016.

The Rocky Horror Picture Show (1975)

This ridiculous musical comedy finds Brad and Janet (Barry Bostwick and Susan Sarandon) as their car breaks down in the middle of nowhere and they are forced to seek shelter in the castle of Dr. Frank N. Furter (a delicious Tim Curry). He is a demented transvestite who

brings a handsome sex boy, Rocky, to life in his laboratory. There's music, and sex, and gay sex, and more sex—along with a great soundtrack. But, upon its initial release, the film was a dud.

However, 20th Century Fox didn't give up on the movie. The film caught on as a cult classic with the gay community and was shown at midnight screenings in New York City. This trend soon spread to college campuses across the country. It was the ultimate audience experience, with the crowd shouting lines back to the screen and soon performance groups began aping the film live during the actual screenings.

My favorite bit was throwing Scott toilet paper in the theatre when Professor Scott is introduced. Don't waste your time watching it at home. You won't get it. You have to see it live and I'm sure it's playing at a midnight screening this weekend somewhere in your city! Look it up!

Now, for the exact polar opposite of Transvestites from Transylvania.

Oh, God! (1977)

Carl Reiner directs another winner with veteran comedy actor George Burns in the title role of God in this supernatural comedy. Mild-mannered grocery store manager Jerry Landers (country music singer John Denver) discovers that he's been chosen by Him to carry out a message of peace and love to the world. Jerry goes on TV to tell about the experience, and is met by angry religious believers that dispel Jerry's faith. He gets dragged into court and hopefully God will help him to prove that the man upstairs does exist.

The movie was a major winner and the critics loved it. The script was nominated for a Best Screenplay Oscar and it's a really fun movie that you should catch if you can.

10 (1979)

Written and directed by Blake Edwards (*The Pink Panther* series, *Breakfast at Tiffany's*), British actor Dudley Moore stars as George Webber, who undergoes his own seven-year itch when he spots beautiful Jenny (not just beautiful, she's a perfect 10 out of 10—hence the title) played by newcomer Bo Derek. George's girlfriend Samantha (Julie Andrews) is faced with losing her husband as he becomes more obsessed with Jenny. George gets everything he hopes for after saving Jenny's new husband from drowning, and together Jenny and George make sweet love to the strains of "Bolero." But, sometimes what you want isn't exactly what you need . . .

10 was a major blockbuster, making over $70 million, and was celebrated by film critics. One iconic scene is Jenny running in slow motion on the beach, her hair in cornrows. Cornrows

suddenly became a very popular look for American women and ranking someone on a scale of 1–10 is still popular today. (Since you're asking, I'm an 8.) [Editor's Note: More like a 6½.]

Arthur (1981)

If there's one thing you can always count on in the comedy department, drunk people are always funny. Nobody's funnier than British actor Dudley Moore, who was able to springboard his role in Blake Edward's *10* (see the two paragraph above) into the title role of a perpetually-wasted millionaire who doesn't want to grow up. He even has his valet bathe him. Trouble is that Arthur will be cut out of the family fortune if he doesn't marry his father's business partner's daughter Susan (Jill Eikenberry).

With Arthur ready to settle down and grow up at his father's behest, he meets Linda (Liza Minnelli) while shopping in Manhattan with his valet Hobson (Sir John Gielgud) when she is caught shoplifting. He gets her out of the predicament and is smitten with her.

With Hobson on Linda's side, he encourages Arthur to end his engagement with Susan. Will true love win out? Will Arthur ever grow up? At least sober up? Will Arthur lose all his money? Too many questions to answer. The movie will explain things a lot better than I can.

Arthur was a monster smash, making nearly $100 million. The film critics loved it, and the movie was nominated for four Oscars, including Best Actor (Dudley Moore), Best Original Screenplay, and the film won two: Best Supporting Actor (Sir John Gielgud) and Best Song for "Arthur's Theme" written by Burt Bacharach, Carole Bayer Sager, Christopher Cross, and Peter Allen. It also won the Golden Globe for Best Film–Musical or Comedy, Best Actor (Dudley Moore), Best Supporting Actor (Sir John Gielgud), and Best Original Song for "Arthur's Theme" as well. I swear I hear that song every time I open up my "70's Cheesy Love Songs Channel" on Pandora.

Diner (1982)

Barry Levinson was a television staff writer transitioned to screenwriting and worked with Mel Brooks on *Silent Movie* and *High Anxiety* (he's actually the hotel bellboy that tries to murder Thorndyke in the shower with a newspaper, ala *Psycho*). After his Oscar-nominated script for the Al Pacino film *And Justice for All*, he got to direct his first film.

Diner tells the story of a group of friends just out of high school in 1959 (Mickey Roarke, Daniel Stern, Steve Guttenberg, Tim Daly, Kevin Bacon, Paul Reiser). They come together at their favorite Baltimore diner to celebrate an upcoming wedding on New Year's Eve.

There isn't a straight narrative as each character faces their own future in different segments. Shrevie (Daniel Stern) is trapped in a terrible marriage with Elyse (Ellen Barkin); Eddie (Steve Guttenberg) is engaged, but is worried that his future wife isn't as much of a Baltimore Colts fan as he is. She has to pass a quiz or they don't tie the knot; and Boogie (Mickey Roarke) is a womanizer that has to lie about his career to score.

All of the guys are in different places in their lives, but face the fact that as you get older, you need to (reluctantly) make the choices that a responsible adult needs to make. It's a very character-driven film with a lot of talking and not a lot of action.

Diner wasn't a big movie. It made a modest return and did well in the reviews. It was a great launching pad for the lead actors who have all gone on to bright careers in film and television. Barry Levinson received an Oscar nomination for Best Original Screenplay and *Diner* is the #57 movie on the AFI Great Comedy Films list.

It was a great era of comedy celebrating so many cultural shifts and creativity from the minds of filmmakers who were coming into their own. Comedy was about to EXPLODE with the development of some pretty major technology that will dramatically change the entertainment industry, and how the audience watches movies.

EXPLOSION WIPE!

CHAPTER 25

FOCUS ON SUBGENRE

Parody, Spoof, and Satire

Scene from *Young Frankenstein* (1974)

Twentieth Century Fox/Photofest

> **CHAPTER FOCUS**
> ▶ What Is a Parody and What Is a Spoof?
> ▶ What Is Satire?

Chapter Focus

Parody films took off in the 1970s thanks to Mel Brooks. The success he had with movies like *Blazing Saddles, Young Frankenstein, High Anxiety, History of the World, Part I, Spaceballs, Robin Hood: Men in Tights,* and *Dracula: Dead and Loving It* (all detailed in Chapter 27) led to the popularity of this subgenre of film comedy.

From Merriam-Webster:

> **Parody, noun:** a piece of writing, music, etc., that imitates the style of someone or something else in an amusing way.

Parody coming from the Greek "parodia," which translates to paro is side-by-side and "odia" is song. Let's just say it's a comparison with flair

The real purpose of a parody is to make fun of an original or creator. Because a parody could be considered insulting, the parody songs of "Weird" Al Yankovic necessitates him to get permission from the original songwriters and performers before he parodies their songs. I read somewhere that one of the performers he wanted to parody was Prince, but he never got the permission. So we never got to hear that ode to high school bullying, "Nurple Pain." (rimshot!)

Successful parody is based on common knowledge of a specific category. If an artist parodies a work or body of work that is not widely known, then the humor doesn't work as effectively.

For example, Mel Brooks made *Spaceballs,* a parody of *Star Wars.* Since most everyone on the planet Earth knows *Star Wars,* then the specific jokes have a better impact with the audience because everyone is familiar with the context.

What Is a Parody and What Is a Spoof?

Now people sometimes mix up a parody and a spoof. Maybe you're one of those people! So let's clear the difference up so you never make that mistake again. A "spoof" is like a parody—except a lot broader comedy-wise. A movie like *Shaun of the Dead* (2004) isn't based on a specific film like *Night of the Living Dead* (1968), but an overall comedic riff on the entire genre of zombie films. So *Shaun of the Dead* is a spoof.

Parody is considered a higher art form than spoof, because the humor is so broad that it doesn't need to reference the source material specifically. Now there can be parodies of specific films *in a spoof*, but you can't spoof a subject *in a parody*.

The Official Top 5 List of Great Comedy PARODY Films THAT ARE NOT BY MEL BROOKS (1st Annual Edition)

Airplane! (1980)

What Mel Brooks started with *Young Frankenstein*, David and Jerry Zucker and Jim Abrahams took to a whole different level with this forever-quotable classic—starting a run of parody and spoof filmmaking that continues to this day. This movie gets its own Super Great Movie Spotlight in Chapter 35.

This Is Spinal Tap (1984)

A parody on two levels—a skewering of the heavy metal rock culture and the other is a picture-perfect parody of documentaries themselves, single-handedly creating the term "mockumentary." Check out the Super Great Movie Spotlight in Chapter 44.

Austin Powers: International Man of Mystery (1997)

Another case where the first film in a franchise is the benchmark, a parody of James Bond films combined with the fish-out-of-water tale of Mike Myers playing two roles. His Austin Powers is a cryogenically frozen British spy experiencing the dull 1990s but more hilariously plays his arch-nemesis, Dr. Evil, a balding madman in the spirit of the James Bond villain Blofeld, who demands the princely sum of "One Miiiillion Dollars" for ransoming the world, only to be told that one million dollars isn't much in the 1990s. It's got gross-out humor, a lot of sex jokes (including a hilarious bit with a penis enlarger), and never fails to hit on all levels.

Galaxy Quest (1999)

It's *Three Amigos!* meets *Star Trek* as the former stars of a long-canceled sci-fi TV show (Tim Allen, Sigourney Weaver, Alan Rickman, Tony Shalhoub, and the hilarious Sam Rockwell) who shill autographs on the convention circuit, are mistaken by aliens as an actual space crew, and are recruited to help save their planet from an evil invasion.

Scary Movie (2000)

The *Scary Movie* film franchise eventually dissolved into a series of spoofs, but this first movie stays true to its roots as it primarily sends up *I Know What You Did Last Summer* (1997) and *Scream* (1996) to hilarious results.

Honorable mentions for Great Comedy Parody Films that are not made my Mel Brooks include *Murder by Death* (1976), Keenan Ivory Wayans's *I'm Gonna Git You Sucka!* (1988), *Scrooged* (1988), *Hot Shots!* (1991), *Monty Python and the Holy Grail* (1975), *Walk Hard: The Dewey Cox Story* (2007), *CB4* (1993), and *The Best Movie Ever Made* (1994).

The Official Top 5 List of Great Comedy SPOOF Films THAT ARE ALSO NOT BY MEL BROOKS

Top Secret! (1984)

From the minds of *Airplane!* filmmakers, Jerry and David Zucker and Jim Abrahams, Val Kilmer stars as rock and roll star Nick Rivers in this spoof on musical Elvis Presley movies and Cold War spy films. Favorite song: "Skeet Surfing" a parody mix of "Surfin' U.S.A.," "Fun, Fun, Fun," and "California Girls" actually written by Brian Wilson and Mike Love from the Beach Boys.

The Naked Gun: From the Files of Police Squad! (1988)

Another gem from the team of Jerry and David Zucker and Jim Abrahams, based on their short-lived TV show about an incompetent cop Frank Drebin (Leslie Nielsen) takes aim in all directions, including baseball umpiring, love movie montages, and the Odessa Steps sequence by way of Brian DePalma's *The Untouchables*. Best scene in the film: wireless microphone left on as Drebin goes to the bathroom—you will cry if you haven't seen that scene before.

Not Another Teen Movie (2001)

The coming-of-age film is roasted alive in this ridiculous take-off on teen films *Can't Hardly Wait, Pretty in Pink, She's All That,* and *10 Things I Hate About You.* Best scene is where they "make-over" the ugly duckling teen by taking down her hair and removing her glasses, and everyone is astounded—awesome stuff.

Shaun of the Dead (2004)

Shaun (Simon Pegg) is having a lousy day. His step-dad hates him, his employees don't respect him, his girlfriend dumped him, and he vows to change his life for the better—if it wasn't for this darn zombie apocalypse that just started. Three words: SLOW MOVING ZOMBIES. [Editor's Note: What happened to that whole "I'm not writing about non-American films nonsense"?]

Team America: World Police (2004)

Yes, it's marionettes instead of human beings, but in Trey Parker and Matt Stone's (*South Park* and Broadway musical *The Book of Mormon*) devious minds—nothing is safe. From the parody of *Rent* and a song about AIDS, to the brilliance of the *It's a Montage* original song, to extended scenes of puppet sex, and Matt Damon and the Film Actors Guild—it's offensive and outrageous, everything that Mel Brooks took to heart when he made *Blazing Saddles*!

Honorable mentions for Great Comedy Spoof Films that are Not Made by Mel Brooks include: *Shrek* (2001), *Hot Fuzz* (2007), *Monty Python's Life of Brian* (1979), *Mars Attacks!* (1996), *BASEketball* (1998), and the *Scary Movie* and *Austin Powers* sequels.

Okay, there's one more subgenre we have to work through, and then I'll leave you alone for the night.

What Is Satire?

I've heard that term a lot, pretty much since high school, but that was so many parties and binge-watching *The Walking Dead* I can't remember. That's why this book exists—not just to help my bank account, but also in order to give you vital information you will need to show up your friend in a betting contest.

Submitted for your approval—here's the official Dictionary.com definition:

> **Satire**, n. a literary composition, in verse or prose, in which human folly and vice are held up to scorn, derision, or ridicule.

So if you're making fun of behavior, society, or culture (or a combination of the three), then it is considered satire.

So let's Cliff's Notes this thing—or Storytelling Devices for Dummies—whichever works for you.

► Parody makes fun of a specific work of art.

► Spoof makes fun of genre and subgenres of art in a silly way.

► Satire makes fun of the society in which the art was created.

The other piece about this literary device is that a good storyteller employs satire not just to ridicule society, but also to hold a mirror up to that same society and culture for all to see. Further, somewhere in the back of the mind of the artist, there is a small hope that the subject of the satire may actually learn something from the satire being presented. That's a pretty lofty goal—nobody likes to be told someone is wrong—but if the audience can gain an understanding of the foolishness, then the film has informed as well as entertained and if art can affect change, that's a role that should be filled as often as possible.

There have been a ton of satires that have been discussed throughout these pages, so here's a list of great satires that you can read about in other places in this book:

The Marx Brothers' *Duck Soup* (1933), Charlie Chaplin's *Modern Times* (1936) and *The Great Dictator* (1940), *To Be or Not To Be* (1942), *Sullivan's Travels* (1942), *Dr. Strangelove* (1964), *The Graduate* (1967), and *Being There* (1979).

The Official Top 5 List of Great Comedy Satire Films THAT ARE NOT IN THE PARAGRAPH I JUST TYPED

M*A*S*H (1970)

It's a satire! It's a black comedy! It's a satire AND a black comedy! One of the most culturally significant satires in motion picture history—that isn't called *Dr. Strangelove*. Read all about it in its own Super Great Movie Spotlight in Chapter 30.

Network (1976)

Over-the-hill news anchor Howard Beale (Oscar Winning Best Actor Peter Finch) is forced into retirement, and instead of walking away gracefully—he threatens to kill himself on-the-air and when he becomes a hit—the network turns him loose on the public as "the mad prophet of the airwaves," screaming his opinions and shouting "I'm as mad as hell and I'm not going to take this anymore!" in this biting satire of the television news business as a morally bankrupt industry willing to do anything to attract viewers.

The Truman Show (1998)

Truman Burbank (Jim Carrey) is a happy guy, until the day he discovers that his entire life is a lie. He's the biggest reality TV star in the world because he's on the biggest television show in history, having been born and secretly filmed every day of his life. Back in 1991, the movie was a satire on television entertainment programming, but now is eerily prescient in our celebrity-obsessed lives and YouTube postings, where anybody can be a reality star—even you.

Office Space (1999) and *Idiocracy* (2006)

Writer/Director Mike Judge hit two home runs with this pair of satires. *Office Space* is the ultimate satire of dull corporate life and how it slowly eats away at your soul, "ummm, yeaaaah . . . did you see the memo about this?"

Idiocracy is gently lifted from Woody Allen's *Sleeper*, where Luke Wilson wakes up in the future and everyone is an idiot. Gold stars for the hugeness of Costco and the overuse of electrolytes.

American Psycho (2000)

Christian Bale is Patrick Bateman, an up-and-coming Wall Street banker, who just happens to be a murderous psychopath, in this satire about shallowness, materialism, and selfishness in the 1980s known as "The Decade of Excess." Kudos to Patrick's bloody axe murder to the Huey Lewis and the News song "Hip to be Square."

Honorable Mentions: *Brazil* (1985), *Catch-22* (1970), *Election* (1999), *Bamboozled* (2000), *Broadcast News* (1987), *Bowfinger* (1991), *L.A. Story* (1991), *The Player* (1992), *Lost in America* (1985), and *Adaptation* (2002).

Lots of subgenres were available as audiences diversified, and more importantly, the artists who were making films had the opportunity to try better and funnier films.

CHAPTER 26

SUPER GREAT MOVIE SPOTLIGHT

The Graduate
(1967)

Dustin Hoffman and Anne Bancroft's alluring leg in *The Graduate* (1967)

Embassy Pictures Corporation/Photofest

- ▶ Starring Dustin Hoffman, Anne Bancroft, and Katharine Ross
- ▶ Directed by Mike Nichols
- ▶ Screenplay by Calder Willingham and Buck Henry
- ▶ Based on the book *The Graduate* by Charles Webb
- ▶ Subgenre: Satire, Coming-of-Age
- ▶ Comedy type: Verbal

"Mrs. Robinson, you're trying to seduce me. Aren't you?"

—Benjamin Braddock (Dustin Hoffman)

It's 1967—the dawning of the counterculture movement and the beginning of the end of the innocent idealism that sedated post-World War II America. The United States had barely survived the Cuban Missile Crisis and the assassination of John F. Kennedy. Nearly a half-million American troops were in the Vietnam "Conflict." The summer of 1967 was known as the "Summer of Love." The Beatles released the first concept rock album, *Sgt. Pepper's Lonely Hearts Club Band*, and Ken Kesey and The Grateful Dead were turning heads and tripping out in Berkeley.

All across the country, the younger generation questioned everything they had been brought up to believe in. You couldn't trust what the Establishment was selling. Sacred institutions like marriage, politics, religion, college, all ideals that had brought stability to American society were now under a microscope of disillusionment.

That's the world where *The Graduate* was created.

On the surface, the film's plot is simple. A college graduate returns home from school with no prospects. He is seduced by one of his parent's friends, and then falls in love with her daughter.

There are two iconic images that perfectly encapsulate the tone and attitude of the film in relation to the culture of the time.

The first image is Benjamin lying on a raft in the pool. Floating in no direction. Typifying the youthful perspective of aimlessness and drifting.

The second image is one of the most iconic images in motion picture history, the "Graduate" shot with Mrs. Robinson's bent at the knee leg framing Benjamin. It's the grown-ups of the world keeping the young trapped under their control.

The film made a star out of Dustin Hoffman, a leading man with plain looks (that nose of his alone would have kicked him out of the casting rooms of Tinseltown) that would have never been cast in the Hollywood of the 1950s and early 1960s. Oscar-winner Anne Bancroft brings a surprising dimension to the character of Mrs. Robinson.

Can't forget the music soundtrack. It's the first film with music from the same band throughout the entire movie. Paul Simon and Art Garfunkel's timeless classic "Mrs. Robinson" is forever tied to the film, as is "The Sounds of Silence" for the opening credit sequence, one long-extended single take of Benjamin on a moving sidewalk at the airport, going where he's supposed to go, even if he doesn't want to.

The Graduate was a tremendous box office hit and opened the door for more films that spoke directly to the youth of America. The generation gap between adults and the young people was never seen more clearly than this film that changed how Hollywood saw younger audiences and the opportunities to tell stories to the next generation. From *The Graduate* came the subgenre of "coming-of-age" films that is still vibrant to this day.

Summary

Benjamin Braddock returns home after graduating from college, and has a terrible case of anxiety. He has no idea what he's supposed to do now that he has his degree. Especially when his parents and all of their friends are all over him, asking what he's going to do next. He doesn't know—he'd rather float in the pool all day, but instead his father would rather have him dive in—wearing a new scuba diving suit that he's been given as a present.

At Benjamin's graduation party, he catches the eye of Mrs. Robinson. She's the wife of his father's business partner, and she asks Benjamin to drive her home. When they arrive, she invites him up and attempts to seduce him by taking off all of her clothes in her daughter's room. Initially he rebuffs her, but ultimately gives in at a nearby hotel. He has nothing better to do anyway, but his anxiety increases as he struggles to keep the affair a secret.

Things get complicated when Mrs. Robinson's daughter, Elaine, also comes home from school. Benjamin asks her out because his parents and Mr. Robinson insist that he should. He tries to sabotage their date by taking Elaine to a strip club, but ends up apologizing. He feels that they have a connection. They end up going to the hotel he's been using for his trysts with Elaine's mother and they recognize him as one of their frequent visitors. Elaine figures out he's having an affair with a married woman, but Benjamin won't tell her who. He promises her that the affair is over. But is it?

Who will Benjamin choose? Is it Elaine or her mother? Will he find some peace and a direction in his life? Or will the ending end so ambiguously that you don't know if it's a happy-ever-after or the worst mistake that Benjamin ever made in his life?

Best Scenes

The Return Party: Benjamin is surrounded by all of his parent's friends as they celebrate his graduation. Mrs. Robinson lays in wait in the background as Mr. McGuire corners him and gives Benjamin some advice on where to focus his life: "I want so say one word to you. Just one word. Plastics."

The Seduction Scene: After Benjamin drives Mrs. Robinson home after the party, he comes to the realization that Mrs. Robinson is trying to seduce him. Isn't she?

The Hotel Scene: When Benjamin goes to the hotel for the first time to rent a room for the night. "Mr. Gladstone" isn't the smoothest operator when it comes to handling the important logistics of the evening. "I just have a toothbrush. I can get it myself, thank you."

The Ending: Benjamin realizes that he has to stop Elaine's marriage. His trip to the church is one for the ages. The last shot of the film is particularly telling.

Awards and Recognition

The Graduate was nominated for seven Academy Awards, including Best Picture, Best Actor for Dustin Hoffman, Best Actress for Anne Bancroft, Best Supporting Actress for Katharine Ross, Best Adapted Screenplay, and Best Cinematography. The film won Best Director for Mike Nichols.

The film also received seven Golden Globe nominations and won for Best Picture, Best Actress (Bancroft), Best Director (Nichols), and both Dustin Hoffman and Katharine Ross won Best New Actor and Actress of the Year.

The AFI loves this movie. *The Graduate* is the #7 Greatest Films of All Time (dropped to #17 for the 10th Anniversary List), the #9 movie on the Great Comedy List, #52 on the Great Romances list, "Mrs. Robinson" is the #6 Movies Song of All Time, and there are two lines in the Top Movie Quotes list: "Plastics." is #42 and "Mrs. Robinson, you're trying to seduce me. Aren't you?" is the #63 quote.

Wait, there's more: *The Graduate* is #36 on the TV Guide's Top 50, #55 film on Entertainment Weekly's Top 100 of All Time, #50 on the Rolling Stone's 100 Maverick Movies, and in 1998, the Library of Congress placed *The Graduate* in the National Film Registry.

CHAPTER 27

ARTIST SPOTLIGHT

Mel Brooks, Neil Simon, Mike Nichols, and Blake Edwards

CHAPTER FOCUS

► Who Is Mel Brooks?

► Who Is Neil Simon?

► Who Is Mike Nichols?

► Who Is Blake Edwards?

Chapter Focus

Keeping the studio comedy tradition alive were three writer/directors that were responsible for over forty movies from the late 1960s through the early 1980s.

Mel Brooks, Neil Simon, Mike Nichols, and Blake Edwards set the stage for movie comedy and produced some of the funniest films in the history of comedy cinema!

Who Is Mel Brooks?

Born in 1926, Melvin Kaminsky grew up as a nice Jewish boy in Brooklyn, New York, where he attended public schools, went to Brooklyn College for a year, and was drafted in the Army during World War II. One of his duties was defusing land mines (so I'm guessing that dealing with film critics and movie "duds" and "bombs" isn't a big deal for him). [Editor's Note: You just read the single worst joke in this book. And we know, we've had to suffer through them all.]

Mel Brooks

©Everett Collection/Shutterstock.com

After leaving the Army at the end of the war, he went to the Catskills Mountains, a popular resort town in Upstate New York. He developed a comedy routine of jokes and impressions, and eventually found his way to staff writing for Sid Caesar's *Your Show of Shows* with future comedy talents Carl Reiner and Pulitzer Prize-winning playwright Neil Simon.

When *Your Show of Shows* ended, he moved on to the *Caesar's Hour* variety show with Reiner, Simon, future M*A*S*H TV writer/producer Larry Gelbart, and a young Woody Allen. It was on *Caesar's Hour* that Mel teamed up with Carl Reiner and the two of them created the "2000-Year-Old Man" comedy routine. Mel would play "The 2000-Year-Old Man" and Carl would interview him about historical figures and everything he's seen. They released five comedy albums with the routine and sold a million records in 1961.

The record sales gave Mel the opportunity to branch out. In 1962, he wrote the book for the Tony-nominated musical *All American*. In 1963, he wrote and narrated *The Critic* and won the Best Animated Short Film Oscar; and in 1965 teamed up with comedian Buck Henry to create the iconic James Bond TV spoof *Get Smart*, which ran for five years and won the Emmy for Best Comedy Series in both 1968 and 1969.

With the success of *Get Smart*, it was time for Mel to try his hand at feature films. His first film was a dynamo.

The Producers (1968)

"Don't Be Stupid, Be a Smarty! Come and join the Nazi Party!"

—Stormtrooper Mel

Writer–Director Mel Brooks created this tale of washed-up Broadway producer Max Bialystock (Zero Mostel), who spends his days having sex with elderly women to invest in

his moribund shows. When accountant Leo Bloom (Gene Wilder) comes to audit his books, they get the idea that a producer can make more money with a bad play that closes in one day than a successful one that has to pay back its investors. Blown away by Leo's notion, Max decides to find the worst play in history and mount it. He convinces Leo to go along with his scheme for a share of the profits.

The worst play they could find is *Springtime for Hitler*, written by passionate Nazi Franz Liebkind (Kenneth Mars). As a bonus, it's not just a play, it's a musical! They hire the worst director Roger De Bris (Christopher Hewitt) and no-talent hippie Lorenzo St. Dubois (known as L.S.D., played by a wacky Dick Shawn) to play Adolph Hitler. Surely the play will collapse!

Max goes into overdrive and woos a ton of little old ladies, raising 25,000 percent of the budget they need. After the opening number "Springtime for Hitler and Germany/Winter for Poland and France," featuring goose-stepping soldiers, girls dressed as pretzels and beer, and the finale unfurling Nazi flags over the stage, the play is a disaster. With people walking out, Max and Leo adjourn to the bar next door to hear how much the audience hates the movie. But Act II is a disaster, for Max and Leo. LSD improvs the script and turns the whole play into a farce. It's a hit! Uh–oh, now what?!!

The Producers was an idea that Mel Brooks had been working on for six years and was able to convince his producer that he can direct the film due to his experience working in television to save money.

The film made money and the reviewers were mixed. Many felt it was tasteless and others thought it was brilliant. But Mel Brooks would have the last laugh. He was nominated for the Golden Globe for Best Screenplay—Musical or Comedy, won the WGA Best Screenplay Award, and even better, won the Best Original Screenplay Oscar in 1968. Gene Wilder was nominated for the Best Supporting Actor Oscar, sending his career upward. The film is the #11 movie on the AFI Great Comedy Films list and was placed in the National Film Registry in 1996 by the Library of Congress.

With the success of *The Producers*, he moved to write and direct 1970's *The Twelve Chairs*. Ever heard of this one? Me neither. Funny what you find when you start doing research! Something about three guys looking for stolen diamonds in chair legs. Didn't do well. Mel thought he'd never work again. You could buy it

Cleavon Little and Gene Wilder star in Mel Brooks's Western spoof *Blazing Saddles* (1974)

Warner Bros./Photofest

on Amazon, and it's in this big Mel Brooks DVD collection from 2006. I'll pass.

His next film was the 1974 film *Blazing Saddles*. How good is this movie? Go check out my Super Great Movie Spotlight in Chapter 28. [Editor's Note: The next chapter after this one.]

Having worked with Mel on *The Producers*, Gene Wilder agreed to come onboard *Blazing Saddles* if Mel promised to help him make this parody film that he was writing called *Young Frankenstein*. Mel agreed. In 1974, two of the films that defined the leg-

Teri Garr, Gene Wilder, Marty Feldman, and Mel Brooks on the set of *Young Frankenstein* (1974)

end of Mel Brooks were both released. Check out Chapter 33 to read about the parody triumph that is *Young Frankenstein*.

With the success of both movies, Mel had an inspired idea to make a silent movie. Thus *Silent Movie* was born.

Silent Movie (1976)

"Non!" Marcel Marceau

Silent Movie was meta before the term meta existed. It's a slapstick silent film about making a slapstick silent film.

Mel plays Mel Funn, a film director that comes up with an idea to make a silent movie. He and his friends Dom (Dom DeLuise) and Marty (Marty Feldman) run around Hollywood trying to cast big stars in the movie after the reluctant studio heads reject it. Burt Reynolds, Paul Newman, Anne Bancroft, and James Caan all agree to be in the movie. Only word of dialogue said in the movie is "Non!" uttered by French mime Marcel Marceau. Pretty clever stuff! Of course, things go awry when the studio bosses realize that Funn will be able to get the movie going. They were planning on acquiring the floundering studio, but Mel's movie will ruin their plans.

How do they stop the film? Will Mel finish his movie? What about the mysterious nightclub singer, Vilma Kaplan (Bernadette Peters), who seduces Mel and may derail everything? And will Marty ever have sex with all the women he hits on during the film?

Silent Movie was a hit with both audiences and critics, and was touted for its satire of the Hollywood film industry, particularly how studios don't care about quality and the people who run them are greedy and soulless. There's a ton of fun physical comedy in the movie and if you are a fan of Chaplin and Keaton, this is a film for you.

High Anxiety (1977)

His next film was another brilliant spoof of the films of the celebrated movie director, Alfred Hitchcock. Mel is Dr. Richard Thorndyke (named after Cary Grant's character in *North by Northwest*) the new head of "Psychoneurotic Institute for the Very VERY Nervous" and discovers something very funny going on. I'm not talking about all of the Hitchcock references in the movie. Jokes based on *Psycho, The Birds, Rear Window, Rebecca,* and many more are all in there. If you know your Hitchcock, then this is the movie for you!

Another big triumph with audiences (a gross of $31 million from a reported budget of $4 million) and with film critics, the movie was nominated at the Golden Globes for Best Motion Picture—Musical or Comedy, and Mel was nominated for Best Actor—Musical or Comedy.

He started Brooksfilms, a production company to make non-comedy films, such as David Lynch's *The Elephant Man* (1980), David Cronenburg's *The Fly* (1986), and *My Favorite Year* (1982), which was based on Brooks's stint as a staff writer on *Your Show of Shows*.

The History of the World, Part I (1981)

"It's Good to Be the King."

—King Louis the XVI (Mel Brooks)

Who's a fan of history? Anyone? Well, after watching this fantastic spoof of historical epics, even you will enjoy learning about such important events in the evolution of human society as presented through the skewed vision of Mel Brooks.

Instead of one story, it's a series of segments (much like Woody Allen's *Everything You Wanted to Know about Sex * (But Were Afraid to Ask))* following history from caveman days to the French Revolution. Mel acted in a number of the segments and cast his favorite actors, including Dom DeLuise, Harvey Korman, Madeline Khan, and Sid Caesar, along with a bevy of cameos.

Most notable is the *The Old Testament* where Mel plays Moses coming down from Mount Sinai with the Fifteen Commandments, the musical number for The Spanish Inquisition, and the French Revolution segment with King Louis of France and a "piss-boy" (also Mel). Last

but not least, the *Coming Attractions for History of the World, Part II* (which will never be made). The movie was another success for Mel, making over $30 million on an $11 million budget.

After acting with his wife of twenty-two years, Anne Bancroft, in a tepid remake of the Ernst Lubitsch film *To Be or Not to Be* (1983), his next parody would take on the iconic science-fiction film, *Star Wars*.

Spaceballs (1987)

Do you like *Star Wars*? Who doesn't like *Star Wars*? Apparently Mel Brooks does—and thus was born his biggest parody of the 1980s.

A long time ago, in a galaxy very, very, very, very far away there lived a ruthless race of beings known as . . . Spaceballs. Led by the evil Dark Helmet (Rick Moranis) (aka Darth Vader except with this giant helmet and a horrible asthmatic condition) who kidnaps vestile virgin Princess Vespa (Daphne Zuniga—yes with a cinnamon bun hairstyle) from the planet Druidia. Along the way, Lone

Rick Moranis is the evil asthmatic Dark Helmet in Mel Brooks hugely successful *Star Wars* parody *Spaceballs* (1987)

MGM/Photofest

Starr meets Yogurt (Mel Brooks) a short alien-mystic with a Yiddish accent (aka Yoda from *The Empire Strikes Back*) who teaches Lone that he has the ability to use the "Schwartz," a powerful "force" that can move objects and bend wills. I think you get that reference.

The best gags in the film are the blatant commercialism of the film that Dark Helmet and President Skroob (Mel Brooks again—get it? It's his name as an anagram!) show off a display of affordable *Spaceballs* merchandising t-shirts, hats, action figures, and even toilet paper with the film's logo attached. At the end of the movie, Yogurt wishes Lone Starr good luck and "God Willing, we'll all meet again in *Spaceballs 2: The Search for More Money*."

It was Mel's biggest budget to date and brought in a small return. The critics were harsh but it's found a loyal following of fans through the years.

Mel did three more films after *Spaceballs* but the films are a mixed bag of results.

Other Movies from Mel Brooks That Aren't as Good as the Others

1991's *Life Stinks* wasn't a parody. It's a straight narrative and the movie is similar to Preston Sturgess's film, *Sullivan's Travels*. [Editor's Note: Chapter 13.] He directs, co-wrote, and stars as rich businessman Goddard Bolt who takes a bet from a rival real estate developer (Jeffrey Tambor). If Bolt wins, he gets a piece of land that they both are bidding on for redevelopment. The critics were not kind to the film and it was a rare box office loser for Mel.

1993's *Robin Hood: Men in Tights* was a parody of swashbuckler films and specifically the 1991 movie *Robin Hood: Prince of Thieves*. It stars Cary Elwes (*The Princess Bride*) as the title character, stealing from the rich and giving to the poor, and is on a quest to save Maid Marion (Amy Yasbeck). The critics were underwhelmed and it did perform at the box office, but not very well.

His last film is the 1995 horror film parody *Dracula: Dead and Loving It*, starring Leslie Nielsen (*Airplane, The Naked Gun* series) in the title role of the Transylvania bloodsucker. There's not much to write about this. The critics roasted it and the movie lost $20 million. It's no *Young Frankenstein*.

Mel has spent the last part of his career bringing his first feature film *The Producers* to life as a Broadway musical. The original stage production starred Nathan Lane (*The Birdcage*) as Max Bialystock and Matthew Broderick (*Ferris Bueller's Day Off*) as Leo Bloom.

Mel wins an Emmy Award

Mel and Carl Reiner win a Grammy Award

©Featureflash Photo Agency/Shutterstock.com

The show ran for seven years on Broadway and blew out the doors at the Tony Awards. *The Producers* received a historic fifteen Tony nominations and it won an equally historic twelve of them, and is one of the few shows in Broadway history to win a Tony Award in every category it was nominated—Best Musical, Best Book (Mel), Best Score (Mel), Best Musical Actor (Nathan Lane), Best Featured Actor (Gary Beach), Best Featured Actress (Cady Huffman), Best Director and Best Choreography (Susan Stroman), Best Orchestrations, Best Scenic Design, Best Costume, and Best Lighting.

In 2005, the Broadway musical was turned into a film musical. Lane and Broderick reprised their roles, and added Uma Thurman as Ulla and Will Ferrell as playwright Franz Liebkind. The film received lackluster reviews but did make a small profit.

Mel then took *Young Frankenstein* and turned it into a Broadway musical as well. The expectations of another hit like *The Producers* did not come to fruition. It did win the Best New Musical Audience Award from Broadway.com, but the show closed within a year. At the Tony awards, *Young Frankenstein* was only nominated for Featured Actor (Christopher Fitzgerald who played Igor), Featured Actress (Andrea Martin for Frau Blucher), and Scenic Design.

Regardless of the duds and bombs in film and theatre, Mel Brooks is one of the most important comedy filmmakers in history. He essentially created the parody film and we wouldn't have had the opportunity to enjoy movies like *Airplane!* and *Scary Movie* without the brilliance of Mel Brooks.

Mel Brooks is currently one of twelve people in history to have an EGOT, which is winning an Emmy Award for television, Grammy Award for Music, Oscar for film, and Tony Award for theatre. He is one of two filmmakers that share the honor, along with writer/director Mike Nichols (*The Graduate*).

He has a star on the Hollywood Walk of Fame, his hands are in the cement at the Chinese Theatre in Hollywood (look for the left hand with the extra prosthetic SIXTH finger—now that's comedy!), and in 2013 Mel Brooks was honored with a Lifetime Achievement Award from the American Film Institute.

©Featureflash Photo Agency/Shutterstock.com

Mel Brooks with Carl Reiner and his son, Max Landis, as Mel gets his Star on the Hollywood Walk of Fame

Mel's 6-fingered handprint in front of the Chinese Theatre

Mel putting his hands in cement

Who Is Neil Simon?

Born in 1927, this celebrated Tony Award and Pulitzer Prize-winning playwright, screenwriter, and author's work helped to bridge the comedy gap for Paramount Pictures, who turned several of his plays into films during the late 1960s and early 1970s. He's best known for his Broadway play *The Odd Couple*, which was turned into the hit 1968 film of the same name starring Jack Lemmon and Walter Matthau.

He started in radio and then moved to television, working on the celebrated Sid Caesar television series *Your Show of Shows*, where Mel Brooks and Carl Reiner started their broadcast careers. While working for Caesar, he took three years to write his first play, *Come Blow Your Horn*, which premiered on Broadway in 1961. That play was turned into a movie with Frank Sinatra in 1963 and he was off to the races.

Neil Simon

The Official Neil Simon Top 3 Great Comedy Film Checklist

The Odd Couple (1968)

Slob Oscar Madison (Walter Matthau) and neatnik Felix Unger (Jack Lemmon) are two divorced men trying to live together as roommates and their polar opposite personalities are like oil and vinegar, not mixing to hilarious results. [Editor's Note: all the way back in Chapter 19.]

The Goodbye Girl (1977)

Richard Dreyfuss won a Best Actor Oscar as Elliot Garfield, a struggling actor who falls in and out of love when he is forced to take in aspiring dancer Paula (Marsha Mason, Neil Simon's wife at the time) and her precocious daughter as they both struggle to make it on Broadway.

Biloxi Blues (1985)

Mike Nichols (*The Graduate*) directs, Matthew Broderick is Eugene (Neil Simon's alter ego), and Christopher Walken is the overbearing Sergeant Toomey in a story that follows Neil Simon's experiences in the Army. This is the second film in the "Eugene" trilogy, in-between *Brighton Beach Memoirs* (1986) and TV-movie *Broadway Bound* (1992), in this award winning trilogy that follows Neil Simon's early life.

In total, he wrote thirty-five plays, was nominated for seventeen Tony awards, and won three (*The Odd Couple, Biloxi Blues,* and *Lost in Yonkers*). He also received a special Tony Award in 1975 for his contributions to theatre and in 1991 won the Pulitzer Prize for Drama for *Lost in Yonkers.*

He's written twenty screenplays and adaptations of his work for the silver screen, and was nominated for four Best Screenplay Oscars: *The Odd Couple* (1969), *The*

Neil Simon at party with friend

©Debby Wong/Shutterstock.com

Sunshine Boys (1975), *The Goodbye Girl* (1977), and *California Suite* (1978). His work dominated comedy in the 1970s more than any writer and kept the Hollywood studios in business with his particular brand of comedy that the audiences loved.

He won two Emmy Awards for his work on *Your Show of Shows*, five Writer's Guild of America Awards (*The Odd Couple, The Last of the Red Hot Lovers, The Out-of-Towners, The Trouble with People,* and *The Goodbye Girl*), and a Golden Globe for Best Screenplay for *The Goodbye Girl*.

Finally, Neil Simon has received more Tony and Oscar nominations combined than any writer in history and in 1983, the Alvin Street Theatre in New York City was renamed the Neil Simon Theatre in his honor. He was a Kennedy Center Honoree in 1995 and in 2006 he received the Mark Twain Prize for American Humor.

Who Is Mike Nichols?

In the Mel Brooks section, I mentioned he was one of twelve artists to win an EGOT. The only other EGOT filmmaker is the legendary Mike Nichols.

Mike Nichols

Mikhail Peschkowsky was born in 1931 in Germany, the son of Jewish immigrants from Austria and Russia. Then Hitler and the Nazis assumed power, and Mikhail and his younger brother were sent to America to be with his father, and his mom escaped shortly after.

Arriving in America, the family changed their last name to Nichols and his father became a successful doctor in New York City, and eventually "Mike" went to school, quit New York University and ended up at the University of Chicago to study medicine.

He met comedian Elaine May [Editor's Note: See Chapter 24] while acting locally and she became his writing and performing partner (and another kind of partner if you catch my drift? Yeah, baby! But then it became strictly professional) after they had both become performers at the Compass Players comedy improv troupe. The Compass Players were the inspiration for the Second City Comedy Troupe which made a huge impact on the world of comedy film. [Editor's Note: Chapter 36 and about twenty other chapters in this behemoth.]

In 1958 they became "Nichols and May," the first male–female comedy duo, and May was one of the first female comediennes to take the stage. Their stage comedy was primarily satire around marriage, and they soon appeared on TV. In 1959, they produced the first of

their three comedy albums. Their second album, 1960's *An Evening with Mike Nichols and Elaine May*, based on their hit Broadway show, won the Grammy Award for Best Comedic Performance. Their third album, *Mike Nichols and Elaine May Examine Doctors* was also nominated for the award in 1961.

Besides their Grammy nomination, 1961 was also the year that they ended their partnership. They reunited several times later on television, and together worked on Nichols's adaptation of the Broadway Play *The Birdcage* with Robin Williams and Nathan Lane in 1996 and his 1998 political satire *Primary Colors* starring John Travolta as a Bill Clinton-esque politician.

After Nichols and May parted ways, he went to Canada and started directing for the theatre, eventually picked to direct playwright Neil Simon's romantic-comedy play *Barefoot in the Park* that ended up running on Broadway for four straight years, nearly unheard of for a non-musical play. He won the Tony Award for Best Direction of a Play. A young Robert Redford starred in the production—and later would reprise his role in the 1967 film adaptation directed by Gene Saks and co-starring Jane Fonda.

Nichols would direct several plays on Broadway, including Neil Simon's *The Odd Couple*, *Plaza Suite*, and *The Prisoner of Second Avenue* for which he won three additional Tony Awards for Best Directing. Overall he would return to the theatre in-between film projects until his final works in 2012 and 2013, including a revival of *Death of a Salesman* and yet another Tony Award for Best Direction. His forty-year career on Broadway accumulated a total of nine Tony Awards and seventeen nominations.

It wasn't long until Hollywood came a courtin', and Warner Brothers hired him to direct the film adaptation of the Tony Award and Pulitzer Prize-winning drama *Who's Afraid of Virginia Woolf?* by Edward Albee. The film stars Elizabeth Taylor, Richard Burton, George Segal, and Sandy Dennis—and the film was a huge success. From a 7 million-dollar budget, the film grossed 40 million dollars and is only the second movie in history to be nominated for *every single Oscar category* including Best Picture. Ultimately it won Best Actress, Best Supporting Actress, Cinematography, and Costume Design—and Mike Nichols received the first of his multiple Oscar nominations for Best Director.

It's his next film in 1967 that knocked the ball out of the park. It was a movie that rocked the American cinema. The satire *The Graduate*, starring Dustin Hoffman and Anne Bancroft. [Editor's Note: back in Chapter 26.] It's the groundbreaking film that cracked open the door for the counterculture movement broken open by Dennis Hopper's *Easy Rider* two years later. Mike Nichols picked up his only Best Director Oscar for his tremendous work on the film that is a part of Comedy Film classes from now until the end of time.

After *The Graduate*, Mike Nichols had his pick of Hollywood films to choose from. He made dramas, romantic comedies, documentaries, musicals, and comedies. It's easy to list some of his notable films, it's just a simple copy-and-paste from IMDb.

Director Mike Nichols with stars Julia Roberts and Tom Hanks at the premiere of Nichols's last film, *Charlie Wilson's War*

There's the sexually-controversial *Carnal Knowledge* (1971), the Cher-starring biopic *Silkwood* (1983) for which Nichols received his second Oscar nomination, 1988's Neil Simon film adaptation of his Tony Award-winning play *Biloxi Blues*, the 1990 Carrie Fisher biopic *Postcards from the Edge* starring Meryl Streep, 1998's political satire of Bill Clinton, *Primary Colors*, the political satire the sexual drama *Closer* (2004) and his final film, the Tom Hanks political-drama *Charlie Wilson's War* (2007) starring Tom Hanks. He also spearheaded bringing the film adaptation of Tony Kushner's Pulitzer Prize-winning dramatic play about dying from AIDS—the critically acclaimed *Angels in America* to HBO, and won his Emmy Award to complete his EGOT.

The Official Mike Nichols Top 3 Great Comedy Film Checklist of Movies Not Named The Graduate

Catch-22 (1970)

In the wake of Stanley Kubrick's *Dr. Strangelove* and Robert Altman's *M*A*S*H*, comes the next great wartime black comedy, *Catch-22*. Based on the award-winning 1961 novel by Joseph Heller, the movie follows the story of Air Force pilot Captain John Yossarian (Alan Arkin) who wants out of the war, and he decides that his best way is to pretend he is going insane. Catch-22 is a term that became popular in the English language which implies a paradox without ending. Basically, he must prove he's insane to stop flying, but if you don't want to fly into battle—then you must be sane. Nichols brought a great cast together, including Buck Henry, Charles Grodin, Bob Newhart, Martin Sheen, Jon Voight, and even Orson Welles in a great ensemble comedy that didn't do well on its initial release but has earned respect through the years.

Working Girl (1983)

Riding the wave of feminist films that started with *Private Benjamin* and *9 to 5*, this Best Picture nominated romantic-comedy/drama follows Tess McGill, played by Oscar-nominated Melanie Griffith, as she tries to climb her way up the corporate ladder from secretary (yes, they were called secretaries back then) to an executive. Along the way she has to navigate her shrewish boss Katharine (Oscar-nominated Sigourney Weaver) and a romantic interlude with Jack Trainer (a roguish Harrison Ford) that threaten her march to the top.

The Birdcage (1996)

Based on a screenplay adapted from the 1978 French-Italian film *La Cage aux Follies* by his old partner Elaine May. Nichols brought together the amazing Robin Williams and in his first live film role, Tony Award-winner Nathan Lane (his first role was the voice of Timon in *The Lion King*—Hakuna Matata indeed!) as a gay couple who own a nightclub in Miami called The Birdcage. Their son brings home his fiancé and her parents the ultraconservative Senator Kevin Keeley (Gene Hackman) and Louise (Dianne Weist)—and they don't know that their son's parents are GAY!

It's sort of *Guess Who's Coming to Dinner* but substitute gay for black and you're on-target. It's a wacky situational comedy with a great ensemble, highlighted by Lane's over-the-top Albert. The film was hugely successful, earning $185 million at the box office and it's still considered a Fresh movie by Rotten Tomatoes.

In a career that spanned fifty years, Mike Nichols was known for being an extraordinary director who could bring out incredible performances from his actors. His films received a total of forty-two Oscar nominations, mostly for his cast. In total, he directed twenty feature films, twenty-two plays on Broadway, produced and directed for television, and his work with Elaine May laid the foundation for stand-up comics and sketch comedy writers and performers. He was honored by the AFI with their Lifetime Achievement Award in 2010. He passed away in 2015 from a heart attack, but left an indelible mark on motion pictures that still rings true to this day.

Who Is Blake Edwards?

Born in 1922, William Blake Crump grew up the son of a silent film director, and started acting during World War II. Though he never did more than bit parts, he learned how to direct from some of the best Hollywood directors, including John Ford. During World War II, he was in the Coast Guard and after the war returned to acting until he got his chance to write and direct for television.

During the mid-1950s to 1961, he created, wrote, and directed several television programs, including *The Mickey Rooney Show, Mr. Lucky*, and *Peter Gunn*, but his heart was always set on making films. He wrote and directed a couple of small films and in 1959 made the film that would put him on the map.

Blake Edwards receives an Honorary Oscar in 2003

The 1959 World War II comedy, *Operation Petticoat*, starred the "King," Cary Grant, as the commander of the USS Sea Tiger, a World War II submarine, and Tony Curtis co-starred as his enterprising supply officer. The submarine was damaged during Pearl Harbor, and instead of going to battle, it's sent to pick up a group of stranded nurses. Predictably, shenanigans ensue especially when the battered submarine tries to find some paint for camouflage and ends up being painted pink and then attacked by their own Navy when they are mistaken for a Japanese sub.

The film was a triumph and secured Blake Edwards's talents as a director. His next film would be the 1961 classic romantic comedy, *Breakfast at Tiffany's*, starring Audrey Hepburn and George Peppard. [Editor's Note: Chapter 18.] A huge hit both critically and financially, and Edwards was nominated for the Directors Guild of America's Outstanding Direction in a Motion Picture Award.

Audrey Hepburn

His next film was the 1962 alcoholic drama *Days of Wine and Roses*, starring Jack Lemmon and Lee Remick. The film was another high-water mark for Edwards and another box office and critical favorite. Lemmon and Remick were nominated for Best Actor and Best Actress Oscars and Edwards was nominated for a Golden Globe for Best Director.

The Pink Panther Films (1963–1993)

In 1963, he directed *The Pink Panther*, and subsequently made four more *Panther* films. Peter Sellers played the ridiculous Inspector Jacques Cousteau over the next fifteen years. In the meantime, he directed 1965's *The Great Race*, starring Jack Lemmon and Tony Curtis and in 1970 he directed and co-wrote *Darling Lil*, a musical starring Oscar Winner Julie Andrews. The film was a commercial bomb and financially ruined Paramount Pictures, but Edwards would eventually marry Andrews so it wasn't all that bad. He then misfired with his next two films, the Western *Wild Rovers* and medical drama *The Carey Treatment*.

His next big film was the 1979 ticket smash *10*, starring Dudley Moore and newcomer Bo Derek. It was one of the biggest movies of the year and Edwards was back on the A-list. He wrote and directed the Hollywood black comedy satire *S.O.B.*, turning his film from a frothy musical into a soft-core porno. Edwards drew on his own experiences of failure on the reactions he got from the rest of the film industry after he flopped with *Darling Lili, Wild Rovers,* and *The Carey Treatment.*

His next film would be another one of his memorable films.

Inspector Jacques Clouseau (Peter Sellers) appeared in five films, all directed by Blake Edwards

Victor Victoria (1982)

A musical comedy based on a 1933 German film, *Victor Victoria* follows struggling performer Victoria Grant (Julie Andrews) as she makes her way through 1934 Paris trying to make it as a singer. She meets up with gay cabaret singer "Toddy" Todd (Robert Preston) who comes up with a grand scheme, dressing her up to look like a female impersonator. So she would be disguising herself as a man, who in turn is disguising himself as a woman. Toddy predicts that she will become the toast of the city. Crazy, right?

Passing herself off as Count Victor Grazinski, one of Toddy's former male lovers, Victoria auditions for the biggest agent in town who loves her/him/her and books her in the best nightclub in the city. In the audience is Chicago business tycoon King Marchand (James Garner), who falls in love with her not believing that she's a he (who is also a she). He sneaks into her and Toddy's suite and confirms that he is actually a she. King's former girlfriend Norma (Leslie Ann Warren) tells King's business partners that he's turned gay, and then things get crazy as they always do in these kinds of transgender movies.

The film was a triumph and was nominated for seven Academy Awards, including Best Actor (Robert Preston), Best Actress (Julie Andrews), Best Supporting Actress (Leslie Ann Warren), Best Adapted Screenplay (Blake Edwards), Best Art Direction, Best Costume Design, and won for Best Music. The film is the #76 movie on the AFI Great Comedy Films list.

After the success of *Victor/Victoria*, Edwards started a run of writing and directing a series of comedies that were either modest successes or financial bombs—but none came close to his earlier success. He received an Honorary Oscar for Lifetime Achievement in 2003, and passed away of complications from pneumonia in 2010.

These four talented individuals made their impact on film and culture as a representative of the Old Guard of Hollywood. They held open the door for a new group of filmmakers and actors to emerge and make their mark on Hollywood from the 1970s into the new decade of the 1980s. As I seem to say at the end of every chapter, everything was about to change for the viewing public at large thanks to a little bit of technology (hint: it has to do with wires, or should I say "cables") that would soon take the world by storm.

CHAPTER 28
SUPER GREAT MOVIE SPOTLIGHT

Blazing Saddles
(1974)

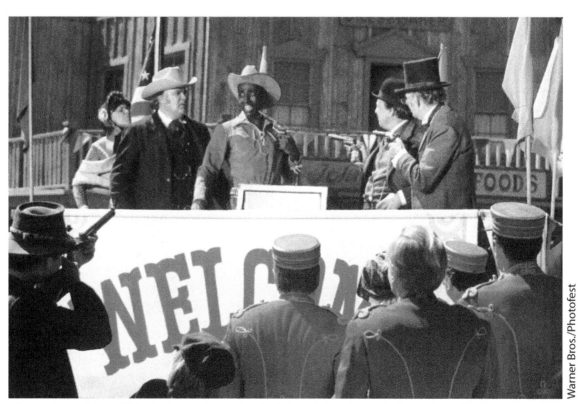

Cleavon Little is Sheriff Bart, along with a bloodthirsty racist mob, in *Blazing Saddles* (1974)

Warner Bros./Photofest

- ▶ Starring Cleavon Little, Gene Wilder, Harvey Korman, Madeline Kahn, and Mel Brooks
- ▶ Directed by Mel Brooks
- ▶ Written by Andrew Bergman, Mel Brooks, Richard Pryor, Norman Steinberg, and Al Uger
- ▶ Subgenres: Spoof, Satire
- ▶ Comedy types: Verbal, Slapstick

"[reading] As honorary chairman of the welcoming committee, it's my privilege to present a laurel and hearty handshake to our new [looks up to see Sheriff Bart] . . . n****r."

—Howard Johnson (John Hillerman)

When it comes to Mel Brooks' spoofs and parodies, it comes down to two camps: The "*Young-Frankenstein*-is-Better" fans and the "You're-full-of-shit-if-you-don't-think-*Blazing Saddles*-is-Better" group.

Young Frankenstein is a great film—but *Blazing Saddles* is the better movie. It sets its sights on a much bigger target than a parody of the Universal monster films. It's spoofing Western movies but raises the bar with its satire of racism. The brilliance of *Blazing Saddles* is that it never shirks from outrageousness. This is the first film to have farting on-screen. That's controversial! Also the whole race thing is up there as well.

Mel Brooks has said that if the film was made in the circa 2016 cultural climate, that he would not use the n-word that is in the quote at the top of this section. But back then, it *was* appropriate. The civil rights fight was still raw and the stigma of the word was finding its place in contemporary society.

If you have a problem with the film's use of the n-word, then you might want to take it up with the ghost of Richard Pryor, the greatest black stand-up comic in history, who worked on the screenplay. Further proof that film comedy is a direct reflection of the culture and times in which it is created.

Richard Pryor was also supposed to star as Sheriff Bart, a role that eventually went to Cleavon Little. The executives at Warner Brothers refused to cast Pryor, saying he was uninsurable because of his controversial nature. Though disappointed, Brooks made sure Pryor got credit for his work on the script.

It's a movie that goes beyond spoof—it skews a host of subjects along the way. It's crude, rude, sexist, racist, and never subtle. Good spoofs works because it plays off of the subject matter. In *Blazing Saddles*, the comedy comes from all directions and takes aim at everything—and hits the mark every time.

Summary

In the Old West of 1874, greedy land developer and State Attorney General Hedley Lamarr (Harvey Korman) is in cahoots with Governor William J. LePetomane (Mel Brooks) to drive out the residents of the small town of Rock Ridge so he can buy the land the railroad can go through. Lamarr hires a gang of hoodlums, led by Taggart (Slim Pickens) to scare them away, but after the townspeople escape a church bombing, they demand a new sheriff. Lamarr wonders aloud and breaks the fourth wall, "If I could find a sheriff who so offends the citizens of Rock Ridge that his very appearance would drive them out of town. But where would I find such a man? Why am I asking you?"

Soon enough, the new Sheriff arrives, Black Bart. Yes, he's black, and the townspeople are up in arms, but Bart is able to calm down the racist crowd. Soon enough, Lamarr sends his men to kill Bart, but thanks to the sharp aim of alcoholic gunslinger The Waco Kid (Gene Wilder), he beats them back and even tames "Mongo" (Alex Karras), one of Taggart's brutes. When Lamarr sends dance hall vixen Lili von Shtupp (Madeline Kahn) to seduce Bart, he outwits her and turns her against Lamarr.

Soon enough, Lamarr recruits the worst of the worst to attack the town. criminals, rapists, Ku Klux Klan members, and the Nazi Party. What will Bart and the Waco Kid do to save the day? Will Lamarr and his army crush Rock Ridge? Will the town learn a thing or two about racial tolerance? Stay tuned!

Best Scenes

The Arrival Scene—The good people of Rock Ridge anxiously await the arrival of the new Sheriff—with a celebratory band, bells ringing, and applause—when everyone sees that the savior of the town is a black man. Extra points for Bart whipping out his proclamation and being held hostage by the most ruthless murderer there—himself.

Bean Dinner—As a bunch of Taggart's men enjoy a delicious dinner of baked beans, they suffer from flatulence. The beauty of the scene is that it's not just one or two of the guys—it's every single man in the group in a wild cacophony of farting that set the bar for movie farting that has never been equaled.

Lili's Musical Number—Dance hall performer Lil von Shtupp (Madeline Kahn) sings onstage with the song "I'm Tired," a song about her having sex all the time and being exhausted. There's sexual entendre, double entendre, and sex without entendre. "Men are always coming and going, and going and coming," and "Is that a ten-gallon hat or are you just enjoying the show," and German soldiers dancing and firing their rifles in the air (how phallic!) at the end of the number.

The Big Ending—In a war scene on par with the ending of Duck Soup, the battle for Rock Ridge spills out from the town, and into the movie studio soundstage next door. Literally "breaking the fourth wall" for the finale. Priceless.

Awards and Recognition

Blazing Saddles was nominated for three Academy Awards: Best Supporting Actress for Madeline Kahn, Best Editing and Best Music, Original Song for the main theme song "Blazing Saddles" sung by Frankie Laine. The film did win the WGA award for Best Comedy Written Directly for the Screen.

The film grossed over $100 million from a budget of $2.6 million, only one of ten films to eclipse that mark.

Blazing Saddles is the #6 movie on the AFI 100 Years . . . 100 Laughs List and in 2006, the Library of Congress placed the film in the National Film Registry.

CHAPTER 29

ARTIST SPOTLIGHT

Peter Sellers, Dustin Hoffman, Paul Newman, and Burt Reynolds

CHAPTER FOCUS

▶ Who Is Peter Sellers?

▶ Who Is Dustin Hoffman?

▶ Who Is Paul Newman?

▶ Who Is Burt Reynolds?

Chapter Focus

The late 1960s into the 1980s were a time of performer-driven comedies that lit up the silver screen.

These four talented actors defined the studio comedies of the era, with a multitude of movies hitting the silver screen. Combined they made over forty comedy films that drew laughs as the studios created as much mainstream fare as they could to continue entertaining the world.

Who Is Peter Sellers?

This English actor was born in 1925 and his parents were both music hall performers. He learned about entertainment at an early age and in college studied acting and improvisation. Because of World War II, Sellers' schooling ended and he learned how to drum. He joined the Entertainment National Service Association, which toured around the country performing for the troops. Besides his musical act, Sellers performed a comic routine and did impersonations. In 1943, he joined the Royal Air Force and performed for troops in England and India.

Peter Sellers

After the war, he auditioned for the BBC and eventually became a regular on several radio programs (or "Programmes" as they like to spell them). He started doing his trademark of multiple characters as a member of "The Goons," a comedy troupe on the highly popular "Crazy People" comedy radio show that ran from 1951–1960. He began doing films in Great Britain with his co-stars from "The Goons." His big break came in 1955 when he played criminal Harry Robinson opposite Alec Guinness in 1955's *The Ladykillers*.

He jumped back and forth between British feature films and television. He even recorded a comedy album, taking on the role of several characters singing and performing comic routines. He was one of Britain's most popular comedians and was compared to Charlie Chaplin.

He was a method actor, frequently disappearing into his film roles, and also was extremely difficult to work with. He loved drugs, fast cars, alcohol, and women. He had affairs with Liza Minnelli and Sophia Loren and was incredibly jealous of anyone who acted with his wife, Britt Eckland (who he married after a 10-day courtship). It is said that he was mentally abusive to her and their children. But he was definitely talented.

The Official Peter Sellers Top 3 Great Comedy Film Checklist:

*(films that are not *Pink Panther* movies or *Dr. Strangelove*)

The Mice That Roared (1959)

This is the first film that Sellers starred in which he played multiple characters. He's the Grand Duchess, the Prime Minister, and a Soldier for a small European nation on the brink of financial ruin. They decide to invade America, surrender, and then accept foreign aid. Of course, things don't go as planned during the invasion, and they have a chance of winning?

Lolita (1962)

In the film adaptation of the controversial Vladimir Nabokov black comedy novel, Professor Humbert Humbert (James Mason) falls in love with twelve-and-a-half-year-old Lolita (Sue Lyon) and goes on the run with her so they can be together. Yes, they have sex. How this got made in 1962—I have no idea!

In his first collaboration with the great Stanley Kubrick, Sellers takes on the memorable role of playwright Clare Quilty, who also develops an unhealthy fascination with Lolita. He follows her wearing various disguises, again playing to his strengths as an actor and performer. He received his first Golden Globe nomination for Best Supporting Actor for the movie.

After *Lolita,* he followed that up with several studio comedies, before taking on the iconic role of his career, that of bumbling Inspector Jacque Clousseau in *The Pink Panther* films. He would end up acting in *The Pink Panther* and its subsequent four sequels. [Editor's Note: Chapter 27.]

With the success of *The Pink Panther,* he had the chance to reunite with brilliant writer-director Stanley Kubrick. Playing multiple roles, as he had in *The Mouse That Roared,* he lit up the screen as Captain Mandrake, President Merkin Muffley, and as the title character in 1964's *Dr. Strangelove: or How I Learned to Stop Worrying and Love the Bomb.* [Editor's Note: Chapter 23.]

After *Dr. Strangelove,* he did thirty more movies, such as the James Bond comedy film *Casino Royale* with Woody Allen, the Agatha Christie parody *Murder by Death,* and more *Pink Panthers* before he hit upon the role in a special movie that gandered a lot of attention.

Being There (1989)

Peter Sellers received his only Oscar nomination for this satire about the media and society as naïve television watcher Chance the Gardener. After a car accident, the simpleton is mistaken for an upper-class educated man, and soon his comments about gardening are mistaken for sage advice and wisdom to the President of the United States.

The film showed the breadth of Sellers's abilities in channeling a single character. It was said he disappeared completely into his characters during filming, and in this film, it clearly paid off. Both audiences and critics applauded his work. He won the Golden Globe for Best Actor–Musical or Comedy and the film is the #26 movie on the AFI Great Comedy Films list.

In all, Peter Sellers was nominated for Best Actor for *Being There* and *Dr. Strangelove*. He was nominated for three Golden Globes: *The Pink Panther* (1963), *The Return of the Pink Panther* (1975), and *The Pink Panther Strikes Again* (1976). He appeared in eighty-nine American and British films and television shows and passed away from a heart attack at age fifty-four.

©Philip Pilosian/Shutterstock.com

Who Is Dustin Hoffman?

Born in Los Angeles in 1937, Hoffman originally wanted to be a piano player, but found a love for acting when he took classes at Santa Monica College. He met Gene Hackman at the Pasadena Playhouse and went with him to New York City and together they roomed with Robert Duvall as the three of them struggled to make it in the acting world.

In New York, he attended The Actor's Studio and learned method acting from Lee Strasburg (just as Marilyn Monroe and Gene Wilder had done), and acted onstage and in small television and feature roles. In 1967, Mike Nichols came along with a little movie called *The Graduate*, and Hoffman's career blew up. Check out the Super Great Movie Spotlight on *The Graduate* in Chapter 26.

©Tinseltown/Shutterstock.com

Dustin Hoffman

Part of Hoffman's charm was that he didn't look like the typical movie star. This was the time in Hollywood where the sheen of celebrity was giving way to the realism of the counterculture. Hoffman's acting prowess was vital because he didn't have movie star looks to carry him through roles. Other actors with this neo-realism and non-reliance on physical looks include Al Pacino and Richard Dreyfuss.

Hoffman's roles steered him away from comedy in such exceptional films as *Midnight Cowboy* (1969), *Little Big Man* (1970), *Straw Dogs* (1971), *Papillon* (1973), and *All the President's Men* (1976).

Dustin Hoffman plays Benjamin Braddock in *The Graduate* (1967)

The Official Dustin Hoffman Top 3 Great Comedy Film Checklist:*

*(films that are not *The Graduate* edition)

Lenny (1974)

Oscar-winning director Bob Fosse (*Cabaret*) brought this autobiographical story of the legendary controversial stand-up comic Lenny Bruce with Hoffman in the title role. Hoffman shows us all aspects of his life, from battling the censors, his family responsibilities, and his drug and alcohol addictions that lead to his untimely death. Okay, maybe it's not so much a comedy, but he does perform comedy. Is that close enough? [Editor's Note: We'll cut you some slack on this one. We're not monsters.] Dustin received his second Oscar nomination for Best Actor, and the film was also nominated for Best Picture, Director, Actress, Screenplay, and Cinematography.

Tootsie (1982)

This was a big film. A monster film. One of the biggest in film comedy history. In fact, it's the #2 movie on the AFI 100 Years. . . 100 Laughs List. That's how big. In the tradition of *Some Like It Hot*, it's another film that proves that guys who dress like girls in the movies to deceive people is the funniest thing ever made.

Out-of-work actor Michael Dorsey is in a bind. He's got a terrible reputation and no one will hire him. When he hears about a part for a female Hospital Administrator on the popular

Dustin Hoffman in *Tootsie*

daytime soap opera, *Southwest General,* he dresses up as a woman and auditions for the role. And gets it.

Not content to playing a typical swooning female role, Dorothy (as Michael is now called) becomes a strong-willed character on the show, and immediately becomes a media sensation. Only his agent George (director Sydney Pollock pulling double duty) and Michael's roommate Jeff (a sublime Bill Murray) share his secret. They hide it from the world and even from Michael's friend-turned-girlfriend Sandy (Teri Garr), who he has sex with in order to hide the fact that he's trying on her clothes.

Things come to a head when Dorothy confronts *Southwest General*'s egotistical TV Director Ron Carlisle (Dabney Coleman), a misogynist who disrespects all women in general and his/ her co-star Julie Nichols (Jessica Lange). Worse, Dorothy is on the run from two men interested in being with "her," Julie's father (Charles Durning) and Dr. John Van Horn (a slimy George Gaynes), the chief of staff on the show and a constant womanizer.

How does Michael survive? What happens when his contract is extended? Can he be with Julie? What about Sandy? What about the two old guys both vying for the heart of Dorothy?

Tootsie was a massive achievement—the second highest-grossing film of the year bringing in over $170 million (behind Spielberg's *E.T.*). The film was nominated for ten Oscars, including Best Picture, Best Actor (Hoffman), Best Supporting Actress (Garr), Best Director, Best Screenplay, Best Song, Best Sound, Best Cinematography, and Best Editing and won Best Actress for Jessica Lange.

Tootsie won the Golden Globe for Best Picture–Musical or Comedy and Dustin Hoffman won Best Actor and Jessica Lange won the Best Actress. The film is the #62 movie on the AFI Great Movies List besides its #2 ranking on the 100 Years . . . 100 Laughs List. In 1998, *Tootsie* was chosen by the Library of Congress to be placed in the National Film Registry.

Wag the Dog (1997)

In this sublime satire on the media and politics from director Barry Levinson (*Diner, Rainman*), political consultant Conrad Brean (Robert De Niro) is forced to come up with a distraction to protect the current President's next election chances. He decides to create a fictional war and enlists famed Hollywood producer Stanley Motss (Hoffman) to handle the marketing campaign, including filming fake war footage, a theme song, and finding a "war hero" (who ends up being criminally insane).

Dustin Hoffman wins the Golden Globe for Best Actor for *Rainman*

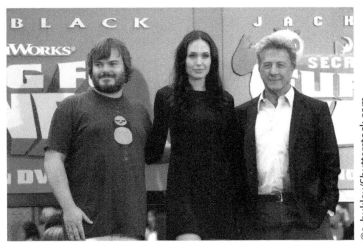

Recent work from Dustin Hoffman includes his voice-over work for the animated *Kung-Fu Panda* film franchise with Jack Black and Angelina Jolie

Along the way, Motss is content to stay deep behind-the-scenes, but his ego gets the better of him, and he demands that Brean tell the world about his involvement in the whole affair. Which may not be the best idea . . .

The film came out a month before President Bill Clinton's affair with intern Monica Lewinsky was made public, which led to a lot of interest in the movie. The film grossed over $60 million and the critics loved it. Dustin Hoffman was nominated for a Best Actor Oscar, along with Hilary Henkin and David Mamet for Best Original Screenplay.

Dustin Hoffman has appeared in eighty films and television programs, has been nominated for seven Best Actor Oscars and won two, for *Kramer vs. Kramer* (1979) and *Rainman* (1989). He's been nominated for eleven Golden Globe awards and won Best Actor Awards for *Kramer vs. Kramer (1979), Tootsie (1982),* his TV-movie *Death of a Salesman* (1985), and *Rainman (1989).*

He also won Best Promising Newcomer for *The Graduate* and received a Lifetime Achievement Award from the AFI in 1999.

Who Is Paul Newman?

Okay, to give one of the biggest movie stars in history, the celebrated Oscar winner Paul Newman a miserable three-and-a-half pages in this book is a freaking outrage. I know, I know. But this chapter is already getting long. So let's just focus on his comedy work.

Born in 1925, he started acting when he was seven, and appeared onstage in Cleveland at the age of ten. Studied theatre at Ohio University and then left college to serve in the Navy during World War II. After the war, he went back to school and started acting onstage. Then he attended Yale for a year to study acting. He moved to New York City to study with Lee Strasburg at the Actor's Studio in New York City, where Marilyn Monroe, Gene Wilder, and Dustin Hoffman all studied method acting.

Paul Newman

He was successful on Broadway and moved to Hollywood where he competed against James Dean for roles. He broke in to leading-man status as boxer Rocky Graziano in *Somebody Up There Likes Me* (1958) and gained his first Oscar nomination for Best Actor in his next film, *Cat on a Hot Tin Roof*, based on the Tennessee Williams play and costarring Liz Taylor.

He appeared in sixty-three films as well as directing three of them all featuring his wife, the celebrated actress Joanne Woodward. He was nominated for ten Best Actor nominations and won for the amazing Martin Scorsese's 1986 film *The Color of Money*. Some of the more popular titles include: *The Hustler* (1961), *Hud* (1963), *Cool Hand Luke* (1967), *Butch Cassidy and the Sundance Kid* (1969), *Absence of Malice* (1981), *The Verdict* (1982), and my son Luke loved his voice-over work in *Cars* (2006).

But he did comedies too!

The Official Paul Newman Top 3 Great Comedy Film Checklist

The Sting (1973)

Paul Newman had a great relationship with Oscar-winning actor Robert Redford. They re-teamed after their celebrated film *Butch Cassidy and the Sundance Kid* (1969) to star in this caper comedy about two con men out to bilk a nefarious crime boss with an elaborate scheme involving a fake betting parlor.

The film was a box office smash, earning $160 million. It was also nominated for ten Oscars, Best Actor (Redford), Best Cinematography, Best Sound, and won a whopping seven, including Best Picture, Best Director, Best Original Screenplay, Best Art Direction, Best Costume Design, Best Editing, and Best Music. In 2005, *The Sting* was placed in the National Film Registry by the Library of Congress.

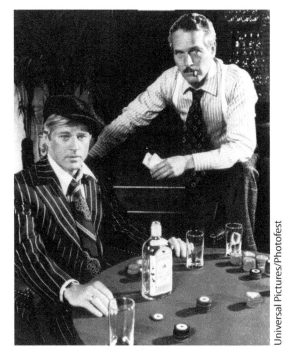

Universal Pictures/Photofest

Extremely good-looking actors Robert Redford and Paul Newman reunited after *Butch Cassidy and the Sundance Kid* to play con artists in the Oscar-winning Best Picture *The Sting* (1973)

Slap Shot (1977)

You like sports comedy? This is one of the best. Sure, it's not in the National Film Registry, but *Maxim Magazine* named it the "Best Guy Movie" in 1998. Set in the world of professional hockey, the Charlestown Chiefs haven't gone to the playoffs in forever. Newman plays foul-mouthed Reggie Dunlop, the Chief's player/coach who's faced with the team's imminent bankruptcy. The team's fortune changes when they bring in the Hanson Brothers, three siblings that love to fight on the ice.

And fight they do and with every brawl the team gets more and more popular. They're headed to the championship, even though the Chief's wealthy and indifferent owner would rather fold the team for the tax write-off. This is said to be one of Newman's favorite films.

Nobody's Fool (1994)

One of the last films that Newman did. This gentle homespun favorite features Newman as "Sully" Sullivan, a carefree soul living in upstate New York. He spends his days suing his former boss, played by Bruce Willis, flirting with his wife (Melanie Griffith), and stealing his snowblower. But life changes for Sully when his estranged son Peter (Dylan Walsh) and grandson Will (Alexander Goodwin) come to live with him after a fight with Peter's wife. In the end, Sully's life has changed for the better.

Paul Newman

Nobody's Fool earned moderate revenue and the columnists hailed Newman's performance. He was nominated for a Best Actor Oscar and a Golden Globe Best Actor award and won both the National Society of Film and the prestigious New York Film Critics Circle Award for Best Actor.

He was a great philanthropist (Newman's Own brands of salad dressing and salsa with all proceeds going to charity), avid race car driver, devoted husband and family man who didn't live in Hollywood. He was awarded an Oscar Lifetime Achievement Award and passed away from lung cancer in 2008, leaving behind a magnificent legacy of cinematic masterpieces.

©Everett Collection/Shutterstock.com

Who Is Burt Reynolds?

A former college halfback from Florida State University who was injured and never saw the football field. Burt had never considered acting until one of his FSU professors suggested he try out for a play. Once the acting bug hit, there was no stopping him. He was an award-winning actor in college and soon he was in New York, taking acting classes and soon he found his way to Hollywood.

He went up the ranks, getting leading roles in B-movies and worked the television ladder until he got his first starring role in *Dan August*. He played a homicide detective and was nominated for a Best Actor Emmy. He moved exclusively to film and in 1972 starred in the classic thriller *Deliverance*, which was a giant box office triumph. The instrumental "Dueling Banjos" won a Grammy Award, and *Deliverance* was nominated for three Oscars including Best Picture. Then he switched to comedy, which made him one of the biggest movie stars in America.

The Official Burt Reynolds Top 3 Great Comedy Film Checklist

The Longest Yard (1974)

Former NFL quarterback Paul "Wrecking" Crewe (Reynolds) orchestrates a prison football game between the guards and the inmates in this sports comedy (remade by Adam Sandler in 2005). It won the Golden Globe for Best Picture—Musical or Comedy and Reynolds was nominated for Best Actor.

Burt Reynolds

Smokey and the Bandit (1977)

Bo "Bandit" Darville (Reynolds) takes a bet to deliver a truckload of beer cross-country in 28 hours. He enlists Cledus "Snowman" Snow (country music star Jerry Reed) to help him, all the while evading Sheriff Buford T. Justice (legendary TV comedian Jackie Gleason) and falling for runaway bride Carrie (Sally Field) along the way. Critics weren't fans but it was huge making over $125 million and spawning two sequels.

The Cannonball Run (1981)

In the spirit of Stanley Kramer's *It's a Mad Mad Mad Mad World* and Blake Edwards's *The Great Race*, it's a slapstick cross-country race following seven teams as they sprint to California. There's a monster ensemble cast including Reynolds, Dom DeLuise, Dean Martin, Sammy Davis Jr., Jackie Chan, Pittsburgh Steelers Quarterback Terry Bradshaw, and Roger Moore (spoofing his own James Bond alter ego)—another sensation and of course it produced a sequel.

Unfortunately, he hit a dry spell that he never recovered from after his film, *Stroker Ace* megabombed at the box office in 1983. He went back to television and won a Golden Globe for the 1990–1994 CBS sitcom *Evening Shade*, and his film career resumed when he won a Golden Globe and was nominated for a Best Supporting Actor Oscar

Burt Reynolds attends the Golden Globes for *Boogie Nights* and later won the Best Supporting Actor Award

for his role as porn filmmaker Jack Horner in the 1997 hit *Boogie Nights*. You should see that one too. It's a good one, but because it's not a comedy, I can't write a whole paragraph about it.

These four performers were film comedy icons of the 1970s, 1980s, and a little bit of the 1990s as well. Their Hollywood films kept the movie studios in business as the "New Hollywood" filmmakers slowly fell by the wayside. Soon the age of the block-buster film would arrive, and comedies would have to adapt or get out of the way.

CHAPTER 30

SUPER GREAT MOVIE SPOTLIGHT

M*A*S*H
(1970)

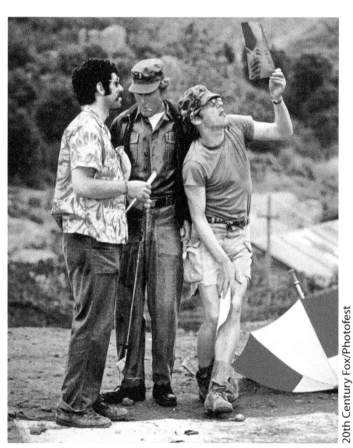

Elliot Gould and Donald Sutherland star in *M*A*S*H* (1970)

- ▶ Starring Donald Sutherland, Elliot Gould, Tom Skerritt, and Sally Kellerman
- ▶ Directed by Robert Altman
- ▶ Screenplay by Ring Lardner, Jr.
- ▶ Based on the novel *MASH: A Novel About Three Army Doctors* by Richard Hooker
- ▶ Subgenres: Black Comedy, Satire, Fish-out-of-Water
- ▶ Comedy types: Black and Dark Comedy, Verbal, Slapstick

"All right, Bub, your fuckin' head is coming right off."

—"Painless" Waldowski (John Schuck)

[Editor's Note: Not only is this the first time that the author dropped an F-bomb in this book, but this line is the VERY FIRST TIME IN A MOVIE where someone used the F-word. We have our own researchers here as well.]

The late 1960s and early 1970s were called the "New Hollywood" or "The Second Golden Age" because writers and directors told personal character-driven movies that flew in the face of conservative film studio mentality. *M*A*S*H* was another film like *Easy Rider, Bonnie and Clyde* and *The Graduate*, films directed straight at the youth of America. And there was nothing more disillusioning than war—especially since the Vietnam War was a big part of the landscape, which made this film's satiric look at wartime especially appetizing from an audience standpoint.

Compared to the early military comedies of Abbot and Costello or Martin and Lewis, *M*A*S*H* came from a different planet.

Director Robert Altman originally came from the world of documentary filmmaking. His use of handheld cameras and zoom ins-and-outs give the movie an immediate and realistic feel. Altman makes you feel like you are there, and this was a completely different style of filmmaking about war than any Hollywood movie had ever done.

There's blood and gore aplenty during the surgical scenes, far more than had ever been seen in a movie either. There is nothing glamorous about this movie. The movie looks at war and the human beings involved as they dance delicately on a razor blade between sanity and insanity.

Everyone who works at this Mobile Army Surgical Hospital (M*A*S*H) #4077 is a lunatic. These irreverent pranksters are recording people having sex and broadcasting it across the camp, and then the next minute they are hacking and sawing through bone to save someone's life.

It's ironic that *M*A*S*H* came out in the same year as George C. Scott's *Patton* because there have never been two films so diametrically opposite in their cinematic interpretations of war.

Summary

During the Korean War, the 4077th Mobile Army Surgical Hospital is a medical unit that serves as a fully functioning hospital in combat operations. The 4077th consists of four surgeons, ten nurses, and fifty-sixty enlisted men. Surgeons rotate from stateside, and the three newest surgeons, Captain "Hawkeye" Pierce (Donald Sutherland), "Duke" Forrest (Tom Skerritt), and "Trapper" John McIntyre (Elliot Gould) arrive for their assignment. Because they're civilians, their attitude is decidedly un-military. They're insubordinate, don't wear uniforms, and don't hesitate to speak their mind.

The film is very episodic with several small stories instead of one overarching storyline. Hawkeye, Duke, and Trapper find themselves constantly battling Major Frank Burns (Robert DuVall) and Chief Nurse Major Margaret Houlihan (Sally Kellerman) who the surgeons have dubbed "Hot Lips" after planting a microphone in her tent to broadcast her having sex with Burns to the entire hospital through the P.A. speaker. The *M*A*S*H* commander, Henry Blake (Roger Bowen) doesn't care for Burns and Houlihan's threats to go over his head—these guys are damn good surgeons and he's not getting rid of them.

There's a lot of great stuff in here, including officers being committed to mental institutions, a lot of sex, Hawkeye and Trapper go on a field trip to Japan to operate on a Congressman's son, and a whole lot more.

Best Scenes

Painless Commits Suicide—The hospital dentist believes he has latent homosexuality due to his sexual failure with a nurse. Hawkeye comes up with a plan to help him kill himself.

The Bet About Hot Lips—Duke bets Hawkeye that Hot Lips isn't a natural blonde, and the two devise a clever way to see for themselves.

The Football Game—The 4077 takes some big bets to play football against one of the other *M*A*S*H* units. As you can guess by now, there will be some trickery involved to try to win the game.

Awards and Recognition

*M*A*S*H* was nominated for five Academy Awards, including Best Picture (ironically losing to Patton), Best Director (again losing to Patton), Best Supporting Actress for Sally Kellerman, and Best Film Editing (lost again to Patton). It did win the Academy Award for Best Adapted Screenplay for Ring Lardner, Jr. (who had been a blacklisted screenwriter during the 1950s) based on the true-life adventures of Richard Hooker's novel.

*M*A*S*H* won the Golden Glove for Best Motion Picture–Musical or Comedy and also the Palme d'Or at the 1970 Cannes Film Festival.

A very successful TV series, also titled *M*A*S*H* was broadcast on the CBS Television Network starting in 1972. The only member of the movie's cast to move on to the television show was Gary Burghoff, reprising his role as Col. Blake's right-hand man, "Radar" O'Reilly. The show ran for eleven years and after it found its audience in 1974, the series was in the top 10 most-watched programs for eight of its nine subsequent seasons.

The final episode in 1983 is still the most-watched and highest-rated single television episode in TV history, with over 125 million viewers. It was nominated for over 100 Emmy Awards and won fourteen including Outstanding Comedy Series and Best Lead Actor for Alan Alda who took over the Hawkeye Pierce role from Donald Sutherland for TV.

*M*A*S*H* is the #7 movie on the AFI 100 Years . . . 100 Laughs List and the #54 movie on the AFI list of Greatest Movies Ever. It's also the #17 film on the Bravo Network's "100 Funniest Movie" list and in 1996, the Library of Congress placed *M*A*S*H* in the National Film Registry.

CHAPTER 31

ARTIST SPOTLIGHT

Woody Allen

Academy-award winning writer-director-actor
Woody Allen

CHAPTER FOCUS

- ▶ The Early Years
- ▶ Comedy Genius on a Roll
- ▶ The Movies after *Annie Hall*
- ▶ Personal Problems and More Movies
- ▶ By the Numbers

Chapter Focus

If you know movies, you know Woody Allen. You might like him, you might hate him, but chances are if you don't like him, you've probably missed most of his films.

He's an actor/writer/director/musician that single-handedly changed comedy. He's the Charlie Chaplin of the latter twentieth century and, like Chaplin, he had a host of personal issues that derailed his audience, but he still does what he does. Every year like clockwork, he writes and directs a movie. He doesn't act as much as he used to, probably because it seems weird that in his movies he's dating twenty-year-old actresses.

He's also eccentric as all get-out. He'd rather play the clarinet at a New York City nightclub than go to the sixteen years of Academy Awards when he was nominated for an Oscar. He didn't even go in 1977, when *Annie Hall* won Best Picture. He doesn't believe that film-

Woody Allen

©catwalker/Shutterstock.com

makers should be competing for anything since they are all artists. He's also had a host of personal issues that have outraged people across the world and detracted from the amazing body of work that he has made.

The Early Years

Much like every entertainer that started before 1965, Woody Allen is a stage name. He was born Allen Konigsberg to Jewish parents in 1935 and grew up in Brooklyn. He wrote and directed a very autobiographical movie that is about growing up, *Radio Days*. His parents fought, his mother was overbearing (the clichéd Jewish mother), and he channeled his home life stress into writing jokes to make money starting at fifteen years old. He was like the Mozart of comedy writers.

At age seventeen, he legally changed his name to Heywood Allen and eventually started going by Woody. Ever the go-getter, he started selling jokes to newspaper writers and Broadway producers, and his jokes got to television personalities like Sid Caesar from *Your Show of Shows*. He moved to Los Angeles after being hired by NBC to write for various shows at the tender age of nineteen. Amazing stuff!

He also married his first of three wives, Harlen Rosen, in 1955. She was seventeen and he was twenty at the time. The marriage lasted three years, and the relationship was great fodder for his jokes.

It's said that he could write jokes for fifteen hours a day, and before long he started writing jokes for himself, instead of others, to start his own stand-up comedy career in 1960. He worked the circuit for almost ten years with such legendary acts as the controversial Lenny Bruce and the improv team of Nichols and May. He honed his nebbish persona and focused on the little details of society and culture and avoided politics. His style was more conversational and observational, as opposed to performing, and he never improvised. His low-key style was groundbreaking and influenced the next generation of stand-up comics.

He was starting to be everywhere. He recorded his stand-up routine and released records, took his routine back to television, performing on *The Tonight Show*. In 1964, he actually had his own show (look what happens when you start doing research—I had no idea he did that until I started this book!).

While on the circuit, he met actress Shirley MacLaine (*The Apartment*) and she introduced him to producer Charles K. Feldman, who hired Woody to write and act in the 1965 feature film, *What's New Pussycat*. He wrote (with Mickey Rose) and directed his first film, *What's Up, Tiger Lily* in 1966. Directed is a bit of a loose term, he took the 1965 Japanese film *International Secret Police: Key of Keys* and redubbed it into a spy comedy searching for a top-secret recipe for egg salad. That same year, he also started writing short stories for *The New Yorker*. (Reading stuff like this really pisses me off. What did I do last year? I washed my car three times and learned how to program my DVR.)

Because 1966 wasn't busy enough, he wrote his first Broadway play, *Don't Drink the Water*, which came to Broadway in 1968 and was eventually adapted into a 1969 movie starring legendary TV comic Jackie Gleason. It's said that Woody was so disappointed with the film that he vowed that when he got the chance that he would never let anyone direct his work ever again. He'd have to wait on that one. He also married his second wife, actress Louise Lasser, and she would appear in three of his films. Their marriage ended in 1970.

In 1967, he had a major role in the James Bond film *Casino Royale*, where he played Bond's nephew. Instead of a serious film it was a broad comedy starring David Niven in the title role and was a parody of the Bond films. It was also a dud. It was remade as a real movie with Daniel Craig as the iconic spy.

In 1968, he wrote his second Broadway production, *Play It Again, Sam*. This Tony award-nominated romantic comedy was about a schmuck who leans on the ghost of Humphrey Bogart for dating advice which ran for over 400 performances. This time, Woody was the star of the show, and he met both actor Tony Roberts and young actress Diane Keaton. Subsequently, they would co-star with him in a number of films, and Woody and Diane Keaton had a short-term romance, which eventually led to a long friendship.

Besides the success of *Play It Again, Sam*, 1969 would be the watershed year for Woody Allen. He finally got to write and direct his first live-action film:

Take the Money and Run (1969)

In one of the first mockumentaries ever made, Woody stars as Virgil Starkwell, one of the world's worst criminals. When I say "worst," I'm not talking insidious and evil. I'm talking wildly incompetent and extremely unlucky. In a story told with stock footage and interviews with Virgil and those who know him (including his parents who wear Groucho Marx disguises to hide their shame), we watch as Virgil's sad life unfolds.

Cinerama Releasing Corporation/Photofest

Woody Allen as Virgil Starkwell, one of the world's worst criminals

Virgil getting bullied as a kid when the big kids take his glasses off his face and crushes them with his foot and then when he's bullied as an adult, they break his glasses the exact same way. His clumsy attempt to rob his first bank with a hold-up note that the teller can't read. He ends up in prison and tries to escape with a gun carved out of a piece of soap. When he gets outside, it's raining and the soap gun melts. I think you get the idea.

It's eighty-five minutes of slapstick and verbal comedy, served at a frenetic pace that became Woody's style for his next few movies. Though the film wasn't a box office hit, the critics were positive and Woody scored a three-picture deal from United Artists. *Take the Money and Run* is ranked as the #67 film on the AFI Great Comedy Films list.

Comedy Genius on a Roll

Woody reached a bellwether of early success. His next five films would cement himself as a comedic force to be reckoned with, and marked a run of success that would have even made Charlie Chaplin green with envy.

Bananas (1971)

In his third feature, Woody plays neurotic and clumsy Fielding Melish, who finds himself trying to impress social activist Marie (Louise Lasser) into going out with him. He goes to the small island of San Marcos, where rebels have assassinated the President (in a hilarious scene told as a segment on ABC's *Wide World of Sports* with host Howard Cosell providing commentary) and offers to help and ends up joining the revolution. One thing leads to another, and Fielding is given the office of President.

He returns to the United States to reunite with Maria and is arrested. He's on trial for his life and the odds seem against him. He's forced to cross-examine himself:

> "I object your honor. This trial is a travesty. It's a travesty of a mockery of a sham of a mockery of a travesty of two mockeries of a sham. I move for a mistrial."

Will Fielding be found guilty? What will happen to him and Maria? What about the country of San Marcos? Check it out on your own time!

Bananas was a big hit for Woody, costing the studio $2 million and earning $11 million. The critics loved it and the film is ranked the #69 movie on the AFI 100 Years . . . 100 Laughs List.

1972 found Woody on two different projects. First, he reprised his starring role in the film adaptation of his Broadway show, *Play It Again, Sam*. The big difference in this film is that Woody didn't direct. It was directed by Herbert Ross, who also directed Neil Simon's film adaptation of his stage plays *The Sunshine Boys* and *The Goodbye Girl*. The film was a hit with audiences and critics.

Secondly, he also got to write and direct his fourth feature.

Everything You Always Wanted to Know about Sex (But Were Afraid to Ask) (1974)

This is an ensemble sketch comedy film based very loosely (as in "not at all") on the best-selling sex manuals written by Dr. David Rubens.

This film featured seven stories with a different cast for each segment, including Woody, Gene Wilder, Louise Lasser, Tony Randall, and Burt Reynolds. Such titles as "What Happens During Ejaculation," which takes place in a man's brain that looks like NASA mission control, "What are Sex Perverts?" a game show where contestants try to guess someone's sexual perversion, and "What is Sodomy?" where a doctor falls in love with a sheep. The film was a major score for United Artists and for Woody Allen, making $18 million from a budget of $2 million. Mazeltov!

His next film would be another huge film for United Artists and Woody Allen.

Sleeper (1973)

Woody enters the world of science fiction in his satirical fish out of water story (co-writing with Marshall Brickman) about Miles Monroe (Woody Allen) a health food store-owner who is accidentally cryogenically frozen (called cryopreservation in the film, but everyone who's seen *Alien* knows it's really *cryogenically frozen*). He wakes up 200 years in the future by a group of scientists hoping to use him to overthrow an Orwellian government by stopping the mysterious "Aries Project."

When the government finds out about his existence, they send the police to arrest him. He ends up meeting and

United Artists/Photofest

George Lucas said that Woody's disguise as a robot in *Sleeper* (1973) inspired him to create C-3PO in the *Star Wars* films. [Editors's Note: He's totally making that one up.]

kidnapping wealthy socialite Luna Schlosser (Diane Keaton) and when the two fall in love he asks her to help him stop the "Aries Project."

Several hilarious slapstick and screwball scenes in this movie, including Miles's discovering the "Orgasmatron"—a phone booth size chamber, a brainwashing scene where Miles is captured by the Government and turned into a compliant citizen, and his robot disguised escape.

Here's a great Woody Allen line from *Sleeper*, responding to Luna asking Miles what he believes in:

> "Sex and death—two things that come once in a lifetime—
> but at least after death you're not nauseous."

This was another sales success, and the critics loved this film as opposed to the mixed reviews for *Everything You Always . . .* The movie is ranked as the eightieth film on the AFI 100 Years . . . 100 Laughs List.

Love and Death (1975)

His next film was from a little denser source material. This satire on Russian literature follows the sorrowful tale (aren't all Russian novels sorrowful) of Boris Grushenko (Woody Allen), a Russian soldier set to defend his homeland against Napoleon's invading army. When he becomes a hero, he has the chance to be with Sonja (Diane Keaton) who he has always loved, but she only has eyes for his brother Ivan.

Sonja decides that the only way that she and Boris can be together is to kill Napoleon. Will they succeed? I don't remember from my high school social studies class that Bonaparte died at the hand of a neurotic Russian.

If you love Leo Tolstoy and the filmmaking of Sergei Eisenstein (and with that, 95 percent of you just tuned out) then *Love and Death* is for you! Even though I'm not a fan of the movie, it still made over $20 million on a budget of $3 million. United Artists and their accountants were officially in love with Woody Allen.

In 1976, Woody starred in his first dramatic role in *The Front* for director Martin Ritt. The movie follows a blacklisted Hollywood screenwriter during the Red Scare, the Hollywood Ten, and the HUAC hearing of Senator Joe McCarthy. The story follows supposed Communist Alfred Miller (Michael Murphy) who hires Howard Prince (Woody Allen) to act as his "front" to sell screenplays for him. The film was nominated for a Best Original Screenplay Oscar and Woody was touted for his excellent acting performance.

The biggest year in Woody Allen's career was 1977. He made the film that defined him and is considered one of the most successful comedies in the history of motion pictures. Check out my Super Movie Spotlight of *Annie Hall* in Chapter 28.

Annie Hall's success opened the door for Woody to produce more mature films than his previous slapstick movies. Winning a Best Picture, Best Director, and a Best Original Screenplay Oscar (with Marshall Brickman) will do that to you. Now a serious filmmaker, Woody wrote and directed 1978's *Interiors*.

Woody's first drama was influenced on the intimate style of Swedish director Ingmar Bergman, telling the dysfunctional family tale of three sisters (featuring actresses Diane Keaton, Kristen Griffith, and Mary Beth Hurt) dealing with the aftermath of their parents' divorce.

Woody's comic fans were disappointed, but the film was nominated for five Oscars, including Woody for Best Director and Best Original Screenplay.

The Movies after *Annie Hall*

His next film would be the movie that married the humor of *Annie Hall* with the nuanced relationships of *Interiors* to create a very special film that laid the foundation for Woody's work over the next thirty years.

Manhattan (1979)

This romantic comedy drama directed by Woody Allen from a script he co-wrote with *Annie Hall* writer Marshall Brickman tells the story of a love triangle set against the beautiful backdrop of the city of Manhattan. Beautifully shot by *Annie Hall* cinematographer Gordon Willis, the movie follows twice-divorced writer Isaac Davis (Woody Allen) who has just quit his job to focus on his new book, while dealing with his ex-wife Jill (Meryl Streep) who is writing her own book about Isaac and Mary's doomed relationship. On the bright side, he's currently dating Tracy (Mariel Hemingway), a seventeen-year-old who dreams of being an actress. In a typical Woody Allen conflict, he's not sure that there is a future due to their twenty-five year age difference. (Don't be an idiot, Isaac!)

Isaac's life gets complicated when he meets Mary (Diane Keaton), the mistress of his friend, and falls for her. Just like Woody's Alvy Singer from *Annie Hall*, there are no happy endings when it comes to finding love in the big city.

United Artists/Photofest

Manhattan was a sensational hit, becoming Woody's most profitable film to date with a gross of $39 million. The movie was nominated for two Oscars, Best Supporting Actress for Mariel Hemingway and Best Original Screenplay for Woody Allen and Marshall Brickman. The movie won Best Picture at the British Academy Awards and is listed as the #46 film on the AFI Great Comedy Film list and the #66 film on the AFI Great Romantic Films list. In 2001, *Manhattan* was selected by the Library of Congress to be included in the National Film Registry.

From there, Woody Allen could do anything he wanted. His films are character-based movies that celebrate the human spirit and all of its comedy and drama. Some of his notable comedies from the 1980s include *Stardust Memories* (1980) which follows the story of Sandy Bates (Woody Allen), a filmmaker dealing with his fans. (I'm going out on a limb and saying that this movie could be based on some of Woody's personal experiences.)

A Midsummer Night's Sex Comedy (1982)

This farce follows three couples on a weekend in the country. The movie is noted as the first film that Mia Farrow, Woody's soon-to-be significant other would star. They would go on to make a total of thirteen films together.

Zelig (1983)

Woody took the mockumentary concept from *Take the Money and Run,* and crafted this incredible film about Leonard Zelig. He's a man so desperate to be liked that he becomes a social chameleon. The forbearer of Robert Zemekis's Oscar-winning Best Picture *Forest Gump*, it had stock footage from historical scenes where Zelig appears with such celebrities as Al Capone, Charlie Chaplin, Adolph Hitler, James Cagney, and Pope Pius XI. The film received Oscar nominations for Best Cinematography (Gordon Willis) and for Best Costume Design.

Broadway Danny Rose (1984)

Another broad comedy, Woody plays the title character, an unsuccessful talent manager in New York City that helps out his client Lou by bringing his mistress Tina to his concert without Lou's wife finding out. But Danny's in trouble when Tina's ex-boyfriend (with mafia ties) goes after Danny, believing him to be Tina's current squeeze.

The Purple Rose of Cairo (1985)

Woody wrote and directed this story of Cecelia (Mia Farrow) who hides out at the movie theatre to escape her abusive husband. Film character Tom (Jeff Daniels) steps out of the movie (similar to Buster Keaton's Sherlock Jr.) after falling in love with her. Unfortunately, the world inside the movie is in trouble when Tom left to be with Cecelia. Universally beloved by critics, it won the BAFTA Best Picture Award and was nominated for the Best Original Screenplay Oscar.

Hannah and Her Sisters (1986)

This film is another fine balancing act between comedy and drama like *Manhattan* before it. The movie follows Hannah (Mia Farrow) and her two sisters, Lee (Barbara Hershey) and Holly (Dianne Wiest), through vignettes of their lives. Elliot (Michael Caine) is married to Hannah but is in love with Lee. Hannah's ex-husband and TV writer, Mickey (Woody), suffers an existential crisis and tries to commit suicide but might be interested in Holly.

This was the second-most critically acclaimed of Woody's movies, getting seven Oscar nominations including Best Picture, Best Director, Best Art Direction, Best Editing, and won three: Best Original Screenplay, Best Supporting Actor (Michael Caine), and Best Supporting Actress (Dianne Wiest). This is the film that fortified Woody's ability to write and direct for actors and create amazing Oscar worthy roles.

Crimes and Misdemeanors (1989)

Crimes and Misdemeanors is a darker film about marital infidelity that still has some great comedic moments.

In *Crimes and Misdemeanors,* a New York doctor (Martin Landau) struggles with the choice of having his mistress killed after she threatens to tell his wife. The second neurotic film-maker (Woody) contemplates having an affair while filming a documentary about his pompous brother-in-law. My favorite scene is where Woody learns about the definition of comedy as "tragedy + time." Basically after a certain amount of time, everything is funny. So when President Lincoln was assassinated, you couldn't make fun of it. But a century later, it's open game.

Woody was nominated for Best Director and Best Original Screenplay, and Martin Landau was nominated for Best Supporting Actor.

Radio Days (1987)

Radio Days follows Woody Allen's character, Joe, as he reminisces on growing up in the 1930s and 40s and how the radio and its personalities heard every week were the entertainment focal point of American lives. Mia Farrow, Dianne Weist, and Julie Kavner all star in a series of vignettes that celebrate the golden age of radio.

Personal Problems and More Movies

In the 1990s, Allen's personal life became tabloid fodder. He had been romantically involved with Mia Farrow since 1982, and he had even adopted two of her younger children. Then she came home to find nude photos of Farrow's twenty-one-year-old adopted daughter Soon-Yi Preven. Woody and Mia split and he went on to marry Soon-Yi in 1997. Okay, it's a little creepy. She's his girlfriend's adopted daughter and he's thirty-five years older than her.

Woody Allen and Soon-Yi

Woody with Soon-Yi

Remember I was talking about the similarities between Charlie Chaplin and Woody Allen? Chaplin also had a fondness for young women, which got him in a bunch of

trouble [Editor's Note: See Chapter 3 for a refresher] and Woody was no exception. He lost a ton of respect and a legion of fans that saw him as a pervert.

If that's not enough, after Mia and Woody broke up, he was accused of sexually abusing Farrow's seven-year-old daughter Dylan. The case was dropped when medical investigators concluded that Dylan had not been molested and they felt that Dylan's story was a little too rehearsed. Woody accused Mia as being so vengeful that she cooked up the whole thing to destroy him.

I'm able to forget about all that when I watch his movies. Maybe you can too?

The Official Woody Allen Top 3 Great Comedy Film Checklist from the 1990s

Mighty Aphrodite (1995)

Lenny (Woody Allen) and Amanda (Helena Bonham Carter) search for the real mother of their genius-adopted son, only to discover Linda (Academy Award-winner Mira Sorvino) is a prostitute and porn star, and also one of the dumbest people ever born. Woody won another Best Original Screenplay Oscar for this broad comedy.

Deconstructing Harry (1997)

In what appears to be slightly based on real-life, author Harry Block (Woody) examines his life through a series of flashbacks. He uses his own selfish experiences with his wives (he had three), friends, sister, and his son to try and beat his writer's block. This film scored yet another Best Original Screenplay Oscar nomination for Woody Allen.

Sweet and Lowdown (1999)

A fake biography telling the story of the greatest jazz guitarist in the world, Emmitt Ray (Best Actor nominee Sean Penn), and his complicated artist life including meeting Hattie (Best Actress Oscar nominee Emily Watson) the mute woman that he falls in love with and can't forget.

The next fifteen years marked a series of hits and misses for Woody Allen. Unfortunately, there were more misses than hits. It's funny but if you think about it Woody's so prolific that a mediocre film for him might be considered a genius movie for another filmmaker. It's unfair but when you make one of the best comedy films in history, then you're judged on a completely different level and the expectations may be a little unrealistic for audiences. Just saying.

The Official Woody Allen Top 3 Great Comedy Film Checklist from the 2000s

Match Point (2005)

A suspense film in the style of Alfred Hitchcock (and yes, I know this is a book about comedy, but this one is excellent) follows former tennis player Chris Wilton (Jonathan Rhys-Meyers). Thematically very close to Allen's previous *Crimes and Misdemeanors*, the film was another Oscar nomination for Best Original Screenplay.

Vicky Cristina Barcelona (2008)

American friends Vicky (Rebecca Hall) and Cristina (Scarlett Johansson) fly to Spain to meet renowned painter Juan Antonio (Javier Bardem), the only thing is his suicidal ex-wife, Maria (Academy Award winner Penelope Cruz). She could throw a wrench in everything. Woody's most profitable film of the decade, making nearly $100 million worldwide.

Midnight in Paris (2011)

Stuck in a marital rut, screenwriter Gil (Owen Wilson) and his wife Inez (Rachel McAdams) visit the City of Lights, and Gil is so enamored that he goes back in time where he meets such luminaries as F. Scott Fitzgerald, Ernest Hemingway, and Pablo Picasso. Woody won his fourth Oscar for Best Original Screenplay for this charming romantic comedy.

©Featureflash Photo Agency/Shutterstock.com

Woody Allen, Owen Wilson, and Rachel McAdams at the Cannes Film Festival Premiere of *Midnight in Paris*

By the Numbers

Just in case you missed it—here's but a few of his many accomplishments (he's also really big in France):

- **24** Oscar Nominations (**16** for Best Original Screenplay, **7** for Best Director, and **1** for Best Actor);

- **4** Oscar Wins (**3** for Best Original Screenplay—*Annie Hall, Hannah and Her Sisters, Midnight in Paris*—and **1** for directing *Annie Hall*);

- **24** British Academy Award Nominations (**5** for Best Picture, **4** for Best Director, **3** for Best Actor, **12** Best Screenplay) and **10** British Academy Award wins;

- **13** Golden Globe Nominations (**6** Best Screenplay, **5** Best Director, **2** Best Actor);

- **2** Golden Globe Wins (Best Screenplays for *Purple Rose of Cairo* and *Midnight in Paris*);

- **13** Writers Guild of America Nominations;

- **5** Writer's Guild of America Wins (*Annie Hall, Broadway Danny Rose, Hannah and Her Sisters, Crimes and Misdemeanors,* and *Midnight in Paris*);

- The Golden Globe Cecile B. DeMille Award for Lifetime Achievement Award;

- Lifetime Achievement from the American Comedy Awards;

- Palme des Palmes, the Lifetime Achievement Award from the Cannes Film Festival.

Suffice to say, Woody Allen is one of the most accomplished filmmakers in history. A true auteur in every sense of the word. His comedy has defined films for a generation (and going on two) and he will keep making movies until he dies. It's what he does.

CHAPTER 32
SUPER GREAT MOVIE SPOTLIGHT

Annie Hall
(1977)

United Artists/Photofest

Diane Keaton and Woody Allen star in *Annie Hall* (1977)

- ▶ Directed by Woody Allen
- ▶ Written by Woody Allen and Marshall Brickman
- ▶ Starring Woody Allen and Diane Keaton
- ▶ Subgenres: Romantic Comedy, Satire
- ▶ Comedy types: Verbal, Slapstick

"A relationship is like a shark. You know? It has to constantly move forward or it dies. And I think what we have on our hands is a dead shark."

—Alvy Singer (Woody Allen)

The "me-generation" of the 1970s revolved around the Baby Boomers rejecting the traditional values of family, faith, and self-involvement and questioning traditional values such as religion, romance, and government. To that end, Alvy Singer, the twice-divorced neurotic protagonist of *Annie Hall,* is the poster child of the self-involved culture that arose from the Sexual Revolution and Counterculture movement that flew in the face of the generation that survived World War II.

Summary

Woody Allen portrays Alvy Singer, a witty, intelligent, and neurotic Jewish stand-up comic with a cynical worldview and fascination with death who talks directly to the audience about his doomed relationship with equally-neurotic free spirit Annie Hall (Diane Keaton), set against the world of pseudo-intellectual New York and Alvy's burgeoning show business career.

Alvy tells the audience about his upbringing, early dating life, and his failures with his first two marriages. When he meets Annie Hall, he thinks that his relationship with Annie will be different. They are instantly attracted to each other, and the film follows them through their ups and downs, with Alvy occasionally stopping the action to give us some insight on the different situations.

But how long can romance last? He finds himself constantly trying to change her—giving her books to enhance her intelligence and cultural awareness, trying to get her to stop smoking weed after sex—and one thing you can't do in a successful relationship is to try to change

them. Alvy finds this out the hard way when Annie leaves him and New York. He realizes what a mistake he's made and rushes to get her back.

Best Scenes

Alvy's Grade School Flashback—Alvy tells us when he first discovered girls in second grade. He pops into the classroom flashback as an adult and argues with his irate teacher about his feelings, and then wonders about what the other students in his class were doing in the present-day. So it's a flashback in a dream in a fantasy—if that makes sense. Laugh-out-loud topper line at the end.

Alvy and Annie's First Conversation—As Alvy and Annie have that talk—you know, the one awkward conversation that all single people have when they first meet someone they are interested in, but this time, subtitles come on-screen to show what they are really thinking to hilarious results.

Waiting in Line at the Movies—Alvy and Annie are stuck in front of a preening intellectual that complains about Fellini and the media and quotes noted author Marshall McLuhan—and a fed-up Alvy decides to literally *bring* Marshall McLuhan into the conversation.

Alvy Boiling Lobster—They make it look so easy at the restaurants—hilarious.

Alvy Tries Cocaine—Proving that Alvy and recreational drugs don't mix—even more hilarious.

Annie's Brother Duane—Christopher Walken, in his first real acting role, tells Alvy all about a dream he has—about killing himself in graphic detail—and the next scene is absolute perfection.

The Ending—In an imperfect world where love is something special and sometimes you can't always get what you want, Alvy tries to make some sense of it all and provide some real closure in the only way he can.

Awards and Recognition

Annie Hall was nominated for five Academy Awards, including Best Actor for Woody Allen. The film won four of them, Best Picture, Best Director (Woody Allen), Best Actress (Diane Keaton), and Best Original Screenplay (Woody Allen and Marshall Brickman). The Best Picture win for the film was a huge upset—everyone thought that *Star Wars* would win.

Annie Hall was different visually than Woody Allen's previous films up to this point. He brought on famed cinematographer Gordon Willis, known as "The Prince of Darkness," for his techniques of low lighting scenes. He had previously filmed *All The President's Men* and *The Godfather* so it was an odd choice. But the success of *Annie Hall* opened the door for a new point in Woody Allen's career as a filmmaker, and Willis would work with Woody on *Zelig* (in which Gordon Willis got his first Oscar nomination), *Broadway Danny Rose*, *Interiors, Manhattan, Stardust Memories, A Midsummer Night's Sex Comedy*, and *The Purple Rose of Cairo*. He was awarded an Honorary Oscar in 2010 for his "unsurpassed mastery of light, shadow, color and motion."

The AFI loves this movie. *Annie Hall* is the #4 ranked movie on 100 Years . . . 100 Laughs List, #31 on the Great Movies list, #11 on the Great Romances list, and the #2 Romantic Comedy of all Time.

In 1992, our friends at the Library of Congress placed the film in the National Film Registry.

CHAPTER 33

ARTIST SPOTLIGHT

Gene Wilder, Richard Pryor, and Steve Martin

CHAPTER FOCUS

► Who Is Gene Wilder?

► Who Is Richard Pryor?

► Who Is Steve Martin?

Chapter Focus

As the 1970s began, pop culture and comedy film were continuing to change Hollywood. Movies were different—relying on extraordinary actors who wrote their own work.

This was a significant change that would forever alter the world of cinema. Performer-based comedy where the actors took the reins on their own careers.

There was also the rise of the stand-up comedians. Filmmakers such as Woody Allen and Mel Brooks started their careers playing in the Catskill Mountain resorts of Upper New York State. They had to write their own material, and this creative opportunity opened the door for a number of performers through the 1970s and beyond.

Who Is Gene Wilder?

Can't get out of the 1970s without talking about comedian Gene Wilder, or should I say Jerome Silberman, his actual name—changing it to Gene Wilder after he left the Army. He fell in love with acting after watching his sister onstage, and was involved in local theatre while in high school. He studied theatre and communication at the University of Iowa, and then studied acting in New York before he was drafted. After serving for two years, he went to study with famed acting teacher Uta Hagen in New York and then moved over to The Actor's Studio with Lee Strasburg.

Gene Wilder

He started onstage and off-Broadway but worked with Anne Bancroft (*The Graduate*) and met her husband, writer/director/actor Mel Brooks, as he was working on his script for *The Producers*. Soon, Wilder auditioned with already-cast Zero Mostel, and the two were cast (more on that film in the Mel Brooks chapter). The film went on to nab Wilder a Best Supporting Actor Oscar nomination. Unfortunately the film performed poorly which didn't help Wilder's casting opportunities.

Next up for Wilder was 1971's *Willy Wonka and the Chocolate Factory*. The cult-classic adaptation of the Roald Dahl novel *Charlie and the Chocolate Factory* tells the story of Willy Wonka, a mysterious recluse candy magnate who gives five children the opportunity to visit his chocolate factory. A worldwide search for the "Golden Tickets" hidden in

Scene from *The Producers*

chocolate bars becomes huge news. What follows is an amazing surreal musical-comedy adventure as Willy Wonka takes the kids on a tour of his incredible factory. I know you've seen this one.

Unfortunately the film was a box-office disappointment, and only in the mid-80s did it find success with the advent of home video. But that didn't help Wilder back in 1971. Now he was 0 for 2 at the box office. He was able to get a leading role in one of the segments of Woody

Allen's *Everything You Always Wanted to Know about Sex * (But Were Afraid to Ask)* which helped him get back to respectability. But it was his next film that propelled him into the stratosphere.

Young Frankenstein (1974)

It took Gene Wilder over a year to convince writer/director Mel Brooks (Wilder forbade him from being in the movie) to climb onboard his parody idea that follows the grandson of Victor Frankenstein as he visits Transylvania to find the castle that he's inherited—and his life is never the same. It was only after working together on 1974's *Blazing Saddles* did Brooks agree to work with Wilder on his hoped-for project, *Young Frankenstein*. The two wrote the screenplay together, and were able to get 20th Century Fox to give them the budget to make the movie. The movie is shot in black and white to evoke the feeling of the horror films of the 1930s.

Respected scientist Dr. Frederick Frankenstein (Wilder) tries to distance himself from all mentions of his infamous grandfather, Victor Frankenstein, who had created a monster in his lab in Transylvania back in the 1930s (parroting the releases of the Universal Studios monster films). He even pronounces his last names as "Fronk-en-steen" to stay clear of the family legacy.

When he learns that he's inherited his grandfather's Transylvania castle, he leaves his uptight fiancé Elizabeth (Madeline Kahn) and travels there. Upon arrival, he meets the castle's strange inhabitants: bug-eye Igor (bug-eyed Marty Feldman), mysterious housekeeper Frau Blucher (Cloris Leachman), that causes horses to neigh whenever they hear her name, and beautiful assistant Inga (Teri Garr) to whom he is immediately attracted.

The townspeople have been suspicious of Frederick since he came to town, "once a Frankenstein, always a Frankenstein." Their fears appear to be genuine when Frederick discovers his grandfather's secret lab and handwritten journals, and Frederick gives in to his destiny and decides to build a monster.

Inga (Teri Garr), Victor Frankenstein (Gene Wilder), and Igor (Marty Feldman) in *Young Frankenstein* (1974)

Frederick and Igor are forced to steal the corpse of a dead criminal and Igor is sent to find a brain, but unfortunately has to get one that is listed as "Abnormal," where Igor reads it to be the name Abbie Normal. And it gets worse from there as young Frankenstein brings his monster (Peter Boyle) to life with a crash of lightning. Then things get a little crazy.

Young Frankenstein was a massive hit, making $86 million from a budget of less than $3 million. The film was nominated for two Oscars, Best Sound, and Wilder and Brooks scored an Oscar nomination for their Best Original Screenplay. The movie is the #13 film on the AFI Great Comedy Films list and was selected in 2003 for the National Film Registry by the Library of Congress.

After the success of *Young Frankenstein*, Wilder made his directorial debut with the modest box office hit *The Adventure of Sherlock Holmes' Smarter Brother*, with Marty Feldman and Madeline Khan. He went on to write and direct two financially profitable films, *The World's Greatest Lover* (1977) and *The Woman in Red* (1984). His last directorial feature was the financial disaster *Haunted Honeymoon* (1986).

Wilder went on to star with controversial stand-up comedian Richard Pryor in *Silver Streak* (1976), another monster hit for Wilder. Next up was another film with Pryor, *Stir Crazy* (1980) and again another major box-office winner. Wilder and Pryor would team up for two more movies (I feel like I typed this already, oh wait—I did—one page ago).

He also met *Saturday Night Live* comedienne Gilda Radner when they starred together in 1981's *Hanky Panky*, and the two were married less than a year later. She had various medical problems that ended with her passing away from ovarian cancer in 1989. He made one more feature film, *Another You*, which would end up being both actor's last starring feature film roles.

Wilder went on to do some television work, working on his own sitcom in the mid-1990s, and a couple of television movies, but he effectively retired from show business in 2005. He wrote his memoirs along with two novels and sadly passed away in August 2016. A true comedy genius that will be remembered for as long as there are movies to watch and "Abby Normal" brains to steal.

Gene Wilder testifies before Congress in 1991— he became a passionate supporter for Ovarian Cancer research after his wife, Gilda Radner, passed away in 1989

Source: Library of Congress

Who Is Richard Pryor?

As vaudeville had done sixty years ago, new comedic talent was coming from the stage. Not Broadway, but the stand-up comedy stage. In 1963, Broadway producer Budd Friedman opened The Improv Comedy Club in New York City and in 1975 opened his Los Angeles location.

The two biggest stand-up comics of the era were Lenny Bruce and George Carlin, who both employed shocking material, political humor, satire, and a lot of obscene language as their acts—shocking to audiences at the time.

Yes, that is Gene Wilder wearing blackface thanks to Richard Pryor in *Silver Streak* (1976)

20th Century Fox/Photofest

Legendary comedians such as Billy Crystal, Lily Tomlin, Eddie Murphy, Jerry Seinfeld, Tim Allen, Jay Leno, Chris Rock, Ellen DeGeneres, and Adam Sandler all got their start on the stand-up comedy circuit.

But there were two major stars that broke out from comedy stand-up that made their marks in the late 1970s and into the 1980s (and a lot more) and led the way for Hollywood to look for stand-up comics as viable talent for the film industry.

Raised by his prostitute grandmother after his mother abandoned him at age ten, Pryor left the brothel for the U.S. Army. His stint was controversial when he got into a fight with a white soldier over a racial insult and landed in military prison. He moved to stand-up comedy in 1963 and along with Bill Cosby became the first black comedians to achieve national acclaim.

Unlike Cosby's television success in traditional fare like *I Spy* (for which Cosby was the first black actor to win an Emmy) and *The Cosby Show* in the 1980s, Pryor went the other way and started performing onstage with a highly outrageous and profanity-laced routine that satirized the disparity between whites and blacks.

He started recording comedy albums and his star rose fast. He won five Grammy Awards for Comedic Recording and began writing for television, winning an Emmy Award for his work on *The Lily Tomlin Show* in 1973.

America wasn't ready for the controversial comedian to come into their living rooms so he never achieved mainstream television success. Notably, he was the first black host on *Saturday Night Live* in its first season in 1975.

He got into feature films in 1967 and he worked with Mel Brooks to write the 1974's classic Western parody *Blazing Saddles*. Mel wanted him to play the lead in the film, but the studio executives refused to cast the controversial comedian, and actor Cleavon Little won the part.

He appeared in fifty movies, primarily black audience films as the Oscar-nominated Diana Ross-starrer *Lady Sings the Blues* (1973), *Car Wash* (1976), *Greased Lighting* (1977), and *Which Way Is Up?* (1977) before moving into mainstream success during the 1980s.

The Official Richard Pryor Top 3 Great Comedy Film Checklist

Silver Streak (1976)

This action-comedy-thriller follows mild-mannered book editor George (Gene Wilder) traveling by train (the Silver Streak of the title) to his sister's wedding. Along the way he meets and falls for art assistant Hilly (Jill Clayburgh) and they both become embroiled in a mystery when Hilly's boss, art historian Professor Schreiner, is murdered and Hilly is kidnapped. Suddenly accused of the murder, George is on the run, gets off the train, steals a sheriff's car, and meets arrested criminal Grover Muldoon (Pryor) in the backseat.

George knows they have to get back on the train to clear his name and in the best scene in the movie, helps to disguise George as a black man, teaching him how to walk and carry himself to get past the police. Will George clear his name? Will Grover get arrested? Will they ever find Hilly?

The film was a big box office smash and critics loved it. The film is the #95 film on the AFI Great Comedy Films list.

This was the first time that Pryor worked with Wilder, who's starring work with writer/ director Mel Brooks in *The Producers* (1968), *Blazing Saddles* (1974), and *Young Frankenstein* (1974) made him one of the biggest comedy actors in the world.

Pryor and Wilder would make three more movies together: *Stir Crazy* (1980), *See No Evil, Hear No Evil* (1989), and *Another You* (1991), which was Pryor's last starring role.

Richard Pryor: Live in Concert (1979)

Taking a cue from his Grammy-winning comedy albums, Pryor filmed and released his first live stand-up film, *Richard Pryor: Live and Smokin'* in 1971. This is the one considered to be his best concert film. He truly set the bar for black comedians in the world. He would do two more: *Richard Pryor: Live on the Sunset Strip* (1982) and *Richard Pryor: Here and Now* (1983), but this is the one to check out.

Brewster's Millions (1985)

Pryor was a very physical comedian, and in the 1980s, he was doing a lot of mainstream stuff. This was probably the biggest box office hit, about Montgomery Brewster (Pryor) who has to spend $30 million in thirty days so he can receive an inheritance of $300 million. The movie includes the hilarious John Candy as his best friend Spike.

Pryor had a ton of personal problems, including alcoholism and drug addiction, and while on a cocaine-fueled binge lit himself on fire. He also had a lot of medical problems, including heart disease from drinking and smoking, and was diagnosed with multiple sclerosis in 1986. In 1998, the John F. Kennedy Center for the Performing Arts awarded him the first Mark Twain Prize for American Humor. He died in 2005 and was awarded a Lifetime Achievement Grammy Award posthumously.

Pryor's legacy is clear—he single-handedly opened the door for black stand-up comics to move from the stage into mainstream media. He was outrageous, controversial, and inspired an entire generation of black comedians and performers that your race didn't matter if you had talent, passion, and the drive to perform in Hollywood.

The other stand-up comic that inspired an entire generation of performers that it was possible to leap from the stage into success was—

Who Is Steve Martin?

Born in 1945, Steve's love for performing came from his father, an aspiring actor. He worked at Disneyland while in school during the summertime in a Magic Shop on Main Street U.S.A. He learned magic, juggling, and making balloon animals—all talents he would use when he started performing onstage while in college. He majored in philosophy and his studies helped crystallize his absurdist joke writing technique.

After dropping out of college, he started writing for TV's *The Smothers Brothers Comedy Hour* and won an Emmy for writing when he was twenty-three (he would go on to be nominated six more times for writing and performing). In-between writing gigs, he started performing stand-up comedy. His stage work led to frequent appearances on *The Tonight Show* with Johnny Carson, he hosted *Saturday Night Live* (in total fifteen times as of 2015), and one of his trademarks were doing "air quotes" for emphasis. I'm doing that "right now" as I "type" this.

Steve Martin

Like Richard Pryor, Martin released Platinum-selling comedy albums—and his first album, 1977's *Let's Get Small* included his signature catchphrase "Well, excuuuuse me!" and his second album *A Wild and Crazy Guy* (1978) included his catchphrase (guess?) "I'm a wild and crazy guy!" and the hit single "King Tut" inspired by the tour of the Egyptian pharaoh's remains in the United States. He's also an accomplished banjo player that still tours nationally and has won two Grammy Awards for his bluegrass albums!

Unlike Pryor, he was never obscene or controversial and he wound up doing concert comedy tours across the country. He was the first "rock star" stand-up comic.

His film work is legendary—his first appearance was in the short film that he wrote, directed, and starred, *The Absent Minded Waiter* (1977), which was nominated for a Best Short Film Oscar. Since then, he's had a meteoric rise to the top echelon of Hollywood comedians. As of 2016, he's appeared in fifty-one movies, of which twelve of them he wrote or co-wrote.

Steve Martin rocks out on the banjo

The Official Steve Martin Top 3 Great Comedy Film Checklist

Okay, this one is really hard to do. I count ten films that are worthy of writing summaries for—how do I do this without disrespecting his work?—I know. I'll make a list of the other seven. But here's the Top 3 in my humble opinion:

The Jerk (1979)

This was the movie that cemented Martin's status as a comedy film star. Directed by Carl Reiner, the film follows simpleton Navin Johnson (Martin) as he relates his life story, how he

was "born a poor black child," works at a circus, and falls in love with Marie (Bernadette Peters), becoming a millionaire when he invents a device to keep eyeglasses from slipping off your nose, and then loses it all.

Martin co-wrote the film with famed screenwriter Carl Gottlieb (*Jaws*) based on a lot of his stand-up material, and the timing of the film was perfect, coinciding with Martin peaking for his stand-up comedy work. *The Jerk* was a huge box office hit, making over $70 million, won universal praise from critics, and is ranked as the #89 movie on the AFI Great Comedy Films list.

Steve Martin in his breakout role as Navin Johnson (or as his friends call him "The Jerk") in the film by the same name from filmmaker Carl Reiner

All of Me (1984)

Continuing his collaboration with director Carl Reiner, this is the movie that solidified Martin as a commercially bankable mainstream actor. Wealthy but near-death Edwina Cutwater (Lily Tomlin) has her soul accidentally transferred into attorney Roger Cobb's (Martin) body as she dies. Not only does she talk to him, but she's also in control of the right side of his body, and he's in control of his left.

Amazing physical comedy work as Martin convincingly pulls off Edwina's female side and his own male side as they battle for control of his body. A modest box office success, it was a critical hit.

Planes, Trains and Automobiles (1987)

From the fertile mind of writer/director John Hughes (we'll get to him soon) brings Steve into his first role as the straight man, instead of the "wild and crazy guy." He's arrogant businessman Neal Page, stranded on his way home for Thanksgiving dinner with his family. Along the way, he meets annoying Del Griffith (a masterful John Candy) and together they try to get to New York from Chicago by any means necessary. Best scene in the movie is when Neal and Del are sleeping together in a fleabag motel and Neal realizes that Del has his hand up Neal's ass. Lots of physical comedy, big destructive scenes, and a great message about friendship!

The other films on my top ten list are *Three Amigos!* (1986), *Roxanne* (1987), *Little Shop of Horrors* (1987), *Dirty Rotten Scoundrels* (1988), *Parenthood* (1989), *L.A. Story* (1991), and *Bowfinger* (1999). I actually do a few summaries along the way for some of these, but you should watch every single one of them right now.

Steve Martin has hosted the Oscars twice and won an Honorary Oscar in 2013, has been nominated for five Golden Globes for Best Actor, won the Lifetime Achievement from the American Comedy Awards in 2000, won two People's Choice Awards, and like Richard Pryor, won the Mark Twain Prize for American Humor in 2005. In 2015, he won a Lifetime Achievement award from the American Film Institute.

The 1970s were truly the second Golden Age of Hollywood. Not only were writer-directors able to make films their own way, but it was an opportunity for performers like Gene Wilder, Richard Pryor, and Steve Martin to creatively push the envelope in ways that their predecessors never could.

CHAPTER 34

ARTIST SPOTLIGHT

Chevy Chase, Dan Aykroyd, and John Belushi

CHAPTER FOCUS

▶ Who Is Chevy Chase?

▶ Who Is Dan Aykroyd?

▶ Who Is John Belushi?

Chapter Focus

The phenomenon of *Saturday Night Live* was a cultural milestone for the next generation of comedy entertainment. It was the original anti-establishment show—thumbing its noses at the network suits on a weekly basis. The comedy was as raw as the talent that walked on Stage 8H in the NBC Studios at 30 Rockefeller Plaza. Over the years, the show has launched an entire generation of comedic personalities into the collective atmosphere of American society.

For the full season of 1975–1976, the "Not-Ready-for-Prime-Time Players" included performers Dan Aykroyd, John Belushi, Chevy Chase, Jane Curtin, Garrett Morris, Laraine Newman, and Gilda Radner. The idea that any one of them could leave the show and go off and make movies was laughable. Who would pay to go to the movies when you can see these actors on TV for free?

The naysayers who thought that *Saturday Night Live* couldn't breed movie stars were about to be proven wrong, starting with the very first Repertory Player to leave the show . . .

Who Is Chevy Chase?

Born Cornelius Crane Chase in 1943, this physical comedian went through several schools and colleges as he was growing up. Legend has it that he was expelled from Haverford College for hiding a cow in his room and he got out of being drafted for the Vietnam War by falsely telling the draft board about his "homosexual tendencies."

Chevy Chase

He started writing comedy and ended up working on the *National Lampoon Radio Hour* in 1973 with John Belushi, Gilda Radner, and Bill Murray and performed at the *National Lampoon: Lemmings* stage show in New York City, a parody of rock festivals with music and sketch comedy, along with Belushi and Christopher Guest. He was also nominated for an Emmy Award for Writing on *The Smothers Brothers Comedy Show*. All of that led to his being one of the first cast members hired for *Saturday Night Live*.

He was the breakout star from the inaugural season of SNL, notorious for his impersonation of President Gerald Ford as a klutz and his introduction to his "Weekend Update" anchor duties as "I'm Chevy Chase . . . and you're not." He won an Emmy for Individual Performance in a Variety or Music Program, shared in the Emmy for Outstanding Writing in a Variety or Music Program with the rest of the SNL writing staff, and was nominated in both categories the following year as well. In 2011, *Rolling Stone* magazine ranked Chevy Chase as the #10 Cast Member in the history of the show.

He left SNL in the middle of the second season, and went to Los Angeles to make movies. He's made some great movies along the way: *Foul Play* (1976) with Goldie Hawn, *Fletch* (1985), and *Spies Like Us* (1985) but he's primarily known for the following films.

The Official Chevy Chase Top 3 Great Comedy Film Checklist

Caddyshack (1980)

In the tradition of sports comedy films like 1975's *The Bad News Bears*, it's a social class comedy where it's "the-snobs-versus-the-slobs," but this time it takes place in the world of country club golf. Chevy plays wealthy slacker Ty Webb, who spends his days playing golf at the upper-crust Bushwood Country Club with his favorite caddy, Danny Noonan (Michael O'Keefe).

Michael O'Keefe, Chevy Chase, and Bill Murray

Danny dreams of bigger things than caddying, like going to college, but he can't afford it. His only hope is to convince Judge Smails (Ted Knight) that he's the ideal candidate for the Bushwood Country Club scholarship. He wins the scholarship and finishes in First Place in the Caddy Golf Tournament.

Life gets upended in two ways—when Al Czervik (stand-up comic Rodney Dangerfield), an obnoxious businessman, decides he wants to join the country club, upsetting the members—and especially Judge Smails—with his undignified and vulgar attitude.

On the other side of the green, uncouth greenskeeper Carl Spackler (the ridiculous Bill Murray in a legendary performance) is contending with his arch-nemesis, an evil gopher that is slowly digging through and destroying the course. In a couple of great scenes, Carl imagines he's winning the Masters and in another, he caddies for Bishop Pickering (Henry Wilcoxson) for the golf game of the clergyman's life.

Everything comes to a head when Judge Smails tells Al that he will never be a member—and Al counters that he's planning on buying the course and leveling it for condos. Ty calms everyone down and proposes a golf match to settle everyone's differences. But when Al gets injured during the big tournament, Ty looks to Danny to replace him and put Judge Smails in his place. Danny's stuck—if he helps Ty, then he will lose his scholarship. Ty promises to make it worth it for Danny to go against the Judge. How will all this end? Who wins—the Snobs—or the Slobs? And will Carl get that gopher?

Caddyshack was writer Harold Ramis' first feature film, and he would go on to make a few more films that you may have heard of—and I'll get to those soon. *Caddyshack* did well at the box office, making $38 million on a $9 million budget. It cemented Chevy Chase as one of the best comedy film actors in the industry and also gave Bill Murray a huge career boost. It's the #71 film on the AFI Great Comedy Films list, the #7 film on the AFI Top Ten Sports Films, and Carl Spackler's quote: "Cinderella story. Outta nowhere. A former greenskeeper, now, about to become the Masters champion. It looks like a mira . . . It's in the hole! It's in the hole! It's in the hole!" is the #92 AFI Movie Quote. ESPN has also named *Caddyshack* the funniest sports comedy of all-time.

National Lampoon's Vacation (1983)

For comedy films, Chevy Chase's performance of overly-optimistic and incredibly unlucky Clark Griswold is a cultural touchstone. In the hands of director Harold Ramis (see, I told you we would see him again!) and writer John Hughes (the king of Youth/Coming-of-Age films), the story of Clark and his family traveling across the United States is one of legend (and frequent cable TV viewing).

To spend more time with the family and give them the vacation they deserve, Clark, his wife Ellen (Beverly d'Angelo), son Rusty (Anthony Michael Hall), and daughter Audrey (Dana Barron) head out in their station wagon on a road trip to Los Angeles to visit Disney-esque theme park Walley World. Things don't go as well as Clark had meticulously planned, including the family nearly getting robbed in the ghetto, Clark's vulgar cousin foisting his grandmother on Clark to drive to Phoenix, near-death car crashes, the Girl in the Red Ferrari (Christie Brinkley) that tempts Clark when they go skinny-dipping in a motel pool, the world's shortest visit to the Grand Canyon in Clark's unstoppable quest to reach his beloved theme park destination. Will they make it? Let's hope so—or it's going to be a pretty short movie.

National Lampoon's Vacation was huge at the box office, making over $60 million. It was so popular that it spawned four sequels, all featuring Chevy Chase as Clark Griswold.

Though not as popular as the first film and the critics were unkind, *National Lampoon's European Vacation* (1985) still has its moments and brought in a pretty good amount of money (almost $50 million). This time we follow the Griswold clan after they win a vacation on a TV game show. Together they travel across the Atlantic to visit England, France, and Germany, along the way destroying Stonehenge, insulting locals, starting fights, killing dogs—it's just another trip in the books!

You can't forget the film that many fans believe is a *better* movie than the original *Vacation*—it's 1989's *National Lampoon's Christmas Vacation*. It's the most magical time of the year, and Clark is determined to give his family the best Christmas they can possibly have. All he needs

is the best tree, he and Ellen both have their parents coming, and Clark's planning on putting up the greatest home light display in the history of Illinois. But everything looks like it's going to be ruined when Clark's hillbilly cousin Eddie (Randy Quaid) comes uninvited and crashes the festivities.

The movie made more money at the box-office than *European Vacation* and the critics were mostly split—either they hated it or they liked it. All I know is that the movie plays constantly in December at my house. And my neighbors call me Clark because I like elaborate lighting displays as well, but I have never been electrocuted. (Did you know there was a sequel made from this sequel that didn't feature Chevy Chase as Clark? *National Lampoon's Christmas Vacation 2* followed Cousin Eddie and his wife on their own holiday? I didn't either.)

Chevy appeared in two other *Vacation* films—1997's *Vegas Vacation*, which was the least successful of the series, and was the first one to be missing the National Lampoon brand when the producer who held the rights to the Lampoon name quit the movie over creative differences. It's also the only film in the series to be rated PG.

Finally, Chevy appeared as Clark in a supporting role in the 2015 *Vacation* reboot, simply titled *Vacation*. Ed Helms plays the grown-up Rusty Griswold, and like father, like son wants to take his own family to Walley World before it closes. The 2015 reboot made over $100 million and I would be shocked if we didn't see another sequel to the reboot come out soon.

Three Amigos! (1986)

Director John Landis (*National Lampoon's Animal House, The Blues Brothers*) came together with Chevy Chase, Steve Martin, and Martin Short for this Slapstick Western comedy written by Steve Martin, Lorne Michaels (*Saturday Night Live*), and music composer Randy Newman. Oscar-winning composer Elmer Bernstein scored the movie in the flavor of one of his greatest films, *The Magnificent Seven*.

Three Amigos! (1986)

Lucky Day (Steve Martin), Dusty Bottoms (Chevy Chase), and Ned Nederlander (Martin Short) are a silent film acting trio called The Three Amigos! Their latest movie is playing in Mexico and Carmen (Patrice Martinez), who lives in a small Mexican village being terrorized by the notorious El Guapo (Alfonso Arau), sees their film and believes they are actual cowboy heroes.

She telegrams them to ask for their help, and they think they are being hired to go film a movie (perfect timing since they just got fired by their studio), and without prospects, they head south after stealing back their ridiculous costumes.

After performing a musical number, "My Little Buttercup" at a local watering hole, they arrive in the village already under siege by El Guapo's men. The Amigos think that the filming for their movie filming has already started—so they jump in and start performing stunts and ultimately chase the bandits away.

When El Guapo confronts the Amigos and shoots Lucky in the arm, he kidnaps Carmen to make her his wife, and promises to kill the Amigos if they don't go back to Hollywood. The villagers' only hopes are the Three Amigos. Ned convinces Lucky and Dusty that they have to become real heroes, save Carmen and the village, and stop El Guapo's reign of terror. However, it's easy to stop the bad guy in the movies, and entirely different expecting actors to do it for real.

Will the Amigos save Carmen? Stop El Gaupo? Rally and save the village? Get hired again back in Hollywood?

Though it only had a modest level of box office success and the critics were lackluster in their reviews, *Three Amigos!* has gone on to achieve cult status since its release on home video and the Bravo cable network named it their #79 movie of the "100 Funniest Movies."

Chevy Chase has had a varied career after his great run films of the 1980s including appearing in the 1986 Paul Simon music video of "You Can Call Me Al." He had a string of bad films, starred in a short-lived TV talk show, acted in the NBC series *Community* from 2009–2012, and appeared on the website "Funny or Die" in the short film, "Presidential Reunions," reprising his role as the klutzy former President Gerald Ford—the role that made him famous on *Saturday Night Live*.

Who Is Dan Aykroyd?

Born in 1952 in Ottawa, Canada, Aykroyd grew up going to Catholic School and was interested in the priesthood until he went to college at Carleton University in Ottawa. He began performing with a drama club on campus, and left school without graduating. He worked as a stand-up comic and when he was still only seventeen, he got his first professional job performing on Canadian television in the sketch comedy show *The Hart and Lorne Terrific Hour*, starring Lorne Michaels.

That relationship would prove useful after Aykroyd joined the Toronto arm of renowned sketch comedy troupe The Second City when he was twenty-one where he worked with future co-stars Bill Murray and Lorraine Newman. He met John Belushi at a blues club where they realized they had a mutual love for blues and soul music, and Dan was cast in the *National Lampoon Radio Hour*.

Dan Aykroyd

©Featureflash Photo Agency/Shutterstock.com

When Lorne Michaels was assembling the pieces for *Saturday Night Live*, he recruited Aykroyd to the writing staff—and Dan eventually joined the first season cast, aka "The Not-Ready-For-Prime-Time Players." A gifted impressionist, some of his more famous characters include President Jimmy Carter, famous chef Julia Child, President Richard Nixon, and *Twilight Zone* host Rod Serling.

I'm also a fan of "The Super Bass-o-Matic Sketch" where he blends fish guts into smoothies and drinks them.

He also killed it as Irving Mainway and his new line of unsafe toys for kids, such as Johnny Switchblade (a doll with a knife that comes out of its chest) and The Bag of Glass (I'm sure you understand that one).

His co-anchoring of "Weekend Update" is highlighted by his insult to Jane Curtin, "Jane, you ignorant slut," during a "Point/Counterpoint" debate.

He has had some recurring characters, notably "Beldar Conehead," an alien living under-cover on Earth with his family—hoping to blend in to observe human customs with their *cone-shaped heads*. The Conehead family would end up having their own ill-fated movie in 1993 and have recently appeared in a series of State Farm Insurance commercials.

Another notable character grew from Aykroyd and castmate John Belushi's love of soul and blues music. Elwood Blues (Aykroyd) and his brother "Joliet" Jake (Belushi) appeared on

Saturday Night Live in 1978—inspired by Belushi's trip to a blues club while filming *National Lampoon's Animal House* in Eugene, Oregon.

On the show, Belushi and Aykroyd would perform some of their favorite blues songs in-character, wearing black suits, black Ray-Ban sunglasses, and black fedoras. They recorded an album, *Briefcase Full of Blues*, that sold 3.5 million copies and their single remake of Sam and Dave's "Soul Man" went to #14 on the Billboard Hot 100.

Aykroyd won two Emmy Awards during his time on *Saturday Night Live*, one for writing in 1977 and an Individual Performance Award in 1978. Rolling Stone ranked Aykroyd as the #5 Cast Member of All Time in 2011.

Both Aykroyd and Belushi left *Saturday Night Live* in 1979 for film careers, and after they both suffered through an ill-fated appearance in Steven Spielberg's box-office-flop *1941*, they pitched their idea for a new movie based on *The Blues Brothers* characters around Hollywood. It was the first of over seventy films that Aykroyd would appear in.

The Official Dan Aykroyd Top 3 Great Comedy Film Checklist

The Blues Brothers (1980)

National Lampoon's Animal House's director John Landis came onboard to direct and co-write the screenplay with Dan Aykroyd, based on the blues musical act of "Jake and Elwood Blues—aka The Blues Brothers," one of the most popular sketches on SNL ever.

When Aykroyd and Belushi decided they could make it a movie, a huge bidding war erupted. Universal Studios won the movie, but the film went wildly over budget and the studio thought they wouldn't make their money back. They were wrong.

In this musical comedy, Jake Blues (John Belushi) is released from prison and his loyal brother Elwood (Dan Aykroyd) tells him that the orphanage they grew up in needs to pay their property taxes. At a Baptist church run by singer James Brown, he gets a sign from heaven to bring their old band back together, and the two brothers hit the road in their "Bluesmobile."

The film becomes a huge chase scene after Elwood drives off from a traffic stop, and soon city and state police are hunting them after the brothers lead them on a destructive car chase through a suburban mall.

The Blues Brothers

Universal Pictures/Photofest

There's also the mysterious woman (Carrie Fisher) who tries to kill them every chance she gets. Meanwhile they meet several music legends, including Aretha Franklin, Cab Calloway, Ray Charles, and several songs are performed. In the end, one of the most elaborate car chases in history—destroying more cars than in any movie in history—as Jake and Elwood rush to make the deadline to turn in the orphanage's tax money.

The Blues Brothers was a huge hit—finishing as the top ten film in the box office receipts for 1980, making a total of $115 million worldwide. There are so many great scenes, memorable dialogue, slapstick moments, and the carnage that John Landis inflicts upon suburban and downtown Chicago is unforgettable.

Dan Aykroyd and John Belushi starred in one more film together, the dark comedy *Neighbors* (1981), After Belushi's untimely death in 1981, Aykroyd started his solo career. He met his future wife, the smoking hot Donna Dixon, in 1983's *Doctor Detroit*, and then teamed up with *The Blues Brothers* director John Landis for one of the smartest comedies that you will ever see.

Trading Places (1983)

This movie has it all—satire on wealth and privilege, social class, fish out of water, slapstick, and sex with a gorilla. What more can you ask for in a movie?

Snobbish Louis Winthorpe III (Dan Aykroyd) has it all—wealth, power, a beautiful fiancée, and a sterling reputation, thanks to his family and his position at Duke & Duke, a Philadelphia commodities trading company. Managing partners Randolph Duke (Ralph Bellamy) and his brother Mortimer Duke (Don Ameche) argue one day about the validity of what makes a person successful in life—is it environment or heredity?

Trading Places

Paramount Pictures/Photofest

After Winthorpe has street hustler Billy Ray Valentine (Eddie Murphy) arrested when he thinks Valentine is going to mug him, the Duke brothers make a bet—they can take a criminal out of the ghetto and make him a success, and likewise take a successful man and turn him to a life of crime once he is deprived of his career and money.

The Dukes frame Winthorpe as a thief and drug dealer. He's arrested, fired, his assets are frozen, and he's kicked out of his house that is owned by the company. Penniless and homeless, his fiancée bails him out and then dumps him. Luckily he meets Ophelia (Jamie Lee Curtis), a prostitute who takes him in and promises to help him get his life back.

Meanwhile the Dukes have bailed out Valentine and believing him to be the kind of resourceful man they need—give him Winthorpe's job, money, and house. When Winthorpe tries to get Valentine arrested at Duke & Duke by planting drugs on him and when he's caught, he pulls a gun and escapes. The Dukes discuss their wager and Valentine overhears them. He's shocked to hear they destroyed Winthorpe's life for a one dollar bet.

Valentine finds Winthorpe and tells him what the Dukes have done, and the two men decide to work together and get their revenge in an elaborate con reminiscent of the Robert Redford/Paul Newman film *The Sting*. Will the Dukes get what's coming to them? Will Winthorpe regain his life, and what happens to Billy Ray?

Trading Places was a huge box office and critical hit, making over $90 million from a $15 million budget. It also cemented *Saturday Night Live* regular Eddie Murphy as a movie star. He would go on to even bigger things from here. The movie won two British Academy Film Awards, Best Actor in a Supporting Role for Denholm Elliot, who plays Winthorpe's valet, and Best Actress in a Supporting Role for Jamie Lee Curtis. *Trading Places* was nominated for two Golden Globes, for Best Picture—Comedy or Musical and Best Actor for Eddie Murphy, and Elmer Bernstein's score was nominated for an Academy Award for Best Score. And one interesting note of trivia—*Trading Places* is a Christmas-tradition in Italy, showing on television once a year.

Aykroyd had come up with an idea for a movie to star him and Belushi about a group of scientists that battle paranormal activity by traveling through time. The idea ended up becoming the comedy behemoth, 1984's *Ghostbusters*.

That film is a cultural touchstone—and gets its own Super Great Movie Spotlight. Check it out in Chapter 39.

After the huge success of *Ghostbusters*, Aykroyd has another film idea that he had wanted to do with Belushi. He worked with Second City performer and writer Dave Thomas (one-half of the McKenzie Brothers) to create this homage to the Bob Hope–Bing Crosby "Road to . . ." Pictures. Unfortunately Belushi had passed away and Aykroyd found another co-star for his buddy comedy.

Spies Like Us (1985)

Dan Aykroyd reteamed with director John Landis for their third film together and the two of them enlisted Aykroyd's *Saturday Night Live* co-star Chevy Chase in this slapstick buddy-comedy following two low-level CIA agents chosen for a dangerous mission that could cause World War III.

Emmitt Fitz-Hume (Chase) and Austin Milbarge (Aykroyd) are incompetent applicants in the CIA recruiting program. When the high brass needs a decoy mission where the agents

are expendable, Fitz-Hume and Milbarge are selected. After a minimal training session, they are airdropped into Pakistan and eventually make their way to Afghanistan.

When the original team fails in their assignment to capture a Soviet missile launcher, the CIA directs Fitz-Hume and Milbarge—who have miraculously survived against all odds—to finish up the mission and launch the missile—straight at the United States. When the CIA's anti-missile defense system fails to stop the missile (the whole point of the mission in the first place) it's up to our intrepid duo—and the smoking hot Russian women they hook up with along the way to save the world! (cue dramatic music)

Even though I just used that dramatic music joke, this movie is ridiculous. The film is such an homage to Hope and Crosby, that Bob Hope actually makes a cameo in the film.

The training scenes are side-splitting hilarious and the torture scenes are outrageous. The film was pretty skewered by the critics, but the film did make a good amount of money—and the film has grown in appreciation over the years.

Dan Aykroyd has had an extremely successful career doing both comedy and dramas in such great movies worth your time as *The Couch Trip* (1988), *Sneakers* (1992), *Chaplin* (1992), *Tommy Boy* (1995), *Grosse Pointe Blank* (1997), and *50 First Dates* (2004).

He did receive an Academy Award nomination for Best Supporting Actor for 1989's *Driving Miss Daisy* and finally got an Honorary Degree from Carleton University in 1994. He is one of the producers and has a cameo appearance in the 2016 reboot of *Ghostbusters* with an all-female cast led by Kristen Wiig (*Bridesmaids*) and Melissa McCarthy (*The Heat*).

©steve white photos/Shutterstock.com

Dan Aykroyd still performs as Elwood Blues, usually at his signature restaurant-bar chain House of Blues

Who Is John Belushi?

Born in 1949 in a suburb outside of Chicago, he was the co-captain of the Wheaton Central High School football team, the Homecoming King, and voted "Most Humorous." He also met his future wife, Jacklin, going to school together. John drifted through more than one college and eventually ended up in Chicago where he joined The Second City comedy troupe.

At twenty-two years old, he was the youngest member of the troupe and with his manic energy and tremendous improvisation skills eventually became one of the stars of the show.

In 1972, John was offered a job with *National Lampoon's Lemmings* stage show and he and Jacklin moved to New York, where they soon were married. He also worked on the *National Lampoon Radio Hour* where he met Dan Aykroyd at a Toronto blues club.

When Lorne Michaels started building the cast for *Saturday Night Live*, John was recommended by Chevy Chase and Dan Aykroyd but Lorne thought that John might be too loud and self-centered. John auditioned with his Samurai Futaba character that he would bring to the show, and Lorne hired him immediately.

He had his breakthrough in the third episode of the show when he did his famed Joe Cocker impression and soon was one of the featured stars of the program. He played several characters during his four years with the show, including Joe Cocker, Samurai Futaba (sixteen sketches over four seasons), the Greek cook from the Olympia Café ("Chee-burger—Chee-burger—Chee-burger"), Henry Kissinger, William Shatner, one of the "Killer Bees," and his biggest character, "Joliet" Jake Blues, along with Dan Aykroyd playing his brother Elwood, known as the musical-comedy act The Blues Brothers.

John's meteoric rise took him to his first starring film role—in a movie that was so huge and revolutionary that it changed comedy film forever.

National Lampoon's Animal House (1978)

"Was it over when the Germans bombed Pearl Harbor??!!"

—John "Bluto" Blutarsky

Welcome to 1962, a time of innocence in America. It's before anyone ever heard of Lee Harvey Oswald, Vietnam was a country that was mentioned briefly in the most boring of high school social studies classes, and the Beatles were insects.

But innocence is the last thing you'll find at Faber College, especially when it comes to the Delta Tau Chi house. With such characters as the outrageous party animal Bluto (John Belushi), womanizer "Otter" (Tim Matheson), and crazy biker "D-Day" (Bruce McGill), they're the bad boys of fraternity row with nightly drinking sex parties and various acts of mischief and debauchery.

Dean Vernon Wormer has had enough and puts the Deltas on "double secret probation." He challenges wealthy snob Greg Marmalard (James Daughton), the President of rival fraternity Omega Theta Pi, to figure out a way to get them kicked out. Without realizing they are

skating on thin ice, the Deltas start a food fight in the cafeteria and accidentally kill a horse owned by Omega Theta Pi member, Douglas Neidermeyer, in the Dean's office.

The Omega Theta's get their revenge when they switch out the answers to a test that the Deltas are stealing to pass a test. When they all fail, Dean Wormer drops the hammer—one more incident and they are all expelled.

Animal House

So do the Deltas hit the books to save their asses? No. Instead they hold a massive toga party featuring house band Otis Day and the Knights, pledgee Pinto (Tom Hulce) almost has sex with the Mayor's underage daughter, and Otter does have sex with Dean Wormer's wife. Then it all goes downhill. The Deltas have failed all of their classes, and Wormer delightfully cancels their charter, kicks them out of school, and notifies the draft board that they are all eligible to be selected.

What happens next is a comedy of epic proportions. If you haven't seen *National Lampoon's Animal House*, then you're missing out on one of the great comedy films of the twentieth century. A film that pushed the borders on tasteful and tasteless, the film that defined what a gross-out comedy really is (though director John Landis says in my interview with him in Chapter 37 that the movie is nothing compared with the gross-out comedy films of today), and it's the movie that made John Belushi a superstar.

There are so many great scenes in *National Lampoon's Animal House* that it's hard to list them all, so I won't even try. But I'll give you a sample: the above-mentioned food fight where Bluto gives his "zit popping" impression, the above-mentioned toga party, the road trip scene leading to the African American roadside café, Bluto's inspiring speech to get the Deltas excited about taking out their revenge, and the Homecoming Parade to end all Homecoming Parades.

The film was also a career boost for the legendary Oscar-winning composer Elmer Bernstein, who had composed the music for such legendary films as *The Ten Commandments*, *The Magnificent Seven*, and *To Kill a Mockingbird*. John Landis was a family friend and asked him to compose the score. Bernstein would go on to score some of the greatest comedy films in history such as *The Blues Brothers*, *Airplane!*, *Ghostbusters*, *Trading Places*, and *Three Amigos!*

National Lampoon's Animal House is one of the most profitable comedies in history, making $141 million (in 1978 money that's amazing) on a budget of $3 million. It's the #36 film on the AFI Great Comedy Films list, #1 on the Bravo's 100 Funniest Movies list, and in 2001, the

Library of Congress named it to the National Film Registry.

Belushi returned to *Saturday Night Live* for one more season and then he and Aykroyd both left to pursue their film careers. The 2011 Rolling Stone ranking of *Saturday Night Live* actors placed Belushi as the #1 cast member of all time.

First up was the 1979 film *The Blues Brothers*, taking the SNL characters to the silver screen. Another huge success for Belushi, and he was in the driver's seat. Actually, it was Elwood who drove. Jake was in the passenger seat.

He made the disappointing *1941* for Steven Spielberg in 1979, romantic comedy *Continental Divide* (1983), and the dark

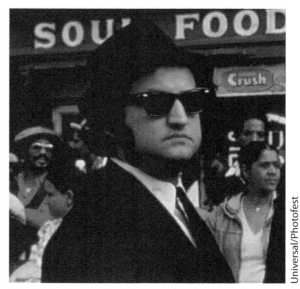

John Belushi as Jake Blues in *The Blues Brothers* (1980)

comedy film *Neighbors*. Belushi plays Earl, a mild-mannered businessman whose life is disrupted when wild man Vic (Dan Aykroyd) and flirtatious Romona (Cathy Moriarity) move in next door.

The film was a difficult one, hampered by Belushi's reported drug abuse, which had slowly grown out of control. *Neighbors* received mixed reviews from the critics and made a modest return. It was also the last movie that he would make.

Tragically, John Belushi died of an accidental drug overdose on March 2, 1985. It's a f***king shame. I would have loved to have done a Top 3 Checklist for him, but there's only two that are worth talking about.

There you go—the first three cast members from *Saturday Night Live* to leave the show and change the history of comedy as we know it. There can be no doubt in anyone's minds that *Saturday Night Live* has been the most consistent avenue for film comedians to entertain on the small screen—and ultimately land on the big screen. Chevy Chase, Dan Aykroyd, and John Belushi were the trailblazers that opened the doors for a cavalcade of comedic performers to grace the silver screen over the last four decades and will continue to do so until the show gets cancelled—or the Coneheads finally invade and destroy the Earth.

FADE TO WHITE LIKE WE ARE GETTING SUCKED INTO THE CONEHEAD'S SPACECRAFT AND WILL SOON BE PROBED IN VARIOUS ORAFICES

CHAPTER 35

SUPER GREAT MOVIE SPOTLIGHT

Airplane!
(1980)

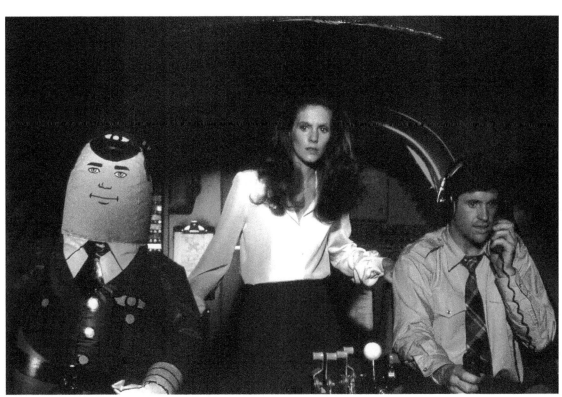

Otto the Autopilot, Julie Hagerty, and Robert Hays in *Airplane!* (1980)

Paramount Pictures/Photofest

- ▶ Starring Robert Hays, Julie Hagerty, Peter Graves, Lloyd Bridges, and Leslie Nielsen
- ▶ Written and Directed by David Zucker, Jerry Zucker, and Jim Abrahams
- ▶ Subgenres: Parody, Dark comedy
- ▶ Comedy types: Verbal, Slapstick, Gross-out

"I am serious . . . and don't call me Shirley."

—Dr. Rumack (Leslie Nielsen)

"Looks like I picked the wrong week to quit sniffing glue."

—Steve McCroskey (Lloyd Bridges)

There are few movies that you can watch again and again, and never see a single flaw. *Airplane!* is one of those films.

Filmmakers David Zucker, Jerry Zucker, and Jim Abrahams took a little known dramatic film called *Zero Hour!*, and turned it completely on its head. The ballsy casting of dramatic actors such as Leslie Nielsen, Lloyd Bridges, Robert Stack, and Peter Graves was ingenious—these are actors that *don't do comedy*. But here they are. The brilliance of the directing is that the actors all play it straight. There's no point where anyone is cracking jokes. It's played seriously, but amped up to 11. (If you know *This Is Spinal Tap* then you'll get the reference. If you don't, there's a Super Great Movie Spotlight with your name on it somewhere around here.) There's a ton of slapstick, physical comedy, deadpan, black comedy, the film has every style of comedy ever invented. Except for satire. There's no satire. But it's got the rest.

Summary

Failed World War II pilot Ted Stryker (Robert Hays) is having a very bad day. His long-time girlfriend and flight attendant Elaine (Julie Hagerty) breaks up with him and is off to the

airport for her latest assignment, Trans American Airlines Flight 209. Unable to fly due to his crippling panic attacks, he overcomes his fear of flying to buy a ticket and get on her plane, hoping to win her back. When she sees him on the plane, she ignores him. They're through.

Meanwhile, dinner is served. It's the chicken or the fish, and the entire flight crew decides to eat the fish. Poor choice as the fish is tainted and nearly everyone on the flight is ill, especially Captain Clarence Oveur (Peter Graves), a fan of young boys and gladiator movies, and co-pilot Roger Murdock (Kareem Abdul-Jabbar), who looks remarkably like L.A. Laker basketball great Kareem Abdul-Jabbar, both pass out.

Elaine fortunately puts "Otto the Autopilot" on to steer the plane and keep it in the air, but who's going to land it? There's only one person—Ted Stryker. But he hasn't flown since the tragedy . . .

Air traffic controller Steve McCroskey (Lloyd Bridges) who must have recently checked out of a 12-step program recognizes Stryker's name and sends for Captain Rex Kramer (Robert Stack), Ted's former Commander before the tragedy to help talk down the plane . . .

Can Ted land the plane? Will he and Elaine get back together? What about "Otto the Autopilot," who seems a little frisky when it comes to Elaine? Did I really type the word "frisky"?

Best Scenes

It's impossible to name the best scenes in this film, since they are served up fast and furious. But how about the best jokes?

How Do You Like Your Coffee?—"I take it black, like my men."

Fun with Linguistics—"Oh stewardess! I speak jive."

Joey Visits the Cockpit—"Joey, do you like movies about gladiators?"

Dr. Rumack Is a Big Fan—"I just want to tell you both good luck. We're all counting on you."

McCroskey's Escalating Drug Problem—"Looks like I picked the wrong week to quit amphetamines."

Awards and Recognition

Airplane! was a huge critical and box office hit. The film grossed $80 million from a budget of $3.5 million and was the fourth-highest grossing movie in 1980. It won the WGA Award for Best Adapted Comedy, and was nominated for the Golden Globe for Best Motion Picture—Musical or Comedy.

Empire Magazine named *Airplane!* as the #1 Comedy of All Time in their "The 50 Funniest Comedies Ever" poll. It is the #6 film on the Bravo's "100 Funniest Movies" and in the United Kingdom, Channel 4 judged it as the second greatest comedy of all time after Monty Python's *Life of Brian.*

Airplane! is the #10 movie on the 100 Years . . . 100 Laughs List, and "I am serious. And don't call me Shirley." is the #79 AFI Movie Quote of All Time.

In 2010, our friends at the Library of Congress placed *Airplane!* in the National Film Registry.

CHAPTER 36

Film Comedy Takes Over the World— The 1980s

OR:

Technology if Man's Best Friend Because Dogs Can't Write a Decent Screenplay to Save Their Lives

Dustin Hoffman in *Tootsie* (1982)

Columbia Pictures/Photofest

Chapter Focus

The year 1975 was an important year in the motion picture industry, and not because *The Godfather* was released. It's the year that the Video Cassette Recorder, or the VCR as it was known, began to sell on the mass market in the United States.

What Is a VCR and Home Video?

Developed by six major electronics companies, RCA, JVC, AMPEX, Matsushita Electric/Panasonic, Sony, and Toshiba, the VCR technology had been kicking around since the early 1970s. Their combined technology came together to give audiences at home the ability to do two things: record broadcast television and watch the recordings, and to watch pre-packaged movies. For the first time, you could watch that movie you love at home.

©Sinisha Karich/Shutterstock.com

This machine is called a "Video Cassette Recorder" and those rectangle things are "VHS videotapes;" these were quite popular back in the day—ask your grandparents all about it

There were a couple of roadblocks along the way, including a price point of over $1,000 to own a unit in your home. There was a slight skirmish where the VCR and Sony's Betamax fought it out for market share; the studios saw an opportunity to make money. In the past, films played in the movie theatres,

and then went to television. That was it. This "home video market" would blow up in a serious way, and much to Sony's chagrin, the VHS tape format became the national standard.

Though the movie studios protested that their films would be pirated, a Supreme Court ruling from 1984 found that home video recording for private and fair use and the copying of purchased movies was legal. To combat those who would make copies, the studios developed technology like "Macrovision" to prevent copying of movies sold directly to consumers.

This is a "Video Store"

These are "Shelves" in a "Video Store"

In 1977, the first video store opened in Los Angeles where consumers could go to rent movies instead of buy them thanks to an agreement where 20th Century Fox contracted with Magnetic Video to produce VHS cassettes from their catalog. Soon enough, video stores exploded as both mom-and-pop stores and major chains came along, including Blockbuster and Hollywood Video. In 1983, the average price of a VCR dropped to less than $500 so it became even more affordable to own. It's estimated that in 1985 there were over 15,000 video stores and one out of every four households had a unit in their homes.*

Around the same time that the home video market was starting, so was the advent of cable television.

What Is Cable Television?

The idea of running wires into someone's home and hooking up their television system to a directed signal was invented in 1948 by James Reynolds in Maple Dale, Pennsylvania, to send over-the-air broadcast signals to remote locations that did not have good antennas.**

* De Atley, Richard (September 7, 1985). "VCRs put entertainment industry into fast-forward frenzy." *The Free Lance-Star. Associated Press.* pp. 12–TV.
** Kennedy, Sam (March 4, 2007). "Cable TV invented in Mahanoy City." *The Morning Call.*

In 1975, cable television programming appeared with the launch of Home Box Office (HBO) as a premium pay channel station that broadcast directly to a satellite. Cable companies could then get a satellite receiver dish and bring down the signal to distribute to their cus-

tomers. HBO, Showtime, and The Movie Channel started broadcasting twenty-four hours a day in 1981. Since they weren't over-the-air broadcasts, the FCC didn't censor them, which led to Cinemax playing soft-core porn every night. Don't be shocked; I've never seen that channel in my life. I've—uh—only read about it on the Internet.

Basic cable programming appeared when Atlanta, Georgia, media tycoon Ted Turner launched WTCG, with a direct feed to a

Early cable TV box with over eight channels of programming!

satellite, becoming the first "Superstation." WTCG was soon changed to WTBS, standing for Turner Broadcasting System. Soon more and more stations joined, and then CNN and Headline News, and then ESPN, and now my cable bill is $300 a month.

Ted Turner, founder of lots of cable stations

CNN logo at Atlanta headquarters

The movie studios were elated, now they had more avenues for distributing their films, and started a system where films would go to the movie theaters, then pay-cable outlets, home video rental and sales outlets, basic cable programmers, and finally to traditional broadcast channels. For a film to get from theatrical release to a broadcast station could take three to four years depending on the popularity of the movie.

For the producers of comedy films, they had a buffet of opportunities available. Films that weren't good enough to go to movie theatres could bypass that avenue completely and go straight to the home video market. The other great benefit of all this technology was the sheer amount of programming that all these outlets needed. Film comedy now could splinter into several subgenres.

It also opened up more opportunities for talented filmmakers and comedians to make movies. *Saturday Night Live* was the main conduit for comedy films in the late 1970s and 1980s (and still continues to this day) with such alumni as Chevy Chase, Dan Aykroyd, John Belushi, and Bill Murray proving that television actors could successfully transition to feature films and be successful.

What Is *National Lampoon*?

Another great avenue for comedy talent was *National Lampoon*, a humor magazine that was started by Harvard graduates that had worked on the college-based humor newspaper the *Harvard Lampoon*. First published in 1876, *Harvard Lampoon* alumni include noted authors George Plimpton and John Updike. Conan O'Brien (*Late Night with Conan O'Brien*), B. J. Novak (*The Office*), and Greg Daniels (*King of the Hill*) all contributed to the *Harvard Lampoon* while attending the prestigious University.

Harvard Lampoon writers Doug Kenney (screenwriter of *National Lampoon's Animal House*), author Henry Beard, and editor Robert Hoffman founded *The National Lampoon* magazine in 1970. The magazine specialized in satire and parody, and its most famous cover features a dog with a gun pressed to his head and the caption, "If You Don't Buy This Magazine, We'll Kill This Dog."

In 1973, National Lampoon launched *National Lampoon's Lemmings*, a live stage show featuring sketch comedy and a mock music festival. Stage writers and performers included John Belushi, Christopher Guest, and Chevy Chase. Guest would write music and do arrangements, setting the stage for his later work on *This Is Spinal Tap* and *A Mighty Wind*. Decca Records released a cast recording in 1973.

Also in 1973, National Lampoon wrapped the stage show and started the *National Lampoon Radio Hour*. It ran for almost a year to 600 radio stations across the country, and featured performers John Belushi, Chevy Chase, Bill Murray, Gilda Radner, Christopher Guest, and Harold Ramis. Five comedy albums were released from the radio show broadcasts from 1974 through 1979.

As the National Lampoon performers transitioned to television, the magazine took articles from their pages and commissioned scripts for feature films. Ivan Reitman came onboard

to produce their first film, with a script written by Doug Kenney, Chris Miller, and Harold Ramis that was based on the three writers' experiences in college.

That movie was called *National Lampoon's Animal House*, and it changed film comedy for all eternity, or until the Earth is destroyed by Intergalactic Space Cats from the planet Remulak, whichever comes first. [Editor's Note: See Chapter 34.]

Soon there was a bevy of National Lampoon branded feature films, including *National Lampoon's Class Reunion, National Lampoon's Movie Madness,* and then things got serious with Lampoon writer John Hughes adapting his own magazine short story "Vacation '58," and with director Harold Ramis created *National Lampoon's Vacation* (1984).

Since then, there have been thirty-seven feature films made under the National Lampoon banner, with some great ones, including the three subsequent *Vacation* sequels: *National Lampoon's European Vacation* (1985), *National Lampoon's Christmas Vacation* (1989), and *Vegas Vacation* (1997).

Then in the early 1990s, the National Lampoon brand was sold. *National Lampoon's Loaded Weapon 1* (1993) and *National Lampoon's Van Wilder* (2002), which introduced actor Ryan Reynolds to the world, were produced by J2 Communications. In 2003, another company took over and branded a number of films with the National Lampoon name, but the quality of the films is way below the movies in the 1980s and 1990s. So much so that the Ed Helms–Christina Applegate 2015 reboot of the original *National Lampoon's Vacation* film was simply titled *Vacation* because the producers didn't want the Lampoon name to be associated with their film.

What Is The Second City?

Shockingly, *Saturday Night Live* wasn't the only game in town when it came to bringing new talent into the feature film world of the 1980s. There have been several sketch comedy shows through the years that have challenged the reign of *Saturday Night Live*. The first came from the minds of The Second City comedy troupe.

Founded in 1959 in Chicago by comedian Bernie Sahlins, filmmaker Howard Alk, and improvisation director Paul Sills, The Second City was a theatre-venue for sketch comedy. Budding comedians take classes on improv and performance and present shows on a nightly basis. The Second City was so popular in Chicago that in 1973 they opened another location in Toronto, Canada. Three years later, co-owner Andrew Alexander wanted to expand into television.

In 1976, The Second City launched *SCTV*, a sketch comedy series centered on the programming of a small independent TV network. This gave the writers, directors, and performers the ability to parody and satire TV news, commercials, movies, various programs, awards shows, and all without the need for a live studio audience. The show was first broadcast on the Global Television Network exclusively in Canada.

The first season of *SCTV* featured the on-screen debuts of comedians that would all go on to find success in the film and television industry. Actors from the Toronto branch of The Second City primarily made up the cast of the show, including John Candy (*Splash; Planes, Trains and Automobiles*), Catherine O'Hara (*Home Alone*), Christopher Guest (*This Is Spinal Tap, Best in Show*), Eugene Levy (the *American Pie* franchise) and Harold Ramis (*Stripes, Ghostbusters*) were the most notable members of the cast.

SCTV star Martin Short was one of the *Three Amigos!* (1986)

In the third season, *SCTV* was picked up by the NBC Network to play on Friday nights. Writer/actor Martin Short (*Three Amigos!*) was added to the cast, and the show was nominated for fifteen Emmys during its two-year run on NBC, winning the Outstanding Writing for Variety or Music program in both 1982 and 1983.

A year later, the producers took the show off of NBC when they lost their time slot on Friday night. It went on to limited run on Cinemax and the Superstation, but clearly the end was near. The show was cancelled in 1984, but not before giving some talented individuals a chance to perform before leaping into the feature film world.

With all of these tremendous actors and performers ready to start making movies, the decade of the 1980s had a tremendous amount of films, all different subgenres. Let's take a look!

What Are the Top AFI Subgenre Films of the 1980s?

Best Satire

Lost in America (1985)

Albert Brooks has been making films since his debut feature, the 1979 mockumentary *Real Life*, and has always dealt with the foibles of the middle-class culture and society and his on-screen persona is as neurotic as Woody Allen's. His 1981 romantic comedy *Modern*

Romance is about relationships and the balance needed to understand and compromise when your significant other is jealous and self-centered. His next film would explore the trappings of marriage and the materialistic world of the 1980s.

David (Albert Brooks) is an ad executive in Los Angeles desperately seeking a promotion he's been waiting his entire career for. When he doesn't get it and the boss asks him to relocate to New York City, David insults him and quits on the spot.

He comes home to his wife, Linda (Julie Hagerty from *Airplane!*), with a bizarre plan. He's rejecting the material ways of society and the constant need to excel and wants to sell all of their possessions and buy an RV to travel the country. Linda reluctantly agrees, and they sell their house and possessions, buy an RV, and with their "nest egg" of $100,000, hit the open road.

They arrive in Las Vegas, and while David sleeps, Linda takes their money and in a crazy night of binge gambling loses every dime they have. No cash, no money for gas—they end up breaking down in Safford, Arizona. Now what?

Lost in America is #84 on the AFI Great Comedy Films List, #80 on the Bravo networks' "100 Funniest Movies," and it won the National Society of Film Critics Best Screenplay Award.

Top Romantic Comedy-Drama

Broadcast News (1987)

Jane Craig (Holly Hunter) is a neurotic television network news producer consumed by her work, and her best friend is Aaron Altman (Albert Brooks, star of the aforementioned *Lost in America*), a brilliant reporter who sticks to the sidelines. Aaron has a thing for Jane, but she's too wrapped up in her career to notice. Their lives are disrupted when Tom Grunik (William Hurt) is hired by the network to be the new network anchor. Tom is everything that Jane and Aaron despise about the television news industry—he's a good-looking guy but completely clueless on world and national affairs.

Tom gets attracted to Jane and asks for her to help him become a better anchor, and she agrees. The two grow closer, which frustrates Aaron as he watches Jane falling for the handsome future of the network. He does ask for Tom's advice when Aaron gets his big chance to anchor the news, but that doesn't quite turn out the way that Aaron was expecting. It could be the single funniest scene that you will ever see about television news broadcasting.

Who will Jane choose? Good-looking Tom or salt-of-the-earth Aaron? What's this rumor about layoffs happening at the network?

Broadcast News was a home run at the box office, with the film grossing $67 million on a $15 million budget. The film was universally loved by film critics, and was nominated for seven Oscars, including Best Picture, Best Actor (William Hurt), Best Actress (Holly Hunter), Best Supporting Actor (Albert Brooks), Best Original Screenplay (James L. Brooks), Best Editing, and Best Cinematography. *Broadcast News* is the #64 movie on the AFI Great Comedy Films list.

Top Fantasy Comedy

Big (1988)

Tom Hanks is one of America's best actors with a varied career and the ability to easily skate between genres. *Big* was his biggest mainstream comedy after his debut in 1984's romantic comedy *Splash* and cemented his status as one of Hollywood's top actors.

Tom Hanks is a kid who grows up to be "Big" in the 1988 movie of the same name, co-starring Robert Loggia and a big piano, and directed by Penny Marshall

Josh Baskin is a typical thirteen-year-old kid who is at a carnival and gets embarrassed in front of a girl when he's not tall enough to ride the roller coaster. As he heads home, he spots an old-time carnival wishing game called Zoltar Speaks. He puts in his money and wishes he was "big." The machine pops out a card that says your wish has been granted and Josh is surprised, since the machine is unplugged.

The next morning, Josh wakes up—and he's grown into a thirty-year-old man. He rushes back to the carnival to find the Zoltar Speaks machine, and the entire carnival is gone. He goes back home to tell his mom (Mercedes Ruehl) what happened, but she thinks he's kidnapped her son. Josh goes to school and finds his best friend, Billy (Jared Rushton), and convinces him what happened. With nowhere to go, Josh rents a room in New York City and gets a job at the MacMillan Toy Company until Billy can figure out where the carnival is going next.

Josh meets Mr. McMillian (Robert Loggia) the CEO of the toy company, and together they play a giant-sized piano. Josh impresses his boss, and is promoted to a new position of testing new toys. Along the way, he meets fellow executive Susan (Elizabeth Perkins) and the two of them begin seeing each other romantically, much to Billy's dismay. He tries to talk Josh out

of acting more and more like an adult, but Josh is quickly forgetting what it was like to be a child.

Will Josh remain an adult forever? What happens if Billy finds the Zoltar Speaks machine? What will happen to Susan and Josh if he decides to become a kid again?

Big was a "big" box office hit. [Editor's Note: Did he really do that? I thought we cut that one?] The movie earned over $150 million on a budget of $18 million. The critics loved the film, and Tom was nominated for his first Best Actor Oscar, and the film was also nominated for Best Original Screenplay. The AFI named *Big* the #42 movie on the Great Comedy Film list, and it's the #10 movie on the AFI Top 10 Great Fantasy Films.

Best Sports Comedy

> Well, I believe in the soul, the cock, the pussy, the small of a woman's back, the hanging curve ball, high fiber, good scotch, that the novels of Susan Sontag are self-indulgent, overrated crap. I believe Lee Harvey Oswald acted alone. I believe there ought to be a constitutional amendment outlawing Astroturf and the designated hitter. I believe in the sweet spot, soft-core pornography, opening your presents Christmas morning rather than Christmas Eve and I believe in long, slow, deep, soft, wet kisses that last three days.
>
> **— "Crash" Davis**

Bull Durham (1988)

Filmmaker Ron Shelton's work is synonymous with sports comedy, having written and/or directed *The Best of Times* (1986), *White Men Can't Jump* (1992), *Blue Chips* (1994), *The Great White Hype* (1996), *Tin Cup* (1996), and *Play it to the Bone* (1999). But it's his first sports film, based on his early career as a minor league baseball player received the most acclaim.

Veteran minor league baseball catcher "Crash" Davis (Kevin Costner) has been sent to the Durham Bulls to teach a young fireball pitcher, Ebby "Nuke" LaLoosh (Tim Robbins) how to make it in the big leagues. Crash starts by razzing the new pitcher trying to help him realize that the other teams are going to try to get into his head. As the insults continue, Nuke finally attacks Crash, and Crash punches him. "Thus endeth the lesson."

Crash meets Annie Savoy (Susan Sarandon), a self-proclaimed "baseball groupie" that invites Crash and Nuke to dinner, and tells them how she chooses one player per season to be with sexually, and she's trying to choose between the two of them. Crash walks out and Annie ends up tutoring Nuke as the season progresses on in sexual activities and poetry. Crash

works with Nuke on the field, and helps him to get his pitching and temper under control. Crash and Annie get closer, and when Nuke is called up to the major leagues, Crash is cut from the team.

What will happen to Crash? Especially since he's only a couple of home runs short from the all-time minor league home run record? Will Nuke make it at the major league level? Will Crash and Annie come together?

Bull Durham has one of the most famous movie monologues in history—when Crash confronts Annie about why he would never get with her in the first place.

Bull Durham was a huge hit with the critics and with the audience, grossing over $58 million on an $8 million budget. The film won the Best Screenplay award from the New York Film Critics' Circle, the National Society of Film Critics, the Los Angeles Film Critics Association, and the Writer's Guild of America, and was nominated for the Best Original Screenplay Oscar.

Sports Illustrated ranks it as the #1 film in its Greatest Sports Movies of All Time list, the #55 on the Bravo network's "100 Funniest Movies," and the #97 movie on the AFI Great Comedy Films list.

Best Farce

A Fish Called Wanda (1988)

The greatest comedy troupe in the history of non-American film comedy is *Monty Python's Flying Circus*. With both their television series and their four films, they set the bar for all sketch comedy programs to aspire.

The closest Monty Python came to an American film is the laugh-out-loud slapstick *A Fish Called Wanda*. Written by Python's John Cleese and British director Charles Crichton (*The Lavender Hill Mob*), this heist-comedy was a huge mainstream hit for all involved.

MGM/Photofest

The cast of *A Fish Called Wanda* (1988) including John Cleese, Wanda, Jamie Lee Curtis, Kevin Kline, and Michael Palin. (It's as close as we get to the British comedy team of Monty Python in our book about American Great Comedy Films)

British thieves George (Tom Georgeson) and his partner, habitual stutterer Ken (Michael Palin) hire American con artist Wanda (Jamie Lee Curtis) and her "brother" (who is actually her lover) Otto (Kevin Kline) to help them steal $20 million worth of diamonds. The only problem is that all four of them want to keep the jewels for themselves. Wanda's plan is thwarted when George moves the diamonds to a secret location before George is arrested on an anonymous tip from Wanda.

Wanda realizes the only way to find the location of the diamonds is by seducing unhappily married Archie Leach (John Cleese), George's attorney who she knows will lead her to the diamonds' location. Unfortunately Otto is insanely jealous and wants to kill Archie at his first chance. Instead, he takes Ken hostage and interrogates him while shoving French fries up Ken's nose and eating Ken's goldfish.

Who will end up with the jewels? Will Archie fall for Wanda and give away the location? What will happen to the rest of Ken's pets?

A Fish Called Wanda was big critical hit, and was nominated for three Academy Awards, including Best Director for Charles Crichton and Best Original Screenplay for John Cleese and Charles Crichton, and the film won Kevin Kline the Academy Award for Best Supporting Actor. At the British Academy Awards, *A Fish Called Wanda* was nominated in seven categories, including Best Film, and won for Best Actor for John Cleese and Best Supporting Actor for Michael Palin. It was also nominated for three Golden Globes, Best Picture, Best Actress for Jamie Lee Curtis, and Best Actor for John Cleese.

A Fish Called Wanda is the #21 movie on the AFI 100 Years . . . 100 Laughs List and is the #27 film on the Bravo network's "100 Funniest Movies" list.

Truly, the 1980s were a time when comedy films for everyone's tastes and moods had an opportunity to be made. There have been a ton of films in the 1980s that have already been discussed in this book: *Ghostbusters, When Harry Met Sally, Tootsie, Good Morning Vietnam, Beverly Hills Cop, National Lampoon's Vacation* twice—so I need another list!

The Top 5 Comedies of the 1980s That Haven't Been Written about in Other Pages of This Book Because the AFI Isn't Perfect

Romancing the Stone (1984)

It's hard to put this movie in a box because it's a little of everything. It's an action-adventure-romantic-comedy-buddy movie with Kathleen Turner as Joan Wilder, a successful romance novel author who is sent a treasure map by her brother-in-law before he was killed, and she must travel to Columbia to bring the map to the men who kidnapped her sister. To

get through the treacherous jungle, she hires mercenary Jack Colton (Michael Douglas) after he rescues her from the men trying to retrieve the map, and as they spend time together—adventure and romance ensue! Bonus trivia—the movie is directed by Robert Zemeckis, who pops up a little later on this list.

Pee Wee's Big Adventure (1985)

Paul Rubens created one of the most memorable characters in film history, the bow-tied, suit-wearing man-child Pee Wee Herman who is devastated when his prized red bicycle is stolen from his house. Pee Wee goes on a cross-country journey and survives peril after peril in a quest to find his bike in this charming and inventive debut feature from director Tim Burton.

Midnight Run (1988)

This solid entry in the buddy-action film in the model of Eddie Murphy's *48 Hours* tells the story of bounty hunter Jack Walsh (Robert DeNiro) who is hired by a bail bondsman to bring an escaped mob accountant Jonathan "The Duke" Mardukas (Charles Grodin) back for trial, both knowing that "The Duke" will never make it back after embezzling $15 million from a mob boss. It's a smart comedy grounded by two intelligent actors at the top of their game.

Little Shop of Horrors (1986)

The 80s had room for every subgenre, so how about the musical comedy? Based on the off-Broadway musical that was based on a low-budget Roger Corman horror movie, Director Frank Oz (the voice of Yoda in *The Empire Strikes Back* and Miss Piggy of The Muppets) creates a flawless world where Rick Moranis plays Seymour, the nebbish flower shop employee who is in love with his co-worker Audrey (Ellen Greene). One day he discovers a rare flower which he names after her. Too bad the flower is actually an alien from outer space who enjoys eating human beings. It just needs to convince Seymour to bring him some fresh victims! Five gold stars for the inspired casting of Steve Martin as the insane dentist Orin!

Back to the Future (1985)

How the American Film Institute kept this movie off of their 100 Years . . . 100 Laughs List, their Great Movies List, their Great Songs List, their Great Quotes List ("Roads? Where we're going, we don't need roads.") and managed to throw it a bone as the #10 movie on the Top 10 Science Fiction Films, makes me so angry that I want to move to Canada, where star Michael J. Fox was born.

If you haven't seen this film, then I gently point you in the direction of your nearest audio-visual device. Marty McFly (Michael J. Fox) lives a teenager's humdrum life when his friend "Doc" Brown (the incredible Christopher Lloyd) builds a time machine out of a DeLorean automobile. When terrorists kill Doc Brown for stealing their plutonium, Marty must escape in the DeLorean and lands in 1955, where his soon-to-be mother and father are supposed to fall in love in high school. But what happens when Marty accidentally comes between them and Lorraine wants to date him? If he doesn't bring them together at the big dance, he'll be erased from existence!

Back to the Future was a huge movie, as in $389 million huge, and spawned two very successful sequels. The film cemented director Robert Zemeckis as a filmmaker, leading to such remarkable films as *Forrest Gump* and *Castaway*.

Entertainment Weekly named *Back to the Future* the #28 movie on their list of "50 Best High School Movies," Total Film named it one of t he 100 Greatest Movies of All Time, and in 2006, the film was selected for the National Film Registry by the Library of Congress. Take that AFI!

Honorable mentions of pretty great films in the 1980s: *A Christmas Story* (1983), *Mr. Mom* (1983), *Revenge of the Nerds* (1984), *Fletch* (1985), *Weird Science* (1985), *Back to School* (1986), *Crocodile Dundee* (1986), *Ruthless People* (1986), *Adventures in Babysitting* (1987), *Dirty Rotten Scoundrels* (1988), *Working Girl* (1988), *Twins* (1988), *Uncle Buck* (1989), *Bill & Ted's Excellent Adventure* (1989), and *Major League* (1989).

The 1980s were the greatest decade in the history of comedy films. Period. End of chapter.

CHAPTER 37

An Exclusive Interview with Director John Landis

Writer-Director John Landis

© Platt Photography

John Landis is the celebrated writer-director of some of the greatest comedy films in the history of motion pictures. His filmography consists of iconic classics including *National Lampoon's Animal House* **(1979),** *The Blues Brothers* **(1980),** *Trading Places* **(1983),** *Spies Like Us* **(1985),** *Three Amigos!* **(1986), and** *Coming to America* **(1988).**

He graciously sat down to discuss his career, some of his movies, style, and collaborations that have resulted in some of the funniest movies ever made.

Chris LaMont: What made you want to be a filmmaker?

John Landis: When I was eight years old, I saw a movie at the Crest Theater on Westwood Blvd in Los Angeles—*The Seventh Voyage of Sinbad*, which is one of Ray Harryhausen's films. And I had what is called suspension of disbelief. I was totally into the movie. It's the movie that really made me go—Wow. Whoa. I was just the perfect age for that film. Nathan Juran directed it. It's not really a great movie. When you see it now, it's corny and low budget, but it does impart a sense of wonder. As a kid, I just loved it. The dragons and cyclops and the sword fight with the skeleton, the Harryhausen creatures. And the evil sorcerer played by Torin Thatcher, all of it made a big impression on me.

I was overwhelmed by the power of cinema. When I went home I asked my mom, "Who does that? Who makes movies?" And she answered, "The director." Which was surprisingly sophisticated of her, because we had no connections to the film business.

I grew up in Los Angeles and I just knew what I wanted to be when I grew up—a movie director. A filmmaker. So from the time I was eight, I was driven, that's all I did. I just watched every movie. Read every book. And because it was Los Angeles in the fifties and sixties, I was able to actually meet so many of the filmmakers who created the language—people like Alan Dwan, King Vidor, Hal Roach, Howard Hawks. I went out and met every filmmaker I could. They all thought I was bizarre, because I was a kid and because I was American. At that time in America, it was not en vogue to admire American filmmakers.

As soon as I was able to get a real job connected with movies, I did. I became a mail boy at Twentieth Century Fox at seventeen. George Stevens was making his last film, mostly shot in Paris, but they did pick-ups on the lot here. It was with Elizabeth Taylor and Warren Beatty—*The Only Game in Town*, it's not a very good movie, BUT it was George Stevens! So I got to meet and talk with George Stevens. I was able to watch directors like Stevens and George Cukor and Robert Altman work. It was fantastic.

CL: How would you describe yourself as a director?

JL: I'd like to think of myself as a craftsperson. You know I do have friends, many friends, who consider themselves *artists* and I don't think moviemaking is necessarily an art. Don't misunderstand me. It often can be art. It can elevate to art, like any craft. If you gave four

Interview reprinted by permission of John Landis

carpenters the same wood and the same tools and said build a table, or build a chair, well, they'll all build a chair and you can sit in it, and it's a chair, but one of those carpenters might be Charles Eames. You know you might have an extraordinary chair that transcends its utility and might be a work of art, and I think that's true in the movies all the time. When I approach something I approach it as trying to do the best I can and communicate and make it comprehensible to the audience.

What people don't understand is **filmmaking is constant compromise**. It's completely collaborative. It's not just artists. You're collaborating with plumbers and electricians and mechanics—you're collaborating with the fucking weather! There's so many elements that go into the simplest scene.

A movie is piecework, it's shot by shot to build the coverage to create your story. Sometimes the actor can't deliver the line the way you want. Or you can't get the exact—whatever. There's so much. There's seamstresses. There's so much that goes into even the simplest movie. I don't think people ever understand that. So there's so much out of the director's direct control, unless you're Spielberg or Kubrick or someone, you really don't have the resources. David Lean was famous for waiting for the right light with the whole company in the desert. It's an inexact craft.

CL: Your sensibilities are so good with comedy and your ability to speak with the audience. How much do you put yourself into what the audience is thinking while you're shooting?

JL: The director has multiple roles, and one of them is that he is the audience. Does it work for me? Do I think it works? When you shoot a film, money equates time, so, you can't always afford the luxury. Charlie Chaplin and Harold Lloyd—those two guys.

They had this amazing thing, Chaplin, it would take him a year to a year-and-a-half to make a movie. He would shoot, he would cut it together, and then—Woody Allen's done it too where they shoot a movie and decide, "Nah." They'd recast it and reshoot the whole movie! Chaplin did that many times.

Harold Lloyd did an extraordinary thing where he'd shoot a movie . . . if you looked at some of Lloyd's movies, Speedy . . . If you put them in front of an audience, even your college audience, and you'd be amazed at the amount of laughter, and it's because Lloyd promoted the whole thing as a technician. He literally would cut his film, preview them with a stopwatch, and he would clock how many laughs per-minute. If he didn't get as many laughs as he wanted, he would go back and recut or reshoot until he got the number of laughs a minute he wanted. And it really works! You watch those movies now, they're hysterical!

CL: From a directorial standpoint, what kind of relationship do you have with actors that you've worked with, where you're asking them to do outrageous things?

JL: It depends. Very often students ask me how do you direct actors? My experience is, every single one is different. Casting is 80 percent of the process in getting the performance you want. There are a lot of directors who say they never really direct actors, they hire the actor and expect them to do their job. Woody Allen rarely talks to actors.

Every actor is different. Some of them want to really intellectualize what they're doing and spend time talking. Some of them just need some kind of interior motivation. Most of them are professional and know how to do their job. **The actors should trust their director.** That's vital.

CL: You've done slapstick and parody. Is there a particular flavor of humor that you always know you can go to?

JL: I'm not the first to say this, but it's very dangerous when you talk about comedy. Probably, it's the most difficult kind of movie to dissect, because comedy, *especially* comedy is subjective. So what's funny to some people is not funny to others. And it's very hard to say what's funny and what's not funny.

The truth is, what people really don't understand, and this is true of everything, is that the director's job is that **they are the one telling the joke**.

I'm a Jew. If someone I know, a relative or a good friend, tells me that anti-Semitic joke—I might think it's pretty funny. Why? Because I know they're not anti-Semitic! Yet, if a stranger tells me the identical joke, I'm offended.

The difference isn't the joke; the difference is my understanding, the audience's understanding of where that joke is coming from. This is a very subtle and sophisticated dance. What the director is doing is setting the tone.

Everything depends on context. And the context is always multilayered. It's not just the plot, the characters, and the performers. It's HOW are we being told this joke.

The most important thing in any film is to generate sympathy for the characters. This is true for all genres. And that's the thing about comedy. You can't make general rules in comedy, because sometimes you can make a comedy where you don't like the characters, but it's still really funny. There's no easy explanation, because some things are funny to some people, and not funny to others.

The breakthrough in *Blazing Saddles* wasn't the black sheriff and the discussion of racism. The breakthrough scene was the one with the farting cowboys around the campfire. If anyone had put a fart in a movie before that movie, there would be outrage. In *Blazing Saddles*,

the cowboys are not making little fart sounds, they're making loud, wet fart sounds—and it keeps going on and on. In that moment, Mel Brooks had created an atmosphere where we are allowed to laugh.

CL: What do you think is your most offensive movie? *Animal House*?

JL: Oh, I don't think any of my movies are truly offensive. They have outrageous moments, but nothing I would consider truly offensive. Remember everything is in context.

John Landis's first major feature film was 1979's *National Lampoon's Animal House* **which is the #36 Film on the AFI 100 Years . . . 100 Laughs List. It launched John Belushi's film career and is the film credited with being the first Gross-Out Comedy.**

JL: I had a moment in *Animal House* when I really didn't know what to do. It was the scene where Bluto is looking in the sorority house window of the topless girls—the co-ed pillow fight. Then he goes to the next window and sees Mandy, and as scripted it says "she takes off her bra, fondles her breasts and then her hands move slowly into her panties and she begins to masturbate." That's what it said. And I thought, "How the fuck am I going to do this?" It was just so shameless.

And when we were shooting it, I had a spur of the moment idea. I just realized that John Belushi was such a marvelous performer—he could communicate with the audience with the slightest change of his facial expression. He had an amazing connection with the audience.

John Landis in the middle of the Delta House Fraternity

Photo © John Landis

I just had Bluto turn around and look into the camera and he raised his one eyebrow—and he made the entire audience a co-conspirator.

But yes we made up stuff all the time. *Animal House* was a great script but we did improv things. In *Animal House*, I also would surprise actors during takes. We'd rehearse something and then during the scene I'd throw things at them. We called it the Delta Poltergeist. If you look at the movie there's flying objects all the time.

CL: And that's you?

JL: Yeah, that's me. There's this one moment where Pinto and Flounder come into the Delta House for the first time and they meet Bluto and this beer bottle comes flying in and John just grabs it. He literally takes it from the air. And that was something I knew I couldn't rehearse, so during the take I just shouted, "CATCH!" Boom. John is so fabulous he just kept in character, caught it and continued.

CL: *Animal House*—is there any other scene where you really felt like you hit it?

JL: John's big inspirational speech. It's very well written. "Was it over when the Germans bombed Pearl Harbor?" The Germans? Forget it, he's rolling. That speech, and the way John delivers it with Elmer's score was just truly funny. Since then, every movie has the big inspiration comedic speech. I even did it in *Three Amigos!*

CL: Was there a film, like *Animal House,* where you were surprised from the audience reception?

JK: I was surprised and thrilled with the audience's response to *Animal House*. I mean, it was my first studio picture and made for $2.3 million, but the .3 was studio overhead. The next cheapest picture being made on the lot was $10 million . . . None of us expected that success. It was just overwhelming.

CL: You talked about people being subjective, comedy goes over well for some and not for others, have you had people after your films come out and be extremely irate with you as a filmmaker?

JL: Sure. All of them! People get offended by different things. There's a line in *Animal House*, Doug Kenney's character Stork says, "Well, what the Hell we supposed to do, ya moron!" It always got a laugh, and I guess it was the way he said it. Universal received a letter from this woman and forwarded it to my office saying, "Here you deal with it."

It was a very sincere letter from a woman somewhere in the country and she wrote that her son was a moron—it turns out that moron is a medical term for a certain form of handicap. She was very offended, so I wrote her an apology, I didn't know what else to say! "We're very

sorry. We didn't know that. We didn't mean to offend anybody." But sometimes you do mean to offend people!

John Landis's next feature film was 1980's *The Blues Brothers* with Dan Aykroyd and John Belushi bringing their *Saturday Night Live* characters to the big screen in a rollicking musical comedy slapstick farce that has one of the greatest car chase scenes ever put on film.

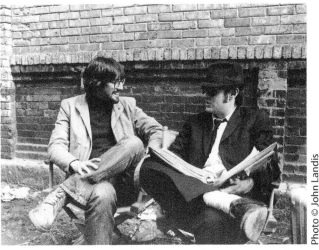

John Landis on the set of *The Blues Brothers* with star Dan Aykroyd

Photo © John Landis

JL: Part of the joke in *The Blues Brothers* is that it is all so deadpan. Regardless of how insane things get, it is always played seriously. John and Danny were doing what we called "comedy noir." One of my favorite exchanges of dialogue in that movie is when that woman asks if they're the police and Elwood answers, "No ma'am, we're musicians."

The main joke of that movie is size. **Everything is on a gigantic scale.** Cars don't just crash, they roll over twelve times. One car doesn't crash, forty cars crash. Everything is so over the top, and at the heart of it are these two totally straight figures. That movie, you can trace everything from Mack Sennett's Keystone Cops, Fatty Arbuckle, Buster Keaton, Harold Lloyd, Laurel and Hardy, and Abbott and Costello. There are so many movies that it's indebted too . . .

Another of my favorite moments in *The Blues Brothers* is when the entire military might of the state comes down on Daly Plaza. And you cut from this massing of soldiers and weaponry and vehicles and all this stuff. And you just cut to these two guys in an elevator with the Muzak playing. The calm at the heart of the storm.

On *The Blues Brothers*, we were in Chicago; we were shooting thirty-five cars going over a hundred miles per hour in downtown Chicago, which meant we had to shoot very early in the morning on Saturdays and Sundays and have 300 production assistants and 120 police. We had to go back almost half a mile, which meant we had to block any entrance to the street. It was like a military operation!

And we're setting up the shot and Ned Tannen, who was head of production at Universal, was getting all kinds of shit about, "What the fuck are they doing out in Chicago?" He announced the budget of the movie was $12 million. Bob Weiss has *Variety* and he turns to me and says, "John, I think we've already spent $12 million!"

That movie ended up costing $27 million, which was huge at the time! But you also have to realize, when you look at that movie, it's all real! There's no CG. It's real cars. Everything's real. There's no tricks. When the Nazis drive off—that's a real Pinto being dropped from a Sykorsky helicopter at 1,400 feet. To do that we had to prove to Cook County, the City of Chicago, and the federal aviation authority that the car would land where we said it would. So we had to drop two of them in a cornfield just to prove—so that was three Pinto's gone. This stuff adds up.

CL: Just from a slapstick standpoint, the action–comedy, that movie has everything . . .

JL: It's a strange movie . . . The real motivation for that film was the love of the music. It's hard for people to remember, but in 1979 when we made that movie, Rhythm and Blues was over, it was all disco. Black music was chic. Danny and John were evangelical about American Rhythm and Blues—it's an unusual situation where you have hot celebrities of the moment focusing their attention on these great artists. People always say how did you get those amazing people? And I say, trust me—we called them.

Regardless of money, actually the movie was very successful—did you know it was released theatrically in France two months ago? It still plays all over the world. But my point is, it was successful on that level, it did bring that music back in a way that it's hard to think it was ever gone.

After the success of *The Blues Brothers*, John Landis's next comedy feature film was 1983's *Trading Places* with Dan Aykroyd and Eddie Murphy. The film is considered one of the smartest comedies ever made.

CL: *Trading Places* has a plethora of social class comedy. When you were working with Dan and Eddie on *Trading Places*—was it too broad sometimes? Or did you feel like playing it straight with a lot of the verbal comedy?

JL: Well that was a very good screenplay and the movie, the way it was shot . . . my intention was, with very few changes, it really was a thirties picture—it's what was called screwball. If you look at the films of Sturgess, Lubitsch, Stevens, McCarey, LaCava, Hawks, and Capra—they are very political. Movies like *My Man Godfrey, It Happened One Night, His Girl Friday, Sullivan's Travels, The Miracle of Morgan's Creek*—they are all extremely political. They deal with class and wealth and inequality. Sexual politics.

When I read *Trading Places*, the screenplay was called Black & White. The first thing I thought was, I hate this title. I said, I'll pay anyone five hundred bucks who gives me a better title. It wasn't until postproduction, in the cutting room when my editor and producer George Folsey said, "Hey, how about Trading Places?" And I thought, "brilliant!" I don't think I ever paid him . . . Don't print that story, because he'll call me . . .

My intention was to make a completely thirties movie, but it has to be contemporary! So, that's why there's profanity and nudity, to make it in the present. But, the social concerns—Reagan was President—are totally valid. It's a very political movie, but it's a comedy.

CL: Do you stay hard and fast to the script? Do you give the performers a lot of freedom?

JL: In *Trading Places* there are scenes in that where I had Eddie and Danny riff on the scenes. When you first meet Eddie's character he is pretending to be a legless Vietnam vet. It was written that a woman walks by and he calls out, "We can make it baby, me and you," but then in rehearsal Eddie added "Once you've had a man with no legs there's no turning back." I thought that was funny, so we kept it in the cut. But then when we shot the scene I kept rolling and as he gets further away from him, Eddie yelled after her, "Ain't you never seen Porgy and Bess, bitch?" Eddie made that up, and it's great!

CL: Was there a performance that you worked on with an actor that just completely surprised you? Brought something more to the role than you ever imagined?

JL: Here's an example of a performer improving a role—Jamie Lee Curtis in *Trading Places*. Her character is the only ridiculous thing in that movie. Ophelia, the hooker with the heart of gold. It's such a cliché. Her character is completely unreal.

She not only takes in this homeless person, but she also cares for him, sleeps with him, and even bankrolls him. She has money in the bank, she's smart, and she looks like Jamie Lee Curtis. So Ophelia was a difficult role to cast. Who could make that work? Jamie really made an unrealistic and impossible character on the page work on-screen.

After *Trading Places,* John directed Dan Aykroyd and Chevy Chase in *Spies Like Us* (1985) and then *Three Amigos!* (1986) with Steve Martin, Chevy Chase, and Martin Short.

CL: How about *Spies Like Us*?

JL: That's a silly movie, but it deals with what was then the Reagan Star Wars defense and the Cold War. What's so funny to me about *Spies Like Us* is . . . no one thinks of themselves as old, but that movie is a Cold War movie, and the politics are so interesting. It was meant to be a Hope and Crosby kinda road picture . . . Bob Hope's in it. It's Bob Hope's last movie! But, what's so bizarre about *Spies* is when the Russians were in Afghanistan. So, the movie goes to Afghanistan. They go to Pakistan. And they meet the Mujahideen who, at that time, were our allies because they were fighting the Russians. We gave them money and arms and now they're Al-Qaeda! The politics of that movie are pretty interesting. It also deals with nuclear weapons, atomic weapons and that's a subject that is so off the table now that Trump just said, "why doesn't Japan have atomic weapons?" It's like what?

CL: Don't you think when you're talking about politics—it makes it easier to digest from a comedic standpoint than drama?

JL: Not necessarily. Godard said "All films are political." Very often filmmakers are very unaware of the politics of the movie that they're making. If you look at *Forrest Gump*, I'm not sure Robert Zemekis meant for that to be as reactionary as it is. I don't believe that Bob is a reactionary or a racist, but his movie is. And I don't think he understood that when he was making it. All movies are political so you have to be aware of it. Sometimes the politics are intentional and sometimes not.

CL: You have these wildly eclectic movies when you're talking about your body of work. Is there any particular movie, if you were to say, if we were going to put a John Landis movie on Voyager and shoot it into Space and it's an example . . .

JL: *Three Amigos!* is one I'm very fond of . . . it's very difficult for filmmakers, or actors, to actually separate the movie itself from the experience of making the movie. You have all this baggage that goes with you. Every so often, I see a movie I made twenty-five, thirty years ago and I'll say, "Well, that was better than I thought!" Or I'll see something and cringe.

Three Amigos! is a very funny movie. I like that movie. That was a screenplay by Steve Martin, Randy Newman, and Lorne Michaels. All funny and talented people. There is amazing music in that film. A terrific score by Elmer Bernstein and great songs by Randy Newman. Elmer and I did ten movies together. On *Three Amigos!*, I told him, "Elmer, I want you to write a score that parodies an Elmer Bernstein score." Listen to the score for *Three Amigos!*, it plays on *The Magnificent Seven* and *True Grit*, all those brilliant Westerns he did.

John Landis has worked with some of the most brilliant comedic actors in the history of motion pictures.

CL: I know this is going to be tough, so I apologize in advance. I want to name some of the performers that you worked with, give me just one sentence to describe them. I'll start with Dan Aykroyd—

JL: Danny is wonderful. I think he's so gifted. If you look at a character like Elwood (*The Blues Brothers)* and then Louis Winthrope the Third (from *Trading Places)*—they're from different planets. He's a fine actor. And he has a genuinely original mind.

CL: John Belushi—

JL: John Belushi was one of a kind. He really was a dancer, I mean he was graceful. He also had the extraordinary ability to communicate with just an eyebrow. John had this direct

connection to the audience. Bluto is pure appetite, and really not attractive as written. I told John that Bluto is a cross between Harpo Marx and The Cookie Monster. What they have in common with Bluto is that they're completely destructive, but also very sweet. He gave Bluto an underlying sweetness.

CL: Like Harpo!

JL: Haven't you ever wondered what Harpo was going to do with those girls he's chasing when he catches them?

CL: Eddie Murphy—

JL: Eddie has real brilliance. He really does. He's a genuine mimic. If you say, sing like Stevie Wonder . . . Sing like James Brown . . . Sing like Frank Sinatra . . . Sing like James Taylor . . . Sing like Sam Cook . . . He can do it so well, that if you close your eyes you wouldn't know it wasn't the real thing. He can do that with characters. If you give him a character, he can run with it.

Watch him in *Coming to America.* These broad wacky characters he does, they're so specific, and well realized! Including the old Jewish guy! He's perfect. But his best performance, and different than any other performance he ever did is Prince Hakeem. He really is Prince Charming in that. He's regal, he's charming, and he's very much not like Eddie Murphy. He's wonderful. I'm a big fan of Eddie's.

CL: Steve Martin—

JL: Steve is a very interesting guy. He's very cerebral and very shy, and genuinely smart. I like him a lot. He has a big brain.

CL: Was there a challenge in directing him?

JL: No, he was easy. If you remember, he was one of the writers of *Three Amigos!* That's a movie that has a real dedication to silly.

CL: And Martin Short?

JL: Marty Short is a real, old-school-styled, vaudeville performer. He's "Broadway!!" Very, very funny. The parts that he's been most successful in are very exaggerated characters. Like in *The Father of the Bride* [Editor's Note: the 1991 remake with Steve Martin.], he's this outrageous wedding planner. There's a Christopher Guest movie in which he plays an agent . . .

CL: *The Big Picture.*

JL: Right! Marty is brilliantly funny in that.

CL: **"I don't know you. I don't know your work, but I understand you're brilliant!" Right?**

JL: (laughs) Yes!

On the Current State of Gross-Out Comedies

CL: **A film like *The Hangover*, what did you think of that picture?**

JL: I thought it was like a Bowery Boys movie. It didn't impress me. There was some funny . . . I liked the baby.

CL: **That's always funny, babies with sunglasses. The trend now is really gross out comedy—**

JL: I go to movies now and think, Jesus, *Animal House* has a lot to answer for . . .

CL: **So it's your fault is what you're saying?**

JL: Well, I hope so—

CL: **Well, that seems to be the trend, when you're talking about *Bridesmaids*—**

JL: *Bridesmaids* —I thought *Bridesmaids* was very funny. Kristen Wiig is wonderful.

CL: **Yeah, but she's also shitting in a pail—**

JL: Well, if you look at that, it was tastefully done. That sounds silly, but look at it, you don't see shit.

CL: **But, from a content standpoint—**

JL: Yeah, but again, in that story context and the way the joke was told, it allowed us to laugh.

CL: **Are you shocked at all from a comedy standpoint when you see a film and say, "Oh my gosh, I can't believe they did that"?**

JL: I'll see things I don't like or that offend me, but I think you can do anything . . .

Wrapping it Up . . .

JL: Turner Classic Movies is re-releasing *Animal House* in theaters this summer. And I'm delighted because it's being shown on big screens in movie theatres, which is the proper way to see a movie. It's so demoralizing that most people see films on their laptops or televisions . . . Even their iPads or iPhones. Movies are meant to be seen on a large screen in a theatre with an audience. Especially comedies and horror films because both laughter and fear are contagious. There is no doubt a funny movie is funnier and a scary movie is scarier when seen with an audience.

That's the other thing—everything went to shit when the newspapers started printing the grosses. Because the financial success of a film does not mean it's good, and the failure of a film does not mean it's bad. It's sad, because it's so cutthroat—it's your first three days and then you're out of there.

CL: Last question—so how do you wake up in the morning and say, "I'm John Landis and I am an awesome film director"?

JL: Well, I don't. I say, "I'm John Landis and I'm out of work," is what I say.

© Platt Photography

Author Chris LaMont and Writer-Director John Landis look like best friends when they met at The Phoenix Symphony's "Celebration of the Music of Elmer Bernstein" in March 2016

CHAPTER 38

ARTIST SPOTLIGHT

Bill Murray, Eddie Murphy, and Robin Williams

CHAPTER FOCUS

► Who Is Bill Murray?

► Who Is Eddie Murphy?

► Who Is Robin Williams?

Chapter Focus

As the 1980s continued to roar, three actors personified the next wave of comedy stars. They weren't writers like the 1970s actors and stand-up comedians, but three talented individuals that came to personify performer-based comedy for the next thirty-plus years.

Who Is Bill Murray?

Born in Evanston, Illinois, in 1950, Bill is one of nine kids. He grew up playing in a rock band and appeared in high school and community theatre. He also loved golf and was a caddy at a local country club to earn money to help pay for his private school education. He dropped out of college and his brother, fellow actor Brian Doyle-Murray, suggested he join The Second City comedy troupe in Chicago. He later moved to New York and joined *The National Lampoon Radio Hour*.

Bill Murray

From there he went straight to television's *Saturday Night Live*, no—not that one. *Saturday Night Live with Howard Cosell* on ABC, a one-year variety show experiment that featured comedy sketches and one of the most famous sports broadcasting personalities in history. He joined NBC's *Saturday Night Live* show in 1977, replacing the departed Chevy Chase. Some of his memorable characters include Nick the Lounge Singer crooning to the *Star Wars* theme, Todd the geek giving noogies to Gilda Radner's Lisa Looper, the Line Cook from the "Cheeseburger" sketch, one of the Killer Bees, and the hands-on Richard Dawson, the host of the *Family Feud*. Rolling Stone ranked Bill as the #6 Cast Member of All Time in their 2011 Ranking poll and Bill won an Emmy for writing *Saturday Night Live* in 1977.

Bill's film career started with 1979's *Meatballs*. Directed by Ivan Reitman (who would later direct Bill in *Stripes* and *Ghostbusters*), Bill played smart-ass Tripper Harrison, the goofball head counselor at Camp North Star. The wacky comedy featured the patented "the-slobs-versus-the-slobs" theme with a rival camp, and is highlighted by Tripper's inspirational speech featuring the chant "It Just Doesn't Matter!" The movie made $43 million on a budget of $1.6 million. Bill Murray, film star, had arrived.

He next appeared as a supporting lead in the 1980 classic film *Caddyshack*, where he put his golf caddying skills from high school to good use playing the memorable greenskeeper Carl Spackler. [Editor's Note: See Chapter 34.]

Bill graduated next to leading roles, notably 1981's *Stripes*. Directed by Ivan Reitman, this film solidified the Bill Murray that we have come to know and love. He's the wise guy Army

Bill Murray in *Caddyshack*

recruit in basic training, clashing with the powers-that-be, and ends up doing exactly what he wants to do on his terms. The film was a monster hit, making $85 million and Bill has never looked back again.

He's appeared in over seventy films and television shows over his thirty-five-year acting career. He's had some turkeys over the years—his Hunter S. Thompson film *Where the Buffalo Roam,* the ill-fated drama *The Razor's Edge,* those cash-grab *Garfield* movies, *Osmosis Jones,* but I'd rather focus on his great films. Since I already have summaries of *Ghostbusters, Tootsie,* and *Caddyshack* elsewhere, let's see what else Mr. Murray has in his filmography . . .

Bill Murray "ain't afraid of no ghosts" in *Ghostbusters* (1984) which cemented him as one of the premier comedic talents of all time

The Official Bill Murray Top 3 Great Comedy Film Checklist

Groundhog Day (1993)

Nobody does cynical and deadpan better than Bill Murray. But in the universe that is *Groundhog Day,* those two traits will have to be overcome for him to move on with his life. Literally. He plays Phil Connors, a selfish, egotistical weatherman from Philadelphia stuck making the annual trek to Punxsutawney, Pennsylvania, the home of the fabled "Punxsutawney Phil," the groundhog that predicts when spring will come. He hates the town and can't wait to get out of there, but he and his attractive producer Rita (Andie MacDowell) and goofy cameraman Larry (Chris Elliott) are snowed in by a blizzard and they are forced to spend the night.

Phil wakes up in the morning and discovers he is living in some sort of déjà vu time loop. It's February 2nd all over again for him and no one else is the wiser. He sees the same people doing the *exact same things* on his way to film the Groundhog Day ceremony, and soon realizes that he's living a life of no consequence. Whatever he does, he wakes up the next morning in the exact same bed at the same time every day. He has sex with women, steals money, gets drunk, and tries to get close to Rita, but to no avail.

Depressed, he tries to kill himself and he wakes up the next morning. He steals the groundhog and they drive off of a cliff, and he wakes up the next morning. Once he realizes he may have to spend eternity in the time loop, his attitude changes and he learns how to be a better person. He learns classic literature, to play the piano, and ice sculpturing. He even starts helping the people in town and as his days continue, he gets closer to Rita. What does fate really have in store for Phil? Will he ever escape the time loop?

I was surprised to find out that the website WhatCulture estimated that Phil spent 12,395 days in Punxsutawney. That's almost thirty-four years!

Groundhog Day was a big critical and box office hit, and has received a number of accolades, including the AFI naming it the #34 film on the 100 Years . . . 100 Laughs List. The AFI also named it the #8 film in their Top 10 Fantasy Films.

Bravo named *Groundhog Day* the #32 film on their "100 Funniest Movies" list. *Total Film* magazine has the movie as the #7 comedy of all time. In 2006, the Library of Congress placed *Groundhog Day* in the National Film Registry.

Rushmore (1998)

After a spate of mediocre comedy films, Bill had the opportunity to make a small independent film written by Wes Anderson and Owen Wilson. The part of Herman Blume had been written specifically for him, and it would launch his comeback to the silver screen. It's reported that Bill liked the *Rushmore* script so much that he worked for the Screen Actor's Guild minimum contract amount, which was about $9,000.

Jason Schwartzman (as Max Fischer), Sara Tanaka (as Margaret Yang), Bill Murray (as Herman Blume), Olivia Williams (as Rosemary Cross) star in Wes Anderson's *Rushmore*

Meet Max Fischer (Jason Schwartzman), the most determined student at the Rushmore Academy. Max is the king of extracurricular activities, working for various clubs and theatrical productions, but he's also on academic probation and doesn't care about his grades.

Max's life changes when he meets Herman Blume (Bill Murray), a wealthy industrialist who strikes up a friendship, and Rosemary Cross (Olivia Williams), a recently widowed new teacher at the school. Max becomes attracted to Rosemary, and attempts to ask her out, but to no avail. Herman tries to cheer up Max, but then falls for Rosemary himself.

When Max discovers that Herman has betrayed him and is having an affair with Rosemary, the gloves come off and Max takes his revenge and tells Herman's wife about Rosemary. Herman retaliates and soon the war between the two former friends is on. Who will emerge victorious? Will Rosemary somehow choose Max? Will she choose Herman? Will Max finish his new play?

Rushmore was the beginning of a wonderful partnership with Bill and writer/director Wes Anderson. They have worked on several films since, including *The Royal Tenenbaums* (2001), *The Life Aquatic with Steve Zissou* (2004), *The Darjeeling Limited* (2007), *Fantastic Mr. Fox* (2009), *Moonrise Kingdom* (2012), and *The Grand Budapest Hotel* (2014).

The film was nominated for two Independent Spirit Awards, Best Director for Wes Anderson, and Best Supporting Actor for Bill Murray. Bill won the Best Supporting Actor award from the L.A. Film Critics Association, The National Society of Film Critics, and The New York Film Critics. *Rushmore* is the #34 film on Bravo's "100 Funniest Movies" list and the #10 film on the Entertainment Weekly Top 25 Modern Romances List.

Lost in Translation (2003)

With this film, Bill's career has reached another phase of his career. No longer the obnoxious, brash smart-ass, he's mellowed into something more. Now he's sardonic and sly, and in this comedy–drama written and directed by Sofia Coppola, he captures the world-weariness of past his prime American actor Bob Harris perfectly.

This is another film that was written specifically for him, and it took her nearly a year to track him down to offer him the film, since Bill no longer has a manager, agent, or phone number. He read it and immediately signed on, and had never met Scarlet Johansson until they met on-set in Japan.

Bill Murray

©Christian Bertrand/Shutterstock.com

International celebrity Bob Harris is in Tokyo after signing a $2 million endorsement contract for Suntory whiskey in Japan. (Most big actors, like Brad Pitt and George Clooney have actually filmed Japanese commercials.)

Stuck in a country where he doesn't know anyone, Bob wanders the hotel and eventually meets Yale graduate Charlotte (Scarlett Johansson), who's stuck waiting for her new husband who is a photographer on assignment. She invites Bob out the next evening with some of her friends, and they explore Tokyo and all of its culture and lifestyle.

It's a meditation on their lives, where Bob looks for understanding about his loveless marriage and his kids who don't recognize him, and Charlotte also doesn't know where she's going in her life. This isn't a torrid love affair between them; it's a platonic friendship that gives them a sounding board for the frustrations that they feel in their lives.

They spend the next couple of evenings together and the night before Bob leaves, he has sex with one of the hotel bartenders, which upsets Charlotte and she storms away. They reconcile that night, and the film ends a little ambiguously as Bob whispers something into Charlotte's ear, and we don't know what he said. Which is a little frustrating!

Lost in Translation was a massive box office success, making $119 million on a budget of $4 million. The film was universally acclaimed by critics, and was nominated in four Academy Award categories: Best Picture, Best Actor for Bill Murray, Best Director for Sofia Coppola, and she won the Best Original Screenplay Oscar.

Lost in Translation won the Golden Globe for Best Picture–Musical or Comedy, Best Screenplay, and Best Actor for Bill Murray. Bill also won the Best Actor Award at the Independent Spirit Awards along with Scarlett Johansson for Best Actress and Best Cinematography.

Since *Lost in Translation*, the films he has chosen to work reflect a Bill Murray that can play any role presented to him. Whether it's dramatic, like *Broken Flowers* (2005), *Get Low* (2010), and *Hyde Park on Hudson* (2012), where he played President Franklin Roosevelt; sardonic and deadpan, like his work with Wes Anderson; and films like *The Monuments Men* (2014) and the voice of Baloo in the live-action *The Jungle Book* (2016), and wild and crazy roles like *Zombieland* (2009), *St. Vincent* (2014), and *Rock the Kasbah* (2015).

Bill Murray is an American institution and we hope he keeps making movies for a long, long time. Can you imagine waking up in the morning and saying "Hey, I'm Bill Murray." Now that would be the coolest thing ever.

Bill Murray at the 2014 Oscars

Who Is Eddie Murphy?

Born in 1961 in Brooklyn, New York, Eddie Murphy faced tragedy early on when his father, Charles Murphy, a cop and aspiring comedian, was murdered by a woman with whom he was having an affair. After a year in a foster home when his mom took ill, he started writing and performing his own routines. The hardship of his life was a catalyst for his comedy, much like many performers in the past.

He started on the stand-up comedy circuit and drew comparisons to Richard Pryor for his outrageous act, including a heck of a lot of swearing. Make that a "hell" of a lot of swearing. He joined the cast of *Saturday Night Live* when he was twenty, the youngest repertory player

in the history at that time. His work is credited with keeping the television series on the air after Executive Producer Lorne Michaels left the show in 1980 over a contract dispute, thankfully returning in 1982.

Murphy

He created an array of dazzling characters that showed the world he was a special performer; prison poet Tyrone Green with his poem "Cill My Landlord," grown-up Lil' Rascal Buckwheat—"Oh-Tay," stop-motion puppet Gumby—"I'm Gumby, dammit!," James Brown—"In the hot tub—heh!," Mr. Robinson—a take-off of Mr. Rogers Neighborhood where the host steals groceries and has to run out the window when the police knock on his door, and in the most brilliant sketch ever, disguising himself as a white guy ("I gotta remember to walk with my butt real tight") to show how well he's treated as a white man, compared to the racism if he were black. For example, he goes into a bank right after a black man is turned down for a loan, and the loan officer hands him stacks of cash without an application, "Go on, take it." Eddie was twice-nominated for acting Emmy Awards and won for Writing in 1984, and Rolling Stone named him the #2 *Saturday Night Live* Cast Member of All-Time.

While still on the show, Eddie did two films back-to-back that immediately kicked his motion picture career into overdrive. The first one, *48 Hours,* co-starring Nick Nolte as Jack Cates, an angry alcoholic revenge-seeking cop, out to catch Albert Ganz, who murdered Cates's men and who nearly killed him.

Cates's plan is to get Ganz's former partner Reggie Hammond (Eddie Murphy) out of jail for 48 hours (hence the title) to help him trap Ganz.

The Official Eddie Murphy Top 3 Great Comedy Film Checklist

48 Hours is credited with being the first "buddy comedy" of two mismatched characters that come together. The formula would be used by such films as the *Lethal Weapon* franchise (1987, 1989, 1992, 1998), *Planes, Trains and Automobiles* (1987), *Midnight Run* (1988), *White Men Can't Jump* (1992), the *Rush Hour* franchise (1998, 2001, 2007), *Bad Boys 1 & 2* (1995 and 2003), the *Men in Black* franchise (1997, 2002, 2012), *Hot Fuzz* (2007), and *The Heat* (2013).

The film was a critical and box office smash, making $78.9 million from a budget of $12 million. Eddie was nominated for the Golden Globe New Star of the Year Award and the world was put on notice that he had officially arrived.

Beverly Hills Cop (1984)

It's the ultimate fish-out-of-water film as reckless smart-ass Detroit detective Axel Foley (Eddie Murphy) travels to snobby Beverly Hills to track down the killer of his best friend Mikey (James Russo). Mikey was a Beverly Hills security guard visiting Axel back home when two men break into Axel's apartment and execute Axel's friend gangland-style in the back of his head.

Axel wants to investigate the case, but Captain Hubbard (Stephen Elliot) refuses because of his personal tie to Mikey. That's when Axel gets the idea to take some vacation time and visit Beverly Hills to conduct his own personal investigation.

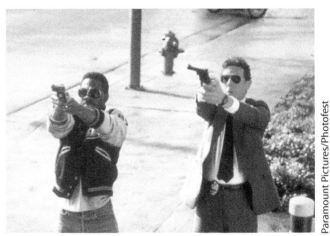

Beverly Hill police detectives Judge Reinhold and John Ashton are about to learn a little about fighting crime on the streets from Eddie Murphy's Detroit detective Axel Foley in 1984's *Beverly Hills Cop*

There he meets up with his friend Jenny (Lisa Elbacher) who got Mikey the job at the art gallery where she works. Axel suspects that Victor Maitland, the gallery's owner, is a drug smuggler. Axel impersonates a flower deliveryman to gain access to the business offices of Maitland, and when he's discovered, Maitland's guards toss him out the gallery storefront window and arrested.

At the Beverly Hills Police Station, Axel's status is verified as a police officer on vacation, and the lieutenant assigns Detectives Rosewood (Judge Reinhold) and Taggart (John Ashton) to keep Axel out of trouble. He promptly ditches them and sneaks into one of Maitland's warehouses and then he's arrested again when he goes to confront Maitland at his country club. Again under the watchful eye of Rosewood and Taggart, he asks them to help him and turn a blind eye when he plans on sneaking into Maitland's warehouse with Jenny's help to catch their drug smuggling operation.

Will Rosewood and Taggart help out Axel? What happens when Maitland captures Jenny? Will Axel bring down the drug kingpin? And will anyone ever fix that banana in the tailpipe?

Beverly Hills Cop earned a worldwide gross of $316 MILLION on a $15 million budget, and was the highest-grossing film in 1984. The movie was the highest-grossing R-rated film in history until 2003 when the awful *The Matrix Reloaded* surpassed it. Adjusted for inflation, *Beverly Hills Cop* is the third-highest R-rated film in history behind *The Exorcist* and *The Godfather*.

The film was nominated for the Best Original Screenplay Academy Award and Best Picture–Musical or Comedy and Best Actor–Musical or Comedy for Eddie Murphy at the Golden Globes. The movie score, punctuated by Harold Faltermeyer's synth single "Axel F." won the Grammy Award for Best Soundtrack. It also won the People's Choice Award for Favorite Motion Picture.

The movie had two sequels, *Beverly Hills Cop II* (1987) which got mixed reviews but made almost $300 million. *Beverly Hills Cop III* (1994) was a critical flop and had a modest box office return.

Beverly Hills Cop is the #63 movie on the AFI Great Comedies List and it's the #22 movie on Bravo's list of 100 Funniest Films. Entertainment Weekly named it the #3 comedy of the last twenty-five years and in 2003 was named one of the 1,000 Best Movies Ever Made.

His stand-up comedy film *Eddie Murphy Raw* (1987) was a big hit, earning over $50 million. He was still popular at the box office with films such as *The Golden Child* (1986) and the aforementioned *Beverly Hills Cop II* (1987), but the critics were mixed in their reactions. There were no mixed reactions for his next film, a big-time smash.

Coming to America (1988)

Reteaming with Director John Landis after their success with *Trading Places,* Eddie plays pampered Prince Akeem of the small country of Zamuda in Africa. Thanks to his parents, King Jaffe (James Earl Jones) and Queen Aeoloen (Madge Sinclair), he has been given a potential bride. But he wants someone who will love him for more than just his title and his money, so he goes to America with his bodyguard Semmi (Arsenio Hall) to find a wife.

The film is notable for proving that Eddie Murphy could star in a romantic comedy, but more importantly had Eddie Murphy (and Arsenio Hall) play multiple roles. Eddie played three additional roles besides Prince Akeem, the elderly barber Clarence, Randy Watson, the lead singer of the band Sexual Chocolate, and old white Jewish barber shop customer Saul. The film was nominated for Best Make-up for Rick Baker's extensive work on creating the multiple roles for Eddie Murphy and Arsenio Hall.

Coming to America was a major box office hit (making over $250 MILLION worldwide from a budget of $39 million), and would set the stage for the next phase of his career as a romantic comedy start as his career moved into the 1990s.

Eddie's next film was the period comedy *Harlem Nights* (1989) co-starring Richard Pryor, a film that Eddie wrote and directed. The movie was a massive disappointment, ending Eddie's directorial prospects. He was in the sequel to *48 Hours*, called *Another 48 Hours* (1990), and

a couple of romantic comedies, *Boomerang* (1992) and *The Distinguished Gentleman* (1992), but nothing matched his previous success.

His next film would reboot Eddie's career for the next twenty years.

The Nutty Professor (1996)

The film is a direct remake of Jerry Lewis's 1963 *The Nutty Professor*, which was originally a take on the Dr. Jekyl and Mr. Hyde story. The film was made with Lewis's participation.

The Nutty Professor tells the story of Professor Sherman Klump (Eddie Murphy) a morbidly obese, 400-pounds-plus brilliant researcher who discovers a formula for losing weight. One day he falls for beautiful grad student Carla Purty (Jada Pinkett Smith) and surprises himself when he invites her to his home to meet his parents and then takes her out dancing. After being publicly mocked at the nightclub because of his weight, he decides to try his formula on himself.

Eddie Murphy had the blessing of Jerry Lewis (who also was an Executive Producer) for his version of *The Nutty Professor*

Suddenly it's not just weight he loses, but Sherman himself slowly disappears as another personality emerges, Buddy Love. He's charming, skinny, and a little obnoxious, but Sherman is sure that he can keep Carla with his new persona. The new persona begins to take over Sherman's life, and then takes credit away from Sherman for inventing the weight loss formula. Carla dumps Sherman as Buddy when he decides to have sex with three women, and Sherman can't do anything about it.

Who will win out in the end—Sherman or Buddy? Will Carla come back if Sherman does? Will Sherman rebuild his life if Buddy destroys what's left of it?

Once again, Eddie played multiple roles like he had in *Coming to America*, and this time Rick Baker won the Oscar for Best Make-up. He played fat Sherman, skinny Buddy Love, Sherman's dad Papa Cletus Klump, his mother Mama Anna Klump, Granny Klump, his brother Ernie Klump, and white exercise guru Lance Perkins.

The Nutty Professor made over $273 million worldwide, and Eddie received a ton of recognition: Best Actor nomination from the Golden Globes, Best Actor and Best Overall Performance at the MTV Movie Awards, and he won the Blockbuster Entertainment Award for Best Actor and the National Society of Film Critics Best Actor Award.

The Nutty Professor II: The Klumps came out in 2000, with Eddie again reprising his eight roles from the first film. That movie made over $160 million worldwide, and got mixed reviews from the critics.

The Nutty Professor opened up the realm of family comedies for Eddie, and he subsequently appeared in *Dr. Dolittle 1 & 2* (1998 and 2001), voice-over work for the *Shrek* film franchise (2001, 2004, 2007, 2010), *Daddy Day Care* (2003), and *The Haunted Mansion* (2003).

His most celebrated moment since *The Nutty Professor* was his work on the film adaptation of the Broadway musical *Dreamgirls* (2006) as arrogant singer Jimmy "Thunder" Early, and he was great in the film. He was nominated for a Best Supporting Actor Oscar, won the Golden Globe for Best Supporting Actor, and won Best Actor in a Supporting Role from the Screen Actors Guild Awards.

Eddie Murphy keeps on making movies, some hit and some miss, but he will always be a force of comedy nature. Here's the most amazing statistic I found about Eddie Murphy: apparently his films have grossed over $6.6 billion worldwide. Holy crap.

Eddie with his Golden Globe Award for *Dreamgirls*

Who Is Robin Williams?

You can't talk about Great Comedy Films in the last thirty years without discussing one of the most talented and versatile actors in recent history. Robin Williams was a primary force of comedy nature and the world is a little less bright without him here.

Born in 1951 in Chicago, Robin started acting in high school theatre and was a popular student. His family moved a lot, going to three different high schools, and when he graduated he was voted "Funniest" in his class.

He studied acting at a community college in northern California and won an acting scholarship to the famed Julliard School in New York City. Julliard is considered the most prestigious arts school in the country and he was one of twenty freshmen to be accepted. His classmates included soon-to-be-famous actors Christopher Reeve, William Hurt, and

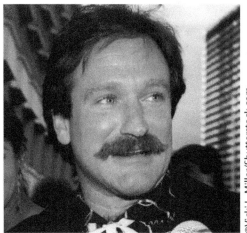

Robin Williams

Mandy Patinkin. With his instructors blown away by his manic energy and comedy, he was actually encouraged to leave by his teachers after three years, saying that there wasn't anything more they could teach him.

He started doing stand-up comedy and working with improv troupes in San Francisco and Los Angeles, where he gravitated to television. He appeared on *The Richard Pryor Show*, which led to him playing Mork the Alien on the 1950s sitcom *Happy Days*. His manic and improv style was a hit with viewers, and he soon starred in his own spin-off, *Mork and Mindy*, from 1978 to 1982. He even was on the cover of both *Time Magazine* and *Rolling Stone* in 1979. It was official—Robin Williams was now a superstar and it was time for him to tackle feature films.

Robin appeared or did voice-over work for seventy feature films, of which forty-eight are comedies. Though it's hard to choose three films that highlight his career—I'm going to give it my level best.

The Official Robin Williams Top 3 Great Comedy Film Checklist

Good Morning, Vietnam (1987)

Based on the true story of Airman 2nd Class Adrian Cronauer (Robin Williams) who arrives in Saigon in 1965 to be the comic host for the morning radio show on U.S. Army Radio. For his first show, he quickly abandons the strict programming guidelines enforced by his superiors Lieutenant Hauk (Bruno Kirby) and Sergeant Major Dickerson (J. T. Walsh) to not play rock and roll music and only read heavily censured news stories. His manic energy, off-the-cuff remarks, voice impressions, and playing contemporary music immediately become a hit with the servicemen who listen to the station.

Robin Williams in *Good Morning, Vietnam*

Buena Vista/Photofest

Cronauer falls for Trinh, a local Vietnamese girl, and meets her by impersonating the English Language class she takes at a local school. Though Trinh is interested, her brother Tuan isn't. They have a drink to sort things out, and Cronauer ends up starting a brawl with two servicemen who don't like a local drinking in a servicemen's bar.

After nearly being killed by a bomb in a Saigon restaurant, Cronauer is suspended for reporting about it on-the-air. Under pressure to reinstate him, Dickerson decides he's had enough of Cronauer's attitude. He sends him into a combat zone, hoping he will be killed . . .

Will Cronauer stay alive and not be nearly blown away when their jeep hits a landmine? If he survives, will Trinh's family allow Cronauer to be with her? What will happen to his English language class? Who ends up winning this war anyway?

For Robin, *Good Morning, Vietnam* was a watershed moment. Director Barry Levinson (*Diner*) gave the actor the ability to improvise most of his radio broadcasts and you can't imagine another actor performing at his level of madness. Robin was nominated for a Best Actor Oscar (his first), won the Golden Globe for Best Actor, and the American Comedy Award for Funniest Actor in a Motion Picture.

Good Morning, Vietnam was also a huge hit both critically and at the box office, earning over $120 million from a $13 million budget. The AFI named *Good Morning, Vietnam* the #100 movie on their Great Comedies List.

Mrs. Doubtfire (1993)

On more than one occasion, we've discussed the absolute fact that anytime a man dresses up as a woman, it's funny. You know the big ones, *Some Like It Hot* and *Tootsie*, but even a movie like *White Chicks* is pretty hilarious. Think about how many films have done the men-dressing-up-as-women thing/women-dressing-up-as-men thing? Those yahoos at Wikipedia have ninety-seven of them! Two of those films are *Psycho* and *Silence of the Lambs*, and then there are a number of dramas about transgenders and transvestites. Let's just say there are more than fifty movies that have genders swapping outfits. That's what I like to call an "educated" guess.

Mrs. Doubtfire tells the story of Daniel Hillard (Robin Williams) a voice-over animation actor that gets into an argument with his producer and gets fired. He comes home and throws a crazy birthday party for his son, and his wife Miranda is steamed. This isn't the first time that he's done something like this, and she's finished with him. She files for divorce and is granted full custody of all three of their kids. Until Daniel gets his life in order he is only allowed to see the kids once a week.

When Miranda decided to hire a housekeeper, Daniel decides to pull an elaborate hoax and with his brother Frank's (Harvey Fierstein) professional make-up experience, masquerade as a woman to get the job. He settles on the persona of Mrs. Iphegenia Doubtfire, a sweet and responsible British nanny who Miranda hires on the spot. The kids aren't sure about her at first, but eventually grow to like her and Mrs. Doubtfire and Miranda become friends.

Meanwhile, Daniel gets a job at a local television station, and impresses the station CEO Jonathan Lundy (Robert Prosky) enough for him to want to sit down with Daniel and talk about what kind of kids' show the station should have on the air.

When his kids, Lydia and Chris, discover that Mrs. Doubtfire is actually their dad, they're happy—but they know they can't tell their mother or their youngest sister, Natalie. Then Miranda brings home her new boyfriend, snobbish Stu Dunmire (Pierce Brosnan) and things look pretty serious.

Things come to a head when Lundy wants to meet Daniel for dinner at the same place where Mrs. Doubtfire must attend a birthday dinner with Miranda and Stu. Can Daniel pull off the scam, jumping back and forth between the two dinners and swapping disguises? What happens if Miranda finds out? Will she have Daniel thrown in jail and never get to see his kids again?

Mrs. Doubtfire was a MONSTER box office hit, making $441 million on a $25 million budget. That's a lot of prosthetic noses. It won the Best Make-up Oscar, the Golden Globe for Best Picture–Musical or Comedy and Best Actor for Robin Williams. It's the #67 movie on the AFI 100 Years . . . 100 Laughs list.

Aladdin (1992)

If you're at least five years old, you probably know the story of *Aladdin*. He's the kid in Arabia who finds the lamp with the Genie inside. The Genie gives Aladdin three wishes and shenanigans ensue. There's a princess in there (isn't that a prerequisite for every Disney film?) and in the end, we all learn a thing or two about what's really important—it's not what you wish for, but what you have that really counts (awwwww).

I know this book is called Great Comedy Films, and I'm using the AFI 100 Years . . . 100 Laughs list as the basis for a number of the profiles that are presented in this book. If you look up the list, you'll notice that there aren't any non-American films on the list and no animated films on the list. Does that mean there aren't any funny foreign films or feature-length animated movies? Of course not! But let's talk about this one because this 1992 Disney film is the greatest representation of who Robin Williams really was. The Genie in *Aladdin* can do anything, make jokes, do impressions, and sing songs. He can joke, and riff, and be sarcastic and also be cute and sweet. He's a tornado of manic energy and excitement with a never-ending torrent of creativity and passion.

Aladdin's screenwriters, Ron Clements and John Musker, wrote the part of the Genie expressly for Robin Williams and impressed him with their vision of how the Genie would perform

in the film—tailored specifically around Robin's gift of manic energy. Robin was given total freedom with his scenes, and the end result is amazing to behold. There has never been an animated character that can be so closely identified with its human counterpart then and now.

When Robin signed on, he was the first major celebrity voice-actor to do a Disney animated film, and his faith in the Disney animation team changed the perception that these were just cartoons. This was also the first animated film that entertained both children and adults. The movie was a huge smash, and the critics pointed to Robin's performance.

And then the box office grosses came in and in and in. *Aladdin* made a jaw-dropping $504 million worldwide. The film won two Oscars for Best Music and Best Original Song for "A Whole New World." At the Golden Globes, it won for both Original Score and Best Song, but even better—Robin was presented with a Special Achievement Award for his exemplary voice-over performance. He also won the MTV Movie Award for Best Comedic Performance.

His work in *Aladdin* gave him an opportunity to work on several family films, including *Jumanji* (1995), *Jack* (1996), *Flubber* (1997), *Robots* (2005), *Happy Feet 1 & 2* (2006 and 2011), and the *Night at the Museum* franchise as Teddy Roosevelt (2006, 2009, 2014).

Here is a list of some great Robin Williams comedies that are highly recommended by the blue-ribbon panel of judges here at the Great Comedy Films headquarters in Phoenix, Arizona: *Moscow on the Hudson* (1984), *The Best of Times* (1984), and *The Birdcage* (1996).

If you're in a dramatic mood, I also suggest you check out Robin's Oscar-nominated performances (besides his first one in *Good Morning, Vietnam*). He was nominated again for his "seize-the-day" performance as teacher John Keating in *Dead Poets Society* (1990) and as the delusional Parry in Terry Gilliam's amazing film *The Fisher King* (1991). Of course, he did finally win the Best Supporting Oscar in 1998 for his role as academic Sean Maguire in *Good Will Hunting*.

Besides those four Oscar nominations with a win, he also won six Golden Globes including the Cecil B. DeMille Lifetime Achievement Award in 2005, four Grammy Awards, two Emmy Awards, the Hasty Pudding Man of the Year in 1989, the Hollywood Film Awards Lifetime Achievement Award in 2006, two awards from the National Board of Review, two SAG Awards, and in 1990 got his star on the Hollywood Walk of Fame.

©Vicki L. Miller/Shutterstock.com

Robin Williams

Yes, he had some demons. He also was a genius. Whatever medical issues he had that caused Robin Williams to take his own life, you have to give it up to him—he went out as a legend on his own terms.

I don't know what else to say about Bill Murray, Eddie Murphy, and Robin Williams except these guys have been, and always shall be, hilarious.

©Featureflash Photo Agency/Shutterstock.com

Robin Williams with his Oscar for Best Supporting Actor for *Good Will Hunting*

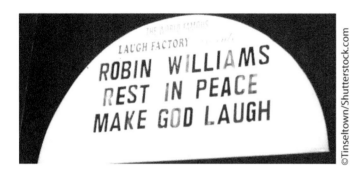

©Tinseltown/Shutterstock.com

CHAPTER 39
SUPER GREAT MOVIE SPOTLIGHT

Ghostbusters
(1984)

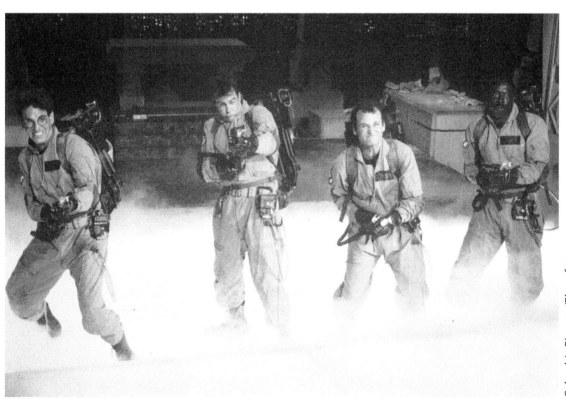

Harold Ramis, Dan Aykroyd, Bill Murray, and Ernie Hudson are the *Ghostbusters* (1984)

Columbia Pictures/Photofest

> ▶ Starring Bill Murray, Dan Aykroyd, Sigourney Weaver, and Harold Ramis
> ▶ Directed by Ivan Reitman
> ▶ Screenplay by Dan Aykroyd and Harold Ramis
> ▶ Genre-Hybrid: Horror–Comedy
> ▶ Comedy types: Slapstick, Verbal Comedy, Black/Dark Comedy

"Human sacrifice, dogs and cats living together . . . mass hysteria!"

—Dr. Peter Venkman (Bill Murray)

So many things had to come together to make this movie the comedy behemoth that it became. First off, Dan Aykroyd had to believe in ghosts. Which he does. He's a confirmed spiritualist and his family has a long history of séances and his father wrote a history book about ghosts.

Lorne Michaels had to create *Saturday Night Live*, and Bill Murray had to be a comedy dynamo that exploded on the screen in films like *Meatballs*, *Stripes*, and *Caddyshack*. Dan Aykroyd had to be successful from *The Blues Brothers* and had originally conceived the idea as a vehicle for himself and John Belushi before the actor's untimely death. Columbia Pictures had to believe that a couple of former television comedians could open a $30 million supernatural horror–comedy and make money at the box office. The thinking was that nobody would pay to see someone at the movies that they could see for free at home on TV. The film would open up the door for *Saturday Night Live* cast members to move into film and they've never stopped.

Ivan Reitman had to peak at the right time, thanks to producing and directing Bill Murray in *Meatballs* and *Stripes*. Harold Ramis had to write a tremendous script with Aykroyd, having previously written comedy winners *Meatballs*, *Caddyshack*, and *Stripes*, in less than a month after the studio had already bought the pitch without a completed script.

The visual effects of the film had to be good. Not just good, but awesome. Richard Edlund, the Visual Effects director for *Star Wars*, *Raiders of the Lost Ark*, and *Poltergeist* had decided to leave the Lucasfilm visual effects company, Industrial Light & Magic, and set out on his own. Thanks to the contract with Columbia Pictures, Richard Edlund started Boss Film Studios, which would end up doing the effects for Oscar-nominated effects films *2010*, *Die Hard*, and *Alien 3*.

Summary

Noted Columbia University parapsychologist professors Peter Venkman (Bill Murray), Ray Stantz (Dan Aykroyd), and Egon Spengler (Harold Ramis) are fired when their grant funding runs out. Knowing there is an unusual amount of heightened supernatural activity in New York City, they set up shop as the "Ghostbusters," a ghost extermination company. They have a cool logo, a catchy theme song, a retrofitted former NYFD engine house as their headquarters, an awesomely retooled hearse, and cool scientific gadgets like giant backpacks that fire proton energy to subdue and capture supernatural spirits.

All they need now are clients. Thanks to a super cheesy commercial, they get a call to bust some ghosts. Cellist player Dana Barrett's (Sigourney Weaver) Central Park West apartment is haunted, and it's not just her apartment. Her neighbor Louis Tully (Rick Moranis from *SCTV*) is also going through some supernatural experiences. It seems the building may be the key to a whole lot of spiritual activity taking over Manhattan.

Because of how much busting they're doing, the Ghostbusters become the talk of the Big Apple. They are so busy that they bring on another Ghostbuster, Winston Zeddemore (Ernie Hudson), to help with the calls. This much activity draws the attention of Walter Peck (William Atherton), an agent with the Environmental Protection Agency (EPA).

Everything goes crazy when ancient spirits hell-bent on bringing a horde of demons to Earth possesses Dana and Louis, and then Peck shuts down the spirit containment system in the Ghostbusters Headquarters, releasing hundreds of ghosts into the city.

Will Gozer destroy the Earth? Will Dana and Peter get together? What does the Stay-Puft Marshmallow have to do with any of this? And what happens when you cross the streams on their proton packs? Will the Ghostbusters save the day?!!

Best Scenes

(This is one of those movies where every scene is awesome, so I'm going to have to keep it to four.)

The Hotel Haunting—Newly hired by a hotel to investigate, a fat glowing green spirit (affectionately known as "Slimer") attacks Venkman and covers him in ecto-plasmic ooze. Then the Ghostbusters head down to the ballroom for their final confrontation with the little troublemaker, completely trashing the hotel to capture him. "We came, we saw, we kicked its ass!"

Dana Gets Possessed—Venkman goes to check on Dana in her apartment, and she's been possessed by a demon named Zul that wants nothing more than to have sex with Venkman. She begins talking and growling and then things get real freaky. "Sounds like you've got at least two people in there already, might be a little crowded."

The Mayor's Office—EPA Agent Peck has arrested The Ghostbusters, but the released spirits are roaming New York City creating havoc, and the Mayor demands answers. Everything comes to a head as Peck explains that the Ghostbusters are nothing but frauds. Venkman has some strong words for Peck: "Yes, it's true. This man has no dick."

The Ending—It's end-of-the-world apocalypse time as the ancient god king Gozer unleashes a monster upon New York City that tears down buildings and terrorizes the masses. That it happens to be a beloved mascot of a baking treat has nothing to do with its potential for destruction. "Something that could never ever possibly destroy us. The Stay-Puft Marshmallow Man."

Awards and Recognition

Critics and audiences universally hailed *Ghostbusters* and the film is considered one of the great comedies in motion picture history. It ended up making $242 million in the United States and totaled out worldwide at $295 million. As of 2016, *Ghostbusters* is the #34 highest grossing film in adjusted dollars, making an equivalent of $610 million, and the third highest comedy in history behind *The Sting* and *The Graduate*.

Ghostbusters was nominated for two Academy Awards, including Best Original Song (title track "Ghostbusters" by Ray Parker, Jr.) and Best Visual Effects. It was also nominated for two Golden Globes, Best Picture–Musical or Comedy and Best Actor–Musical or Comedy (Bill Murray). Who needs all those awards when you make so much freaking money and create a franchise that spawned an animated series, and a sequel *Ghostbusters II*, which made over $200 million but wasn't as well regarded by the critics and audiences.

The success of the movie would eventually create a whole spate of special effects-driven comedies, such as *Back to the Future I* (1985) and *Back to the Future II* (1989), *Cocoon* (1985), *Who Framed Roger Rabbit* (1988), and *Honey, I Shrunk the Kids* (1989). But nobody knew that at the time. There's an old adage about Hollywood, courtesy of screenwriter William Goldman. "Nobody knows anything . . . Not one person in the entire motion picture field knows for a certainty what's going to work. Every time out it's a guess and, if you're lucky, an educated one." No truer words have been spoken about a film like *Ghostbusters*.

In 2016, there was a *Ghostbusters* reboot, starring four female Ghostbusters, played by Kristen Wiig, Melissa McCarthy, Kate McKinnon, and Leslie Jones. There was a lot of online protests by fanboys who have nothing better to do with their time than disrespect the idea that women could be Ghostbusters.

Though the special effects were tremendous, the film itself was mediocre (it would have been a lot better if it treated it as a sequel, rather than a reboot) and it didn't come close to earning its budget back. The fate of another *Ghostbusters* movie is officially up-in-the-air.

Ghostbusters is the #28 movie on the Great Comedy Films list and was voted by the IGN website as The Greatest Comedy Ever. Entertainment Weekly named it the Funniest Movie of the Past 25 Years, and in 2015, the Library of Congress placed the film in the National Film Registry.

CHAPTER 40

FOCUS ON SUBGENRE

Romantic Comedy—Part II

OR:

This Is the Concluding Chapter about the One where a Man and Woman Fall in Love, or a Man and a Man, or a Woman and a Woman, or a Man and a Robot, or a Woman and a Robot, or a Robot and a Robot

Meg Ryan and Billy Crystal in the iconic diner scene in *When Harry Met Sally* (1989)

Columbia Pictures/Photofest

> **CHAPTER FOCUS**
> ► Female Audiences Become a Prime Demographic
> ► The Rebound of Romantic Comedy
> ► Romantic Comedy Viability at the Box Office
> ► The Best of the New Century

Chapter Focus

Three things happened in the early 1980s that changed things: Women were now throughout the workplace, and were equals, except they weren't paid as much as their male counterparts (which as of this writing in 2017 is still the case).

Also, the birth of cable television stations like TBS and TNT and pay cable television networks like HBO gave more avenues for films to be shown. In short, there was a huge need for content. With the advent of the home video industry, audiences could buy movies and watch them on their own. Who is home a lot? You got it, women who become housewives. That means even more revenue for Hollywood!

Female Audiences Become a Prime Demographic

Over the last thirty years, women have emerged as a highly coveted audience demographic. Women age 25–45 have disposable income and as the heads of households (let's face it, men may think they are the heads of households, but they will never be) they are also in control of the finances. Today, they make 85 percent of the buying decisions for the household.*

In my household, I get 4 percent of the buying decisions—which motor oil for the cars do we buy, and which cereal do I want.

And as mentioned previously, if a guy wants to take a woman to a movie it's going to be a romantic comedy. God help the poor sucker who has to take a special lady friend to the latest dramatic tearjerker Nicholas Sparks adaptation.

*Learned, A. (2002). The Six Costliest Mistakes You Can Make in Marketing to Women. Inc. http://www.inc.com/articles/2003/01/25019.html 15. Shipman, C., & Kay, K. (2014).

The Rebound of Romantic Comedy

With all of these socio-economic factors, the romantic comedy made a comeback in the 1980s. Here are a few of the notable ones for your viewing pleasure.

Splash (1984)

A real fish-out-of-water film (hah!) where director Ron Howard made a "splash" (double hah!) with his first Hollywood studio film about Allen Bauer (Tom Hanks in his breakout film) who meets a mysterious woman who is secretly a mermaid (Daryl Hannah in her on-screen debut) while in Cape Cod. She follows him to New York City where they fall in love, but obsessive scientist Dr. Walter Kornbluth (Eugene Levy) is determined to capture her. *Splash* was a huge box office and critical success that put everyone involved on the Hollywood map to stay.

Roxanne (1987)

In this adaptation of stage play Cyrano de Bergerac, stand-up comedian turned movie star Steve Martin stars as C. D. "Charlie" Bales (C.D.B.—get it? Cyrano de Berg—oh, just forget it) a big-nosed, small town fire chief who falls for newcomer Roxanne (Daryl Hannah, back again), but she's not into him. She's into hunky Chris (Rick Rosovich), one of Charlie's firemen. Unfortunately, Chris isn't the brightest bulb in the box, so Charlie coaches him on how to be the ideal boyfriend. Chris has the looks and Charlie, whispering in his ear through a walkie-talkie, is the real heart, brains, and soul of the operation. But what happens when Roxanne finds out about the deception?

Moonstruck (1987)

Here's a great line from the 1994 film *Nobody Loves Me*—"a woman over thirty is more likely to get hit by a bomb than find a man." Meet Loretta (Cher), the thirty-seven-year-old accountant still living with her outrageous family after her husband died in a bus accident several years ago. With no other prospects, she gets engaged to her much older beau Johnny (Danny Aiello) even though her parents, Cosmo (Vincent Gardenia) and Rose (Olympia Dukakis), aren't crazy about him. Things go awry when she meets Johnny's estranged brother Ronny (Nicolas Cage), a baker with a wooden hand, and falls in love with him. Now she's stuck between the two brothers and doesn't know what to do next.

This film was a box office and critical smash and the fifth highest grossing film of 1987. The film was nominated for six Oscar nominations, including Best Picture, Best Supporting Actor and Best Director, and won three of them, Cher for Best Actress, Olympia Dukakis for Best Supporting Actress and Best Original Screenplay. The film is the #41 film on the AFI Great Comedies List, the #17 film on the AFI Great Romances List, and the #8 film on the AFI Top Romantic Comedy list.

Say Anything (1989)

In this teen/coming-of-age film, Lloyd Dobler (John Cusack) had no aspirations after high school graduation except to become a professional kickboxer. But now he has an immediate goal. He's going to ask high school valedictorian Diane (Ione Skye) out on a date. Even though everyone is incredulous, including Diane's over-controlling father (John Mahoney), she slowly falls for Lloyd. Will she stay to be with the under achieving Lloyd or head out on her own?

Say Anything has two signature moments: the first is one of the great lines in cinema history: when Diane breaks up with Lloyd under her father's insistence, she gives him something to remember her by and he tells his friends "I gave her my heart and she gave me a pen."

The second moment is iconic. After Diane and Lloyd have broken up, Lloyd appears outside of her bedroom window with a boombox, playing their song "In Your Eyes" by Peter Gabriel. Gives me a chill every time.

In 2002, *Entertainment Weekly* magazine named *Say Anything* the #1 Movie Romance and it is also the #11 film on their list of the 50 Best High School movies.

When Harry Met Sally . . . (1989)

This is it. The film that defines romantic comedy in the 1980s and 1990s. It made a star out of Meg Ryan, and established Billy Crystal as a mainstream Hollywood star who was able to start writing, directing, and starring in his own films. It launched jazz singer Harry Connick Jr. into the stratosphere with the Grammy-winning soundtrack for the film, solidified Rob Reiner as one of the great comedy directors, and brought writer Nora Ephron a huge opportunity to eventually write and direct Hollywood features.

Harry (Billy Crystal) and Sally (Meg Ryan) know each other through friends and share a ride from college to New York City, where they are both settling after graduating. Harry reveals his belief to her that men and women can't be friends, because sex gets in the way. Sally says she has plenty of male friends, to which Harry assures her that they all want to sleep with her.

They keep bumping into each other as they are both in existing relationships. Are they destined to always be friends, or maybe they can be more?

In one of the most memorable scenes in comedy film history, Harry and Sally debate on whether or not Harry can tell if women he is with can fake orgasms. Harry says they never have, and Sally shows him how easy it is to fake it. She proceeds to reenact a full-blown orgasm at the table, bringing the entire restaurant to a standstill. Across the room, a woman (who happens to be director Rob Reiner's mother) tells a waitress, "I'll have what she's having." That line is the #33 list of the AFI Top 100 Movie Quotes.

A huge box office smash, *When Harry Met Sally . . .* was a critical success that garnered writer Nora Ephron an Oscar nomination for the film. It's the #23 film on the AFI Great Comedy Films list, the #6 film on the AFI Top Ten Romantic Comedies, and *Entertainment Weekly* named it one of the Top 10 Romantic movies of all time and #3 on their list of Top 25 Modern Romances.

Pretty Woman (1990)

Julia Roberts lights up the screen in her first leading role as Hollywood hooker Vivian Ward, hired to have a night of sex with uber-rich ruthless business tycoon Edward Lewis (Richard Gere). He's taken by her infectious spirit and decides to hire her to be his escort for his week

Scene from *Pretty Woman* (1990)

Buena Vista Pictures/Photofest

of business meetings. Owing a lot to *My Fair Lady*, Edward hires his hotel manager Barney Thompson (Hector Elizando) to teach her how to be a proper socialite and companion. There may be love blooming for the mismatched couple, but it will take a lot for Edward to change from his greedy moneymaking ways.

Pretty Woman was the fourth highest grossing film of 1990 and is one of the highest grossing romantic comedies in history (see the chart that I included later). Finally, Julia Roberts was nominated for Best Actress for the Oscars and won the Golden Globe for Best Actress. In 1999, she and Gere reunited in *Runaway Bride* as she became the biggest female movie star in the world.

Sleepless in Seattle (1993)

Take the two biggest film stars on the planet, Tom Hanks and Meg Ryan, and put them in a romantic comedy written and directed by Oscar-nominated screenwriter Nora Ephron and you should have a hit. It doesn't hurt that the critics ate up this story of Sam Baldwin (Tom Hanks) who is still recovering from the sudden death of his wife from cancer a year and a half ago. His plucky son Jonah (Ross Malinger) calls into a radio talk show to find him a new wife, and Baltimore reporter Annie (Meg Ryan) hears the story of Sam and his grief. Listening to him she becomes infatuated with the widower, even though she is engaged. She flies to Seattle to try and meet him, and then things get interesting. Will Sam and Annie get together?

There is a big iconic scene in *Sleepless in Seattle* where Annie and Sam meet atop the observation deck of the Empire State Building, just like in one of Annie's favorite films, the Cary Grant–Deborah Kerr tearjerker *An Affair to Remember*. *Sleepless in Seattle* was nominated for two Oscars, Best Original Screenplay and Best Original Song, and the film received Golden Globe nominations for Best Picture, Best Actor (Hanks), and Best Actress (Ryan). She would receive another Golden Globe nomination for Best Actress when she starred again with Tom Hanks in the 1998 hit *You've Got Mail*, and cement herself as the "it girl" for romantic comedy during the 80s and 90s.

Jerry Maguire (1996)

Writer-director Cameron Crowe (*Fast Times at Ridgemont High, Say Anything*) brings us one of those rare male-centric romantic comedies, where the guy realizes that he's an idiot when the girl of his dreams is right in front of him. It takes a whole lot of humbling before he gets it right.

Jerry Maguire (Tom Cruise) is a hotshot sports agent who has a crisis of faith about his career and longs for the days where agents had personal relationships with their clients. He

is subsequently fired by his agency, dropped by his fiancée, and fired by his number one draft pick prospect. As he begins to pick up the pieces of his life, he finds himself drawn to Dorothy.

Will Jerry get the big contract that will resurrect Jerry's reputation in the business, and could Jerry and Dorothy overcome Jerry's relationship issues to make him a better man?

A few memorable moments in this film include the use of the Bruce Springsteen song "Secret Garden," and in the climax when Jerry says to Dorothy, "You complete me." Her response is "You had me at hello." The biggest scene in the film is the "Show Me the Money!" scene where Jerry tries to convince Rod to stay with him as his agent.

The movie was a monster hit and is still one of the highest grossing romantic comedies in history (see the nifty chart on the next page). The film was nominated for five Oscars, including Best Picture, Cruise for Best Actor, Best Screenplay, Best Editing, and Cuba Gooding Jr. won for Best Supporting Actor. Cruise won Best Actor at the Golden Globes, and the film continued to cement him as one of the biggest stars in the world. The AFI lists the film as the #10 of their Top Ten Sports Films.

As Good As It Gets (1997)

It's the story of another guy who can't get his act together, but this time the guy is an old pain in the ass. Smart and racially insensitive, Melvin (Jack Nicholson) is a successful novelist with OCD working on his sixty-sixth novel. One problem is his neighbor, gay painter Simon (Greg Kinnear), owns a terrier dog. His other problem is that the waitress at his favorite diner, Carol (Helen Hunt), isn't there to serve him. Melvin watches his familiar OCD-life routine come apart. Simon is assaulted and Melvin pays for Carol's son's medical expenses to get her back to the diner.

The film becomes a relationship film as Melvin learns to adapt to his changing world, and works up to a possible romance with Carol. Will Melvin and Carol come together, and will Simon get back on his creative feet?

As Good As It Gets was a box office hit (you really must check out the chart) and nominated for seven Oscars, including Best Picture, Best Supporting Actor (Kinnear), Best Editing, Best Original Score, Best Original Screenplay, and won Jack Nicholson his Best Actor Oscar and Helen Hunt the Best Actress Oscar. They both won in the same category at the Golden Globes and the film also won Best Comedy or Musical.

Notting Hill (1999)

Take the biggest actress in Hollywood, Julia Roberts, and cast her as the biggest actress in Hollywood, and then pair her with lovable Hugh Grant, who had become a romantic leading man after *Four Weddings and a Funeral* and *Nine Months*. Bring them together in this tale of a shy bookstore owner who bumps into and falls in love with the Hollywood starlet who visits his store. (Remember the "meet cute" with the spilled orange juice? That's the one.) Yes, they come from two different worlds! Can they possibly make it work? Maybe . . . just maybe if you believe in love!

Romantic Comedy Viability at the Box Office

Here is a chart showing how popular these films were at the box office. A good romantic comedy is worth its weight in audience gold.

Top 15-Grossing Romantic Comedy Films 1978–2015, adj. for Ticket Price Inflation

Rank	Movie	Release Date	Distributor	MPAA Rating	Total Gross	Inflation-Adjusted Gross
1	**My Big Fat Greek Wedding**	Apr 19, 2002	IFC Films	PG	$241,438,208	$349,597,209
2	**There's Something About Mary**	Jul 15, 1998	20th Century Fox	R	$176,483,808	$316,974,668
3	**Jerry Maguire**	Dec 13, 1996	Sony Pictures	R	$153,620,822	$288,003,641
4	**What Women Want**	Dec 15, 2000	Paramount Pictures	PG-13	$182,805,123	$280,906,593
5	**As Good as it Gets**	Dec 24, 1997	Sony Pictures	PG-13	$147,637,474	$266,964,393
6	**Runaway Bride**	Jul 30, 1999	Paramount Pictures	PG	$152,149,590	$252,475,372
7	**Hitch**	Feb 11, 2005	Sony Pictures	PG-13	$177,784,257	$233,809,869
8	**Notting Hill**	May 28, 1999	Universal	PG-13	$116,089,678	$192,644,872
9	**The Proposal**	Jun 19, 2009	Walt Disney	PG-13	$163,958,031	$184,288,829
10	**Knocked Up**	Jun 1, 2007	Universal	R	$148,761,765	$182,276,402
11	**Something's Gotta Give**	Dec 12, 2003	Sony Pictures	PG-13	$124,685,242	$172,549,565
12	**Shakespeare in Love**	Dec 11, 1998	Miramax	R	$100,241,322	$167,644,122
13	**50 First Dates**	Feb 13, 2004	Sony Pictures	PG-13	$120,776,832	$163,953,089
14	**While You Were Sleeping**	Apr 21, 1995	Walt Disney	PG	$81,052,361	$157,073,880
15	**Enchanted**	Nov 21, 2007	Walt Disney	PG	$127,706,877	$156,074,310

To put this in an interesting context, *My Big Fat Greek Wedding* grossed more than *Guardians of the Galaxy*. That's impressive.

Romantic comedies are a staple of American cinema, and there have been some great romantic comedies made since the AFI Great Comedy List was published in 2000. I'm particularly fond of films like *About a Boy* (2002), *Moonrise Kingdom* (2012), *Knocked Up* (2007), *Silver Linings Playbook* (2012), and *Forgetting Sarah Marshall* (2008).

The Best of the New Century

Let's speculate what films from 2000–2010 will end up on the AFI Great Romantic Comedy List when they make it in the year 2100. You know when we're all in self-flying cars and exploring black holes like Christopher Nolan's *Interstellar*?

The Top 5 Romantic Comedies That Should Be on the Next AFI List

Bridget Jones' Diary (2001)

Adorable Renee Zellweger plays the title character from the hit chick novel about a thirty-two-year-old (the death knell for women looking for men being the age of thirty) who resolves to change her life and find love with her boss Daniel (Hugh Grant).

High Fidelity (2000)

Based on the best-selling Nick Hornby novel (yes, him again too), record store owner Rob (John Cusack) tries to figure out why he can't be in a relationship. He decides to search out his top five breakups, and find out what happened. Jack Black as store clerk Barry totally steals the show.

Juno (2007)

Diablo Cody's Oscar-winning screenplay follows pregnant sixteen-year-old Juno (Ellen Page). She discovers she's pregnant and juggles choices of abortion, adoption, and keeping the baby. Along the way, she faces her relationship with the child's father, Paulie (Michael Cera).

(500) Days of Summer (2009)

In an unusual narrative that flashes back and forward through a year-and-a-half (hence the title), greeting card writer Tom (Joseph Gordon Levitt) falls for his coworker, Summer (Zooey

Deschanel). She isn't interested in anything long-term, but Tom believes in fate and destiny. Features a great musical number to Hall & Oates "You Make My Dreams Come True."

Eternal Sunshine of the Spotless Mind (2004)

Joel Barish (the remarkable Jim Carrey) and Clementine Kruczynski (Kate Winslet in her Oscar-nominated role) meet on a train and fall in love. But that wasn't the first time they met. They've fallen in love, broke up, and both decided to undergo a process that wipes the memories of the person from your brain like a digital file going in the trashcan. But in Charlie Kaufman's brilliant Oscar-winning screenplay, love is something that can never truly be erased if it's meant to be.

(I'd like to throw *Wall-E* and *Amelie* in to the mix, but those AFI people are very stubborn when it comes to their lists. Has to be an American film and has to be a live-action narrative. But damn those movies are good. I think *Wall-E* is my favorite of the bunch. I freaking lose it at the end.)

> Undeniably, the romantic comedy is the most popular subgenre of comedy films and its success parallels the culture of which it reflects. As women have grown into an economic force, so too has the romantic comedy. Yes, there's a formula to these types of films, there've been a lot of good ones, and there've been a LOT of bad ones—but it's a formula that continues to generate entertainment for the masses, and a lot of money for Hollywood.

CHAPTER 41

FOCUS ON SUBGENRE

Teen/Coming-of-Age Comedy

Universal Pictures/Photofest

Sean Penn as Jeff Spicoli and Ray Walston as Mr. Hand square off in *Fast Times at Ridgemont High* (1982)

> **CHAPTER FOCUS**
> ▶ What Are Teen/Coming-of-Age Films?
> ▶ Quantifiable Statistics about Teen Audiences
> ▶ The Teen/Coming-of-Age Film That Shook the World
> ▶ The Films of John Hughes
> ▶ Notable Coming-of-Age Films

Chapter Focus

Looking back on the history of me, I hope you would share my fondness for the innocent days of being a teenager. There was not having to pay bills, the mistaken belief that you could do anything you want if you set your mind to it, experimenting with alcohol and drugs and crime with no thought of consequence because you were a minor, the battles with my parents because you "lived under their roof," the joy of getting your first car, the dismay of crashing your first car, and the hormonal longing for the opposite or same sex to do the nasty—I mean, lose your precious flower.

What Are Teen/Coming-of-Age Films?

The teen part is easy. Anyone between the ages of thirteen and nineteen. One down and one to go!

Here's the official definition for Coming-of-Age Films from Dictionary.com:

> ### COMING-OF-AGE FILMS

That's right, they don't have one. Once again, the youth of the world are getting disrespected. You adults are always keeping us down. Screw you Internet!

The new definition from *Great Comedy Films* that *I* will make up on the spot:

COMING-OF-AGE FILMS
n. films that tell the story of young people turning into adults, whether they like it or not

The early 1950s and 1960s had movies that were all about youth, those umpteen Beach movies with Frankie Avalon and Annette Funicello, and more serious films like *Rebel Without a Cause* (1955) with James Dean, and *Blackboard Jungle* (1955) spoke to youth and the unhappiness of being a teenager in this repressed homogenous era.

An entire subgenre of films for youth sprang forth in the early 1970s that proved to the world that movies focused on youth growing up were films worthy of taking space in the local movie house. Successful films like *The Graduate* (1967), *Harold and Maude* (1971), and *American Graffiti* (1973) were the pre-cursors for the explosion of the Teen/Coming of Age films in the 1980s, when the Hollywood studios needed content to fill cable and home video programming to satisfy public appetites.

Quantifiable Statistics about Teen Audiences

The movie studios finally understood the idea of programming films for the specific audience demographics, rather than just classify movies as family films or adult films. They have the basic "four quadrant" target audience indicator:

And then there are the more specific age demographics that show that the 12–24-year-old demographic is the biggest group of audience members.

Most Frequent Moviegoers by Age Group, 2010

Age	Percentage of Moviegoers	Percentage of Population
2–11	7%	14%
12–17	16%	8%
18–24	19%	10%
25–39	28%	21%
40–49	9%	14%
50–59	9%	14%
60+	12%	19%

MPAA U.S./Canada Theatrical Market Statistics, 2011

The young audience is especially coveted because they have the most disposable income. They don't have bills to pay, so where does their allowance money and summer job cash go to? Video games and going to the movies. Especially if you are a guy and you want to get with a prospective future romantic partner. The first time you hold hands in the movie theatre is one of the most electrifying moments of your life. Or so they tell me. Some of us struck out quite a lot in high school, if you know what I mean. [Editor's Note: The author is truly pathetic.]

Though gross-out comedies like *Porky's* (1981) and *The Last American Virgin* (1982) started to accelerate the trend, it was this movie here that laid the groundwork for teen coming-of-age films to invade the movie world.

The Teen/Coming-of-Age Film That Shook the World

Fast Times at Ridgemont High (1982)

In this ensemble comedy that takes its lead from *American Graffiti*, meet Brad (Judge Reinhold), Stacy (Jennifer Jason Leigh), Mike (Robert Romanus), Linda (Phoebe Cates), and Jeff Spicoli (Sean Penn) as they navigate their way through a school year at Ridgemont High School in southern California.

Brad is working his way through his senior year at All-American Burger and wants to break up with his girlfriend to play the field. His younger sister Stacy wants to lose her virginity. Mike is a ticket scalper and ladies' man who gives Mark "Rat" Ratner (Brian Backer) advice on how to pick up chicks. He encourages Mark to try out his new skills and ask out his long-time crush Stacy. Jeff Spicoli is a stoner surfer trying to graduate and is forced to deal with his history teacher Mr. Hand (Ray Walston), who isn't a fan of Spicoli's antics, such as eating a delivered pizza in the middle of class.

Will Brad survive his senior year? What happens when he gets fired from All-American Burger and has to work a humiliating job at Captain Hook Fish & Chips? Will Stacy lose her virginity to Mark? What happens when Mr. Hand decides to put the hammer down on Spicoli, and threatens him with not graduating?

The film is a special movie for two reasons. Screenwriter Cameron Crowe (who would later go on to write and direct *Say Anything* and *Jerry Maguire*) was a young Rolling Stone reporter when he snuck into a high school for a year and wrote the book about real high school students, so it is "literally" the most authentic film about teenagers in the history of motion pictures.

It also was a feature film with early or debut performances for a slew of actors that would go on to major success in film. Sean Penn's Jeff Spicoli is easily the most memorable character in the film and the movie propelled him to the A-List, eventually winning him two Oscars for his acting in *Mystic River* and *Milk*. Jennifer Jason-Leigh would go on to a number of films, including an Oscar nomination for Quentin Tarantino's *The Hateful Eight*. Two other Oscar winners, Nicolas Cage and Forest Whitaker, appear in small roles.

The film was popular at the box office, with the film making $27 million from a budget of $4.5 million. It's the #87 film on the AFI Great Comedy Films list, the #2 film on Entertainment Weekly's list of "50 Best High School Movies," and in 2005, *Fast Times at Ridgemont High* was selected for the National Film Registry by the Library of Congress.

With the growing home video industry and cable television venues, both the coming-of-age film and flat-out teen comedies would become a viable subgenre that exploded over the next few years. Now don't get the two terms confused! Coming-of-age films have a slight edge to them, due to the whole "learning to deal with being a mature adult that's right around the corner" as opposed to teen comedies, which are fun comedies that aren't teaching anybody about anything. Most of these have a lot of sex in them.

Let's look at the more mature films first.

The Films of John Hughes

When you look at the growth of coming-of-age films in the 1980s, you only have to look at one filmmaker, John Hughes.

He is one of the most prolific writer/directors in the history of film comedy. Hughes had a unique way of capturing the angst and frustration of the teenage years, and could also inject enough humor to make the films human and enjoyable.

The Official Top 3 List of John Hughes' Coming-of-Age Movies

Sixteen Candles (1984)

It was the first of Hughes' coming-of-age films and released in the same year as *Fast Times at Ridgemont High*. This movie made a star out of Molly Ringwald, who plays Samantha "Sam" Baker as she celebrates her sixteenth birthday. Unfortunately, nobody in her family remembers it's her birthday, since her older sister is getting married the next day. She's also got her own problems to deal with, mainly her crush on football hero Jake. There's also Sam's friend, Ted (aka "Farmer Ted"), played by Anthony Michael Hall, who is in love with Sam. He bets his friends that he can get with her, and after he tells her Jake has been asking about her, she gives Ted her panties to show off to his friends.

Will Sam find true love with Jake? Will Ted get laid? What about all of this wedding nonsense? Who is Long Duc Dong? And for the love of God—can someone remember Sam's birthday?

The film was well received by the critics and did well at the box office, making $23 million on a budget of $6.5 million. It gave Hughes the ability to make his next film . . .

The Breakfast Club (1985)

This is the movie that changed the way that teenagers were portrayed in the movies. Though *Fast Times at Ridgemont High* dealt with subjects like sex and abortion with a comedic spin, *Sixteen Candles* is a romantic comedy and a broad farce. *The Breakfast Club* went the opposite. It treats its subjects as real people and tackles subjects important to teenagers head-on.

Taking place in one day, five students: Bender (Judd Nelson), Claire (Molly Ringwald), Andy (Emilio Estevez), Allison (Ally Sheedy), and Brian (Anthony Michael Hall) find themselves in school for all-day detention on Saturday morning. Besides Andy and Claire, they don't

know each other because they all travel around in different cliques, Bender with the stoners, Claire with the popular crowd, Andy with the jocks, Allison with the outcasts, and Brian with the geeks. Watching over them is the Vice Principal, Mr. Vernon (Paul Gleason) who assigns them each a 1,000-word essay and disappears for the day (occasionally checking in on them, of course. He's not completely irresponsible.).

Once together though, they abandon the essay writing and begin to talk. They get past their talk and share about how their lives are going (they all have problems with their parents) and they all bond. It sounds a little cheesy, but they learn to appreciate each other's differences, and more importantly, bridge those differences and form friendships. Or do they?

The movie was a tremendous critical and box office hit. It made $51.5 million on a budget of $1 million and launched the careers of its five stars into the stratosphere. Collectively, the group became known as "The Brat Pack," and they took over coming-of-age movies for the rest of the decade. Entertainment Weekly named *The Breakfast Club* the #1 film on its "50 Best High School Movies" list.

Pretty in Pink (1986)

Though only written by Hughes, it is the quintessential high school social class love triangle. Molly Ringwald stars in her final Hughes project as Andie Walsh, a girl from the wrong side of the tracks who's attracted to Blaine (Andrew McCarthy), one of the popular rich kids. She's stuck in the middle between Blaine and her best friend Duckie (an excellent Jon Cryer) who's been in love with Andie forever. When Blaine asks her out, she's on cloud nine, until he brings her to a party and realizes how the rest of Blaine's friends look down on her because she's poor.

Duckie is devastated that Andie chose Blaine, but gamely steps up and supports her when she doubts herself. Meanwhile, Blaine asks Andie to the prom, but then breaks up with her after his rich friend Steff (James Spader) tells him that she's ruining his social status.

Will Andie go to the prom by herself with a great new dress that makes her "pretty in pink"? Does she go with Duckie? Will Blaine change his mind and push past his social status because he loves her?

Pretty in Pink was celebrated by critics for its focus on the social class aspect of teenagers, and the box office brought in $40 million in the US on a budget of $9 million. The soundtrack of *Pretty in Pink* was the first full soundtrack released for a John Hughes film and featured a great collection of new wave songs, such as the title track from The Psychedelic Furs, the romantic hit "If You Leave" by OMD and tracks by New Order, INXS, and The Smiths. Rolling Stone ranked it as one of the "25 Greatest Soundtracks of All Time."

John Hughes also wrote, directed, or produced such teen comedies as *Weird Science, Ferris Bueller's Day Off* (check out Chapter 43), and *Some Kind of Wonderful* before changing gears for more mainstream films. But his legacy during the 1980s was impactful and affected an entire generation of young moviegoers.

Notable Coming-of-Age Films

There have been plenty of dramatic coming-of-age films since *The Breakfast Club*, such as *Stand by Me* (1986), *Boyz n the Hood* (1991), *Almost Famous, Boyhood*, and *The Spectacular Now*. But this is a book about comedies . . .

The Official Top 5 List of Coming-of-Age Movies

The Graduate (1967)

Dustin Hoffman as Benjamin Braddock learns to pick a direction in life, and not let his slutty dad's friend's wife Mrs. Robinson do it for him.

Dazed and Confused (1993)

Richard Linklater channels the spirit of *American Graffiti* on the last day of school in 1976, where students come together in a wild night of parties to forget about what's about to happen next. Matthew McConaughey steals the show as David Wooderson, "That's what I love about high school girls, man. I get older, they stay the same age."

Breakfast Club (1985)

Five teenagers in a room for a day. Discuss.

American Graffiti (1973)

It's the summer of 1962, the last innocent days of America in George Lucas's love letter to his childhood of cruising, rock and roll music, and teenage crushes while growing up in Modesto, California. This was the original "group-of-characters-in-a-movie-that-takes-place-on-a-pivotal-night-and-completely-changes-everyone-for-better-or-worse" movie.

Fast Times at Ridgemont High (1982)

It's not *one night* that changes you like in *American Graffiti*; it's what happens during *an entire school year* in this film based on screenwriter Cameron Crowe's undercover stint in a Southern California high school. Life, love, sex, drugs, masturbation, abortion, pizza, and popsicles—it's all here in the first film that gave audiences a real glimpse of teenage life.

Honorable Mention: *Sixteen Candles, Say Anything, Mean Girls, 10 Things I Hate About You, Can't Hardly Wait, Rushmore, Me, Earl & The Dying Girl,* and *Dope.*

Okay, enough of the Coming-of-Age "I'm learning stuff" comedies. What about those Teen comedies that are just hilarious?

The Official Top 5 List of Teen Comedy Movies and Most of Them Are Already In This Book

Risky Business (1983)

Tom Cruise breaks out as Joel, a good kid who's got the house to himself over the weekend and things get waaaay out of control. Ray-ban sunglasses, dancing in your underwear to "Old Time Rock and Roll," and having sex on the L-train became uber-cool after this film.

Better off Dead (1985)

It's John Cusack + the ridiculous animation with the dancing hamburgers + the cool Howard Jones songs, + the hot foreign exchange student (fraanch fries?), + the overzealous paperboy ("I want my two dollars!") = a teen comedy classic.

American Pie (1999)

Take four friends who want to lose their virginity, and a warm apple pie, and you've got one of the biggest gross-out films in history, keeping the torch burning for teen comedies through the 2000s.

Superbad (2007)

Should be simple enough to become one of the cool kids, all you have to do is buy the alcohol for the big party! Luckily Seth (Jonah Hill) and Evan (Michael Cera) have McLovin' (Christopher Mintz-Plasse) with his fake ID in this Judd Apatow-directed perfect blend of "bro-mance" and gross-out comedy.

Ferris Bueller's Day Off (1986)

Ferris Bueller (Matthew Broderick) is the coolest teenager in the world in the film as he breaks the fourth wall, impersonates the "Sausage King of Chicago," teaches his uptight friend Cameron (Alan Ruck) to relax, and takes Chicago by storm from the top of a parade float. Check out Chapter 42 for a more in-depth analysis.

Honorable Mentions: *Election, Porky's, Real Genius, Bill & Ted's Excellent Adventure, Real Genius, Mean Girls, She's All That, Napoleon Dynamite, Not Another Teen Movie.*

That's the one thing about coming-of-age and teen comedies, we keep getting older and they stay the same . . .

CHAPTER 42
SUPER GREAT MOVIE SPOTLIGHT

Ferris Bueller's Day Off (1986)

Matthew Broderick is the title character in *Ferris Bueller's Day Off* (1986)

Paramount Pictures/Photofest

- ▶ Starring Matthew Broderick, Alan Ruck, and Mia Sara
- ▶ Written and Directed by John Hughes
- ▶ Subgenres: Teen/Coming-of-Age
- ▶ Comedy types: Verbal, Slapstick, Farce

"Life moves pretty fast. If you don't stop and look around once in a while, you could miss it."

—Ferris Bueller (Matthew Broderick)

"Bueller? Bueller? Bueller?"

—Economics Teacher (Ben Stein)

If done with enough intelligence, wit, and emotion, there are certain films that are more than "just a movie" that help pass the time in-between the other moments of your life, when you feel like shutting off all those damn voices in your head and just chilling out. Then there are films that transcend the medium, that somehow elevate themselves into the rarified air of cultural acceptance. I'm talking about a film that is universally celebrated as something special. Ladies and Gentlemen of the Jury, I submit to you one of those films, *Ferris Bueller's Day Off*.

John Hughes is an amazing writer/director, but can you directly quote more than two lines of dialogue from *The Breakfast Club, Sixteen Candles, Weird Science, Pretty in Pink,* or *Some Kind of Wonderful*? I can't—and I get paid a lot of money to know comedy films. I remember flashes, images, emotions, but no film resonates with the collective conscious of America like the madcap adventures of an uber-cool smart-ass teenager who ditches school to show his buddy how great life can be. It's a movie about friendship that celebrates life and all of its potential.

Summary

There's that one guy in school who is the coolest ever. He can do anything, knows everybody, relates to anyone, and makes things happen. He's one righteous dude. From a suburban high school outside of Chicago, that guy is Ferris Bueller.

Ferris speaks directly to the camera about his life from the opening scene—it's a beautiful spring day, the kind that shouldn't be wasted going to class, and it's easy to convince your parents that you're sick. His only problem? Ferris has missed eight days of class already this year. The ninth time could be the last and he might not graduate. But only if he gets caught . . .

Which is exactly what Principal Ed Rooney (Jeffrey Jones) intends to do. If he can catch Ferris not being sick, then he can force him to go to summer school. With Rooney on the case, Ferris has to resort to jumping through hoops to make the day ideal. He convinces his long-suffering hypochondriac best friend Cameron Frye (Alan Ruck), already missing school due to his current malady of the day, to help him spring Ferris's girlfriend Sloane Peterson (Mia Sara) from school as well. Cameron is reluctant to help out his friend, but Ferris can be persistent, and soon enough, Cameron is calling Principal Rooney disguised as Sloane's father, telling him that Sloane's grandmother passed away and he is coming to pick her up.

As the entire school thinks that Ferris is so sick he needs a kidney transplant, for our three heroes it's a day like no other—Ferris forces Cameron to go to the city to show him the best day ever, forcing Cameron to reluctantly borrow his dad's priceless Ferrari so they can drive around town, the three of them go to a Cubs game, see a parade, check out a museum—with Rooney on the hunt for Ferris. If he can just break into his house to prove Ferris isn't there!

Will Ferris get caught? Will Cameron finally free himself from the anxiety that's plagued him forever? How does Ferris's sister Jeannie (Jennifer Grey) fit into all of this? And what happens to Cameron's dad's car?

Best Scenes

The Cubs Game—What's the best thing that can happen at a baseball game? Ragging on the other team "Hey batta-batta—Swwwing batta!", catching a foul ball AND getting on the Jumbotron—all while avoiding Principal Rooney, who seems to be everywhere!

Rooney vs. The Bueller House—It seems so simple for Ed Rooney—he just needs to break into Ferris's house and prove that he isn't sick. That's easier said than done when the Bueller's dog is roaming around, and when Jeannie comes home from school searching for Ferris to turn him in—Rooney is ill-prepared for this level of mayhem.

The Sausage King—Trying to get into a fancy downtown restaurant for lunch without a reservation, Ferris impersonates "Abe Froman—the Sausage King of Chicago" with the help of a quick-witted Sloan. But is that Ferris's dad eating lunch there in the back?

The Parade—*Danke Schoen. Twist and Shout.* Enough said.

The Death of the Ferrari—It's the end of the day, and Cameron realizes that the Ferrari has accrued a bunch more miles than it did when the car was sitting pristinely in the Frye garage. Ferris suggests they jack up the car to make the odometer run backward. When Cameron realizes that he's busted, he doesn't shirk from it—it could be the biggest moment of his life. It's the scene that helps *Ferris Bueller's Day Off* rise above the typical teen comedy and become something more. It resonates.

Getting Home In Time?—OH—YEAH. It's the most spectacular backyard leaping ever seen in a coming-of-age comedy in history.

Awards and Recognitions

Ferris Bueller's Day Off was universally adored by the film critics and the audience loved the film. It made $70 million on a budget of $5.8 million. It was the tenth highest grossing film in 1986, and Matthew Broderick was nominated for a Golden Globe for Best Actor in Motion Picture–Musical or Comedy.

The film is the #10 movie on the Entertainment Weekly's "50 Best High School Movies," the Total Film #23 Greatest Comedy of All Time, and Empire Magazine's #1 teen movie of all time.

"You're still here? It's over. Go home. Go."

—Ferris Bueller (Matthew Broderick)

CHAPTER 43

FOCUS ON SUBGENRE

Mockumentaries and Gross-Out Comedy

Universal Pictures/Photofest

American Pie (1999): definitely not a mockumentary, for sex and more deviancy, you'll need to skip ahead in the chapter

> ► What Is a Mockumentary?
>
> ► What Is a Gross-Out Comedy?

What Is a Mockumentary?

Now we turn 180 degrees to the other side of the coin, the world of intellectual film comedy. To make a mockumentary, the filmmaker has to assume (and hope and pray) that the audience understands the context that the movie is framed. Essentially a mockumentary is a parody of the style of documentary filmmaking, which focuses on real people and events.

Our official definition, presented to you by Merriam-Webster.com (you don't need to put in the capital letters but I think it's important).

> ### MOCKUMENTARY
> **n.** a facetious or satirical work (as a film) presented in the style of a documentary

The history of mockumentaries is well known. In 1938 Orson Welles presented his version of H. G. Wells's classic novel *The War of the Worlds* as an actual broadcast over the national air waves. He freaked out the entire United States with his authentic-sounding series of interrupting news reports as if an alien invasion was actually happening *right now* in New Jersey. Everyone panicked because when audiences tuned in late, they missed the disclaimers that the whole thing was a staged reading.

The first motion picture mockumentary was Woody Allen's 1968 film *Take the Money and Run*. The story of the "world's worst criminal" was presented entirely as fact through interviews and re-enactments. (Check out Chapter 31 about Woody Allen for more about this groundbreaking movie.)

Self-deprecating comedian Albert Brooks (*Lost in America*) created a tremendous mockumentary that you probably have never seen called *Real Life* (1979). Lifting the style and premise of the first reality TV

Woody Allen in *Take the Money*

Cinerama Releasing Corporation/Photofest

show, PBS' *An American Family,* Albert Brooks plays himself as he creates a reality TV series that will follow Warren Yeager (Charles Grodin) and his family from Phoenix, Arizona, for a year. From the "spacesuit cameras" that were supposed to observe unobtrusively to Brooks asking the family to be more dramatic "for the good of the show," and then inadvertently inserting himself into the show when Mrs. Yeager (Frances Lee McCain) becomes attracted to him. It's positively brilliant.

Since you didn't see *Real Life* (and you really should if you love the subgenre), you probably saw the biggest mockumentary of all time, 1984's *This Is Spinal Tap,* which has it's own Super Great Movie Spotlight in Chapter 44. This film not only fooled viewers, which purportedly included rocker Ozzy Osbourne, but gave the actors the opportunity to play as the band and tour around the world.

Christopher Guest, who starred as Nigel Tufnel and co-wrote *This Is Spinal Tap,* loved the subgenre so much that his career has been spent creating mockumentaries since then. The former National Lampoon performer worked with John Belushi and Chevy Chase in the off-Broadway *National Lampoon's Lemmings,* and then worked for a year on the 1984–1985 season of *Saturday Night Live* alongside Martin Short and Billy Crystal before moving on to films such as *The Princess Bride.*

His mockumentaries are wild and varied, and he has put together a troupe of comedic performers that have worked with him on all of his projects:

Waiting for Guffman (1996)—The film tells the story of off-off-off-off-Broadway director Corky St. Clair (Christopher Guest) and the Blaine Community Players (including Fred Willard, Catherine O'Hara, Parker Posey, and Eugene Levy) hoping for their big break when a big time theatre critic promises to come see their original musical production of "Red, White and Blaine."

Best in Show (2000)—In a series of interviews, five dog owners—Gerry and Cookie Fleck (Eugene Levy and Catherine O'Hara), Meg and Hamilton Swan (Parker Posey and Michael Hitchcock), Harlan Pepper (Christopher Guest), Sherri Ann and Leslie Ward Cabot (Jennifer Coolidge and Patrick Cranshaw), and Scott Donlan and Stefan Vanderhoof (John Michael Higgens and Michael McKean)—come together with their loveable four-legged contestants to vie for the "Best in Show" Award at the Mayflower Kennel Club Dog Show.

A Mighty Wind (2003)—When folk music manager Irving Steinbloom passes away, it's up to his son Jonathan to put together a memorial concert with some of Irving's favorite clients in a big reunion: Mitch and Mickey (Eugene Levy & Catherine O'Hara), The Folksmen (Mark Shubb and Harry Shearer), Alan Barrows (Christopher Guest) and Jerry Palter (Micheal McKean) and The New Main Street Singers (Paul Dooley, John Michael Higgins, Jane Lynch, Parker Posey, and Fred Willard) in a concert that has all the looks of a disaster.

For Your Consideration (2006)—The story of three actors—Marilyn Hack (Catherine O'Hara), Victor Miller (Harry Shearer), and Callie Webb (Parker Posey)—working on a low-budget drama called *Home for Purim*, when word leaks out that there is talk that one of them might be nominated for an Oscar for their work on the movie.

Some mockumentaries aren't necessarily overt comedies. They're a terrific framework to hold up a mirror to society and major issues. Though critics say that Michael Moore's work borders on mockumentary, his work is entirely real. Though if he did a documentary it could be brilliant.

Movies like *C.S.A.: The Confederate States of America* (2004) shows what America would be like if the Union had lost the Civil War. It specifically satirizes the African American experience of living in slavery. Another good one came out in the same year, *A Day Without a Mexican* (2004), depicting life in southern California without the Mexican population to do all of the menial labor and even border guards are devastated for losing their jobs.

The Official Top 5 List of Mockumentary Comedies

Drop Dead Gorgeous (1999)

Go behind-the-scenes with an all-star cast including Allison Janney, Kirsten Dunst, Ellen Barkin, Denise Richards, and a young Amy Adams following the cut-throat beauty pageant world.

Borat: Cultural Learnings of America for Make Benefit Glorious Nation of Kazahkstan (2006)

The brilliance of Sasha Baron Cohen's biggest feature is taking the camera with hidden cameras and watching the reactions of unsuspecting people dealing with racist and sexist reporter Borat. Sublime.

Take the Money and Run (1969)

I've beaten the drum on this gem from Woody Allen and his on-screen idiot persona, Virgin Starkwell (who may very well still be in prison!).

Best in Show (2000)

It's Christopher Guest and his brilliant troupe of improv comedians, including Fred Willard, Eugene Levy, Catherine O'Hara, Michael McKean, and Guest himself, taking a wild look at dog owners and their dreams of winning the Mayflower Kennel Club Dog Show and the aftermath. Picture perfect comedy.

This Is Spinal Tap (1984)

This film goes to 11.

Honorable Mentions for Mockumentaries: Woody Allen's *Zelig* (1983) and *Sweet and Lowdown* (1999), *Bob Roberts* (1992), *CB4* (1993), *Waiting for Guffman* (1997), *A Mighty Wind* (2003), and foreign film gems *Man Bites Dog* (1992), *What We Do in the Shadows* (2014), and *The Rutles: All You Need is Cash* (1978) about a band like the Beatles with Monty Python's Eric Idle.

You know, if you think about it—this whole book is a mockumentary. It looks like a legitimate book, but there's so many weird things going on, maybe it isn't a real book. I think I'm actually riffing on what a book is supposed to be.

What Is a Gross-Out Comedy?

WARNING: THIS PART OF THE CHAPTER IS FULL OF OBSCENITIES AND DISGUSTING DESCRIPTIONS OF THE MOST OUTRAGEOUS ACTS THAT HUMAN BEINGS ARE WILLING TO DO FOR THE SAKE OF FILM COMEDY. READ ALONG AT YOUR OWN RISK. SIGNED, THE EDITORIAL STAFF.

In the beginning, there was John Waters—before he picked up a movie camera.

And then there was everything after it.

He's a Baltimore filmmaker that spent his early career making countercultural "transgressive" shorts and feature films. Even I had to look up the term "transgressive" at freedictionary.com. Check it out!

TRANS-GRES-SIVE

Adj.

1. Exceeding a limit or boundary, especially of social acceptability.

2. Of or relating to a genre of fiction, filmmaking, or art characterized by graphic depictions of behavior that violate socially acceptable norms, often involving violence, drug use and sexual deviancy.

John's films have been characterized as "an exercise in poor taste." That's not a critic saying that—it's the actual tagline for his 1972 comedy *Pink Flamingos*. His films always had an outrage to them, but this is the film that gave him the most notoriety. He would go on to do such mainstream fare as *Hairspray* (1998) and then the subsequent Broadway Musical which turned into a film musical in 2007.

But *Pink Flamingos*, that's a whole different mind trip. Waters's mainstay, drag queen Divine stars as herself, recently branded the "Filthiest Person Alive" by a tabloid, and she draws the ire of Connie and Raymond Marble, who believe that they are the filthiest people alive. They are determined to wrest the crown from Divine's disgusting hands.

How tasteless is *Pink Flamingos*? Here's a list:

- ▶ Kidnapping women and impregnating them to sell their babies to lesbian couples on the black market;
- ▶ Selling heroin to elementary school kids;
- ▶ Public exposure of the male genitalia;
- ▶ Crushing a live chicken in-between two people having sex;
- ▶ Eating human feces;
- ▶ Topless dancing with a snake;
- ▶ A contortionist who flexes his anus to the song "Surfin' Bird";
- ▶ Murdering policeman;
- ▶ Oral sex;
- ▶ Male castration (off-screen—well, there's something restrained).

Whoa! I almost gave the whole thing away. There's even more than that, but I'm repulsed just typing this stuff. Okay fine—Divine eats dog shit. Real dog shit. No fancy special effects, or Baby Ruth bars like the ones thrown in the pool in *Caddyshack*. Hand of God people, he/she eats dog shit.

The film became a huge hit on the underground film circuit and found distribution with New Line Cinemas. It's a cult classic that had midnight film screenings in New York City, and started cultivating an audience that would embrace other underground film fare, including *The Rocky Horror Picture Show* in 1975.

Gross-out comedy is just that: movies intended to disgust and repulse the audience with the intention of making the audience laugh.

Underground cinema is one thing, but getting into the mainstream is a whole other thing. Remember the carefree days of the Hays Code, when you couldn't put a couple in a single bed? Can you imagine audiences in the 1950s watching Frankie Avalon in *Beach Blanket Bingo* drinking a cup full of sperm like Stifler does in *American Pie*?

The Hays Code was replaced by the much more lenient Motion Picture Association of America (MPAA) Rating System in 1966.

It started with G for General Audiences, M for Mature Audiences, R for Restricted to persons under 16 unless accompanied by a parent or adult guardian, and then the ubiquitous X rating, which is flat-out, nobody under 16 at all. Eventually the M turned into PG, and then PG-13 was added after PG wasn't a good enough rating for films like *Indiana Jones and the Temple of Doom* (1983) when Mola Ram pulled a live beating heart out of a man's chest.

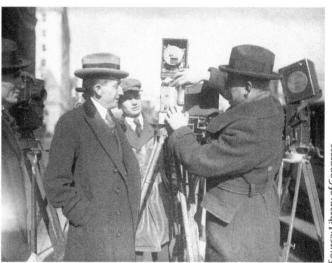

Will Hayes' corpse was found spinning in his grave after the release of John Waters' *Pink Flamingos*

Source: Library of Congress

Along the way, X got taken away and replaced by NC-17. NC-17 stands for No Children Under 17, which is the same exact thing as the X rating, but seems slightly less abrasive when you put it on a movie poster. It's like the legal team at my Publisher's office took over the ratings system.

As television became more prevalent, and social morays relaxed in the 1980s, it became easier for comedy film to start bending the envelope. *M*A*S*H* dropped the F-bomb in 1970. In 1972, *Blazing Saddles* depicted the first on-camera farting, and then things got seriously gross when a little movie called *National Lampoon's Animal House* hit the silver screen in 1978.

In my exclusive interview with director John Landis, he insists that *National Lampoon's Animal House* is tame by today's standards. Yes, the "I'm a zit, get it?" projectile vomiting moment is pretty rank, but there's also a female masturbation scene, gratuitous nudity, almost having sex with a 13-year-old, obscene language (which is now known as "adult language"), and a litany of others.

Audiences should have been repelled by such vulgarity. On the contrary, the film made over $140 million and set a standard for on-screen comedy that has not been matched and surpassed ever since.

A couple of other films had some great gross-out moments, the fake piece of crap in the swimming pool in 1980's *Caddyshack* and the oral sex jokes with Otto the Autopilot in *Airplane!* (1980) continued the momentum that *Animal House* started. And both films were huge movies, continuing to push what was respectable in film comedy.

The next big gross-out movie was 1981's *Porky's*, directed by future *A Christmas Story* director Bob Clark. Its most outrageous scene is when the high school guys peep into the girls' locker room, and they're naked. When the girls catch one of them looking, Tommy (Wyatt King) sticks his tongue through the peephole.

Then he drops his pants and sticks his penis (can I type penis?—no Editor's Note? Keep typing, quickly!) in the hole, just in time for the militant female gym teacher Ms. Balbricker to see it, grab it, and PULL. Yikes! Talk about breaking distance! You know a film is a good example of gross-out when you offend famed movie critics Gene Siskel and Roger Ebert. *Porky's* made so much money ($111 million) thanks to that scene that they had two more sequels made.

It's not all about sex. Okay, it is all about sex. But when it comes to gross-out comedy, it's not *entirely* about sex.

Hands down the most disgusting and repulsive scene in a film comedy (again completely forgetting about *Pink Flamingos*) goes to the "Mr. Creosote" scene from 1983's *Monty Python's The Meaning of Life*. If you haven't watched the scene when the "World's Fattest Man" (Terry Jones) goes to eat dinner at an upscale restaurant, it is truly out of control. To the gratuitous vomiting, to more gratuitous vomiting, and then even more gratuitous vomiting, I suggest you review the film on an empty stomach. Big high-five to John Cleese for holding the bucket!

As the 1980s continue, the need to create a gap between television and film continues to grow. There are so many outlets for comedy films, from the pay-cable networks like HBO that don't need to censor anything (you know why they call it Skin-o-max, right?) to purchasing videos for your home, the media industry is hungry for content. Whatever sells and drives the box office.

The year 1994 was a watershed year for gross-out comedy with the release of two films that would start a chain reaction of films for the next fifteen years.

Clerks (1994)

Writer-director Kevin Smith's debut feature film following convenience store employee Dante (Brian O' Halloran) who doesn't want to be at work, but he's stuck anyway. It's a day he'll long remember as he discovers his girlfriend had sex with three different guys, but discovers that she gave out thirty-seven blowjobs before they started dating. The film also has a ton of other sexual language, adult language, and drug references. No nudity though. That would have to wait until *Zack and Miri Make a Porno*.

Dumb and Dumber (1994)

Peter and Bobby Farrelly's debut feature film stars Jim Carrey (Lloyd) and Jeff Daniels (Harry) and was the mainstream film industry's trumpeted return to good old-fashioned gross-out slapstick humor in this tale of two idiots who go across the country in pursuit of a girl. The Farrelly Brothers made a lot of money and a successful career in the subgenre. There are a couple of great scenes in this one—like when Lloyd spikes Harry's coffee with laxative and Lloyd urinating in bottles so they don't have to stop while they're driving and the cop who pulls them over accuses them that it's beer. No sir, they are not. Have a drink . . .

Scene from *Dumb and Dumber*

New Line Cinema/Photofest

The Farrelly Brothers would go on to make several gross-out films, including *Kingpin* (1996), *There's Something About Mary* (1998), *Me, Myself & Irene* (2000), *Shallow Hal* (2001), *Stuck on You* (2003), *Hall Pass* (2011), and *Dumb and Dumber To* (2014).

Actor Jim Carrey would also go on to a series of gross-out comedies, such as *Ace Ventura: Pet Detective* (1994—the same year as *Dumb and Dumber*), *Ace Ventura: When Nature Calls* (1995), *Me, Myself & Irene* (2000) (reuniting with the Farrelly Brothers), and *Dumb and Dumber To* (2014).

In 1999, the movie that should be credited as the second-most important gross-out movie was released, and it was a game-changer. It married the coming-of-age film with the gross-out

comedy that *Porky's* had done sixteen years before. The big difference was that society had changed the socially acceptable boundary for what is acceptable to put in a movie. Simply put, after this movie, a comedy film could do anything and get away with it.

The beauty of *American Pie* (1999) was its devotion to crass, over-the-top physical and scatological humor. And a lot of sex. So much sex. The movie is about four high school friends who bet that they would lose their virginity before the end of their senior graduation. The movie's title comes from Jim (Jason Biggs) having sex with a hot apple pie because he was told it simulates the feel of being inside a girl. Also the web-cam stripping scene with foreign exchange student Nadia (Shannon Elizabeth), Stifler's Mom (Jennifer Coolidge) and the pool table and the introduction of the term "MILF" into the culture, Finch and his aversion to public bathrooms, Michelle (Alyson Hannigan) talking about the one time she went to band camp and used her flute for something I'm sure it was never intended . . . (please don't let me get that graphic here).

American Pie made $235 million on an $11 million budget and three sequels: *American Pie 2* (2001), *American Wedding* (2003), and *American Reunion* (2012), and you can't forget the straight-to-DVD sequels *American Pie: Band Camp* (2005) and *American Pie: Beta House* (2007). They all have pretty gross things in them, but you know what they say—they're never as good as the original.

From that point on, gross-out comedy was firmly entrenched as a mainstream comedy staple. It's no longer the bastard sex-starved curiosity that occasionally scandalizes viewers.

Gross-out comedies can be divided into two categories, but that doesn't mean that audience members in both categories can't cross over to the other side. In fact, I highly encourage it.

The Official Top 5 List of Gross-Out Comedies for the UNDER-25-Year-Old Demographic

Road Trip (2000)

Kyle (DJ Qualls) complains about his French toast, so the waiter (Horation Sanz) licks it and drops it down his pants. Kyle LOVES the taste!

Harold & Kumar Go to White Castle

Lots of drugs, the boys get to watch a girl pooping contest and every scene with Neil Patrick Harris playing himself, doing things no self-respecting former child should ever do in public.

Superbad

It's *American Pie* with three guys trying to get laid, tons of language, Seth (Jonah Hill) and his pre-occupation with drawing penises and wanting to get laid, the smearing of that girl's period and who doesn't love McLovin?

South Park: Bigger, Longer and Uncut

How many times little kids drop the f-bomb, Satan having gay sex with Sadaam Hussein, insults about everything including homosexuals, that bit about self-abortion, Terrance and Phillips' *Asses on Fire* cartoon. This is not *The Simpsons Movie*.

American Pie

I could totally just cut-and-paste the above paragraph. But I won't. Read it for yourself, you lazy yahoos. [Editors' Note: That might have been an insult. We're checking on that.]

Honorable mentions for Under-25 gross-out films: *Road Trip* (2000), *Jackass: The Movie* (2002), and *National Lampoon's Van Wilder* (2002).

The Official Top 5 List of Gross-Out Comedies for the OVER 25-Year-Old Demographic

The 40 Year-Old Virgin (2005)

Andy Stiltzer's (Steve Carrell) fully-erect boner in the opening credits, the stun gun demos, the male chest hair waxing scene, and the condom scene. Good stuff!

Team America: World Police (2004)

Yes, it's puppets—but it's puppets performing things that no puppets should ever do in the wildest erotic scene ever that should be left to porn.

The Hangover (2009)

Just the end credits scene alone is enough to make this list, but don't forget Mr. Chow (Ken Jeong) full frontal jumping from the trunk.

Borat: Cultural Learnings of America for Make Benefit Glorious Nation of Kazahkstan (2006)

The rare film that is both a gross-out comedy AND a mockumentary. It's all about that wild all nude hotel chase scene.

There's Something About Mary (1998)

Franks and Beans and the Hair Gel. Any questions?

Honorable mentions for the over-25 gross-out comedies: *Old School, Super Troopers, BASEketball, Waiting, Scary Movie, Deuce Bigalow, Male Gigolo*, and *This is the End*.

So yes, these movies DO attract our attention. If you've been reading this book [Editor's Note: Congratulations on making it this far.], you know that comedy films make a TON of money. How much you ask?

From Box-Office Mojo, Here's a List of the Top 5 Highest Grossing Gross-Out Comedy Movies in History (U.S. Gross)

1. *The Hangover* (2009)—$277 Million
2. *The Hangover Part II* (2011)—$254 Million
3. *Ted* (2012)—$219 Million
4. *Wedding Crashers* (2005)—$209 Million
5. *There's Something About Mary* (1998)—$176 Million

I don't know if any of you know how to use the calculator on your phone, but that's $1.13 BILLION.

How much do audiences love gross-out comedies? A lot.

CHAPTER 44
SUPER GREAT MOVIE SPOTLIGHT

This Is Spinal Tap (1984)

Harry Shearer, Christopher Guest, and Michael McKean are the stars of *This Is Spinal Tap* (1984)

Embassy/Photofest

> ► Starring Christopher Guest, Michael McKean, Harry Shearer, and Rob Reiner
> ► Directed by Rob Reiner
> ► Written by Christopher Guest, Michael McKean, Harry Shearer, and Rob Reiner
> ► Subgenre: Mockumentary
> ► Comedy types: Verbal, Slapstick, Deadpan

"These go to eleven."

—Nigel Tufnel (Christopher Guest)

The music industry has always been a fertile ground for comedy. Look at all of those Elvis Presley movies. *This Is Spinal Tap* is such a perfect mockumentary of the music business that many fans thought that it was real. (Spoiler Alert: It isn't.) From throwing tantrums about food in the green room, fighting with the record companies about album covers and tour dates, the tragedy of rock stars dying, girlfriends breaking up bands—no cliché is left unturned.

This Is Spinal Tap is a film that was borne from a sketch that Michael McKean, Christopher Guest, and Harry Shearer performed on *The TV Show* in 1978. All of the music recorded for the film is original and performed by the actors. Out of a reported 100 hours of footage shot for the film, most of the dialogue was improvised. Though not the first mockumentary, it successfully led to a huge renaissance of mockumentaries (see Chapter 43) that is still a successful subgenre to this day.

Summary

Director Marty DiBergi (Rob Reiner—the real director of the film—how meta!) is a huge fan of the "world's loudest" heavy metal band "Spinal Tap" and when he heard they were going on tour for their new album, *Smell the Glove*, he wants to be there to film everything.

He introduces us to the lead-guitar-playing founders of the band, David St. Hubbins (Michael McKean) and Nigel Tufnel (Christopher Guest) and learns how the band came together, as a hippie-pop band in the sixties through today. Through his one-on-one interviews we quickly learn that though they are very well meaning and talented musicians, they are also idiots. The rest of the band consists of bass player Derek Smalls (Harry Shearer), keyboardist Viv Savage (David Kaff), and a series of drummers that have the unhappy coincidence of dying in tragic circumstances, like choking on vomit. Not their own vomit, mind you.

Making matters worse is the slow realization that the band isn't as popular as they used to be, and still think they are. Several concert dates get canceled and they end up playing any gig their manager Ian (Tony Hendra) can book. Also David's girlfriend Jeanine (June Chadwick) comes on tour and starts doing her best Yoko Ono impression to mess with the band. Finally, their record company reports that no one wants to carry their album because of the sexist album cover, a scantily clad young woman on all fours wearing a leash and collar sniffing a glove.

As pressure mounts with a disastrous performance highlighting their song "Stonehenge," their manager is fired, leaving Jeanine to take over managing the band. Nigel is not happy and quits. The rest of the tour remains—can Spinal Tap survive in a world where they aren't relevant? Will Nigel rejoin the band? Is there any hope that they can regain their luster before the inevitable break-up? Will the new drummer die?

Song Samples

Here's a sample of some of the songs in the movie. I think you can tell what kind of film this is pretty easily:

- ▶ "Big Bottom"—about girls with, you guessed it, huge asses—"The bigger the cushion, the sweeter the pushin'"
- ▶ "Sex Farm"—about having sex on a farm—"Getting out my pitch fork, poking your hay."
- ▶ "Hell Hole"—about living in a bad apartment—"The window's dirty, the mattress stinks"

Best Scenes

Stonehenge—Before a concert, Nigel commissions their manager Ian to have a gigantic replica of one of the Stonehenge monuments come down onstage during the song "Stonehenge." Unfortunately things don't go that well when the monument was built to the incorrect specifications.

Airport Security—As the band goes through the airport, Derek is flagged for having metal in his pockets. He unloads everything and goes back through and the machine goes off again. He gets wanded by security, and we come to find out exactly why the alarm went off.

The Cleveland Show—The band tries to get onstage and ends up getting lost.

The Air Force Dance Show—When Nigel's wireless guitar amp suddenly starts broadcasting transmissions from the Air Force tower.

Every Scene—I'm telling you that this is pretty much a perfect movie. It's the one I've seen the most in the book, and it stands up even today. As long as you know anything about the music business, this one will have you from "goes to 11."

Awards and Recognition

This Is Spinal Tap was not a big financial success at the box office, but many critics raved about the film, including Roger Ebert. The film caught on during the 80s and 90s thanks to the home video market.

The actors were able to turn the film into a lucrative music career, touring the world as "Spinal Tap" which included them playing Wembley Stadium to 100,000 people.

This Is Spinal Tap is the #29 ranked movie on the AFI Great Comedy Films selection, and Time Out London lists it as the best comedy film of all time.

This Is Spinal Tap appears in several "greatest movies of all time" lists for such periodicals as *The New York Times*, *Empire*, and *Entertainment Weekly*. It is also listed in Steven Schneider's book *1001 Movies You Must See Before You Die*. (I own a copy!)

This Is Spinal Tap is the only movie on the Internet Movie Database (IMDb) that is rated on a scale of 11, rather than 10.

In 2002, the Library of Congress placed the film in the National Film Registry.

CHAPTER 45

Welcome to the 1990s–2000s

OR:

How a Little Skiing Village in the Utah Mountains Changed Hollywood

Will Smith and Tommy Lee Jones ready to kick some serious-alien-ass in *Men in Black* (1997)

Columbia Pictures/Photofest

CHAPTER FOCUS

▶ The Emergence of Indie Film Comedies

▶ The Hollywood Studios Were Also Around

▶ The *Saturday Night Live* Feature Film Factory

▶ Top Subgenre Comedies of the 1990s

▶ The Top 5 Comedies of the 1990s That Haven't Been Written about in Other Pages of This Book

Chapter Focus

In the 1990s, Hollywood would continue to crank out comedies at a breakneck pace, but another set of films emerged during the decade, the ones produced by independent filmmakers.

In 1989, the USA Film Festival in Park City, Utah, was having financial difficulty. Fortunately they had an avenue to turn for assistance. Filmmaker Robert Redford ran the Sundance Institute, a non-profit film workshop and laboratory that gave filmmakers the resources they

HOT—Oscar Winner Ben Kingsley in Park City

NOT HOT—"Celebrity" Paris Hilton in Park City

needed to make independent films. It was only natural that the USA Film Festival would change its name to the Sundance Film Festival.

With the festival rebranded and sporting Robert Redford's guidance, the festival became the place for Hollywood to see and be seen. There had always been a prolific number of filmmakers that had made small introspective comedies that played the festival circuit, such as Jim Jarmusch's *Strangers in Paradise* (1984) following the story of a hipster in New York City who takes in his cousin from Hungary. Like I said, small introspective comedies. What they call in the business as "micro-budget."

The Emergence of Indie Film Comedies

In time, major independent filmmakers would take Hollywood comedy by storm in their own intimate way. Joel and Ethan Coen, aka "The Coen Brothers," would write and direct a ton of terrific comedies. (They've got their own section in Chapter 49.)

There are plenty of other films and filmmakers that made their mark in the world of film comedy.

Michael Moore

Roger and Me (1989)

Michael Moore's documentary somehow finds humor in the heartbreaking story of his hometown in Flint, Michigan, and what happened when the General Motors automotive plant shut down and put half of the town out of work.

Michael Moore would create some of the most memorable documentaries in recent history, such as *The Big One* (1997) about corporate downsizing and jobs sent overseas, *Fahrenheit 911* (2004) that explored the aftermath of the United States foreign policy after the World Trade Center attack, Oscar-winning Best Documentary *Bowling for Columbine* (2002) focusing on gun control, and *Sicko* (2007) exposing the corporate greed of health care. His films retain his sardonic and cynical sense of humor, and it's the humor that helps tell some of the most controversial stories affecting America in a relatable way.

Slacker (1991)

Richard Linklater (*Dazed and Confused*) wrote and directed his debut feature as a study on different people across the landscape of Austin, Texas. There really isn't a plot per se, but Linklater has a great fondness for his characters and their opinions and attitudes.

Several of Richard Linklater's films have been comedies, including *Dazed and Confused* (1993), a high school ensemble coming-of-age film, *School of Rock* (2003), the Jack Black-starrer about a high school rock singer that teaches his students about music, the remake of *The Bad News Bears* (2005) with Billy Bob Thornton, Jack Black reunited with Linklater for the black comedy *Bernie* (2011), and *Everybody Wants Some!!!* (2016), another high school ensemble comedy, in the vein of *Dazed and Confused*, that takes place in the 1980s.

Richard Linklater

©Helga Esteb/Shutterstock.com

Reservoir Dogs (1992)

When it comes to dark and black comedy, nobody comes close to Quentin Tarantino, who can take the worst of people and somehow make us laugh.

In this wild tale about a jewelry story heist gone awry are scenes of trademark Tarantino, from the argument about who gets to call themselves "Mr. Black," the flashback with Tim Roth hiding drugs in the public bathroom and the ear-cutting off torture scene set to Stealers Wheels "Stuck in the Middle with You" opened the door for one of the most innovative artists in Hollywood to ply his trade.

Quentin Tarantino

©s_bukley/Shutterstock.com

Tarantino's films always have an edge of black comedy and wicked dialogue that no one in film comes close to matching. Whether it's the "Royale with Cheese" dialogue in *Pulp Fiction* (1994), the sweet romance in *Jackie Brown* (1997), the individual flashbacks in *Kill Bill: Volumes 1 and 2* (2003 and 2004), the entire laughable premise of a killer with a car in *Death Proof* (2007), the dark comedy of Nazism that he pulls off in *Inglorious Basterds* (2009), and the delicate balance of slavery and dark comedy in *Django Unchained* (2012),

and even the cowboys of *The Hateful Eight* (2015) all possess a hip attitude that helps audiences maintain the distance when horrible things happen to horrible people.

Clerks (1994)

Kevin Smith

Kevin Smith killed it at the Sundance Film Festival with this gross-out comedy about slackers in a convenience store (take a gander at the gross-out stuff in Chapter 43) and his riffs on sex, drugs, irate customers, and independent contractors working on the Death Star and their untimely fate show a terrific knack for humorous dialogue.

Kevin's subsequent films have all had a fun center to them; *Mallrats* (1995) about two guys recovering from being dumped, to *Chasing Amy* (1987), and the frustration of falling for someone who's not attracted to you *or your gender*. Smith's film *Dogma* (1999) has some teeth to it, about an abortion clinic worker that has to save humanity by stopping two rogue angels. But when the angels are played by Matt Damon and Ben Affleck, how truly evil could they really be?

His subsequent films fall back into standard comedy, such as a spoof on filmmaking with stoners in *Jay and Silent Bob Strike Back* (2010), another visit to the now slightly-older slackers at the convenience store in *Clerks II* (2006), his single dad family film *Jersey Girl* (2004), and even the sweet nature of *Zack and Miri Make a Porno* takes what could be a completely tasteless film, and elevates it into a sensitive love story between friends. That could be the only time in history that the words "Porno" and "sensitive love story" ever appear in the same sentence.

Being John Malkovich (1999)

Spike Jonze

Director Spike Jonze, working with a script from Oscar-winner screenwriter Charlie Kaufman (Adaptation, *Eternal Sunshine of the Spotless Mind*), tells the story of puppeteer Craig (John Cusack) and his girlfriend Lotte (Cameron Diaz) and what happens when Craig discovers a portal in an office building that leads straight into the consciousness of actor John Malkovich, playing himself. Spike was nominated for a Best Director Oscar for the film.

Spike's surreal comedy style would continue with another Charlie Kaufman script, *Adaptation* (2002), about the struggles of Charlie Kaufman (Nicolas Cage) working on the adaptation of the non-fiction "The Orchid Thief" into a screenplay and dealing with his twin brother who also fancies himself a screenwriter. In a parallel story, the book's author, Susan Orlean (Meryl Streep), falls in love with an orchid hunter. Somehow they all intertwine at the end in mesmerizing fashion.

His movie, *Her* (2013), was Spike's solo writing effort about Theodore (Joaquin Phoenix) who falls in love with his computer operating system, voiced by Scarlett Johansson. Spike won the Oscar for Best Original Screenplay for the film.

She's Gotta Have It (1986)

Writer/Director/Actor Spike Lee shook the independent world with his hilarious takes on dating in the inner city of New York, and the film announced the arrival of a new voice in cinema that would shake things up for moviegoers for the next three decades.

Spike has been one of the most creative and innovative filmmakers in the last thirty years, and his filmography is ridiculous—especially when it comes to the chances he's taken when it comes to comedy.

Spike Lee

©Andrea Raffin/Shutterstock.com

His second feature, *School Daze* (1988), was a musical comedy-drama about college frats and sororities, and his masterful *Do the Right Thing* (1989) had to have a certain amount of humor to allow the seriousness of the racial tension in Brooklyn to ease up enough so the story wouldn't stop in its tracks.

Crooklyn (1994) is a semi-autobiographical coming-of-age film, and *Bamboozled* (2000) is a satire on the media and how black men are portrayed as Pierre Delacroix (Damon Wayans), a frustrated television executive, pitches the idea of reviving the minstrel shows of the early 1910s and 1920s to disastrous and successful results.

She Hate Me (2004) tells the story of John Armstrong (Anthony Mackie), who loses his job due to his whistle-blowing and decides to make a living as a sperm donor for lesbians. Never one to shirk from controversy, Spike Lee continues to be a force in film and in film comedy.

Some other independent 1990s comedy films worth mentioning are Whit Stillman's *Metropolitan* (1990), Tom DiCillo's film school staple *Living in Oblivion* (1995), Alexander Payne's *Election* (1999), and Doug Liman's *Swingers* (1996).

The Hollywood Studios Were Also Around

With a renaissance of comedy filmmaking debuting at film festivals around the world, Hollywood wasn't going away. The boom of the 1980s continued, especially as the amount of movie theater screens increased. Check out this cool chart from the National Association of Theatre Owners:

Year	Indoor	Drive-In	Total
1999	36,448	683	37,131
1998	33,418	750	34,168
1997	31,050	815	31,865
1996	28,905	826	29,731
1995	26,995	848	27,843
1994	25,830	859	26,689
1993	24,789	837	25,626
1992	24,344	870	25,214
1991	23,740	899	24,639
1990	22,904	910	23,814

That's right math freaks—we're talking about a 64 percent INCREASE in movie screens over a ten-year period. Further, the Nielsen Company reported that the average American home experienced a tremendous growth in the number of broadcast, pay-cable channels, and basic and tiered cable television increased from an average of 33.2 channels in 1990 to 74.6 channels in 2000. You read it right, that's a 124 percent INCREASE during the decade to keep feeding the public more and more content.

The Saturday Night Live Feature Film Factory

When you're looking for one of the more productive film companies during the era, look no further than Lorne Michaels and the talented actors and writers from NBC's *Saturday Night Live*. The SNL movie brand started in 1979 with the successful release of *The Blues Brothers*, but it wasn't until the 1990s that there was a strong opportunity available in the marketplace to take existing characters from the iconic comedy program and parlay them into movies.

The film that started the SNL movie train was "excellent" as Wayne Campbell would say. What? You don't know Wayne Campbell? Read on and party on!

Wayne's World (1992)

In the biggest box-office smash to come from the stable of *Saturday Night Live* characters, slackers Wayne Campbell (Mike Myers) and his best friend Garth (Dana Carvey) live in Aurora, Illinois, and host their own weekly public-access cable TV show. When shady TV producer Benjamin Oliver (Rob Lowe) offers to buy their show and turn them into overnight sensations, they take the deal—and regret it when Oliver starts changing their show while trying to break up Wayne and his new girlfriend Cassandra (Tia Carrere). Ultimately Wayne is fired from his own show and his friendship with Garth is destroyed and Cassandra dumps him.

Can Wayne get back the show? Will Garth and Wayne bury the hatchet? Can Cassandra forgive Wayne and will Benjamin get his come-uppance? It's worth a watch! Wayne constantly breaks the fourth wall, there are several fantasy sequences, and it has the best Car Karaoke scene in motion picture history featuring Queen's "Bohemian Rhapsody" (which was nominated for the AFI Best Song list).

A lot of audience members did—the film made over $125 million at the box office, making it one of the biggest films of 1992. *Wayne's World* was nominated for the AFI Great Comedy Films list, as well as "Schwing!" and "We're not worthy. We're not worthy!" on their Great Movie Quotes list.

With the success, Paramount Pictures gave Lorne Michaels a studio deal to start making movies starting with *Wayne's World 2*. Unfortunately the films that came after the first movie weren't the hits that the studio was hoping they would be.

Name	Budget	Box Office Gross
Wayne's World 2 (1993)	$ 40M	$ 48 M
Coneheads (1993)	$ 33M	$ 21.3 M
Stuart Saves His Family (1995)	$ 6.3M	$ 912,000
A Night at the Roxbury (1998)	$ 17 M	$ 30.3 M
Superstar (1999)	$ 14 M	$ 30.6 M
The Ladies Man (2000)	$ 24 M	$ 13.7 M

After *The Ladies Man*, the wealth of *Saturday Night Live* characters had pretty much run its course. Since then, there haven't been any other films with SNL characters produced by Lorne Michaels.

Top Subgenre Comedies of the 1990s

Here's a collection of my very-educated opinion of the top subgenre films from the 1990s—apparently they're not "AFI 100 Years . . . 100 Laughs" worthy, but these films are pretty terrific, so grab a pen and paper (do people still use those?) and make yourself a list of films worth finding in the DVD dollar bin at your local pharmacy. You know the bin I'm talking about, with the big sign that says "Hollywood's Greatest Hits" and ends up being movies that are decades-old that never saw the inside of a movie theater, and inexplicably contains more obscure C-list Nicolas Cage movies than have ever been grouped together in a single setting.

Top Family Comedy

Home Alone (1990)

When you're looking for big movies from the 1990s, this is the top dog. Seems simple enough: it's Christmas time and troublemaking eight-year-old Kevin (Macauley Culkin) is accidentally forgotten by his parents when they head out on a huge family vacation. The kid lives it up with no supervision until two idiotic burglars, Marv (Daniel Stern) and Harry (Joe Pesci), target his family home. The slapstick shenanigans ensue when Kevin rigs his house with various traps to deter the burglars.

In a great article in *The Week**, journalist Lauren Hansen interviews Dr. Ryan St. Clair of the Weill Cornell Medical College about what kind of physical damage that Marv and Harry would have suffered if the home invasion happened in real life. The worst of them is Marv getting hit in the face by a steam iron, which would cause "a 'blowout fracture' that can lead to serious disfigurement and debilitating double vision." Also both Marv and Harry are hit by two paint cans in the face, which they "wouldn't expect either of the Wet Bandits to walk away from this with all of their teeth." Ouch!

Home Alone was a box office behemoth. From a budget of $18 million, the movie made $467 million worldwide! It was the #1 film at the box office for three straight months (only *Titanic*, *Beverly Hills Cop*, and *Tootsie* held the top spot longer) and is the Guinness Book of World Records Holder as the "Highest-Grossing-Live Action Comedy in History." The movie itself received mediocre reviews, but was nominated for two Academy Awards, Best Original Score for maestro John Williams, and Best Original Song for "Somewhere in My Memories." The movie spawned four sequels, three video games, two board games, a book, and a bunch of merchandising. Lastly, the movie is a beloved Christmas holiday viewing staple in Poland!

The Week http://theweek.com/articles/469307/diagnosing-home-alone-burglars-injuries-professional-weighs

The only bad thing about *Home Alone* is it marked the end of John Hughes's run as an auteur filmmaker. Known for single-handedly creating the Teen/Coming-of-Age subgenre in the 1980s, he left that behind for more mainstream fare after the success of *National Lampoon's Christmas Vacation*. He was always a prolific writer (legend has it that he wrote *Home Alone* in four days with no rewrites) and ended up settling into family comedy films that were mediocre financially and critically, such as *Dennis the Menace* (1993), *Baby's Day Out* (1994), *Flubber* (1997), and the second *Home Alone* sequel, and ultimately left the film industry and passed away in 2009.

Top Sci-Fi Comedy

Men in Black (1997)

Based on an obscure comic book by Lowell Cunningham, the movie follows the travails of the M.I.B., a secret government agency responsible for keeping track of all alien life forms on Earth. After losing his partner to retirement, Agent K (Tommy Lee Jones) is forced to recruit someone new and settles on streetwise cop James Edwards III (Will Smith) to join him, giving up his own identity to become Agent J.

It's a fish-out-of-water tale for J as he discovers a whole new world, and it's a bug-out-of-water had tale when an alien crashes and plots to take over the world, hilariously inhabiting the body of country bumpkin Edgar (Vincent D-Onofrio) as he heads for New York City.

Masterfully directed at a breakneck pace by Barry Sonnenfeld, the cinematographer shot such films as *Raising Arizona* (1987), *Big* (1988), *When Harry Met Sally* (1989), and directed *The Addams Family* (1991) and its sequel, *Addams Family Values* (1993), and *Get Shorty* (1995) before helming this huge film. How huge was the movie?

Huuuuge. On a budget of $90 million, *Men in Black* made $589 million worldwide. It spawned an animated TV series and two sequels which made oodles of money, and the original was nominated for three Academy Awards, Best Original Score, Best Art Direction, and won Best Makeup for Rick Baker.

Top Gross-Out Comedy (That Isn't There's Something About Mary or American Pie)

Dumb and Dumber (1994)

Best friends Lloyd (Jim Carrey) and Harry (Jeff Daniels) are two morons living a simple life when a beautiful customer named Mary Swanson (Lauren Holly) leaves her briefcase in

Lloyd's limousine. He has no idea that the briefcase is a money drop for the ransom money to set Mary's husband free from kidnappers. Lloyd discovers that the briefcase is full of money and resolves to take it back to Aspen where Mary lives. He forces Harry to drive his Mobile Pet Grooming Truck across the country and that's when things get crazy!

Dumb and Dumber was a huge hit making $247 million at the box office, and the critics were mixed in their reviews. The film made Jim Carrey an international superstar and Total Film named *Dumb and Dumber* the 5th greatest comedy film of all time.

It spawned a prequel *Dumb and Dumberer: When Harry Met Lloyd* that the Farrelly's had nothing to do with and it was a horrible film. The Farrelly's did write and direct the sequel *Dumb and Dumber To* (2014) that had some laughs, and a lot of negative reviews, but the film made $169 million at the box office. The popularity of studio gross-out comedies can be attributed to this LOL (the kids say this stands for "Laugh-Out-Loud") movie that cemented Jim Carrey as a performer-led comedy force (see more about him in Chapter 47).

Top Musical Comedy

Sister Act (1992)

Some people forget that Whoopi Goldberg was once a serious dramatic actress. This Uta-Hagen trained actress was performing her one-woman play "The Spook Show" when Mike Nichols (*The Graduate*) helped bring her to Broadway. In 1985 she caught the attention of Steven Spielberg (*1941, Hook, Always*—just kidding—*Raiders of the Lost Ark, Jurassic Park, Schindler's List*) who cast her in the leading role of the big-screen adaptation of Alice Walker's novel *The Color Purple*. She was nominated for Best Actress for the movie, and the movie was famously nominated for eleven Oscars and didn't win any of them.

She appeared in a series of big-screen comedies, a couple of TV movies and a short-lived sitcom with mixed results, and started the Comic Relief organization with friends Robin Williams and Billy Crystal. She hit her career plateau in 1991, when she won the Oscar for Best Supporting Actress for her role of Oda Mae Brown in the romantic fantasy film *Ghost*. She was the second black actress to win an acting Oscar after Hattie McDaniel in *Gone With the Wind*.

The following year, she starred in *Sister Act*, which became the highest-grossing film of her career. Whoopi plays Deloris Wilson (nee Deloris Van Cartier), a Reno lounge-singer who witnesses her mafia boss boyfriend shoot his chauffer. She escapes certain death and goes into witness protection.

She's forced to hide in a San Francisco convent and disguise herself as a nun, under the name of Sister Mary Clarence, until his upcoming trial. She eventually finds herself in the convent choir, and with her musical training she takes over as choir director, and takes traditional hymns and arranges them with rock and roll beats, and vice-versa—taking popular songs and turning their lyrics and music into church songs, like the Mary Wells song "My Guy" becomes "My God." Soon the choir catches everyone's attention, from the public-at-large and the Pope, to the mobsters who are trying to kill her.

Sister Act was one of the highest grossing films of the year, making $231 million from a budget of $31 million. It spawned a sequel, *Sister Act 2: Back in the Habit* (1993), and a stage musical version that was nominated for five Tony Awards including Best Musical, and has been running around the world since 2006.

Top Action Comedy

Rush Hour (1998)

Fans of Hong Kong cinema know exactly who action film star Jackie Chan is and what he can do for motion picture entertainment. Which is pretty much everything. He's a martial artist that performs his own movie stunts.

He's also injured himself in countless ways. Here's a list of a few of them!

- Supercilliary bone (eyebrow bone!) damaged, almost causing blindness: *Drunken Master* (1978)
- Broken Nose: *Young Master* (1980), *Project A* (1983), *Miracles* (1989), *Mr. Nice Guy* (1997)
- Knocked out tooth: *Snake in the Eagle's Shadow* (1978)
- Dislocation of right shoulder: *City Hunter* (1993)
- Broken breastbone: *Armour of God II: Operation Condor* (1991)
- Broken finger bones: *The Protector* (1985)
- Skull fracture, bone cave-in behind left ear, and brain bleeding from falling out of a tree: *The Armour of God* (1986)
- Cheek bone dislocation: *Police Story 3: Super Cop* (1992)
- Cervical spine damage from falling from a 25-meter clock tower: *Project A* (1983)
- Spinal damage from falling from a pole: *Police Story* (1985)
- Pelvis dislocation almost causing partial paralysis: *Police Story* (1985)
- Tailbone damage causing temporary partial paralysis: *The Accidental Spy* (2001)
- Thigh injury from being caught between two cars: *Crime Story* (1993)
- Broken ankle: *Rumble in The Bronx* (1995), *Thunderbolt* (1996)

He's a latter-day Harold Lloyd. He has slid down the side of buildings, ridden in insane motorcycle chases, leapt through plate glass windows from a moving truck, jumped out of speeding cars, battled bad guys on stilts, and wrestled great white sharks, but had never achieved mainstream Hollywood success (except for a role in the Burt Reynolds comedy *The Cannonball Run*) until this film.

Rush Hour stars Jackie as Detective Inspector Lee, on the hunt for a missing Chinese Consul's daughter in Los Angeles. It's a culture clash of epic proportions as he's forced to team up with smart-ass Detective James Carter (Chris Tucker) in a film that gives Jackie a chance to show off his acrobatic skills, and Chris Tucker shows off his motor-mouth comedy skills. My favorite line: "Never touch a black man's radio."

The movie was a big hit, making $244 million worldwide, and the critics were supportive of the buddy-comedy movie. It spawned two sequels, which also made tons of money.

There are other great comedies from the 1990s that can be found elsewhere in this incredible publication. I'll put a few of them here in case you don't feel like reading anymore of this doorstop such as *Wayne's World* (1992), *Mrs. Doubtfire* (1993), *Groundhog Day* (1993), *Ace Ventura: Pet Detective* (1994), *Office Space* (1999), *Clueless* (1995), *Liar Liar* (1997), *Austin Powers: International Man of Mystery* (1997), *There's Something About Mary* (1999), *10 Things I Hate About You* (1999), and *American Pie* (1999). Go to the Index at the back and have some fun and find more!

However, there are a few comedies that haven't been featured in this book yet that are worth watching . . .

New Line Cinema/Photofest

The buddy comedy finally gets into the twentieth century when Chris Tucker and Jackie Chan (two guys that aren't white) starred in the 1998 action–comedy *Rush Hour*

The Top 5 Comedies of the 1990s That Haven't Been Written about in Other Pages of This Book

Tommy Boy (1995)

No comedy film book is complete without mentioning *Saturday Night Live* big guy star Chris Farley, who died way too young at the age of thirty-three, just like his idol John Belushi. This team-up with fellow SNL-er David Spade (they would also star together in the similarly-themed *Black Sheep*) starred Chris as Tommy Callahan, the well-meaning (but not-so-bright) son of wealthy auto factory owner Big Tom Callahan (Brian Dennehy) who attempts to save the factory from his new stepmother (the still vivacious Bo Derek) and her "son" Paul (Rob Lowe), who want to sell it for a lot of cash and will subsequently put a lot of people out of work and could cripple the town of Sandusky, Ohio. Big slapstick comedy with my favorite Chris Farley scene where he's singing, "Fat guy in a little coat."

My Cousin Vinny (1992)

It's the ultimate fish-out-of-water comedy, when Bill (Ralph Macchio) and his buddy Stan (Mitchell Whitfield) get arrested for murder in a small Southern town, and calls his cousin Vinny, who just graduated from law school (Joe Pesci) and his girlfriend Mona Lisa (Marisa Tomei in her Oscar-winning Best Supporting Actress role) to represent them in their trial. A bunch of hilarious verbal comedy scenes as Vinny tries to deal with Judge Haller (Fred Gwynne) and the small town population to save the guys' lives. The film was a big hit with the legal community, celebrating the notion that clients can always choose their own lawyers. Maybe not the smartest and most articulate legal representation, but it's definitely their own counsel.

Friday (1995)

It had been a long time since a good stoner comedy hit—um—was released—in movie theaters until Ice Cube (*Barber Shop*) and Chris Tucker (*Rush Hour*) lit up—uh, appeared on the silver screen in this hip-hop comedy that laid the groundwork for mainstream black comedies with broader audience appeal. The movie is one day in the lives of Craig and Smokey as they have until 10 p.m. to pay off $200 to their drug dealer. Big box office hit, making $27 million on a $3.5 million budget, spawned two sequels and an animated series. Yes, I just typed "animated series" and "*Friday*" in the same paragraph.

A League of their Own (1992)

Director Penny Marshall (*Big*) and actor extraordinaire Tom Hanks (*Big, Splash, Sleepless in Seattle*) re-teamed in this female sports comedy based on the true story of the All-American Girls Professional Baseball League that was started during World War II to save baseball since all of the male players were overseas. Two ultra-competitive sisters, Dot (Geena Davis) and Kit (Lori Petty), join the all-girl Rockford Peaches under the disgruntled leadership of former major leaguer Jimmy Dugan (Tom Hanks) with the famous line "There's no crying in baseball!", which is the #54 line on the AFI Great Film Quotes list. The film grossed $132 million at the box office and in 2012 was placed in the National Film Registry by the Library of Congress.

The Player (1992)

It had been awhile since director Robert Altman (*M*A*S*H*) hit a home run, but this satirical black comedy film about Hollywood brought him back to life. Tim Robbins (*Bull Durham*) plays Griffin Mill, a studio executive that mistakenly kills a screenwriter who he thinks is threatening him. The movie has one of the coolest opening scenes in motion picture history, mirroring Orson Welles's *Touch of Evil* three-minute single shot with a seven-minute opener of its own. *The Player* received three Oscar nominations, including Best Director for Robert Altman, Best Adapted Screenplay for Michael Tolkin, and Best Editing and won the Golden Globe for Best Picture–Comedy or Musical.

If you're still looking for some good 1990s comedy, here's the honorable mentions: *White Men Can't Jump* (1992), *Private Parts* (1997), *Bad Boys* (1995), *Chasing Amy* (1997), *Cool Runnings* (1993), *Tin Cup* (1996), *Multiplicity* (1996), *PCU* (1994), and perennial kid's favorite *The Sandlot* (1993).

> The Hollywood studios fondly look back on the 1990s as the last of the golden days. Soon the technology and audience appetites that had given them so many opportunities to make movies would change everything. Again.

CHAPTER 46

ARTIST SPOTLIGHT

Billy Crystal and Adam Sandler

CHAPTER FOCUS

► Who Is Billy Crystal?

► Who Is Adam Sandler?

Chapter Focus

Hard to believe, but *Saturday Night Live* was in danger of being cancelled after Lorne Michaels left the show to explore feature films. Producer Jean Doumanian took over the reins in 1981, and that season was a disaster. She was quickly replaced by Dick Ebersol, who sheparded the show until 1985, when Lorne Michaels agreed to return.

One of the smartest things that Ebersol did, which was unprecedented in the show's history, was hold off on bringing in new talent from The Second City, and instead he recruited already-established comedians Billy Crystal, Christopher Guest, and Martin Short to keep the season afloat in 1984 after Eddie Murphy left for feature film success. Guess what? It worked.

With *Saturday Night Live* back on its feet, the show became what it is today, the lifeblood of comedy entertainment in the United States. Comedy star upon comedy star has started their careers from obscurity and found their way on Lorne Michaels's show. In this chapter, we take a look at two of the most influential film comedians from the program in the 1990s.

Who Is Billy Crystal?

Born in 1948 in New York City, Billy was drawn to comedy at a very young age and attended Marshall University on a baseball scholarship, but ultimately left Marshall and moved back to New York City to attend NYU, where he graduated with a BFA in Film with an emphasis on film and television directing in 1970. One of his instructors was Martin Scorsese and he went to school with both Oliver Stone and Christopher Guest.

He started performing as a stand-up comic and became known for his impression of sportscaster Howard Cosell, which led to several TV appearances, including the first season of *Saturday Night Live*. From 1977–1981, he made broadcast history as the first openly gay character on TV playing Jody Dallas on the primetime comedy *Soap*.

Billy Crystal

©Helga Esteb/Shutterstock.com

After his own short-lived variety show, Billy ended up as a featured repertory player on *Saturday Night Live* for the 1984–1985 season. His most notable characters were Fernando Lamas who's catch-phrase was "You Look Mahvelous," Elderly Jewish news commentator Lew Goldman, Willie from Willie & Frankie with Christopher Guest when the two would compare injuries—"Don't ya hate it when . . .," and Las Vegas lounge singer Buddy Young, Jr. *Rolling Stone* magazine named Billy the #30 *Saturday Night Live* Cast Member of all time.

His feature film work started as the lead actor in 1978's *Rabbit Test* where he played the first pregnant man, then he had a memorable cameo as Morty the Mime in *This Is Spinal Tap* (1984). He's known for his classic line "Mime is money." He then played a smart-ass detective in 1986's *Running Scared* and then hit a remarkable run of films that have defined his career.

The Official Billy Crystal Top 3 Great Comedy Film Checklist

The Princess Bride (1987)

This is a pretty awesome movie, and even though Billy isn't the star of this, I still had to figure out a way to get it into this book. Rob Reiner (*When Harry Met Sally*) directs this delightful fairy tale about a grandfather (Peter Falk) telling his grandson (Fred Savage) a bedtime story.

Hold on to your hats for an exciting romance and swashbuckling adventure about young maiden Buttercup (Robin Wright), betrothed to the repulsive Prince Humperdink, but all she can think of is her true love, Westley (Cary Elwes), who was supposedly killed years ago.

When Buttercup is kidnapped before the wedding by criminal genius Vizzini (Wallace Shawn), the brutish Fezzik (Andre the Giant), and swordsman Inigo Montoya (Mandy Patinkin), she is rescued by the Dread Pirate Roberts, the most notorious rapscallion to sail the Seven Seas! But the pirate turns out to be—Westley, still alive! But then the Prince's guards appear and capture them both. The Prince has Westley killed so that he can have Buttercup all to himself.

And that's where Billy Crystal comes in as Magic Max, and his wife, Valerie (Carol Kane), help to revive Westley and together he and the outlaws go to recue Buttercup. Will they succeed? Do fairy tales REALLY have happy endings?

The Princess Bride was a modest box office success and a critical favorite, and since its release it's grown to be a beloved classic. Total Film named it the 38th greatest comedy film of all time and the AFI named it the #88 film on their Great Romance Films list.

When Harry Met Sally (1989)

It's the romantic comedy to top all romantic comedies in this film that put Billy Crystal on the map as a bona fide movie star. Check out Chapter 40 to read about the movie built entirely on Harry Burns (Billy Crystal)'s philosophy to Sally Albright (Meg Ryan) "Men and women can't be friends because the sex part always gets in the way." Does it?

City Slickers (1991)

Good Western comedies are hard to do (the dubious *A Million Ways to Die in the West*) but when they are done well (hello *Blazing Saddles*!) then they are a solid piece of American entertainment. *City Slickers* is the classic fish out of water tale of three well-to-do New Yorkers—Mitch (Billy Crystal), Phil (Daniel Stern), and Ed (Bruno Kirby)—that escape their individual mid-life crises by flying to a Dude Ranch in New Mexico.

Billy Crystal

©s_bukley/Shutterstock.com

The big draw to the ranch is participating in a real cattle drive to Colorado.

Under the supervision of gruff Curly Washburn (Jack Palance), the three men learn the ropes (so to speak) of how to be cowboys. Along the way, Mitch and Curly bond when Mitch accidentally starts a stampede, and when Mitch and Curly help a cow give birth to a new calf, before Curly has to put it out of its misery. Mitch names the calf Norman and adopts him.

Robin Williams, Whoopi Goldberg, and Billy Crystal

When Curly takes ill in a permanent way, the group is torn. Abandoned by all of the ranch's cowboys, the three must work together. Can they get rid of their city slicker ways to finish the cattle drive?

City Slickers was a monster hit at the box office, making $179 MILLION from a budget of $26 million. Jack Palance won both the Oscar and the Golden Globe for Best Supporting Actor, Billy was nominated for a Best Actor Golden Globe, and the film was nominated for Best Picture–Musical or Comedy. Billy also won an MTV Movie Award for Best Comedic Performance. The AFI named *City Slickers* the #86 movie on the Great Comedy Films list.

Billy Crystal has made some incredibly hilarious movies, such as *Throw Momma from the Train* (1987), *Analyze This* (1999) with Robert DeNiro, and the voice of Mike Wazowski in Pixar's *Monsters Inc.* (2001) and *Monsters University* (2013). My kids, Luke and Lindsay, are huge fans of *Parental Guidance* (2012) because Billy gets hit in the crotch with a baseball bat.

Billy Crystal wins an Emmy for hosting the Oscars

Billy also started Comic Relief USA with comedians Robin Williams and Whoopi Goldberg, which raised over $50 million for the homeless in America. He's hosted the Grammy Awards three times and the Academy Awards a staggering NINE times. And he's still funnier than Anne Hathaway and James Franco on his worst day.

He's received three Golden Globe nominations, eighteen Emmy Award nominations and won five of them. He's won six American Comedy Awards, four cable ACE Awards, and won the AFI Star Award at the U.S. Comedy Arts Festival. In 1991, he received a star on the Hollywood Walk of Fame.

Who Is Adam Sandler?

Born in Brooklyn in 1966 and raised in Manchester, New Hampshire, Adam was the penultimate class clown in high school. He tried stand-up comedy in Boston when he was seventeen and continued to perform while attending NYU. He snagged a supporting role as "Smitty" on four episodes of TV's *The Cosby Show* from 1987–1988 while a freshman.

Adam Sandler

©Tinseltown/Shutterstock.com

After graduating in 1988, he starred in the forgettable low-budget comedy *Going Overboard,* appeared on the MTV game show *Remote Control,* and did stand-up comedy in Boston and then moved to Los Angeles to work at the famed Improv Club. *Saturday Night Live* cast member Dennis Miller saw Adam onstage and recommended him to Lorne Michaels.

In 1990 he was hired as a writer at SNL and was able to appear on the show to perform his holiday songs "The Thanksgiving Song," and most memorably, "The Chanukah Song." He became a featured player in 1991 with small roles such as Cajun Man and Opera Man during "Weekend Update."

Over the next four years, Adam impersonated Axl Rose, Bruce Springsteen, Tina Turner, and Bono. He performed such characters as Canteen Boy, one of the Gap Girls, and the Herlihy Boy and for some unknown reason, he and Chris Farley were both fired in 1995. In an interview with Marlow Stern from *The Daily Beast* published on September 12, 2014, Sandler recounts the circumstances of his dismissal:

> "Yes, we were [fired]," says Sandler. "We *kind of* quit at the same time as being fired. It was the end of the run for us. The fact that me and him got fired? Who knows. We were on it for a few years, had our run, and everything happens for a reason. We kind of understood because we did our thing. It hurt a lot at the time because we were young and didn't know where we were going, but it all worked out."

Adam is ranked the #17 Performer of All Time on the Rolling Stone rankings list and he would get his revenge on Lorne Michaels by becoming one of the most popular (and profitable) comedy stars for the next twenty years.

He permanently moved into feature films. He had acted while on the show in the box office bomb *The Coneheads* in 1993 and co-starred with Brendan Fraser and Steve Buscemi in

Airheads about a band that holds a radio station DJ hostage so he will play their music. His next film would start him on the path to starring in his own films, and he also co-wrote the screenplay.

In 1995's *Billy Madison*, Adam plays the title character, a twenty-seven-year-old son of a rich CEO who wants to take over the family hotel business, but his dad, Brian Madison (Darren McGavin), tells him that if he wasn't smart enough to get through school then how can he be the CEO? His dad reveals that Billy would have flunked out of every grade if he hadn't bribed Billy's teachers. Billy offers to prove himself by going back to school, starting in first grade, and work his way up to getting his high school degree by taking class and passing the final every two weeks. Brian agrees if Billy can do that, he will get the company.

Along the way, Billy meets third grade teacher Veronica Vaughn (Bridgette Wilson) who he falls for, but Billy's rival, sneaky VP Eric Gordon (Bradley Whitford), sabotages Billy's chances by blackmailing the school principal into telling Brian that he was bribed to pass Billy in his classes. Billy's dad cancels his agreement with Billy.

Will Billy finish his schooling and win back his dad's company? Will Billy and Veronica get together? Will Eric eventually get his comeuppance?

Billy Madison made a small return at the box office and the critics were unkind. But Adam was nominated for an MTV Movie Award for Best Comedic Performance.

His next film fared worse, the 1996 critical and box office bomb *Bulletproof*, with Damon Wayans, an action comedy that failed to get any momentum. Somehow, Adam was able to make another film, and this would be the movie that would make him a huge comedy star . . .

The Official Adam Sandler Top 3 Great Comedy Film Checklist

Happy Gilmore (1996)

Everyone likes a good sports comedy, and this is one of the best for its sheer ridiculousness. Happy Gilmore (Adam Sandler) is an aspiring hockey player with a wicked slapshot and a hot temper that keeps him from making a team. When he finds out that his grandmother (Frances Bay) needs $270,000 or she will lose her house, Happy discovers he has a knack for hitting golf balls and is encouraged by former golf pro Chubbs Peterson (Carl Weathers) to play in an upcoming tournament. Thanks to his unorthodox style, Happy wins the event (even though his putting is terrible) and though Chubbs said he needs more training, Happy can't leave his grandmother in the awful rest home where a sadistic supervisor (an uncredited Ben Stiller) forces the residents into making clothes in a sweat shop ("Good news, everybody, we're extending arts and crafts time for four hours today.")

Happy joins the tour and does well, but draws the ire of the Golf Commissioner Thompson (Director Dennis Dugan) and star player Shooter McGavin (Christopher McDonald) who say he's bad for the game. Luckily for Happy, Marketing VP Virginia Venit (Julie Bowen) convinces them to keep Happy on the tour, citing the higher ratings and attendance because of Happy.

Bob Barker and Happy Gilmore have a disagreement

Things come to a head when Happy is paired with *The Price Is Right* host Bob Barker (playing himself) at a pro-am, and when a heckler distracts Happy, he ends up losing the match. Bob and Happy get into a brawl ("The Price is *wrong*, bitch!") and Happy is kicked off the tour.

What happens when Happy finds out that Shooter hired the heckler? Will Chubbs help Happy get back his form and learn to putt? Is there a possible romance in the air for Happy and Veronica? Can Happy save his grandmother and her house?

The film had a decent return, making $41 million on a $12 million budget, and Adam and Bob Barker won the very first MTV Movie Award for "Best Fight."

The Wedding Singer (1998)

Written by Adam's co-writer on *Happy Gilmore*, Tim Herlihy (who Adam played as a character on *Saturday Night Live*) crafts a gem of a romantic comedy starring Adam as Robbie Hart, a winning entertainer for wedding receptions. He's left at the altar himself by his fiancée, Linda, who is disappointed that he never went back to being a rock singer.

When Robbie meets Julia (Drew Barrymore), she asks him to help her plan her upcoming wedding. There seems to be a spark between them. But Robbie's torn, he's falling for Julia and privately wishes that her fiancé, Glenn, would drop out of the picture, especially after he discovers that Glenn doesn't love her anymore and will continue to have affairs even after they are married. After talking to a friend who convinces him to tell Julia how he feels, he goes to her house and sees her trying on her wedding dress and walks away. He has no idea that she has doubts about Glenn, and could see herself with Robbie.

What happens when Robbie finds out that Julia and Glenn are eloping? Will Robbie and Julia get together? How does rocker Billy Idol fit into all this?

The Wedding Singer was exactly what Adam needed. Positive reviews from critics and the movie made $123 million worldwide. The movie's soundtrack is pretty killer too, with a ton of music from the 1980s that Robbie and his band covers.

The Waterboy (1998)

Bobby Boucher (Adam Sandler) is a mentally incompetent backwoods Cajun with a fixation on water. (He talks in a combination of Cabin Boy and Cajun Man from his *Saturday Night Live* days.) His father died from dehydration and Bobby's goal in life is to keep the football players from the University of Louisiana as hydrated as he can. When head coach Red Bealieu (Jerry Reed) fires him, he goes to small South Central Louisiana State University's Coach Klein (Henry Winkler) and offers to help the tattered football program and their current forty-game losing streak.

Bobby's mother, Helen "Mama" Boucher (Kathy Bates), is fine with him being the waterboy, as long as he doesn't play football. At SCLSU's practice, the players harass Bobby and Coach Klein encourages him to fight back. He viciously tackles the quarterback and Coach Klein wants him to be the new linebacker. But when the coach goes to see Mama, she refuses. Coach Klein convinces Bobby to give football a chance and holds out the opportunity for Bobby to go to school. He says yes and ends up becoming the most feared linebacker in college football. "You can do It!" says one excited fan (Rob Schneider) in a running gag through the film.

What will happen when Mama finds out that Bobby is playing "fools ball"? Will Coach Klein overcome his anxiety against his rival and start coming up with some new plays? What about when Bobby's former girlfriend, Vicki (Fairuza Balk), shows up interested in being with Bobby again? What about the rumor that Bobby didn't graduate from high school?

The Waterboy was a huge disappointment with critics, but another huge financial success for Adam. The movie made $186 million worldwide on a budget of $23 million.

His films are mostly slapstick and some are hits-and-misses. He's had some good comedies since that remarkable three-picture run between 1996 through 1998. With over fifty-nine film and television programs, quality films like *Big Daddy* (1999), *Punch-Drunk Love* (2002), *Anger Management* (2003), *50 First Dates* (2004), *Click* (2006), and *I Now Pronounce You Chuck & Larry* (2007), have continued to keep him in the public eye.

He's been nominated for a Best Actor Golden Globe for the Paul Thomas Anderson dramedy *Punch-Drunk Love* (2002) and gotten seventeen MTV Movie Awards nominations with wins for Best Fight with Bob Barker in *Happy Gilmore*, won Best Kiss with Drew Barrymore in *The Wedding Singer*, won Best Comedic Performance for *The Waterboy* and *Big Daddy* (1999), and won Best On-Screen Team with Drew Barrymore for *50 First Dates* (2004).

The Cast of *Grown-Ups* (2010)

His production company "Happy Madison Productions," has been making films since 1999, starting with the gross-out comedy *Deuce Bigalow: Male Gigolo*. The company has produced more than forty-nine film and television projects for his fellow comedians Rob Schneider (*Deuce Bigalow 1 & 2*), David Spade (*Joe Dirt, The Benchwarmers*), and Kevin James (*Paul Blart: Mall Cop 1 & 2*), and television program *Rules of Engagement*.

He's had a remarkable run of films grossing over $100,000,000 at the box office, of fifteen movies, including his two *Hotel Transylvania* films that have grossed a combined $318 MILLION at the box office.

In 2014, Adam signed a four-year exclusive deal with Netflix to produce and star in a number of comedies. The first film from the deal was 2015's *The Ridiculous 6*. It was the most-watched film on Netflix for its first month of availability, and the critics hated it. But Adam Sandler is critic-proof.

His films *Big Daddy* (1999), *Grown-Ups* (2010), *The Waterboy*, and the remake of *The Longest Yard* that had starred Burt Reynolds, all made over $150 million. Though his films haven't done well with critics, you don't need to worry if you're Adam Sandler when you have a dedicated audience of slapstick comedy fans that will come and see your next film, regardless of what the reviewers say.

Adam Sandler

CHAPTER 47

ARTIST SPOTLIGHT

Jim Carrey, Ben Stiller, and Will Ferrell

CHAPTER FOCUS
- ▶ Who Is Jim Carrey?
- ▶ Who Is Ben Stiller?
- ▶ Who Is Will Ferrell?

Chapter Focus

Since 1994, three performer-based actors have set the bar for comedy excellence and between them have made over 150 film and television programs.

These talented comedians all started doing sketch comedy on network television, and their TV success opened up the door for them to enter the world of features films.

All three would not only create some of the funniest films of the end of the twentieth century, but they also would have the opportunity to make films outside of the comedy world.

Who Is Jim Carrey?

This rubber-faced King of Slapstick puts himself entirely into his roles, with often-hilarious results. Born in Ontario, Canada, in 1962, Jim gravitated toward comedy doing impressions at a young age. He started doing stand-up comedy as a teenager in Toronto, and was discovered by comedian Rodney Dangerfield (*Caddyshack*), which led to Jim moving to Hollywood. He was performing nightly at The Comedy Store and booked his first appearance on *The Tonight Show* when he was only twenty-one years old.

It took seven years to get a regular high-profile gig, but Jim was cast on Fox-TV's sketch-comedy show *In Living Color* for director Keenan Ivory-Wayans (*I'm Gonna Get You Sucka!*, *Scary Movie*) where he played a variety of characters, including Vanilla Ice, Captain Kirk, and overly-enthusiastic Fire Marshall Bill ("Let Me Show You Somethin!") over four years.

Jim Carrey

©Tinseltown/Shutterstock.com

After leaving *In Living Color,* Jim hit the big screen, and he's never looked back.

In 1994, Jim starred in *Ace Ventura: Pet Detective*, playing a goofy private eye specializing in finding lost pets. His gift? Like a gifted criminologist profiler, he has the ability to get inside a missing animal's head to find out where they are. He finds himself confronted with his biggest case to date—finding the missing mascot of the Miami Dolphins.

Even though the critics hated it, it didn't matter. It's over-the-top and ridiculous, two characteristics of movies that Jim Carrey would adopt for his brand of physical comedy. That same year, Jim starred in *Dumb and Dumber* for the Farrelly Brothers and cemented his status as the comedy star of the 1990s.

The Official Jim Carrey Top 3 Great Comedy Film Checklist

The Mask (1995)

There is no performer in the history of film comedy that had a year like Jim Carrey did in 1995. He starred in three films, the aforementioned *Ace Venture: Pet Detective*, *Dumb and Dumber*, and in-between was this superhero slapstick farce film that affirmed what everyone

who had seen him perform on *In Living Color* and his starring-turn as Ace Ventura knew already, that Jim Carrey was a star.

Based on a graphic novel, Jim stars as Stanley Ipkiss, a mild-mannered bank clerk who's shy around the ladies, finds an ancient mask that channels the spirit of the Norse trickster God Loki. When Stanley puts it on, he's transformed into a green-faced, zoot suit-wearing crazy reflection of himself: a wild ladies' man with a penchant for craziness and the ability to do anything—he's a living cartoon. He meets nightclub singer Tina (Cameron Diaz in her feature film debut) and his insane alter ego gets in trouble with her mob boss, especially when The Mask foils one of the boss' robberies.

Jim scored his first Golden Globe nomination for *The Mask*, the film grossed over $350 million worldwide, and combined with Jim's other two films, his 1994 films totaled over $800 million worldwide.

Liar Liar (1997)

After playing The Riddler in the tepid *Batman Forever* with Val Kilmer, falling flat in Ben Stiller's satirical dark comedy *The Cable Guy* with Matthew Broderick, and reprising his role in the box office hit *Ace Ventura 2: When Nature Calls*, Jim found himself in a movie that is the standard-bearer for the quintessential "Jim Carrey movie."

Reuniting with his *Ace Ventura: Pet Detective* director Tom Shadyac, Jim plays attorney Fletcher Reede, a lawyer with a penchant for exaggeration. He's a well-meaning divorced dad who makes up excuses for missing out on time with his son Max (Dominc Cooper). His ex-wife Audrey (Maura Tierney) is sick of it. So is Max, who makes a birthday wish for his dad to stop lying. And like all good wishes, it comes true. What follows is a comedic tour-de-force as Fletcher tries to survive his inability to do anything dishonest, and worse—he has no filter and must always tell the truth. *Liar Liar* was a big hit with the critics and with the audience, making $302 million worldwide and Jim was nominated a second time for a Golden Globe for Best Actor in a Musical or Comedy.

The Truman Show (1998)

In the late 1990s, "reality TV" wasn't in the public vernacular. Documentaries and MTV's *The Real World* were the closest thing to the phenomenon that "reality TV" would become a way of life. With iPhones and YouTube and the search for cheap television programming to fill hundreds of cable channels, reality television has become life.

So when director Peter Weir (*Witness, Dead Poet's Society*) released *The Truman Show*, it was a satirical revelation that fifteen years later is eerily prescient. Truman Burbank (Jim Carrey) is a good-natured regular guy with a beautiful wife, a great job, and lives in a wonderful neighborhood. But the whole thing is a lie. He's the unwilling star of Producer/Director Christof's (Ed Harris) "The Truman Show," a twenty-four-hour cable television show documenting and broadcasting every moment of his life from birth for the entire world to see. His wife Hannah (Laura Linney) and all of his friends and family are actors, and the town is a giant set. Things get upended when a worldwide movement to release Truman from the show starts to pick up steam and Truman suspects that all isn't as it seems to be.

The Truman Show was a monster hit with both critics and the audience, making $264 million worldwide. It was nominated for six Golden Globes and won three—Jim Carrey for Best Actor in a Drama, Ed Harris for Best Supporting Actor, and Best Score for Philip Glass and Burkhard Dallwitz. The movie was nominated for three Oscars including Best Director for Peter Wier, Best Supporting Actor for Ed Harris, and Best Original Screenplay for Andrew Niccol.

Jim Carrey won the Golden Globe for Best Actor for both *The Truman Show* (1998) and *Man on the Moon* (1999)

The Truman Show gave Jim Carrey the ability to move seamlessly between comedy and drama. He played the late iconic comedian Andy Kaufman in *Man on the Moon* (1999) and won another Golden Globe for Best Actor. He reteamed with the Farrelly Brothers on *Me, Myself and Irene* (2000) and also *Dumb and Dumber To* (2015). He starred as *The Grinch Who Stole Christmas* (2000) and was nominated for a Best Actor Golden Globe as a TV reporter who gets God's powers in *Bruce Almighty* (2003). The surreal love story *Eternal Sunshine of the Spotless Mind* (2004) earned Jim another Golden Globe Best Actor nomination (and the movie won Best Original Screenplay at the Oscars that year), and dozens of other comedic and dramatic films.

When you're Jim Carrey, you can pretty much do anything you want, and if it's a comedy, you know you're in for a whole lot of laughs.

Who Is Ben Stiller?

Born in 1965 to comedians Jerry Stiller and Anne Meara, Ben grew up in a showbiz family and started making movies in elementary school. He appeared onstage and on his mother's TV show, and when he graduated from high school, he attended UCLA for a year and then left for New York City to make it as an actor.

After acting on Broadway, he started making his own short films, eventually leading to his own sketch comedy show in 1992, *The Ben Stiller Show*, co-executive produced by Judd Apatow. Though the show won the Emmy for Outstanding Writing in a Variety or Music Program, it was canceled after thirteen episodes.

Ben directed his first feature, the Generation X romantic comedy *Reality Bites* (1994), in which he also stars with Winona Ryder and Ethan Hawke as three college graduates that face an uncertain future under the watchful gaze of Ryder's documentary camera. The film did well enough at the box office

Ben Stiller

©s_bukley/Shutterstock.com

to give Ben a couple of independent feature films to star in and an opportunity to make the 1996 black comedy *The Cable Guy* with Jim Carrey (*Ace Ventura: Pet Detective*) and Matthew Broderick (*Ferris Beuller's Day Off*). That movie is famous for paying Jim Carrey a 20 million dollar salary, but critics hated it and the box office was mediocre. He wouldn't get to direct another feature until five years later.

After his starring role as Ted in the 1998 breakthrough comedy *There's Something About Mary* [Editor's Note: Chapter 48.], he starred in several films including dramas *Your Friends & Neighbors* (1998) and *Permanent Midnight*, along with comedies *Mystery Men* (1999) and *Keeping the Faith* (2000). Then he hit his stride—

The Official Ben Stiller Top 3 Great Comedy Film Checklist

Meet the Parents (2000)

Director Jay Roach (*Austin Powers: International Man of Mystery*) helms this romantic comedy following the story of Greg Focker (Ben Stiller), a male nurse who is forced to meet the parents (hence the title) of his intended fiancé, Pam (Teri Polo) at her sister's wedding. Things don't go well when Greg makes a terrible impression on Pam's father Jack (actor extraordinaire Robert De Niro), a retired CIA agent who takes an immediate dislike to him. From Greg's Jewish heritage to Jack's suspicion that Greg is on drugs, it gets worse as Greg tries way too hard to impress Jack. The best scene is when Jack gives Greg a lie detector test to gauge his true intentions.

Ben Stiller won the MTV Movie Award for Best Comedic Performance for *Meet the Parents* (2000)

The pairing of Ben Stiller and Robert De Niro proved to be worth its weight in box office gold as *Meet the Parents* grossed over $330 million worldwide. Robert De Niro also was nominated for a Golden Globe for Best Actor and Ben Stiller won the MTV Movie Award for Best Comedic Performance and Funniest Actor in a Motion Picture at the American Comedy Awards. The film also spawned two sequels: *Meet the Fockers* (2004) and *Little Fockers* (2010). Collectively the three films have earned over $1.2 billion!

Zoolander (2001)

Based on the performance of *Meet the Parents*, Ben had the opportunity to direct his third feature film, a spoof based on a male model character he created for the VH1 Fashion Awards. Derek Zoolander (Ben Stiller) is the clueless three-time Male Model of the Year famous for his signature look "Blue Steel." But when a new model, Hansel (Owen Wilson) usurps Derek's

Male Model of the Year status, Derek quits the business to try and reconnect with his family, but ultimately becomes the pawn of a worldwide assassination plot engineered by ruthless fashion designer Jacobim Mugatu (Will Ferrell) to brainwash Derek into murdering the Prime Minister of Malaysia, who is trying to shut down Mugatu's child sweat factories.

The film was a modest hit with critics and it earned roughly twice it's budget back at the box office. Since then, the character of Derek Zoolander has gone on to achieve cult-like status. Fifteen years later, Stiller returned to direct the sequel *Zoolander 2*, released in 2016 with Stiller, Owen Wilson, and Will Ferrell returning. The movie ended up getting poor reviews and didn't do well at the box office. But don't let that dissuade you from watching a truly hilarious character and his ridiculous world of the original film.

Tropic Thunder (2008)

It's not often that a comedy film comes along that is so original it blows your mind, but *Tropic Thunder* is one of those movies. It's the most successful film about making movies in the history of cinema, making $188 million and was a triumph for Ben Stiller as director and co-writer.

This Hollywood satire tells the story of egotistical action film star Tugg Speedman (Ben Stiller), who's career is floundering after his misfire as the mentally challenged dramatic title role of "Simple Jack" and his next movie has to be a home run. He's teamed with Australian Oscar-winning method actor Kirk Lazarus (Robert Downey Jr.) who had gone through a controversial skin coloring procedure to play a black soldier, comedian Jeff Portnoy (Jack Black) star of the *Fatties Fart* comedy franchise, rapper Alpa Chino (Brandon T. Jackson) and fresh young actor Kevin Sandusky (Jay Baruchel) in a true-life story about a rescue team in Vietnam.

Ben at the premiere of *Tropic Thunder*

The film is over-budget, the director Damien Cockburn (Steve Coogan) is clearly over his head with his prima donna actors, so studio executive Les Grossman (a nearly unrecognizable Tom Cruise in a fat suit and bald cap) convinces Damien to shoot the film guerilla style, and that's when the actors get separated from the film crew and end up in the middle of a drug war. It's the new millennium's *Three Amigos* as the actors must work together as a team

to save Tugg after he's kidnapped since the drug lords apparently LOVED *Simple Jack*.

The critics universally raved about the film, and Robert Downey Jr. was nominated for a Best Supporting Actor Academy Award, eventually losing to the posthumous honor for Heath Ledger as The Joker in *The Dark Knight*. Both Downey Jr. and Tom Cruise were nominated for Supporting Actor Golden Globe Awards and Ben Stiller won the Hollywood Film Award for Comedy of the Year.

Dustin Hoffman, Robert De Niro, Jessica Alba, and Ben Stiller in *Little Fockers* (2010)

Even better, there is a mockumentary parody of *Hearts of Darkness: A Filmmakers Apocalypse*, which is the behind-the-scenes look at the making of Francis Ford Coppola's *Apocalypse Now*. Entitled *Rain of Madness*, it follows the making of *Tropic Thunder*, which is technically the making of *Tropic Thunder*, so it's a parody movie-within-a-satire-movie-within-an-action movie.

Ben Stiller has also done a ton of other films, from his acting in the *Night at the Museum* trilogy (2006, 2009, 2014) that have collectively grossed over $1.3 billion, to his voice-over work in the animated *Madagascar* trilogy (2005, 2008, 2012) which has grossed nearly $2 billion worldwide. Some of his comedy highlights are the sports parody *Dodgeball: A True Underdog Story* (2004), the remake of *The Heartbreak Kid* (2007), *Tower Heist* (2011), and his latest directorial effort, the remake of *The Secret Life of Walter Mitty* (2013).

It's rumored that Ben may not act again, but focus exclusively on directing. If that's the case, it will be a shame—his work for over twenty years has been solid and he's made some great films that have truly entertained the world.

Ben Stiller makes his handprints at the Chinese Theatre in Hollywood

Who Is Will Ferrell?

Born in 1967 in Irvine, California, Will was a class clown and an athlete in high school, and went to the University of Southern California to study sports journalism. His mother encouraged him to try comedy professionally and he joined the Los Angeles improv group The Groundlings in 1991.

Will Ferrell

©Joe Seer/Shutterstock.com

While at The Groundlings, he began doing impersonations (his big one was Harry Caray the Chicago Cubs broadcaster) and worked his way up to the main stage as a feature performer in 1994. He was encouraged to submit an audition to Lorne Michaels for *Saturday Night Live*, and joined the show in 1995.

He was on SNL until 2002, and became one of the breakout stars of the show. His impersonation characters included his old reliable Harry Caray, President George W. Bush, legendary singers Neil Diamond and Robert Goulet, and as Alex Trebek on the infamous *Jeopardy* sketches with Darrell Hammond's perverted Sean Connery.

His stable of original characters included Steve from *A Night at the Roxbury* (which would be turned into a poorly performing feature film), music teacher Marty Culp, Spartan cheerleader Craig, and his notable turn as Blue Oyster Cult Gene Frenkle in the infamous "Cow Bell" with Christopher Walken is the stuff of legend.

During his time on SNL, he also had the opportunity to play characters in a number of roles, including Mustafa in 1997's *Austin Powers: International Man of Mystery* ("I'm very badly burned down here."), 1998's *A Night at the Roxbury*, 1999's *Superstar*, 2000's *The Ladies Man*, and evil fashion designer Mugatu in Ben Stiller's 2001 comedy *Zoolander*. Will was nominated for two writing Emmys and an Individual Performance Emmy for his work on *Saturday Night Live* in 2001. He is the #12 Cast Member in the *Rolling Stone* magazine ranking of the Best SNL Cast Members of All Time.

After leaving *Saturday Night Live*, he struck out on his own, and he became the biggest comedy star in the 2000s and 2010s. He was the standout in 2003's *Old School*. Will plays "Frank the Tank" Ricard, a reformed party animal that has put his crazy days behind him when he gets married. His buddies Mitch (Luke Wilson) and Beanie (Vince Vaughn) long for the good old days before Beanie had kids and as Mitch recovers from learning that his now-ex-girlfriend Heidi (Juliette Lewis) is a slut that sexes it up in wild orgies.

Beanie takes the opportunity to help Mitch recover by throwing a huge party at his house, and it's a big success—even though Frank gets so wasted that he streaks through town and his furious wife catches him. In the aftermath of the party, Dean Pritchard (Jeremy Piven) tells Mitch he needs to leave since the house is now zoned for college use only. That's when the guys get the idea to start a fraternity to keep the house and infuriate the Dean, who hated the guys back in college.

They recruit students who have been rejected by other fraternities and after hazing them, throw another huge party that ends in tragedy as Blue (Patrick Cranshaw), their oldest fraternity member in his 70s has a heart attack during a "lube fight" between two hot chicks. Frank's wife kicks him out and he moves into the frat house. This party is the last straw, and Dean Pritchard sets his sights on ending the fraternity.

Will Dean Pritchard succeed? Will Mitch find true love with his old girlfriend, Nicole? Will Frank get back with wife? Will Beanie's kids learn how to wear those earmuffs?

Old School was a huge hit with the audiences, making $87 million worldwide at the box office on a budget of $24 million. Will was nominated for an MTV Movie Award for Best Comedic Performance and he, Luke Wilson, and Vince Vaughn were nominated for Best On-Screen Team.

The Official Will Ferrell Top 3 Great Comedy Film Checklist

Elf (2003)

In what has become a Christmas standard for many families, Will Ferrell plays Buddy the Elf, a human who was found abandoned by Santa Claus (Ed Asner) and brought to the North Pole to be raised as one of his own by Papa Elf (Bob Newhart). It's a double fish out of water story as Buddy tries to adapt to life in the world of the tiny elves, but has no luck with making toys or fixing the sleigh.

Papa Elf finally tells Buddy that he's not an elf and who his father is, Walter Hobbs (James Caan), a grumpy book editor that no idea Buddy existed. He puts on his best elf outfit and travels to New York City to meet his dad.

The world of the big human city is unlike anything Buddy has ever seen, and he eventually finds himself at Gimbel's department store after Walter kicks him out of his office. Buddy meets Jovie (Zooey Deschanel) and then spends the night decorating the Santa's Village section for the arrival of Santa Claus the next morning.

When Santa arrives, Buddy knows he's not the real Santa and calls him out in front of the shocked parents and kids, "You sit on a throne of lies!" and they get into a brawl that results

in Buddy getting arrested. With nowhere else to turn, Buddy turns to Walter, who bails him out and takes him to his home to meet his wife, Emily (Mary Steenburgen), and his son, Michael (Daniel Tay). After helping Michael defeat some neighborhood bullies in an epic snowball fight, his new brother encourages him to ask Jovie out on a date. Buddy does, and falls for her.

Everything's great until Buddy stops in Walter's office and meets children's author Miles Finch (Peter Dinklage) a little person that Walter hopes will save the day for the ailing company. Buddy mistakes Miles for a fellow elf, and Miles thinks he's being insulted and attacks Buddy. Walter orders Buddy out and says he's no longer his father and to go back to the North Pole.

Will Buddy reunite with his father? What will happen to Buddy and Jovie? What happens when Santa Claus comes to town on Christmas Eve and crashes in Central Park?

Elf was a huge movie, the biggest film of Will Ferrell's career. The movie grossed an incredible $220 MILLION worldwide on a $33 million budget. The critics enjoyed the film and *Empire* magazine named it as their #2 Christmas movie ever, Total Film named it their #3 Christmas movie, and the Hollywood Reporter named it the #6 Christmas movie of all time. The movie launched a Broadway musical in 2010.

The movie gave Will the opportunity to make more family films, including *Kicking and Screaming* (2005), *Curious George* (2006), *Land of the Lost* (2009), *Megamind* (2010), *The Lego Movie* (2014), and *Daddy's Home* (2015).

His next big film is *Anchorman: The Legend of Ron Burgundy* (2004)—but that gets its own Super Great Movie Spotlight in Chapter 50, so check it out there!

The success of *Anchorman* paved the way for a series of Will Ferrell starring films with bizarre characters such as Franz Liebkind in the remake of the Broadway musical of *The Producers* (2005), Ricky Bobby in *Talladega Nights: The Ballad of Ricky Bobby* (2006), Chazz Michael Michaels in *Blades of Glory* (2007), Armando in *Casa de mi Padre* (2012), and his reprisal of Ron Burgundy in *Anchorman 2: The Legend Continues* (2013).

Step Brothers (2008)

In a screenplay written by Will Ferrell and director Adam McKay, Will returned to his gross-out comedy roots as Brennan Huff, your typical forty-year-old arrested development slacker who still lives at home. One day, Brennan's mom, Nancy (Mary Steenburgen from Elf), tells him that she's met Robert (Richard Jenkins) and they are getting married. To make matters worse, her new husband has a son, Dale (John C. Reilly, who starred with Will in *Talladega Nights*), who is just like Brennan, a no prospects loser living at home.

When Dale moves into Brennan's home, they immediately clash. Brennan has one rule—DO NOT TOUCH HIS DRUM SET. Of course, Dale does the mature thing and respects his new stepbrother's wishes. Not quite—Dale whips out his genitals and proceeds to rub them all over, including the drumsticks. Now that's gross-out comedy.

Will Ferrell and John C. Riley

But Dale and Brennan eventually come to a mutual understanding—based on their hatred for Dale's younger brother, Derek (Adam Scott), who mocks both of them for their epic failures in life. In retaliation, Dale punches him and Brennan has newfound respect for him.

Robert wants both Brennan and Dale to go out and make something of themselves, so he forces them to go on job interviews, which all end badly. When their parents decide to retire, sell the house, and sail around the world on Robert's prized yacht, the boys have to scramble. They start an entertainment company and accidentally break Robert's boat in the process. Robert spanks Brennan and Nancy decides to leave him. The stepbrothers are devastated for causing their parents to divorce.

Will Brennan and Dale get their act together or do they go their separate ways? Can they bring Nancy and Robert back together? Will Derek eat his words? Can the stepbrothers turn this into a happy ending?

Step Brothers made $128 MILLION, but it had a budget of $65 million, which makes it a modest return. The critics were not fans, but it continues to prove Will's drawing power at the box office.

The Other Guys (2010)

Will crossed over into the mainstream world of straight comedy films by becoming the klutzy straight man in the next phase of his career, and this is the film that gave him that opportunity in this send-up of buddy action films.

When the NYPD's most respected police officers, Chris Danson (Dwayne Johnson and Samuel L. Jackson is a great take on the *Lethal Weapon* franchise) are killed on the job,

someone needs to take their place. Detective Terry Holtz (Mark Wahlberg)—a disgrace to the uniform after he inadvertently shot New York Yankee Derek Jeter in Game 7 of the World Series and the Yankees lost—has been stuck on desk duty ever since.

He's reluctantly teamed up with mild-mannered forensic accountant Allen Gamble (Will Ferrell) and assigned the worst case possible by their apprehensive TLC-quoting Captain Mauch (a terrific Michael Keaton) to investigate a scaffolding accident, but along the way Allen discovers that the accident is the tip of the iceberg in a high-stakes rivalry between two powerful CEOs and millions of dollars at stake. It's the kind of case that could make their careers.

Allen's only problem is that he has a dark side (he ran a dating service in college which he claims was not an escort service), which comes back to haunt him with all the stress from the new case. His antics cause his beautiful wife Sheila (played by Eva Mendes, and in a great running gag, Terry is incredulous how a schmuck like Allen could ever land a hottie like her) to kick him out of their apartment.

Can Allen get back with his wife? Can Terry and Allen solve the case? Can they blow more things? Shoot a lot of bad guys? And still learn to bond as partners?

The Other Guys brought in $170 million worldwide on a budget of $100 million, which is still a pretty sizable profit. The film is non-stop hilarity and the critics responded favorably. The movie was nominated for three Comedy Awards, Best Actor for Will Ferrell, Best Director for Adam McKay, and won Best Film. It also received five nominations at the Teen Choice Awards, including one for Mark Wahlberg's Hissy Fit for "Best Hissy Fit."

Will parlayed his success in *The Other Guys* into other straight-guy roles in movies such as *Everything Must Go* (2010), *The Candidate* (2012), *Get Hard* (2015), and *Daddy's Home* (2015).

He has also been able to stretch himself in more subdued roles, such as 2007's *Stranger than Fiction*, in which he was nominated for a Golden Globe for Best Actor and 2010's *Everything Must Go* and the 2015 TV movie *A Deadly Adoption* that he and Kristen Wiig played as a straight movie. That was bizarre.

Will has had a tremendous career and continues to make movies.

Will Ferrell and Zack Galifanikis promote 2012's *The Campaign*

He's been nominated twice for Golden Globes for *The Producers,* and *Stranger Than Fiction,* won a Kid's Choice Award for *Daddy's Home* (2015), nominated for ten MTV Movie Awards with and won the Comedic Genius award in 2013, five nominations from the People's Choice Awards, won two ESPY awards for *Semi-Pro* (2008) and *Talladega Nights,* has a star on the Hollywood Walk of Fame, and was selected in 2011 for the prestigious Mark Twain Prize for American Humor.

Will Ferrell

CHAPTER 48

SUPER GREAT MOVIE SPOTLIGHT

There's Something About Mary (1998)

Cameron Diaz is the title character, along with some pretty disgusting hair product, in *There's Something About Mary* (1998)

20th Century Fox/Photofest

- ▶ Starring Ben Stiller, Cameron Diaz, and Matt Dillon
- ▶ Directed by Bobby and Peter Farrelly
- ▶ Written by Ed Decter & John J. Strauss and Peter Farrelly and Bobby Farrelly
- ▶ Subgenres: Gross-Out, Dark and Black, Romantic Comedy
- ▶ Comedy types: Verbal, Slapstick, Farce, Dark and Black Comedy

"Is that . . . is that hair gel?"

—Mary (Cameron Diaz)

Bobby and Peter Farrelly had made gross-out films, *Dumb and Dumber* (1994) and *Kingpin* (1996), before tackling *There's Something about Mary* in 1998. *Dumb and Dumber* was about two idiotic brothers (Jim Carrey and Jeff Daniels) and their journey cross-country to find love and grossed over $200 MILLION at the box office. *Kingpin* was a sports comedy about an alcoholic ex-professional bowler (Woody Harrelson) and his protégé, Amish Ishmael Borg (Randy Quaid) and their quest to defeat champion Ernie McCracken (Bill Murray) for bowling immortality.

Kingpin had a small return at the box office, and the Farrelly Brothers decided if their next movie was going to be their last, they would make the most outrageous dark comedy in history. Dark comedy? Sure—the movie is about stalking.

There are some huge LOL moments in *There's Something about Mary*. Bawdy, outrageous, tasteless, and with so many scenes that are just plain wrong, the film was a gigantic hit, making over $350 million. That means it's good, right? (Trust me, it is.) [Editor's Note: Trust us, we don't trust him. But the film is a gut-buster.]

Summary

It's prom night and young geek Ted Stroemann (Ben Stiller) is floating on air. He's taking his dream girl Mary (Cameron Diaz) to the big dance, and what could possibly go wrong? But Ted uses the restroom and inadvertently gets his "Franks and Beans" caught in his zipper. It's the talk of the neighborhood as Ted is wheeled into an ambulance, his dream date crushed by a cruel twist of fate.

Fast-forward thirteen years later, and Ted realizes he's still in love with Mary. He hires private investigator Pat Healy (Matt Dillon) to find her. He tracks her down to Miami, Florida, where she's living with Magda (Lin Shaye) and as he spies on her, Pat falls in love with Mary too. He blows Ted off by lying about her and moves to Miami to make his move.

While there, Pat uncovers two other men who are in love with Mary. Things get worse for him when Ted can't stop thinking about her, so he goes to Miami to be reunited. Suffice to say, Ted is not happy when he discovers Pat's deception and soon it's every man for himself competing for Mary's heart.

Who ends up with Mary? Who's her ex-boyfriend Brett that she keeps talking about? And how outrageous will this film get? You have no idea!

Best Scenes

Prom Night—The single most disgusting full frontal penis moment in the history of motion pictures. That's all you need to know.

Pat's Wooing of Mary—Trying to impress Mary, Pat goes to extreme lengths to lie, using his surveillance to turn himself into the perfect guy. To show how compassionate he is, he tells her such gems as he works with "retards," and also refers to them as "those goofy bastards."

Ted and Mary Have a Sticky Reunion—After given advice to relieve the stress of a first date that you should masturbate before going out, Ted can't find his sperm. But Mary does . . .

Magda Straightens Up—Magda and her dog Puffy have both been inadvertently drugged by Pat, and when Ted and Mary come home from their big date, the effects of the drug are one of the best dog scenes you've ever witnessed. "Hey, are you the little guy making all that big noise?"

End Credits—Set to The Foundations' "Build Me Up Buttercup," the sequence is the musical equivalent of the "Where are They Now" segment in *American Graffiti*. Super cute!

Awards and Recognition

There's Something About Mary was a box office behemoth, making over $369 MILLION worldwide from a budget of $23 million. That's a lot of franks and beans.

Cameron Diaz was nominated for a Golden Globe for Best Actress–Musical or Comedy, won an American Comedy Award for Best Actress, the New York Film Critics Circle Award for Best Actress, and a MTV Movie Award for Best Performance.

The AFI named *There's Something About Mary* the 27th Film on the 100 Years . . . 100 Laughs List and I hope the Library of Congress reads this book and puts it in the National Film Registry. Probably long after I'm dead.

CHAPTER 49

ARTIST SPOTLIGHT

The Coen Brothers, Wes Anderson, and Judd Apatow

CHAPTER FOCUS

► Who Are The Coen Brothers?

► Who Is Wes Anderson?

► Who Is Judd Apatow?

Chapter Focus

Through the 1990s and into the early 2000s, the avenues for comedy films continue to expand. The independent film movement launched by the cultural explosion of the Sundance Film Festival opened audiences' eyes to the brilliance of non-traditional comedic voices. Both Joel and Ethan Coen, along with Wes Anderson, epitomize the truly original comedic filmmakers telling their stories as the decades continue.

Judd Apatow also came from the fertile world of television to become one of the most important comedy writer-director-producers over the last ten years. His unique brand of "bro-mances" and a layered nuance for characters that surprisingly rise above some of his more risque material.

Their authentic voices continue to push boundaries and give comedy film lovers different stories told from varying perspectives that always lead to laughs.

Who Are The Coen Brothers?

Joel Coen (born 1954) and Ethan Coen (born 1957) grew up outside of Minneapolis, Minnesota. They both started making movies when they were in grade school, both attended Bard College, and then went their separate ways. Joel went to the Tisch School of the Arts at New York University to major in film-making, and Ethan went to Princeton and earned a degree in philosophy.

Joel met director Sam Raimi after graduating from NYU, and he was the assistant editor for the classic low-budget horror film, *The Evil Dead*. Joel and Ethan then wrote and directed their first film, the crime noir *Blood Simple* that premiered at the US Film Festival (the festival would later change its name

The Coen Brothers

to the Sundance Film Festival), and the movie gave them a high profile in the independent film industry. The film had a modest box office return, but more important were the universally positive reviews from the nation's film critics.

They wrote a small comedy film for Sam Raimi called *Crimewave* in 1985, and set their sights on making a completely different film from *Blood Simple* for their next writing/directing feature, a completely off-the-wall dark comedy that would set the tone for the rest of their comedy film careers.

The Official Coen Brothers Top 3 Great Comedy Film Checklist

Raising Arizona (1987)

H. I. McDonnough (Nicolas Cage) is a career criminal who falls in love with police officer Edwina aka "Ed" (Holly Hunter) when he's getting his mug picture taken at the local precinct. To see her again, he keeps breaking the law and getting arrested on purpose, and after H. I. promises to renounce his criminal ways, they fall in love and get married.

When it's time for H. I. and Edwina to think about having a family, they discover that H. I. is sterile and they can't have kids ("My seed could not find purchase.") and they consider adoption, but know they won't get approved because of H. I.'s criminal record.

A solution presents itself in the high-profile birth of the "Arizona Quints," five children born to furniture maven Nathan and Florence Arizona (Trey Wilson and Lynne Dumin Kitei). Ed

believes they won't miss one of them, and H. I. sneaks through their bedroom window and kidnaps Nathan Jr.

Things go awry when two of H. I.'s former cellmates, Gale and Evelle (John Goodman and William Forsythe) escape from prison and need a place to stay. Ed wants them out of the house because of the new baby and when Glen (Sam McMurray), H. I.'s boss at his respectable machine shop job, figures out that Ed and H. I.'s new baby is Nathan Jr., then everything falls to pieces. Glen demands that H. I. and Ed turn over Nathan Jr. to him and his wife or he goes to the cops. When Gale and Evelle hear that the baby is the missing kid from the TV, they kidnap Nathan Jr. for themselves to hold him for ransom.

Who will end up with Nathan Jr.? Will Ed and H. I. find happiness, even when H. I. starts to drift to the other side of the law? How does the "Lone Biker of the Apocalypse" fit into all of this?

Raising Arizona was Joel and Ethan Coen's first comedy film and was fairly popular at the box office, making $29 million on a $6 million budget. The film was screened at the 1987 Cannes Film Festival and is the #31 movie on the AFI Great Comedy Films list.

Fargo (1996)

Used car salesman Jerry Lundegaard (William H. Macy) is in trouble. He's been embezzling funds from the auto dealership and the owner is going to find out. He needs money and he needs it fast. He comes up with a crazy idea, hires someone to kidnap his wife, Jean (Kristin Rudrud), so that his rich father-in-law, Wade Gustafson (Harve Presenell), will pay the ransom, and then Jerry can take the money and pay off the outstanding funds. Seems pretty simple!

Fargo, 1996

Gramercy Pictures/Photofest

Jerry hires two criminals, Gaear Grimsrud (Peter Stormare) and Carl Showalter (Steve Buscemi), to snatch up his wife and Jerry will take care of the rest. When Jerry somehow talks Wade into giving him money for a fake real estate deal, he has the money to pay off the embezzled funds. Since there's no need for the kidnapping to take place, Jerry tries to cancel it—but it's too late. Grimsrud and Showalter kidnap Jean and on the way to their hideout, they are forced to kill a state trooper that pulled them over and two eyewitnesses.

Enter extremely pregnant Marge Gunderson, who is a really good detective. She quickly tracks down Jerry's involvement in the kidnapping and shootings. Feigning innocence, he tells Gustafson that the kidnappers will only deal with him, and they are asking for a million dollars, enough to pay off the embezzled funds and the two criminals, leaving plenty for Jerry.

Will Jerry somehow get away with all this? Will Marge figure this thing out? Will Jean make it out of this alive? And whose body gets stuffed into a wood chipper?

Fargo was a triumph, making over $60 million at the box office and was nominated for seven Academy Awards, including Best Picture, Best Director (Joel Coen), Best Supporting Actor (William H. Macy), Best Cinematography, Best Editing, and won Oscars for Best Actress (Frances McDormand) and Best Original Screenplay (Joel and Ethan Coen).

It also won five Independent Spirit Awards, Best Film, Best Director (Joel Coen), Best Female Lead (Frances McDormand), Best Supporting Actor (William H. Macy), and Best Screenplay (Joel and Ethan Coen).

Fargo is the #84 movie on the AFI Great Movies List, #93 on the AFI 100 Years . . . 100 Laughs List, and Marge Gunderson is the AFI #33 Hero on the AFI Top 100 Heroes and Villains List.

The Coen Brothers and Frances McDormand on Oscar night

©Everett Collection/Shutterstock.com

The Big Lebowski (1998)

No list of the top Coen Brothers comedy films would be complete without this surreal, farcical crime-caper that has grown into a full-blown cult classic. By cult, I mean there's an annual "Big Lebowski" Festival in Lexington, Kentucky, that has spread across the United States and even to Great Britain. By "cult," I mean there is "The Church of the Latter-Day Dude" online, which claims to be the slowest-growing religion in the world, Dudeism.com, and I don't see a religion based on *The Rocky Horror Picture Show*. It doesn't get more "cult" than *The Big Lebowski*.

Jeff "The Dude" Lebowski (Jeff Bridges) is a pot-smoking slacker that spends his days hitting the bong and then hitting the bowling lanes with his buddies, Donny (Steve Buscemi from *Fargo*) and Walter (John Goodman from *Barton Fink*). It's a low-key life for a guy with a love of White Russians and no ambition that takes one day at a time (but not in an AA-way). That

is until two guys break into his apartment and assault him for the money that his wife, Bunny (Tara Reid), owes them. It's only after realizing that The Dude is the *wrong* Jeff Lebowski that they leave, but not without one of them peeing on The Dude's nice carpet.

When Walter and Donny find out about the transgression, Walter is incensed. A former Vietnam veteran, he tells The Dude that there's another Jeff Lebowski, aka The Big Lebowski, a wealthy multi-millionaire that can easily replace The Dude's rug. "It really ties the room together," laments The Dude and goes to confront this "other Lebowski."

When his meeting with "The Big Lebowski" (David Huddleston) doesn't go as planned, he tells the rich man's assistant Brandt (Philip Seymour Hoffman) that he was told to help himself to any rug in the house. As he's leaving with the purloined carpet, he spots Bunny poolside. She offers to blow him for $1,000 and The Dude takes off.

What happens next is a loose adventure where The Dude gets a call to help The Big Lebowski when Bunny is kidnapped, and The Big Lebowski asks him to deliver the ransom money to the kidnappers. Will Bunny be rescued? How is eccentric painter Maude (Julianne Moore) involved—and why does she ride on a sex swing in the nude? Will The Dude get through this with the few brain cells he has left intact?

The film made a significant return of $46 million on its $15 million budget, but the reception of the film was divided. Many critics felt the pace of the film was a little slow, but were impressed by a film that is unlike any other ever made.

In 2008, Entertainment Weekly ranked *The Big Lebowski* #8 on its list of "The Funniest Movies of the Past 25 Years" and in 2004, the Library of Congress placed the film in the National Film Registry. The Dude abides, indeed.

The Coen Brothers have made several comedies over the years: Hollywood satire *Barton Fink* (1991), the screwball comedy homage *The Hudsucker Proxy* (1994), the bluegrass musical-comedy *O Brother, Where Art Thou* (2000), the romantic comedy *Intolerable Cruelty* (2003), the heist caper *The Ladykillers* (2004), the black comedy *Burn After Reading* (2008), and the Hollywood farce *Hail Caeser!* (2016).

Films they have written on their own or written/directed themselves have collectively been nominated for forty-four Academy Awards and won seven, including Best Picture for the 2007 neo-Western thriller *No Country for Old Men*.

They've also been nominated for fourteen prizes at the Cannes Film Festival and won six, including the prestigious Grand Prix for 2013's *Inside Llewyn Davis*, twenty-one Golden Globe nominations with three wins, including Best Picture–Musical or Comedy for *O Brother, Where Art Thou?*

In France, the Coen Brothers were inducted as Commanders of the Order of Arts and Letters in 2013, the country's highest cultural honor. The best part is that they are still making highly original movies and will hopefully continue to do so for a very long time.

Who Is Wes Anderson?

Wes Anderson

©Tinseltown/Shutterstock.com

A thinking-man's comedy filmmaker, he was born in Houston, Texas, in 1969. He started making movies in elementary school, and while at the University of Texas at Austin, he studied philosophy and met a young actor by the name of Owen Wilson. Their partnership would usher them both into the comedy film industry.

Their initial effort was a thirteen-minute short film, *Bottle Rocket* (1994), about Dignan (Owen Wilson) and Anthony (Luke Wilson), two small-time crooks who manage to pull off a small heist. Really small. The short caught the attention of James L. Brooks (*As Good as It Gets, The Simpsons*) who gave Wes and Owen the chance to turn the short into a feature film also titled *Bottle Rocket*. The film was a hit with critics and a bomb at the box office, but it opened the door for Wes, Owen, and Luke to enter the world of Hollywood filmmaking.

Owen and Luke have gone on to act in a huge amount of Hollywood comedies; Owen has appeared in over fifty films, including the buddy-action film *Shanghai Noon* (2000) with Jackie Chan (*Rush Hour*); *Meet the Parents* (2000), *Zoolander* (2001), and *Zoolander 2* (2016) with Ben Stiller; *Starsky & Hutch* (2004), *Wedding Crashers* (2005), *You, Me and Dupree* (2006) for the Farrelly Brothers; *Midnight in Paris* (2011) for Woody Allen; and the *Night at the Museum* franchise (2006, 2009, 2014). He's also re-teamed with Wes Anderson, co-writing *Rushmore* (1998) and *The Royal Tenebaums* (2001), and starring in *The Royal Tenenbaums* (2001), *The Life Aquatic with Steve Zissou* (2004), *The Darjeeling Limited* (2007), and *The Grand Budapest Hotel* (2014).

Luke has also done over fifty films, including *Rushmore* and *The Royal Tenenbaums* for Wes Anderson, as well as *Charlie's Angels* (2000), *Legally Blonde* (2001), and its sequel *Legally Blonde 2: Red, White & Blonde* (2003), *Old School* (2003) with Will Ferrell, *Idiocracy* for Mike Judge (2006), and several television programs.

After Anderson's successful second feature *Rushmore* (1998) starring Bill Murray (check out Chapter 38), Anderson graduated to the elite world of writer-directors with unique world-views and a distinct auteur filmmaking style. His films focus on characters and the interrelationships of family and friends, long extended takes that allow his actors the opportunity to explore his distinctive stories, and extensive use of music soundtracks set him apart from his contemporaries.

Jason Schwarzman and Bill Murray in *Rushmore*

The Official Wes Anderson Top 3 Great Comedy Film Checklist

The Royal Tenenbaums (2001)

When you're talking about family, no film epitomizes the style of Anderson as this ensemble comedy about a dysfunctional family of quirky geniuses (played by Ben Stiller, Gwyneth Paltrow, and Luke Wilson) who reunite with their long-missing father, Royal Tenenbaum (legendary actor Gene Hackman), after he announces that he's dying. The huge cast includes Bill Murray, Anjelica Huston, Luke Wilson, and Danny Glover. The film was nominated for an Oscar for Best Original Screenplay for Anderson and Owen Wilson, and Gene Hackman won the Golden Globe for Best Actor.

Wes Anderson at *The Royal Tenenbaums* premiere

Wes Anderson and the Cast of *Moonrise Kingdom*

Moonrise Kingdom (2012)

Young love never seemed so poignant as Anderson's coming-of-age story about twelve-year-old pen pals Sam (Jared Gilman) and Suzy (Kara Hayward) who fall in love and run away together on a small island in the New England coastline. A huge storm is on its way, in the form of both the weather and the calamity of Suzy's parents (Bill Murray and Frances McDormand), a Social Services worker (Tilda Swinton), Scoutmaster Ward (Edward Norton), and Captain Sharp from the island police (Bruce Willis) as they attempt to find the two young paramours. The film opened the 2012 Cannes Film Festival, received a great response from the critics, was a box office smash, won the AFI Award for Movie of the Year, and Anderson and co-writer Roman Coppola were nominated for the Best Original Screenplay Oscar.

The Grand Budapest Hotel (2014)

If you're looking for a star-studded farce, then look no further than this social class comedy of manners taking place in the remote European country of Zubrowka. Ralph Fiennes (*Schindler's List*, the *Harry Potter* series) stars as Monsieur Gustave, the concierge of a famous hotel that tries to keep his sanity in a maelstrom of sex with well-to-do elderly women, the irate family of a woman who bequeathed him a painting, and the fall-out when he is accused of murder. The cast includes Adrien Brody, Willem DaFoe, Edward Norton, Jeff Goldblum, Harvey Keitel, F. Murray Abraham, Jude Law, Tom Wilkerson, Jason Schwartzman, Tilda Swinton, Owen Wilson, and Bill Murray.

The Grand Budapest Hotel was a major success. It brought in over $170 million at the box office, was universally praised by critics, was nominated for nine Oscars, including Best Picture, Best Director, Best Screenplay, Best Cinematography, Best Editing, and won four awards: Best Costume Design, Production Design, Original Score, and Make-up. It's a clever motion picture and definitely worth a viewing if you haven't seen it before.

As a director, he continues to grow and master his craft, and the world looks forward to his many original upcoming films. But he's not the only original voice that came to the world of great comedy films at the turn of the new century . . .

Who Is Judd Apatow?

Born in Flushing, Queens, in 1967, Judd gravitated to the world of comedy at a young age, performing stand-up comedy in high school and moved to Los Angeles after graduating to attend USC to major in screenwriting. He met up with Ben Stiller and helped to launch *The Ben Stiller Show* in 1992 and won an Emmy Award for Writing even though the show was canceled after one year.

Judd Apatow

©Tinseltown/Shutterstock.com

He worked in television on various programs, became co-executive producer of the highly acclaimed HBO comedy series, *The Larry Sanders Show*, starring comedian Garry Shandling from 1993–1998. He created NBC's short-lived critical darling *Freaks and Geeks* in 1999 and *Undeclared* with Seth Rogen from 2001–2003.

In 2004, he produced the incredibly successful *Anchorman: The Legend of Ron Burgundy* (see Chapter 51 for the glorious details) and got to start writing and directing his own films.

Considered one of the biggest comedy producers since 2004, he's been behind-the-scenes for over ten years (and counting) of some of the best comedy films to grace the silver screen, including *Talladega Nights: The Ballad of Ricky and Bobby* (2006), *Walk Hard: The Dewey Cox Story* (2007), *Step Brothers* (2008), *Pineapple Express* (2008), *Bridesmaids* (2011), *This is 40* (2012), *Anchorman 2: The Legend Continues* (2013), and *Trainwreck* (2015).

He's become a brand of his own, known for character-driven teen and adult comedies, rather than the typical gross-out comedies that permeate the Hollywood studio system. Don't get me wrong—there are definitely some gross-out moments in the Apatow comedies. But there is also an innate sweetness to his movies as well. Films like *Forgetting Sarah Marshall* (2008), *Funny People* (2009), *The Five-Year Engagement* (2012), and *This is 40* (2012). He's also credited for creating the "bro-mance" films, where two male characters get to bond and reveal feelings! Feelings!

Movies like *Superbad* and *Pineapple Express* (2008) contain male characters that have more emotion and dimension than the typical guy-centric comedy. Movies such as *Wedding Crashers* (2005), *I Love You Man* (2009), *The Hangover* (2009), and *Horrible Bosses* (2011) can be traced to Apatow's influence on popular culture.

The Official Judd Apatow Top 3 Great Comedy Film Checklist

The 40-Year Old Virgin (2005)

Steve Carrell (who also co-wrote the film with Apatow) had appeared in the memorable role as clueless meteorologist Brick Tamblin in *Anchorman: The Legend of Ron Burgundy* when he hooked up with Apatow for his first starring role. He's Andy Setitzer, and like the title implies, he's a 40-year-old geek who likes action figures and video games. When his co-workers (Paul Rudd, Seth Rogen—in his first supporting role—and Romany Malco) find out he hasn't had sex yet, they resolve to make it happen. The film is noted for the single-most horrific scene in the history of motion pictures: Andy's chest hair waxing.

The film was a monster at the box office (making over $177 million worldwide) and cemented Steve Carell as a huge comedic talent. The critics celebrated Judd Apatow's smart writing and direction, and how the film had bypassed the easy route of single-dimension characters by portraying them as real people. All Apatow traits that we would continue to see in his ongoing work.

Knocked Up (2007)

In Apatow's second directorial effort, Katherine Heigl plays Alison Scott, an up-and-coming entertainment news broadcaster who gets drunk at a bar celebrating her new promotion and somehow ends up in bed with pothead Ben Stone (Seth Rogen in his first starring role). Eight weeks later, Alison finds out she's pregnant—and goes back to Ben to figure out what they are going to do. Ben's got nothing going on, except his friends, his bong, and his job working on a celebrity porn website with his roommates.

This newfound reality of impending fatherhood is a wake-up call forcing Ben to grow up. Alison has some growing up to do, accepting the fact that Ben could be the right choice for her once he cleans up his act. Another Apatow smash at the box office, and movie critics were impressed with the depth of relatable characters.

Superbad (2008)

I was on the fence about the last film. Since I discuss *Superbad* in the Teen/Coming of Age and the Gross-Out sections of this book (Chapters 41 and 43), I thought that maybe I should pick the Amy Shumer-starrer *Trainwreck* (2015) since it's a solid movie that shows Apatow's later direction toward strong-women films that started with 2011's *Bridesmaids*. But it's a little early to give *Trainwreck* accolades in a book since it just came out. Maybe in the third edition!

On the other hand, *Superbad* is a classic. When I studied film comedy of the 2000s, *Superbad* is a pivotal film that formally kick-started the "bro-mance" movie formula. Its roots also are similar in its understanding of teenagers in the same way that John Hughes had done for a previous generation with *Sixteen Candles*. It also takes place in one day, similar to *American Grafitti* and *Dazed and Confused*, where Seth (Jonah Hill) and Evan (Michael Cera) resolve to impress a couple of girls on the last night of high school and they

Michael Cera, Christopher Mintz-Plasse, Jonah Hill

enlist their friend Edward with the fake ID (with the patently-ridiculous moniker of "McLovin") to help them out.

Along the way they meet two of the coolest cops you will ever meet, played by Bill Hader and Seth Rogen (who wrote the script with friend Evan Goldberg back in high school, based on their own experiences), and wouldn't you know it, but things get out of control!

This film was another monster hit, and came out two months after Apatow's *Knocked Up*. 2008 was the summer of Judd Apatow, and he hasn't stopped since.

As the mid-2000s progresses, comedy films will continue to be shaped by Hollywood's standard fare of romantic comedies and gross-out films. But unique voices such as Wes Anderson and Judd Apatow will be the torchbearers for a more sophisticated style of

Judd Apatow wins an award at Cinecon

comedy that is respected and appreciated by audiences and critics the world over.

CHAPTER 50

SUPER GREAT MOVIE SPOTLIGHT

Anchorman:
The Legend of Ron Burgundy
(2004)

Paul Rudd, Will Ferrell, David Koechner, and Steve Carell are the Channel 4 News Team in *Anchorman: The Legend of Ron Burgundy* (2004)

▶ Starring Will Ferrell, Christina Applegate, Paul Rudd, and Steve Carell

▶ Directed by Adam McKay

▶ Written by Will Ferrell and Adam McKay

▶ Subgenres: Farce, Romantic Comedy, Spoof

▶ Comedy types: Verbal, Slapstick, Farce, Dark and Black Comedy

"I don't know how to put this, but I'm kind of a big deal."

—Ron Burgundy (Will Ferrell)

This book details the world of comedy film from 1895's *The Sprinkler Sprinkled* or *Watering the Garden* (or whatever those wacky French called it) all the way to 2010ish. That's over a hundred years.

When I originally decided to write this book, I used the AFI 100 Years . . . 100 Laughs List as my criteria—what I think is a great comedy film would not be the most esteemed choices—the only problem is that the list ends in the year 2000. It took me ten years to write this thing, so what do I do for these other ten-plus years?

My point is to deem a film after 2000 AD is all on me. I don't have the AFI to blame if you don't appreciate my choices. So here it goes . . . it is my firm belief that *Anchorman: The Legend of Ron Burgundy* is one of those movies worthy of its own Super Great Movie Spotlight. I would be shocked if the AFI doesn't put it in their next Great Comedy Film list. The Library of Congress is definitely putting it in the National Film Register. Because this movie is a national treasure and I don't give a damn if I'm the only author around here who knows it.

Will Ferrell left *Saturday Night Live* two years before *Anchorman: The Legend of Ron Burgundy* was produced. He had done a series of supporting roles for years, but his first two starring roles have since defined his career: *Elf* (2003) and *Anchorman: The Legend of Ron Burgundy* (2004).

Working with producer Judd Apatow (see Chapter 49) and former *Saturday Night Live* digital short filmmaker Adam McKay, the three of them sat down and created a film that shall live in the hearts, minds, and souls of all who have viewed it. And if you're one of those audience members who don't care for it, I pity you. I really do.

I could just type an entire page of *Anchorman: The Legend of Ron Burgundy* quotes, but I'll play it straight and roll it out like the rest of my Super Great Movie Spotlights!

Summary

Welcome to 1974 and the world of San Diego's Number #1 News Anchor, the legendary Ron Burgundy (Will Ferrell). Ron's best friends, lead reporter and ladies' man Brian Fantana (Paul Rudd), former baseball jock-turned-sportscaster Champ Kind (David Hoechner), and oblivious and possibly brain-damaged weatherman Brick Tamland (Steve Carell) make up his #1 News Team. He has a great dog, Baxter, who is wise beyond his dog years, "You're like a miniature Buddha, only covered with hair."

All that changes when the network decides it's time to embrace diversity, and hires A FEMALE CO-ANCHOR to join Ron at the news desk. He's appalled—it is 1974 after all! Women belong at home, making cookies! Not on the news!

However, the beautiful Veronica Corningstone (Christina Applegate) is determined to stand up to Ron and the rest of the News Team's sexist attitude. Ron thinks she's nothing but eye candy (delicious eye candy, but eye candy nevertheless), but she wants to be taken seriously as a journalist. That doesn't stop Ron from hitting on her, and she relents to go on a date. After the date, Ron seduces her into bed. She asks him to keep it a secret, and of course he doesn't—announcing their affair on the evening news broadcast the next evening.

Veronica gets her revenge when she messes with Ron's teleprompter, causing him to read his tagline, "Stay classy, San Diego" to "Go fuck yourself, San Diego." Ron is subsequently fired. He drops off the map, unemployed and penniless. A shell of the man he once was.

Can Ron regain his luster and return to the News Desk? Will he and the News Team survive the grudge match between rival anchor Wes Mantooth (Vince Vaughn) and his weapons-packing Channel 9 News Team? Will Veronica and Ron find love together? Will Brick ever make sense—and where did he get that hand grenade?

Best Scenes

The Dinner Date—Ron takes Veronica out on the town, and proceeds to impress her with his witty conversation. When the restaurant manager begs Ron to play a song on the jazz flute for the crowd, Ron is reluctant. After all, he's on a date. But luckily for Veronica and the crowd, he just happened to bring it with him!

News Anchor Street Fight—As the News Team goes out to buy some on-air wardrobe, they are confronted by a variety of News Anchors from across the city. It's a street brawl the likes have never been seen. Who brought the mace? Oh yeah, Brick did.

The Cologne Collection—Lead reporter Brian Fantana is quite the ladies' man, and he divulges his secret, his enormous—collection of colognes. He decides to hit on Veronica wearing "Sex Panther." As Fantana approaches her, the toxic smell causes the staff to run away and scream such lines as "It smells like a turd wrapped in burnt hair!"

The Teleprompter Scene—In retaliation for Ron calling her "Tits McGee" on-the-air, Veronica hacks into the teleprompter and causes some problems that will destroy Ron's career, without him even realizing what he's saying. His usual closing line, "Good night, I'm Ron Burgundy, stay classy, San Diego," turns into "Good night, I'm Ron Burgundy, Go f*** yourself, San Diego."

Awards and Recognitions

Anchorman: The Legend of Ron Burgundy made about $90 million worldwide from a budget of $26 million, and the critics were generally favorable.

The film spawned a sequel, *Anchorman 2: The Legend Continues*, with the original cast returning. The sequel made $173 million, from a budget of $50 million. How they spent $50 million dollars on that film is mindboggling. Hollywood . . . what do you do? But it continued Will's dominance at the box office.

McKay and Ferrell have since worked on several films after *Anchorman: The Legend of Ron Burgundy*, including *Talladega Nights: The Ballad of Ricky Bobby*, *Step Brothers*, *The Other Guys*, and *Anchorman 2: The Legend Continues*. Ferrell and McKay also created the "Funny or Die" Internet website that promotes short film content.

Empire magazine ran a poll that named Ron Burgundy the #26 Greatest Movie Character, and the film was the #113 film on their "500 Greatest Films Ever" list. Finally, Entertainment Weekly named Ron Burgundy the #40 Character in their list of "The 100 Greatest Characters of the Last 20 Years." Why he isn't #1 is another shame.

"Stay classy, Great Comedy Film readers."—Ron Burgundy, if he was a real person and was my friend, which would be awesome, because then we could hang out and shoot pool, and maybe go sing some karaoke.

CHAPTER 51

Comedy Films in the Twenty-First Century

OR:

A Coherent and Thoughtful Analysis of the Current State of Comedy Filmmaking from an Objective and Informed Perspective

Scene from *The Hangover* (2009)

Warner Bros./Photofest

CHAPTER FOCUS

▶ Technology Killed the Video Store

▶ Streaming Video Is Slowly Killing the DVD and Cable TV

▶ Independent Film Comedy

▶ Targeted-Audience Films

▶ Hollywood Studio Comedies

Chapter Focus

Welcome to the twenty-first century, and we might not have flying cars and jet packs, but technology has changed our lives in ways only science fiction writers dared to dream.

The world of comedy films has also changed a lot—just like sound, then color, then television and cable all changed the way we watch movies, it was about to get a whole lot crazier.

Technology Killed the Video Store

There were over 30,000 video rental stores across the country in the 1990s and Blockbuster Video was the largest retail video rental store franchise in the United States with over 9,000 locations. In 1998 they started making room on their shelves for a new media delivery system, the DVD. No longer would you need magnetic tape to watch a comedy film. The films could be turned into digital files. That's the breakthrough that changed the way we watch movies to this day.

©Nikolich/Shutterstock.com

No, these aren't CDs (what's a CD, Grandpa?), they are Digital Video Disks, aka DVDs. I have a whole ton on my movie shelf. Come on by and take them.

The DVD would be the primary delivery for hard media until the release of the Blu-ray format in 2006 that presented a High-Definition picture on a disc that was ten times bigger in storage capability than the traditional DVDs. But it was still on a disk that you had to buy or rent.

In 1998, the Hollywood film industry discovered a little company that co-founder Reed Hastings started after he had to pay $40 in overdue fees to a video store for a copy of *Apollo 13*. His was a company that would offer DVD rentals via the mail, where a customer could keep the DVD as long as they wanted.

It was a little company called Netflix.

This company would single-handedly change the media industry, and the audience entertainment experience. Interestingly, Netflix offered to sell themselves to Blockbuster Video in 2000 for the measly price of $50 million. Blockbuster passed.

In retrospect, not the best choice for the giant retailer, as Netflix's in-home service also changed the way Blockbuster did business. Starting in 2003, the yellow and blue box store offered competing monthly subscriptions, an online ordering system, and a mail-service exactly like Netflix but at a lower cost.

Man, I should have bought this stock when it was super-cheap!

Author Chris LaMont and his son Luke found an actual brick-and-mortar video store, Family Video, in Bucyrus, Ohio, on Route 4 during a family vacation. The mom-and-pop retailer has 785 stores in the Midwest with actual shelves full of actual DVDs!

Streaming Video Is Slowly Killing the DVD and Cable TV

Netflix saw a great opportunity that Blockbuster wasn't prepared to tackle, the concept of streaming movies through the Internet.

In 2006, Apple launched the iTunes movie library, selling television shows and feature films for downloading onto Apple's handheld and computer devices. In the first year, Apple had sold 1.3 million feature length films and also 50 million TV episodes.

Netflix adopted their streaming platform in 2007 and since then the company has become a primary streaming opportunity of content for audiences across the world. In 2017, Netflix is reported to have over 100 million subscribers.

Blockbuster Video, Hollywood Video, and Movie Gallery all went bankrupt in the early 2010s. Retail giants such as Wal-Mart and Target continue to sell DVDs and Blu-ray disks. And in the year 2017, even Netflix has competitors in streaming distribution services offered through such companies as Amazon, Hulu, VUDU, Ultraviolet, and Flixster.

With so many opportunities for distribution, audiences can be targeted down to very specific parameters. The landscape of film comedy today can be found in three categories: Independent Films, Targeted Audience Films, and Hollywood Studio Films.

Independent Film Comedy

Independent filmmakers make original lower-budget comedy movies that rely on self-financing. If the filmmakers are successful, they move into the Hollywood Studio mainstream. The same with Audience-Specific Films, carving out a successful niche audience. Once the audience has been established and has shown to be financially stable, then the Hollywood Studio mainstream comes calling and creates films catering to that specific audience.

Independent comedy filmmakers made waves starting in the early 1990s and the advent of better and less-expensive technology, such as digital filmmaking and desktop editing has given a boost to the creation of these movies.

There have been a lot of great independent films made since 2000 that are discussed elsewhere in this publication, such as *Lost in Translation, The Royal Tenenbaums, Juno, Borat: Cultural Learnings of America for Make Benefit Glorious Nation of Kazahstan, Adaptation,* and *Juno.* Here's a few more that aren't!

Three Great Independent Film Comedies of the New Millennium

My Big Fat Greek Wedding (2002)

Struggling actress Nia Vardalos wrote and starred in her ethnic-centered one-woman play and was discovered by Tom Hanks's wife, Rita Wilson. From there, she got the opportunity to write and star in her own feature film romantic comedy as Toula, a single Greek woman being pressured by her very Greek family to get married to a nice Greek man. When she meets hunky Ian Miller (John Corbett), she keeps it a secret until everyone finds out, and then she has to introduce him to her crazy family. A critic's darling and a sleeper hit that eventually grossed over $368 million worldwide (making it one of the most profitable movies in history), and Nia's heartwarming script was nominated for the Best Original Screenplay Oscar.

Napoleon Dynamite (2004)

This Sundance Film Festival cult classic follows the title character, an unpopular high school student with a penchant for tater tots (played with eternal sweetness by newcomer Jon Heder) who meets Pedro (Efren Ramirez), a new kid from Mexico with an awesome bike, and together they run Pedro for Class President. The film made $46 million at the box office from a $400,000 budget, launched Jon Heder to Hollywood comedy status and Jared Hess the opportunity to write and direct Jack Black in *Nacho Libre* (2006).

Little Miss Sunshine (2006)

Another film to debut at the Sundance Film Festival, this dysfunctional family movie about seven-year-old Olive Hoover (Abigail Breslin) and her hopeful dream of winning the "Little Miss Sunshine" beauty pageant features a top-notch cast. Her dad, struggling self-help author Richard (Greg Kinnear), her overworked mother Sheryl (Toni Collette), her suicidal Uncle Frank (Steve Carrell), her stepbrother Dwayne (Paul Dano), who's taken a vow of silence, and her heroin-addicted Grandpa Hoover (Alan Arkin) all pile into a VW van to take her to the out-of-state competition. Nominated for four Oscars, including Best Picture and Best Supporting Actress for Abigail Breslin, and won the Best Supporting Actor for Alan Arkin and the Academy Award for Best Original Screenplay.

Targeted Audience Films

If you think about it, independent film does focus on a specific target audience, the brainy college graduates who earn at least $50,000 a year that attend film festivals and enjoy artsy British period pieces and any movie starring Judi Dench (the *James Bond* films not withstanding) or based on a Jane Austen book (*Pride and Prejudice* and *Zombies* also notwithstanding).

In this case, studios tend to shy away from audience-specific films, because they can't be sure that the audience will respond to films. Once they do, then all bets are off. It's a major tribute to the filmmakers that have taken their chances with projects that don't fit into the Hollywood norm.

A movie like *My Big Fat Greek Wedding* is a great example of an audience-specific film. Because of its Greek-culture foundation, if you don't know Greeks, then Hollywood didn't think that the film would work. The biggest change that studio executives wanted to do was change the family to Hispanic and replace Nia Vardalos with Marisa Tomei (*My Cousin Vinny*). Fortunately, Tom Hanks and his production company Playtone Records took a chance and changed the rules.

Black Audience-Specific Films

When you look at the history of African American or Black film comedy (not to be confused with Black Comedy), it all starts with Richard Pryor, then goes to Eddie Murphy, a little bit of Spike Lee, Will Smith, and—well, that's a good question. Pretty much that was it.

Ice Cube's stoner comedy *Friday* (1995) showed that African American audiences would come out and support smaller non-Hollywood feature films. Ice Cube created two sequels, *Next Friday* (2000) and *Friday After Next* (2002) that both received poor reviews but each made around $30 million at the box office.

Every now and then Hollywood releases a comedy targeted specifically for urban audiences. Romantic comedies such as *How Stella Got Her Groove Back* (1998), *The Best Man* (1999), *Love and Basketball* (2000), *Brown Sugar* (2002), *Deliver Us From Eva* (2003), *Think Like a Man* (2012), *The Best Man Holiday* (2013), and *About Last Night* (2014),

Controversial rap star Ice Cube turned into a beloved Actor-Writer-Director in such films as *Friday* (1995)

©Featureflash Photo Agency/Shutterstock.com

consistently are focused specifically for black audiences. They usually gross in the neighborhood of $20–$30 million.

Broad comedies tend to fare much better. Ice Cube starred in *Barbershop* (2002), about a son who sells his father's neighborhood barbershop, and then realizes how important it is to the community.

The movie featured a mainly black cast, including Anthony Anderson, Cedric the Entertainer, Keith David, and Eve. The film made $77 million at the box office and spawned two sequels with the cast of the original coming back for *Barbershop 2: Back in Business* (2004) which made $66 million. *Barbershop: The Next Cut* (2016) made $54 million. *Barbershop* even had a spin-off, *Beauty Shop* (2005), starring Queen Latifah, Alicia Silverstone, and Alfre Woodard that earned $37 million.

Then an obscure Georgia-based writer-director-actor came along and changed the viability of programming for the urban audiences.

Tyler Perry started writing stories as self-therapy from the memories of a horrible childhood of molestation. He channeled his energy into a series of stage plays that he financed himself when he was twenty-two years old. He wrote plays and staged them himself, and in 1999 created the character of Medea. She appeared in four of Perry's plays, and in 2005 he raised

Tyler Perry

money for his first feature, *Diary of a Black Woman*, based on his second play. If you're not familiar with Medea, she's a foul-mouthed septuagenarian played by Perry himself, in drag, a fat suit and makeup. Audiences love it when men dress as women (*Some Like It Hot, Tootsie*) and Tyler Perry's films are no exception.

In 2005, Tyler Perry unleashed *Diary of a Black Woman* upon the world. Written and starring Tyler Perry as both Medea and her brother Joe, Medea takes in her granddaughter Helen (Kimberly Elise) after she is kicked out of her house when her husband Charles dumps her for a younger woman. The family is in upheaval from that moment on as Helen and Medea go to Charles's house to vandalize it and they both get arrested. Then things get even crazier.

Defying all expectations, the movie was a monster hit opening as the #1 movie in America and making $50 million at the box office. Though the critics hated the movie, it spoke directly

to African American audiences with its themes of family, love, and relationships. Tyler then parlayed his success to a sequel, *Madea's Family Reunion* (2006), bringing back the popular character. That film earned $63 million and put Tyler into the rare position of doing whatever he wants. He's made over thirty feature films and his movies have grossed over $500 million—primarily generated from audiences in the United States.

Hollywood has learned that one African American targeted genre-hybrid is a proven winner at the box office. Action-comedies, from Richard Pryor and Gene Wilder, to Eddie Murphy in the *Beverly Hills Cop* franchise, the *Bad Boys* movies with Will Smith and Martin Lawrence, the *Men in Black* films also with Will Smith, and the *Rush Hour* franchise with Chris Tucker have always performed well at the box office.

Martin Lawrence scored with *Big Momma's House* (2000), *Big Momma's House 2* (2006), and *Big Mommas: Like Father, Like Son* (2011) that not only seemingly gave birth to the Tyler Perry Medea films, but also raked in a cumulative $382 million.

Recently, comedian Kevin Hart has emerged as the latest African American comedy star to make headway in the film comedy world. His action-comedy film with Ice Cube, *Ride Along* (2014), made $154 million at the box office, and its sequel, *Ride Along 2* (2016), made $124 million and 2016's *Central Intelligence*, starring Dwayne "The Rock" Johnson, grossed $127 million in the US and $217 million worldwide.

These action-comedies aren't targeted specifically for African American audiences, but have the universal appeal that Hollywood looks to invest in. As the movie audience continues to blur based on the

Martin Lawrence

©s_bukley/Shutte stock.com

various forms of distribution, the hope is that film comedies will broaden their appeal across all audiences, and not just niche box offices. The viability of comedy films depends on it.

Female-Centric Films

If Hollywood thinks that African American audiences are a tough sell, imagine the headspinning when studio executives try to figure out movies aimed for women. Women have recently edged out men as the more frequent moviegoers, and Hollywood has always seen a need to have female-driven movies.

But the female-centric movies tend to be dramas and romantic comedies, where they are in relationships with men. What about films where women are the protagonists and don't need men to rely on as the main comedic characters?

In 2014, 85% of films had no female directors, 80% had no female writers, 33% had no female producers, 78% had no female editors, and 92% had no female cinematographers, according to the Center for the Study of Women in Television and Film at San Diego State University. http://variety.com/2015/film/news/women-hollywood-inequality-directors-behind-the-camera-1201626691/

Why are women constantly ignored and misrepresented in the Hollywood film industry? Easy answer, it's men who are writing the screenplays and making the movies. These men either don't understand women or have a total lack of creativity when it comes to storytelling.

There have been a small amount of successful female-centric films that have come out since 2000, following in the footsteps of such strong women as Marilyn Monroe and Jane Russell in *Gentlemen Prefer Blondes;* Dolly Parton, Jane Fonda, and Lily Tomlin in *9 to 5*; Whoopi Goldberg in *Sister Act*; and Geena Davis and Lori Petty in *A League of Their Own.*

Female targeted films can be broken down into two categories: Teen Girls/Coming-of-Age films and Women-centric films.

The Teen Girls/Coming-of-Age comedies are a relatively new phenomenon, starting in 1995 with director Amy Heckerling's *Clueless*. Since then, a number of films have been made, specifically with women writing and directing their movies.

Mean Girls (2004)

Lorne Michaels produced this film for *Saturday Night Live* Head Writer and "Weekend Update" news co-anchor Tina Fey wrote the screenplay for this satirical tale of high school social cliques and the "mean girls" who run them. Cady Heron (Lindsay Lohan before her meltdown) has been home-schooled while her family has been in Africa, and now back in America, it's time for public high school.

She meets Janis and Damian, known as the "out-krowd" who warn her to stay away from the clique called "The Plastics," led by Regina (Rachel McAdams) the queen of the snobby girls that bully and taunt the rest of the school. When Cady gets on the wrong side of Regina, war is declared between the two girls. Will the "out-krowd" get their victory over "The Plastics" and everyone be treated with respect? The film was a huge hit, making over $125 million at the box office, and the teenage audience embraced the film.

Juno (2007)

Cody Diablo won the Best Original Screenplay Oscar for her script about Juno (Ellen Page), a wiser-than-her-years teenager who accidentally gets pregnant from her best friend Paulie (Michael Cera from *Superbad*). The film follows Juno as she deals with her parents, friends, and schoolmates as she struggles with what to do with the baby. The movie was also nominated for Best Picture and made $231 million at the box office.

Pitch Perfect (2012)

Television writer Kay Cannon (*30 Rock* and *New Girl*) adapted a non-fiction book about collegiate a cappella singing competitions into this incredibly successful musical comedy. Anna Kendrick, fresh from her Oscar nomination for Best Supporting Actress in *Up in the Air*, stars as college freshman Beca, who comes to Barden University and joins the "Barden Bellas" all-female a cappella singing group and leads the way to the national championship. The movie grossed $115 million at the box office, and its sequel, *Pitch Perfect 2* (2014), made a staggering $287 million worldwide, making it the most financially successful musical comedy in history.

It's a hip romantic-comedy with biting satire and a strong teenage female character—sounds like a still photo from Oscar-winner for Best Screenplay—2007's *Juno*, starring Ellen Page and Michael Cera

Honorable Mentions: *Election* (1999), *She's All That* (1999), *Bring it On* (2000), *The Princess Diaries* (2001), *The Sisterhood of the Traveling Pants* (2005), *She's the Man* (2006), *Juno* (2007), and *Easy A* (2010).

Three Great Female-Centric Comedies of the New Millennium

Legally Blonde (2001)

Karen McCullah and Kirsten Smith, screenwriters of *10 Things I Hate About You*, *Ella Enchanted*, and *She's the Man* adapted the novel by Amanda Brown about her own experiences in law school. Reese Witherspoon stars as Elle Woods, jilted by her college boyfriend, who decides to follow him to law school to try and win him back. Along the way, she has to deal with the snooty East Coast intellectuals that believe that because she's a blonde from Beverly Hills, she's not meant to be a Harvard lawyer. The film spawned two sequels, a Broadway

musical, made $141 million at the box office, and both the film and Reese Witherspoon were nominated for Golden Globes.

The Devil Wears Prada (2006)

Aline McKenna wrote the adapted screenplay from the novel by Laura Weisberger, who worked in the fashion industry before turning to writing. Anne Hathaway stars as recent college graduate Andy Sachs, who is hired to be the Assistant to Runway Magazine's Executive Editor Miranda Priestly (Meryl Streep). Miranda is the worst possible boss, and Andy has to choose whether to put up with her cruel attitude or stand up for herself. The film was a critical and box office smash, earning $326 million worldwide, Meryl Streep was nominated for her fourteenth Best Actress Oscar nomination, and won the Golden Globe for Best Actress.

Bridesmaids (2011)

Just when Hollywood had decided that women-centric comedies were box office poison, along came this movie that changed everything. *Saturday Night Live* cast member Kristen Wiig co-wrote the screenplay with actress/writer Annie Mumolo, and Wiig stars as Annie Walker, a single woman in her late thirties with no future and no prospects. When her best

Meet the *Bridesmaids:* Melissa McCarthy, Ellie Kemper, Rose Byrne, Wendi McLendon-Covey, Maya Rudolph, Kristen Wiig

Universal Studios/Photofest

friend Lillian (Maya Rudolph) is engaged, Annie relishes the opportunity to be her Maid of Honor, and meets her other bridesmaids, Rita (Wendi McLendon-Covey), Becca (Ellie Kemper), Lillian's future husband's sister, the crass Megan (Melissa McCarthy), and the groom's boss' wife Helen (Rose Byrne), who aggressively tries to steal away Annie's Maid of Honor responsibilities and make Annie look bad.

Bridesmaids was a colossal hit with critics and with audiences. The film made $288 million worldwide, and received two Oscar nominations—one for Best Original Screenplay and the other for Best Supporting Actress for Melissa McCarthy. It is the highest-grossing film in producer Judd Apatow's career (see Chapter 49) and opened the door for a slate of female-centric comedies, *Pitch Perfect* (2012), *Pitch Perfect 2* (2015), Amy Shumer's *Trainwreck* (2015), and Melissa McCarthy's films *The Heat* (2014), *Spy* (2015), and the reboot of *Ghostbusters* (2016) have all benefitted from the success of *Bridesmaids*.

Honorable Mentions: *Miss Congeniality* (2000), *Bridget Jones Diary* (2001), *Sex and the City* (2008), *The House Bunny* (2008), *Baby Mama* (2008), *Bride Wars* (2009), *In a World . . .* (2013), *The Heat* (2014), *Obvious Child* (2014), *The Intern* (2015), and *Trainwreck* (2015).

It appears that the future is bright for women-centric films, as long as talented women are making movies. Even better, the landscape of television has turned specifically toward female-centric audiences. The success of such programs as *Orange is the New Black*, *Madam Secretary*, and Shondra Rimes's various series (*Grey's Anatomy, Scandal, How to Get Away With Murder*) have opened the door for more female writers, directors, and producers than ever. How soon that will change the landscape of comedy films is a hope that remains to be seen.

Hollywood Studio Comedies

Mainstream success brings a lot to the table as a comedy filmmaker. Access to bigger budgets, expansive marketing, and better distribution avenues guarantee that audiences will have the ability to find a comedy film, provided the movie is good enough to climb the Social Darwinist ladder that is the Hollywood studio world.

Since the year 2000, there have been some very funny movies. A number of these pages have been devoted to a ton of films made over the last fifteen years (i.e., Judd Apatow's films in Chapter 49) but I'll highlight some of the ones that I haven't mentioned. You may want to check them out for the first time, or you might want to watch it again (now that you've learned so much from this book!). [Editor's Note: We look forward to hearing from you if you are willing to admit that you actually *learned something* from this enormous financial debacle.]

Top Crime-Caper Film

Ocean's Eleven (2001)

Independent filmmaker Steven Soderbergh teamed up with actor-director-producer George Clooney to create this remake of the 1960 Frank Sinatra Rat Pack film *Oceans 11*. Recently paroled thief Danny Ocean (Clooney) teams up with Rusty Ryan (Brad Pitt), Linus Caldwell (Matt Damon), and eight other accomplices to pull off the biggest heist in Las Vegas history—simultaneously hit three casinos owned by ruthless businessman Terry Benedict (Andy Garcia), who happens to be dating Danny's ex-wife Tess (Julia Roberts). The film made $450 million worldwide and it's two lesser-quality sequels, *Ocean's Twelve* (2004) and *Ocean's Thirteen* (2007), earned over a combined $600 million to put the franchise over the $1 billion mark.

Top Romantic Comedy

Crazy Stupid Love (2011)

This ensemble film follows three interweaving stories: Cal (Steve Carrell) and Emily (Julianne Moore) face a divorce after he learns she had an affair, Jake (Ryan Gosling) a womanizer that can score with every woman he wants, except for Hannah (Emma Stone) who somehow resists his charms, and Cal and Emily's son Robbie (Jonah Bobo) who has a crush on his babysitter, Jessica (Analeigh Tipton). How it all comes together is a joy to behold, with a smart script that doesn't pander to the formula of traditional romantic comedies. Ryan Gosling was nominated for a Golden Globe for Best Actor and Emma Stone won both Favorite Actress and Favorite Comedic Actress at the People's Choice Awards.

Top Holiday Dark Comedy

Bad Santa (2003)

This is not your grandparents' *A Miracle on 34th Street*. Oscar-winning actor Billy Bob Thornton (*Sling Blade*) plays Willie Stokes, an alcoholic, sex-addicted con man that takes jobs as a department store Santa, along with his friend Marcus who dresses as an elf, and together they rob stores on Christmas Eve. This year is the exception, when Willie falls for Sue (Lauren Graham), a bartender with a Santa fetish, and meets Thurman (Brett Kelly) a kid who still believes in Santa. It's rude, crude, and utterly funny if you like your comedy dark. The critics love this film directed by indie filmmaker Terry Zwigoff (*Ghost World*), it made nearly triple its budget back, Thornton was nominated for the Golden Globe for Best Actor, and a sequel is scheduled for release in late 2016.

Top Gross-Out Comedy

The Hangover (2009)

Hollywood loves their gross-out comedies, and it's the most reliable moneymaker of all the comedy subgenres. You don't need big stars, or huge special effects, or even a good script. Just a couple of penis jokes, at least one pair of naked female breasts, maybe a male buttock shot to keep things interesting, and a whole lot of drugs and alcohol.

That being said, *The Hangover* is clearly one of the best comedy films made in the last twenty years. It is so outrageous that it can't be accurately described in a couple of token paragraphs in the last chapter of this book. If the AFI gets off their asses and makes another 100 Years . . . 100 Laughs List, then this movie better be waaaay up there, or rioting will ensue.

Groom-to-be Doug Billings is convinced by his friends, Phil (Bradley Cooper) and Stu (Ed Helms), to all go to Las Vegas for his bachelor party. Unfortunately, they are forced to take Doug's eccentric future brother-in-law, Alan (scene-stealing Zack Galifianakis), along for the ride. They go to the roof of Caesar's Palace to start the night with a drink—and then—Zip. Nothing. Nada.

They wake up the next morning in their now-trashed hotel suite with no clue about what happened. Worse, Doug has disappeared, Stu is missing a tooth, there's a baby in the wardrobe, and a live tiger in their bathroom. And how is former boxing champion Mike Tyson involved? Where is Doug's father-in-law's Mercedes convertible? Too many questions and the clock is ticking to figure out what the heck they did last night, and where the groom is with two short days before the wedding.

At the time, *The Hangover* became the biggest comedy in movie history with a box office gross of $467 million worldwide. The critics gave it decent reviews, and it won the Golden Globe for Best Motion Picture–Musical or Comedy. The AFI named it one of the Top Ten films of the year. It spawned two sequels, *The Hangover Part II* (2011), which had the biggest opening weekend for a comedy in history and eventually grossed more than the first film, with $568 million worldwide. *The Hangover Part III* (2013) suffered some backlash due to the negative reaction to the first sequel and only made $360 million at the box office, making *The Hangover* franchise one of the most profitable in movie history.

The Hangover franchise also started a tsunami effect of "Bro-mance ensemble gross-out comedies" that have brought to life such films as *Hot Tub Time Machine* (2010), *Horrible Bosses* (2011), *Hall Pass* (2011), *21 Jump Street* (2012), *This is the End* (2013), *Let's Be Cops* (2014), *22 Jump Street* (2014), and *The Night Before* (2015).

Final Thoughts

What does the future hold for comedy film? As the twenty-first century continues to play out across our computer screens, smart TVs, and handheld tablets, movie theatres raise their prices every year while movie choices whittle down and are spread out across so many platforms that it's hard to keep track of them. Will we sit around wearing Google Glasses and veg out as the latest Will Ferrell movie is jacked straight into our cerebral cortex? Who knows? Definitely much smarter and wealthier people than me.

But I do know this. Having a sense of humor is an important quality that can directly contribute to having a great life. No matter how bad it gets, if you can find the chance to laugh a little each day, then take that opportunity. And great comedy films will make you laugh. No matter how bad life can get, you can always lose yourself in the laughter of comedy cinema. Also, every romantic comedy says that having a good sense of humor is an important characteristic that every significant other is looking for in a potential mate. So you'll have that going for you!

For over one hundred years, film comedy has been the cornerstone of the cinematic experience. It's darn hard to make a good comedy film. It's even harder to make a GREAT comedy film. I look forward to watching comedy films and working on the next edition of this book. Which will have just enough information to force you to buy it again and not get a used copy off of Amazon.

May the Schwartz Be With You!

Editor's Final Summary

After a nearly ten-year battle with the author to revise the second edition, the publisher's attorneys need a moment to put official statements on the record for all readers of *Great Comedy Films: or How I Learned to Stop Worrying and Love Funny Movies:*

First, if you didn't like the book, there's nothing you can do. You bought it and have to live with it. Our sincerest apologies.

Second, on the off chance that you *did* like the book, we appreciate you telling your friends and neighbors through various social media with the #greatcomedyfilms. We have invested a significant amount of money in this book and are hoping to climb out of the incredibly deep black hole that the author has brought to our fiscal balance sheet.

Lastly, the author has a website, greatcomedyfilms.com, and you are more than welcome to direct your opinions, good or bad, directly to him. Please keep us out of it. We have mouths to feed, insurance payments to make, and a lot of debt on our credit cards. Washing our hands of this entire affair and moving on is our best move at this point.

On behalf of the team here, we appreciate your patience and understanding. As God is our witness, we promise to never work with this author ever again. Except if this thing blows up, and then all bets are off . . .

FADE TO BLACK!

THE REVIEWS ARE IN!

Review by Gregg Maday
Professor of Screenwriting
Arizona State University

"An extremely comprehensive and insightful look at the history of comedy in film. Written in an easily accessible and often humorous style, Professor LaMont has created a must read for students of film as well as working professionals in the biz. If you love film, you will love this book."

Review by Philip Taylor
Film Professor
Arizona State University

"Once in a very long while, I am sent a book for review which rips up the rules and gives us a new perspective on an aspect of cinema that we assumed had been viewed from every angle . . . Chris LaMont's book on comedy films has that same breakthrough quality . . . LaMont's book adopts an innovative approach to the subject. He sets out to make us laugh. What a concept! Instead of a dry, academic litany of the highlights of comedy film-making, he takes us on a delightfully humorous introduction to the stellar comedic talents who have made a lasting imprint on the genre over the past century.

I cannot recommend this book highly enough. I only wish there was someone of LaMont's erudition and wit writing when I was in college."

Review by Brian Kohatsu
Professional Stand-Up Comic
Briankohatsu.com

"I recently had the privilege to read *GREAT COMEDY FILMS, Or: How I Learned to Stop Worrying and Love Funny Movies* by Chris LaMont. This book provides an amazing overview of the great comedy films and does it in a fun way. LaMont has really done his research and covers everything about the subject and more.

As a comedian, I understand all too well that comedy is very subjective to each individual. What is hilarious to you, may be complete nonsense to the person sitting next to you. Keeping that in mind, Chris LaMont has done a great job of presenting all the various types of comedy genres and sub-genres. He gives the reader enough information to encourage them to seek out these great films and to revisit their favorites.

I have read other books on comedy films and I've even had film classes that barely scratch the surface of comedy, but *GREAT COMEDY FILMS, Or: How I Learned to Stop Worrying and Love Funny Movies* is the most thorough. From the classic great comedies of the past to the future of comedy, this book covers it all. Chris LaMont has done an excellent job in putting together a wonderful comedy film resource for generations to come."

INDEX